The Rosary Cantoral

Eastman Studies in Music

Ralph P. Locke, Senior Editor
Eastman School of Music

Additional Titles in Music before 1750

Aspects of Unity in J. S. Bach's Partitas and Suites: An Analytical Study
David W. Beach

Bach and the Pedal Clavichord: An Organist's Guide
Joel Speerstra

Bach's Changing World: Voices in the Community
Edited by Carol K. Baron

The Chansons of Orlando di Lasso and Their Protestant Listeners: Music, Piety, and Print in Sixteenth-Century France
Richard Freedman

Dieterich Buxtehude: Organist in Lübeck
Kerala J. Snyder

Explaining Tonality: Schenkerian Theory and Beyond
Matthew Brown

The Gardano Music Printing Firms, 1569–1611
Richard J. Agee

Historical Musicology: Sources, Methods, Interpretations
Edited by Stephen A. Crist and Roberta Montemorra Marvin

Music and Musicians in the Escorial Liturgy under the Habsburgs, 1563–1700
Michael Noone

Music and the Occult: French Musical Philosophies, 1750–1950
Joscelyn Godwin

The Music of the Moravian Church in America
Edited by Nola Reed Knouse

Musicking Shakespeare: A Conflict of Theatres
Daniel Albright

Pentatonicism from the Eighteenth Century to Debussy
Jeremy Day-O'Connell

The Substance of Things Heard: Writings about Music
Paul Griffiths

Theories of Fugue from the Age of Josquin to the Age of Bach
Paul Mark Walker

A complete list of titles in the Eastman Studies in Music Series, in order of publication, may be found at the end of this book.

The Rosary Cantoral

*Ritual and Social Design in a
Chantbook from Early Renaissance Toledo*

LORENZO CANDELARIA

University of Rochester Press

The University of Rochester Press gratefully acknowledges generous support from the Otto Kinkeldey Publication Endowment Fund of the American Musicological Society.

Copyright © 2008 Lorenzo Candelaria

All Rights Reserved. Except as permitted under current legislation, no part of this work may be photocopied, stored in a retrieval system, published, performed in public, adapted, broadcast, transmitted, recorded, or reproduced in any form or by any means, without the prior permission of the copyright owner.

First published 2008
Transferred to digital printing and reprinted in paperback 2010

University of Rochester Press
668 Mt. Hope Avenue, Rochester, NY 14620, USA
www.urpress.com
and Boydell & Brewer Limited
PO Box 9, Woodbridge, Suffolk IP12 3DF, UK
www.boydellandbrewer.com

ISSN: 1071-9989
Cloth ISBN-13: 978-1-58046-205-1
Cloth ISBN-10: 1-58046-205-7
Paperback ISBN-13: 978-1-58046-354-6

Library of Congress Cataloging-in-Publication Data
Candelaria, Lorenzo F.
 The Rosary Cantoral : ritual and social design in a chantbook from
 early Renaissance Toledo / Lorenzo Candelaria.
 p. cm. — (Eastman studies in music, ISSN 1071-9989 ; v. 51)
 Includes bibliographical references (p.) and index.
 ISBN-13: 978-1-58046-205-1 (hardcover : alk. paper)
 ISBN-10: 1-58046-205-7 (alk. paper)
 1. Rosary Cantoral. 2. Illumination of books and manuscripts, Renaissance—Spain—Toledo. 3. Music—Spain—16th century—History and criticism. I. Title.
 ML93.C32 2008
 782.32'320262—dc22

2007030974

A catalogue record for this title is available from the British Library.

This publication is printed on acid-free paper.

*To my first teachers,
Carmen and Frank Candelaria*

Contents

List of Illustrations		viii
Acknowledgments		ix
Introduction		1
1	The Mystery of the Rosary Cantoral	6
2	San Pedro Mártir de Toledo	22
3	"El Cavaller de Colunya": A Legend of the Rosary	39
4	The Emblem of the Five Wounds	58
5	Hercules and Albrecht Dürer's *Das Meerwunder*	79
6	Roses for the Blessed Virgin: The Music	94
7	The Confraternity of Toledo and Its Patronage	116
Epilogue		128
Appendices		131
Notes		149
Bibliography		191
Index		207

Illustrations

Music Examples

3.1	Cantiga 121, "De muitas maneiras" (*virelai*) from *Las Cantigas de Santa María*	53
4.1	"Los set goytx" (ballade, round dance) from *El Llibre Vermell de Montserrat*	76
6.1	"Kyrie cunctipotens domine," Rosary Cantoral	96
6.2	"Xpriste patris genite," Rosary Cantoral	97
6.3	(a) "Omnes virgines," Rosary Cantoral; (b) Marian Sanctus, *Officia ad missas*	98
6.4	"Compound trope" for the Agnus Dei, Rosary Cantoral	100
6.5	"Ave maria celi regina," Tortosa, Biblioteca Capitular	101
6.6	(a) Kyrie "Summe deus" (incipit), Rosary Cantoral, with the *tocus* and *uncus*; (b) "Summe deus" (incipit) without the *tocus* and *uncus*	102
6.7	Various uses of *estrunto* in the Rosary Cantoral: (a) ornamenting a monotonous melodic line; (b) ornamenting a lower neighbor; (c) ornamenting a cadence	103
6.8	Transcription of a mensural chant for the Gloria, Rosary Cantoral	104
6.9	(a) Anonymous, "Et incarnatus est" on "L'homme armé," Rosary Cantoral; (b) "Et incarnatus est" of a Marian Credo, Rosary Cantoral	106
6.10	Anonymous, "L'homme armé"	107
6.11	Polyphonic "Et incarnatus est" (incipit), El Escorial, Cantoral 210	108
6.12	(a) *Altus* from the "Et incarnatus est" by Giovanni Pierluigi da Palestrina, *Missa quarta* (*L'homme armé*); (b) *Superius* from the anonymous "Et incarnatus est" on "L'homme armé," Rosary Cantoral	110
6.13	(a) melodic segment corresponding to "d'un haubregon de fer" in "L'homme armé"; (b) melodic segment corresponding to "Maria Virgine" in the anonymous "Et incarnatus est" on "L'homme armé," Rosary Cantoral	111
6.14	Josquin Desprez, "Et incarnatus est" of the *Missa sine nomine*, Rosary Cantoral	112

Figures follow page 127

Acknowledgments

Much of the research for this book was undertaken with the generous support of grants and fellowships from the University of Texas at Austin where I have been on faculty since 2001. I am especially grateful for the Walter & Gina Ducloux Fine Arts Fellowship and the release time I was granted as a Dean's Fellow at the College of Fine Arts. Both allowed me to complete this book in a timely fashion. The University of Texas Humanities Institute, directed by Dr. Evan Carton, provided a stimulating environment for shaping and polishing sections of this book. Earlier stages of research were made possible thanks to a J. William Fulbright Grant, grants from the Social Science Research Council, and a summer fellowhip at the Beinecke Rare Book and Manuscript Library.

The pleasure of writing this book was due in no small part to a number of colleagues who offered sound advice, provided sources, and stimulated my thinking in a variety of ways. Foremost, is my friend and mentor Professor Craig Wright at Yale University who introduced me to the chantbook at the heart of this study over ten years ago and who has followed its developing story with interest ever since. I am also indebted to Professors Ellen Rosand, Carlos Eire, and Margot Fassler at Yale University; Professor Anne Walters Robertson at the University of Chicago; Professor Steven Plank at Oberlin College; Dr. Tess Knighton at Cambridge University; Professor Robert Stevenson at the University of California, Los Angeles (emeritus); Professor Ismael Fernández de la Cuesta at the Real Conservatorio Superior de Música in Madrid; Dr. Robert Babcock, curator at the Beinecke Rare Book and Manuscript Library; Dr. William Voelkle, curator at the Pierpont Morgan Library; Friar Jesús Santos, OP, at Santo Domingo de Ocaña; Friar Jafet Ortega, OSA, at San Lorenzo de El Escorial; Father Ángel Fernández Collado and Father Ramon Gonzálvez at the Cathedral of Toledo; and, Dr. Michael J. Noone. At the University of Texas, I wish to thank Professor Michael C. Tusa, Professor Rebecca A. Baltzer, Professor Jeffrey Chipps Smith, and, Dr. Robert S. Freeman, Dean of the College of Fine Arts. At the University of Rochester Press, I thank my editors, Ralph Locke, Suzanne Guiod, and Katie Hurley, for shepherding me through the process of publishing this book.

Sections of this book were previously published in academic journals. Parts of chapters 3 and 7 appeared in "*El Cavaller de Colunya*: A Miracle of the Rosary in the Choirbooks of San Pedro Mártir de Toledo," *Viator: Medieval and Renaissance Studies* 35 (2004): 221–64. A preliminary version of chapter 5 was published as "Hercules and Albrecht Dürer's *Das Meerwunder* in a Chantbook from Renaissance Spain," *Renaissance Quarterly* 58, no. 1 (2005): 1–44. Part of chapter 6 appeared in "Tropes for the Ordinary in a 16th-Century Chantbook from Toledo, Spain," *Early Music* 34, no. 4 (2006): 587–611. I gratefully acknowledge the permissions to draw from these articles.

I reserve my warmest and most heartfelt thanks for my loving wife, Monique, and our three beautiful children, Geneva, Raphael, and Gabriela. The sheer joy and happiness they bring to life made the writing of this book something of a family affair. I will always reflect on the experience fondly because of them.

Finally, a note to my parents, Carmen and Frank Candelaria.

Mom and Dad—you were my first teachers, my best teachers, and the most supportive parents a son could hope for. This book is dedicated to you.

<div style="text-align: right;">
Lorenzo Candelaria

Austin, Texas

St. Patrick's Day, 2007
</div>

Introduction

The Rosary Cantoral is an illustrated book of music for the Mass compiled in Spain around the year 1500. It is a large plainchant manuscript for a religious institution and thus a *cantoral*, which, in modern Spanish usage, distinguishes books such as this one from a *libro de coro*. The latter term refers to a book consisting of polyphonic music (as opposed to plainchant) that is usually liturgical. The iconography in this *cantoral* reflects its close ties to a Catholic lay confraternity devoted to the rosary—an exercise in pious meditation that consists of 50 iterations of the Marian prayer "Ave Maria gratia plena" (Hail, Mary full of Grace, derived from Gabriel's angelic salutation to the Virgin Mary) divided into decades by five recitations of the "Pater noster" (Our Father, The Lord's Prayer). At each "Pater noster" one is obliged to reflect on a prescribed event called a "Mystery" from the life of Christ or the Virgin Mary. Typically, the cycle is repeated three times, so the result is 150 "Ave Marias," 15 "Pater nosters," and 15 Mysteries that constitute, in effect, a mini-Gospel for the layperson.

After one spends nearly a decade researching the manuscript at the heart of this study, "Rosary Cantoral" rolls easily off the tongue. The two words casually reflect very basic things about the manuscript's content (it is a chantbook), origin (it is Spanish), and affiliation (it was tied to a rosary confraternity). But just a few years ago even those simple facts were uncertain.

The Beinecke Library at Yale University acquired the Rosary Cantoral (Beinecke Library, Ms. 710) in 1989 as part of the "Witten Purchase," one of the largest single additions to its collection of Medieval and Renaissance books and manuscripts.[1] The chantbook was among various items in an impressive lot purchased from Laurence Witten Rare Books in Southport, Connecticut. The lot included twenty Medieval and Renaissance manuscripts, ten *incunabula* (books printed before 1500), sixteen printed books from the sixteenth century, and numerous others that were more recent. Among those, however, the Rosary Cantoral was the clear standout—initially for its sheer size. Each of the two boards binding the manuscript measures an extraordinary 96 × 62 cm (their total span is 127 cm when the book is opened) and inside are 103 folios of vellum. The folios are so large that every one of them would have required a full calfskin.

The first opening of the manuscript draws one closer with its magnificent illumination (see figs. 1 and 2), particularly the fully painted letter inhabited by the

Virgin and Child, which alone measures nearly 30 × 30 cm. Closer inspection of the large illumination reveals that the Madonna and Child are not alone. They are flanked by two men who pose on either side of the Virgin's throne and create the impression of a donor portrait. At the bottom of each folio, two angels hold a white cloth in the manner of a heraldic emblem. The cloth is marked by the Five Wounds of Christ and an inscription in gold along the bottom that reads "Miserere Mei" (Have mercy on me). Solitary angels hold smaller versions of the emblem in the side margins of each folio.

The style of decoration is Franco-Flemish and reflects a date of production very close to the year 1500. One border painting, modeled after an engraving by the renowned Albrecht Dürer (1471–1528), his *Das Meerwunder* (The Sea Monster) from 1498, suggests the year after which it must have been compiled (see figs. 1, 17, and 18). To the left of that painting, just beyond the emblem of the Five Wounds, is a miniature of Hercules wrestling the Libyan giant Antaeus (see figs. 1 and 15). Immediately to the right of *Das Meerwunder* is a depiction of Hercules wearing the hide of the Nemean lion with his club raised to strike the Hesperian dragon (see figs. 2 and 16).

Throughout the manuscript eight additional folios are lavishly decorated with full or partial bar borders incorporating a rich assortment of flowers, fruits, insects, birds, vines, *putti* (plump cherubs), and other figures.[2] Aside from the grand illuminated "R" in the first opening of the chantbook, there are sixty-eight large painted initials (on average 14 × 11 cm) and four small painted initials (around 5.5 × 6.5 cm) on gatherings that were part of the initial compilation. (As we shall see, several additions have been made over time.) With few exceptions, the painted initials are either blue or pink foliate letters against a light brown background that has been carefully shaded and highlighted with light gold brushstrokes to fool the eye into perceiving a three-dimensional quality. Finally, to underscore the Marian theme projected in the opening illumination, six times throughout the manuscript the name "Maria" is highlighted in goldleaf and azure.[3] The likeness of a jewel-encrusted crown also adorns her name in most instances, alluding to her advocation as the Queen of Heaven (see fig. 1).

The manuscript's size and rich decoration riveted observers as clear indicators of the time, money, and labor expended on this chantbook. Once those initial impressions faded, its musical contents pointed toward greater depth and complexity.

Most of the music in the Rosary Cantoral is plainchant for the unchanging texts of the Mass Ordinary: the Kyrie, Gloria, Credo, Sanctus, and Agnus Dei. It is thus a Kyriale—a liturgical book that served the choir of some ecclesial institution. As books containing the most regularly chanted texts for the Mass, Kyriales (particularly those of such a late date) are not typically very exciting. The Rosary Cantoral is exceptional, however, as most of the Ordinary chants in its repertory are richly ornamented by tropes. This is unusual for a manuscript from around 1500 because tropes are broadly understood as textual and/or

musical additions to chants of the Mass that flourished from the ninth to twelfth centuries but gradually fell out of fashion afterward. Tropes are thus distinctly Medieval creations. Yet the Rosary Cantoral transmits no fewer than twenty-two tropes for the Mass Ordinary: thirteen for the Kyrie, one for the Gloria, five for the Sanctus, and three for the Agnus Dei.

One of the tropes for the Kyrie appears on the opening folios of the manuscript (see figs. 1 and 2). The melody for the chant there is fairly widespread and of no particular importance; the text itself normally would have been "Kyrie eleyson / Christe eleyson / Kyrie eleyson" (Lord have mercy / Christ have mercy / Lord have mercy). But that customary text—recited at the start of every Catholic Mass, on every day of the year—is ornamented here by new verses to make the chant more relevant to the Marian feasts indicated by the rubric ("in festivitatibus beatissime virginis marie"). Thus, on days that venerate the Virgin Mary—the Feast of the Purification (February 2) or the Feast of the Annunciation (March 25), for example—the text that follows would have been performed. Note the "eleyson" retained in each line as a vestige of the original text. The "Christe" at the start of the second verse also forms part of the original.

> Rex virginum amator deus marie decus ELEYSON
> CHRISTE deus de patris homo natus maria matre ELEYSON
> O paraclite obumbrans corpus marie ELEYSON
>
> O Lord, beloved of virgins, privileged God of Mary, HAVE MERCY
> CHRIST, God of the Father, man born by Mother Mary, HAVE MERCY
> O Holy Spirit, overshadowing the body of Mary, HAVE MERCY

In a broader sense, the troped chants in the Rosary Cantoral are the aural counterparts to its lavish illuminations: one embellishes the visual field, the other embellishes the soundscape created around the book as people sing from it. Chapter 6 will discuss the decorated chants in this chantbook more fully. It suffices for the moment to highlight two additional instances of cues for aural ornamentation in the Rosary Cantoral. These involve polyphony and, in this case, music written for four distinct parts in four different vocal ranges: *superius* (highest), *altus*, tenor, and *bassus* (lowest).

Although the significance of the chants only gradually became apparent, music historians quickly realized the importance of two polyphonic works that appear in the manuscript. One is attributed to Josquin Desprez (ca. 1455–1521), the most celebrated composer of the Renaissance, and appears on the recto of folio 99 (see fig. 24). The music sets the "Et incarnatus est" of the Credo and is, in fact, an excerpt from the composer's *Missa sine nomine*. The other work is unattributed and appears without a text on the verso of folio 101 (see fig. 25). It is not among Josquin's known works; indeed, a few awkward moments reflect the compositional skill of an amateur. The work remains of

interest, however, because the bottom two lines (the tenor and *bassus*) were clearly derived from the popular song "L'homme armé" (The Armed Man), which served as the basis for at least thirty-five polyphonic Masses composed between 1450 and 1600, many by the best-known composers in Western Europe.

The polyphony on "L'homme armé," the excerpt from Josquin's Credo, and the painting after Dürer's *Das Meerwunder* derive from a work, a composer, and an artist that any comprehensive course on Renaissance culture would highlight as exemplary of the period. And yet, through the medium of this chantbook, they share liturgical space with a rich legacy of Medieval tropes. An astute observer around 1500 might have noticed that this Kyriale had one foot planted firmly in the present while the other remained in the past.

Collation and Contents

The state of the manuscript reflects that its material was used over a long period of time and was altered extensively. Its 103 folios are organized into seventeen quires with this collation: I–VI8, VII5, VIII2, IX5, X^8, XI2, XII6, XIII–XIV4, XV3, XVI6, XVII10. Foliation in Arabic numerals was added at a later date and runs to the number 111, with folios 61 and 70–76 missing; these were lost or removed after the Arabic numerals were added. Only Gatherings I–V are in their original states. Gatherings VI, VII, and XI though XV formed part of the initial compilation, but several folios have been removed, corrected, or are otherwise palimpsests (that is, they have been scraped clean of original material and something new has been written on them). Gatherings VIII, IX, and X are quires from unrelated manuscripts inserted at a later date. Gatherings XVI and XVII are later insertions on folios that, judging from their measurements and overall design, were probably from a companion Antiphoner or Gradual. A small banner around a calligraphic initial on folio 106 in the final gathering (XVII) preserves the incription "1597"—the hardest evidence of a date for the later material in the Kyriale. With that date, and the date of 1498 suggested by the *Meerwunder* painting, we can surmise that the Kyriale was used at least throughout the sixteenth century. The extensive alterations undoubtedly reflect the various attempts at liturgical reform that culminated in the papally sanctioned Medicean Gradual of 1614 and 1615.[4]

In addition to the core repertory for the Ordinary, the Rosary Cantoral includes one Sequence for Easter ("Victime paschali laudes"), two Sequences for Pentecost ("Veni sancte spiritus" and a fragment for "Sancti spiritus"), and two antiphons for the "asperges" ("Asperges me" and "Vidi aquam")—the ritualized sprinkling of holy water on the assembly prior to the Mass. Material inserted at a later date includes several more recent chants for the Ordinary, Josquin's "Et incarnatus est," the anonymous fragment on "L'homme armé," and ten Tracts for various feasts. The Tracts would have substituted for the

Alleluia during Lent and are the only chants inconsistent with the material typically found in Kyriales. All of the Tracts appear at the end of the Rosary Cantoral in Gatherings XV through XVII. Appendix E presents a full inventory of the forty-eight liturgical items in this chantbook.

The Rosary Cantoral has been recognized as an important cultural artifact since its acquisition in 1989. Codicologists were struck by its size, art historians by its opulent decoration, music historians by its polyphony, and liturgical scholars by its unusual collection of tropes. No one could determine, however, where precisely the Kyriale had originated. The provenance of the Rosary Cantoral was a mystery and, as the largest book in the Beinecke's collection, a prominent mystery at that.

Chapter One

The Mystery of the Rosary Cantoral

A thick collection of letters from scholars, curators, and rare book dealers in the acquisition file for Beinecke Ms. 710 reflects a persistent drive to solve the mystery of the origins of the Rosary Cantoral. Although the letters are many, the leads are few and often contradictory. To some observers it seemed Flemish, to others Italian. Laurence Witten's description offered little information, noting only that the "Giant Choir Book, c. 1525 . . . is said to have come from Switzerland."[1] Witten later revised his claim in a letter to the Beinecke Library's curator in which he described a revelation of sorts that led him to wonder whether the chantbook was not, in fact, Spanish. The reassessment was spurred by Witten's memory of having sold a leaf to a collector in New Haven, Connecticut, that bore some resemblance to the design of the Beinecke Kyriale. That leaf, Witten said, "is certainly Spanish in my opinion, is huge and has borders containing angels supporting the holy cloth depicting the wounds of Christ" (see fig. 3). Witten continued:

> I feel certain it's from the same original source as the big Diurnal you just bought. That's the revelation, now the speculation: why indeed is the Diurnal not Spanish, too, with the illumination all Flemish-inspired as so often? I feel like an idiot for not having thought of this sooner. Besides, nearly all these huge antiphoners of that period are Spanish, aren't they?[2]

Witten's inclination toward a Spanish provenance was supported by historians who noted similarities to manuscripts from Ávila, Burgo de Osma, Burgos, Cáceres, Palencia, Segovia, and Toledo.[3] The emblem of the Five Wounds was especially thought-provoking for many who saw it. Sandra Sider, then curator of manuscripts and rare books at the Hispanic Society of America in New York City, reasoned that "the stigmata could be connected to St. Francis, thus tying your manuscript to a Franciscan house in Spain."[4] Art historian Lynette Bosch, an expert on Spanish manuscript illumination, ventured a connection between the emblem and the figures accompanying the Virgin and Child in the illuminated letter: "the kneeling figure indicates some royal patronage and the five wounds

are perhaps a reference to the arms of the Acuña family."⁵ The kneeling figure and the emblem of the Five Wounds led Jaume Riera, an expert in Spanish heraldry at the Archivo de la Corona in Barcelona, to comment on what he perceived as a major problem in the manuscript. It was one of several features that puzzled him.

> Another anomaly that I see in this Kyriale is a contradiction between the emblem and the representation of the donor [in the illuminated letter]. The emblem is religious . . . and we should attribute it to a convent or monastery; but the presence of the donor obliges us to attribute to him the emblem found on the borders of the folio where he is represented. The puzzle of this arrangement has no solution: either the donor has no emblem (which is inadmissable), or the book was commissioned by the religious order (in which case the presence of the donor makes no sense).⁶

The perceived "anomaly" in the Kyriale led Riera to say that he would not be surprised if the chantbook turned out to be the work of a nineteenth- or twentieth-century forger.⁷ Raising the specter of a forger, however, failed to quell the need for resolution. If anything, speculation over the Kyriale's authenticity only placed greater urgency on answering a very basic question: Where had this manuscript come from?

Discovery of Related Folios

The specter of a forger also did nothing to discourage the Beinecke from purchasing a related leaf just a few years later. In September 1994, Sam Fogg Rare Books in London sold a single folio to the Beinecke (Beinecke Library, Ms. 794) that bears an emblem of the Five Wounds inscribed with the motto "Miserere Mei" and an illuminated letter with a subject identical to that in the Kyriale (see fig. 4).⁸ Its dimensions (91.5 × 63.5 cm) reflect that it was extracted from a book very similar in size. Additional decoration includes a small row of roses along the top; four angels holding trumpets along the right border; Saints Andrew, Paul, Philip, and James the Less along the left; and the Old Testament Prophets Jeremiah and Zacharias on either side of the emblem centered at the bottom. The leaf is a palimpsest. The original chant, "Sacerdos et pontifex," was an antiphon for the Magnificat performed at Vespers on feasts commemorating a confessor bishop. That chant was subsequently scraped from the vellum and replaced with the current chant, "Intret in conspectu tuo," the Introit for the Mass on feasts of two or more martyrs outside of Eastertide. Fortunately, the large illuminated letter "S" from the original chant was spared from erasure at the time of the change. The original rubric was left intact as well. Nonetheless, the changes to the chant suggest the leaf had once formed part of an Antiphoner (a book containing antiphons for the Divine office: Matins, Lauds, Prime, Terce,

Sext, None, Vespers, and Compline) but was then extracted and transplanted into a Gradual (a book containing all the Proper chants for the Mass including the Introit, Gradual, Alleluia or Tract, Offertory, and Communion).

The acquisition of Beinecke Ms. 794 in 1994 brought to the forefront many of the unanswered questions about the Kyriale the library had purchased in 1989. This time, however, the correspondence it generated led to an astonishing revelation: both Beinecke manuscripts were part of a larger mystery that dated back to the 1950s.

* * * * *

In 1958 the Pierpont Morgan Library in New York City acquired two large folios (92.8 × 60 cm) marked by the emblem of the Five Wounds and inscription "Miserere Mei" from William S. Glazier (1907–62), an investment banker with Lehman Brothers and a collector of Medieval and Renaissance manuscripts.[9] Both leaves contain chants from the Proper of the Mass and thus formed part of a Gradual. They are cataloged at the Morgan as Ms. M887-1 and Ms. M887-2. The former transmits the chant "Ad te levavi," the Introit for the first Sunday in Advent (see fig. 5). Its large illuminated initial "A" depicts the same figures (the Virgin, Christ Child, and two men) as the initials in the Beinecke's Kyriale (Ms. 710) and single folio (Ms. 794). Two vignettes showing Hercules and the Hesperian dragon along the lower border present further correspondences with the decoration in the Kyriale. The folio M887-2 transmits the Introit for the Mass on Easter Sunday ("Resurrexi et adhuc"). Its illuminated letter "R" shows the Resurrection of Christ; two vignettes in the lower border depict Christ's subsequent appearance before Mary Magdalen and the Virgin Mary. Neither leaf has been traced to its original owner.[10]

The Morgan Library researched its Gradual leaves with an intensity on par with the Beinecke's investigation into the Kyriale it acquired around thirty years later. The Morgan had few details about either leaf in 1958, but there appears to have been no doubt they were Spanish.[11] Where *exactly* in Spain they were from was another matter.

As with the Beinecke's Kyriale, the suspected donor portrait on one of the leaves and the shared emblem of the Five Wounds drew most of the attention. John Plummer, then curator at the Morgan, sought the counsel of Harvard University's eminent art historian Chandler Rathfon Post, whose authority still rests firmly on his monumental *A History of Spanish Painting*, published in fourteen volumes between 1930 and 1966.[12] True to form, Post made an important clarification in a letter to Plummer dated May 25, 1959. He reported that the subject of the illumination was not a donor portrait but depicted "a very common theme in Spanish painting, the Miracle of the Gentleman of Cologne," which he associated with the cult of the rosary.[13] Post had addressed the theme in his 1938 volume of *A History of Spanish Painting*, which included this synopsis:

The commoner version of the story runs that this gentleman, having slain a friend in a quarrel, was beset by the victim's revengeful brother, who eventually came upon him praying before an altar of the Virgin. The brother noticed, however, that the murderer was not alone but that the Mother of God stood by his side and that roses were issuing from his mouth which she wove into a garland and placed upon his head. The immediate result of the vision was that the avenger desisted from his purpose and was reconciled with his enemy.[14]

The story corresponded perfectly with the illumination in Morgan M887-1 (see fig. 5). Careful scrutiny of the image reveals that the man kneeling to the left of the Virgin wears the fabled garland of roses. The Virgin holds a needle and golden thread. In the Beinecke's Kyriale (see fig. 1), the man kneeling to the left also wears a garland of roses, while the Virgin and Child each hold a single rose. Post's interpretation of the subject was a major breakthrough. Nonetheless, he remained confounded by the emblem of the Five Wounds, noting to Plummer with evident frustration: "I stupidly cannot explain the escutcheon of the wounds of Christ."[15]

* * * * *

In 1959, the year following William Glazier's presentation of two leaves at the Morgan, the Detroit Public Library acquired four others of similar size and design. One is still preserved in the Burton Historical Collection. It displays the emblem of the Five Wounds, an illuminated initial with Post's "Miracle of the Gentleman of Cologne," and the chant "Nos autem gloriari."[16] The chant is the Introit for the Mass on the Thursday of Holy Week (the week leading up to Easter Sunday), which identifies the source as a Gradual.

The Detroit Library purchased its four leaves in 1959 from Philip C. Duschnes, a rare book dealer and publisher in New York. Duschnes initiated the sale in a letter on June 11, 1959, to Mabel Conat, the Detroit Library's curator of books.

> At the request of Mr. John S. Newberry, Jr., we have sent to you today four magnificent antiphonal leaves with the largest historiated initials I have ever seen. It is not only because of the size that these leaves are so desireable but because of the quality of the paintings. Mr. Newberry is quite enthusiastic about these and wishes to present them to the library.
> I am sure that you will find this group to be one of the library's most treasured and important acquisitions. Two of the leaves from this same antiphonal were presented to the Pierpont Morgan Library and are proudly displayed in their exhibitions. Mr. William Glazier presented them at a special ceremony about a year and a half ago; supplied from the same source.[17]

Duschnes peddled his wares with the flair of a circus barker. The enclosed description for one of the leaves announced in grandiose terms: "vellum leaf with historiated initial of heroic proportions from a Spanish Antiphonal of the

late fifteenth century." The description offered the welcome details that the leaf was "from an Antiphonal belonging to a monastery near Toledo, Spain *circa* 1490" and that its emblem "appears to be the sign of the monastery for which this Antiphonal was executed."[18] Spurred by Duschnes's indication of "a monastery near Toledo," the Detroit Library soon initiated correspondence with the Cathedral of Toledo, Spain, hoping to uncover more about the origins of its folios. The result was mixed, as one letter from Toledo seemed to lend clarity to the emblem of the Five Wounds but greatly undermined what Duschnes had expressed about the provenance of the leaves. In response to an inquiry from Frances J. Brewer, chief of the rare books division at Detroit, the canon archivist of Toledo Cathedral, Juan Francisco Rivera, reported on January 21, 1962:

> In examining the photographs that you sent, I could not come to definite conclusions as to the provenance or date. Traditionally, from the liturgical text, we date such manuscripts from the end of the 15th to the middle of the 16th century. Anyway, in this form we cannot even be sure that they were written in Toledo. The coat of arms and emblems mean nothing concrete but they are ascribed to the Franciscan order. Franciscan convents exist abundantly in the whole nation. I have inquired with the antiquarian book trade of Toledo, especially those dealers from which they may have been acquired, but nobody remembers having sold these leaves. They must have been purchased from some other place.[19]

The best potential lead had turned into a blind alley. On November 2, 1962, Frances Brewer wrote the Morgan Library about their "unresearchable Spanish leaves."[20] With that letter, and with all of the setbacks and maddening contradictions, work on uncovering the origins of the leaves sputtered to a halt.

The Search Continues

In 1986, almost a quarter of a century later, William Voelkle, curator of Medieval and Renaissance manuscripts at the Morgan Library since 1983, reopened the investigation into the "unresearchable Spanish leaves" and, in the process, discovered several additional folios. All of the new leaves were tied to Norman Strouse (1906–93), a former advertising executive and an ardent bibliophile. Strouse spent a lifetime working for the J. Walter Thompson Company, a career that took him from his hometown, Olympia, Washington, to Seattle, San Francisco, and, ultimately, Detroit, Michigan, in 1946. After establishing himself in Detroit with successful work on Thompson's advertising contracts with the Ford Motor Company, he moved quickly through the ranks of manager, director, president, chief executive officer, and chairman of the board. In 1968, Strouse retired to St. Helena, California, where he and his wife, Charlotte, helped found the Silverado Museum, dedicated to the life and works of Robert Louis Stevenson.[21]

Strouse's connection to the leaves was brought to Voelkle's attention in a letter from Ellen Shaffer, curator at the Silverado Museum. The letter, dated March 29, 1986, notes that Strouse had in his home a large Spanish leaf with an initial showing the descent of the Holy Spirit over the Apostles on Pentecost and "three angels in the margins displaying white cloths with the five wounds."[22] Within days she followed up with a photograph confirming that the emblems were identical to those in the Morgan and Detroit leaves.[23] From that photo, it is clear that the chant is "Spiritus domini," the Introit for the Mass on Whit Sunday (Pentecost), which identifies the source as a Gradual. A major break came later that year when Strouse mailed out a set of Christmas cards decorated with the leaf in question. (It did not seem to matter that Christmas and Pentecost are on opposite ends of the liturgical year.) Shaffer was one of the recipients, and she forwarded the card to the Morgan Library. What made that card so significant was an engraved message on the inside that offered valuable information about the image on the cover:

> One of nine illuminated Fifteenth Century manuscript pages brought out of Spain to Paris at the beginning of the civil war in 1936.
> Nothing is known about the provenance of the choir book from which these leaves came, except that it was rumored to have been in a convent near Toledo.
> Many famous songs have been brought down through the centuries by way of medieval choir books. So that the choir could read the words & notations in a dimly lighted chapel, the leaves often attained huge proportions and were lavishly decorated. The one reproduced here, from my collection, is two by three feet in size, and shows Pentecost.
> Of the remaining eight leaves, two are in The Pierpont Morgan Library, four are in the Detroit Public Library, and two [are] in a private collection.[24]

The current whereabouts of the Pentecost leaf are unknown. We can be certain, however, that it was last owned by Norman Strouse in 1986. By then it was a long-standing tradition in the Strouse family to mail Christmas cards decorated with images of manuscripts from their collection. A card they had mailed out years earlier, in 1961, proves Strouse's connection to at least one more "of the remaining eight leaves."

* * * * *

In 1961, Norman Strouse and his wife (then living in Detroit) sent out Christmas cards that were almost identical to the one Shaffer would receive in 1986, a quarter of a century later. The format of the card was the same, the information inside the card was virtually identical, and the leaf pictured on the outside was also marked by the emblem of the Five Wounds. But instead of

the illumination for Pentecost, that folio depicted "The Miracle of the Gentleman of Cologne."[25]

Fortunately, the leaf decorating the Strouses' 1961 Christmas card found its way into a public collection. It was purchased in 1995 by the Getty Museum in Los Angeles from Sam Fogg Rare Books and Manuscripts in London. It is cataloged at the Getty as Ms. 61 (see fig. 6). The chant, "Judica me deus," is the Introit for the Mass on Passion Sunday (the fifth Sunday of Lent) and identifies the source for the leaf as a Gradual.

The known provenance of the Getty leaf is complex but extremely valuable, as it connects the folio to Philip C. Duschnes and the Detroit Public Library. According to the Getty's records, Duschnes sold it to the Detroit Public Library (presumably as part of the four leaves offered in 1959), bought it back, then sold it to Norman Strouse (presumably in 1960 or 1961, while Strouse was in Detroit working for the J. Walter Thompson Company). Another bit of vital information in the Getty's records is the key indication that, before Duschnes, Getty Ms. 61 was owned by a rare book dealer in Paris.

As historical documents, Strouse's Christmas cards from 1961 and 1986 demand caution. But, used cautiously, they can provide important corroborating evidence. Here they allow us to discern that Strouse's Pentecost leaf and Getty Ms. 61 were among "nine illuminated Fifteenth Century manuscript pages" from a book that "was rumored to have been in a convent near Toledo" and, furthermore, that the leaves were "brought out of Spain to Paris at the beginning of the civil war in 1936." Sometime after 1936, Getty Ms. 61 fell into the hands of a book dealer in Paris. We can assume that Strouse's Pentecost leaf had too. If we follow the Getty's records, that Parisian book dealer was named Arthur Rau.[26]

Arthur Rau: Parisian Book Dealer

The rare book and manuscript trade is a labyrinthine business full of twists, turns, and blind alleys. And so it is that we find ourselves back where we started: with Beinecke Ms. 794 (see fig. 4), the folio that led to the discovery of related manuscripts. This folio, as it turns out, was also connected to Arthur Rau.

The histories of Getty Ms. 61 and Beinecke Ms. 794 present striking parallels. The Beinecke Library acquired Ms. 794 from Sam Fogg Rare Books in September 1994, the year before the Getty Museum purchased Ms. 61 from the same firm. Sam Fogg had bid successfully for the Beinecke's leaf at Sotheby's just three months earlier and almost immediately placed it on the market again. Sotheby's catalog offers the crucial details that the leaf "was said to have come from a convent near Toledo, and was apparently bought by Duschnes in the late 1950s, from Arthur Rau, in Paris, sold to the Detroit Public Library and then repurchased by Duschnes half a dozen years later."[27] To fit this piece back into

the puzzle: Sotheby's entry, Norman Strouse's Christmas cards, and the Getty Museum's acquisition records for Ms. 61 allow us to conjecture that Beinecke Ms. 794 was also among the four leaves Duschnes sold to the Detroit Public Library in 1959. In sum, the evidence points to this scenario: Duschnes sold four leaves to Detroit, then bought back at least two of them, which were subsequently sold to other clients. One of the two leaves ended up in the Getty Museum (Ms. 61) and the other in the Beinecke Library (Ms. 794). Both have documented ties to the Parisian dealer Arthur Rau. We can assume, moreover, that the unlocated Pentecost leaf does too.

Moving beyond any assumption, Beinecke Ms. 794 allows us to establish further links to Arthur Rau. After Duschnes bought the leaf back from the Detroit Public Library, he put it on the market again in his 1965 sales catalog, where it was listed as lot number 21. He described it with his characteristic circus bark as "a vellum leaf of heroic proportions from a Spanish Gradual of the early sixteenth century" and added two key details. First, he pointed out that "two leaves from this identical Gradual are in the Pierpont Morgan Library." Second, he specifically identified the leaves by their catalog number at the Morgan: "M.887."[28]

The direct citation of the Morgan leaves provides important corroborating evidence for their ties to Arthur Rau. The Morgan's acquisition file for M887-1 and M887-2 has a letter of solicitation that presents key information but whose author has not been identified. The letter is dated June 2, 1958, and addressed to Everett D. Graff, president of the Art Institute of Chicago:

> It is just six months since I had the pleasure of seeing you and left, for your consideration, one of my Spanish leaves.
> As you may have heard, *the Pierpont Morgan Library acquired two others from me* and I understand that Mr. John Plummer, their expert on illuminated manuscripts, has made some exciting discoveries about the group. Would you like me to ask him to let you have the details which would perhaps remove any hesitation you may still feel about acquiring this remarkable example? (Emphasis mine)[29]

The letter is signed simply "A.R." Those initials must stand for Arthur Rau, who appears to have contacted several people on his own in an attempt to unload his Spanish leaves.

At first glance, Arthur Rau's connection to the Morgan leaves would seem to contradict what we know about their history: specifically, that they were presented to the Morgan by William S. Glazier in 1958. Not so, as it turns out. In fact, evidence in Rau's favor can be gleaned by revisiting one of the letters we have already seen: the closing paragraph of Philip Duschnes's letter to Mabel Conat in Detroit on June 11, 1959:

> I am sure that you will find this group [of "four magnificent antiphonal leaves"] to be one of the library's most treasured and important acquisitions. Two of the leaves from

this same antiphonal were presented to the Pierpont Morgan Library and are proudly displayed in their exhibitions. Mr. William Glazier presented them at a special ceremony about a year and a half ago; *supplied from the same source*. (Emphasis mine)[30]

William Glazier might have presented the two leaves to the Morgan in 1958, but their source—"the same source" that supplied the four leaves Duschnes offered the Detroit Library in 1959—was Arthur Rau.

The paper trail tied to these manuscripts is as labyrinthine as the rare book trade that created it. But the information on Norman Strouse's Christmas cards provides a thread that guides us to these conclusions: of the "nine illuminated Fifteenth Century manuscript pages brought out of Spain to Paris at the beginning of the civil war in 1936," the leaves now owned by the Beinecke Library (see fig. 4), the Pierpont Morgan Library (see fig. 5), the Detroit Public Library, and the Getty Museum (see fig. 6) seem to account for five of them. Norman Strouse's lost Pentecost leaf (its current location unknown) accounts for the sixth. Corroborating evidence places all of these with a Parisian book dealer named Arthur Rau and, before that, with an unknown monastery near Toledo.

What about the remaining three?

William Voelkle acquired a photograph of a related folio while researching the Morgan leaves in 1986. The leaf has an illumination showing the Nativity and bears the emblems of the Five Wounds with the inscription "Miserere Mei."[31] As with the majority of leaves documented thus far, it too is from a Gradual. The chant, clearly readable in Voelkle's photograph, is "Puer natus est"—the Introit for the Mass on Christmas Day. The source of the photograph is not documented, and the location of the folio remains unknown.

Another leaf was featured in a catalog published by the rare book dealers Jörn Günther and Bruce Ferrini in 1999 (see fig. 7). Its size, the emblem of the Five Wounds, and its large illumination featuring Post's "Miracle of the Gentleman of Cologne" immediately suggest a connection. Günther and Ferrini's description confirms it beyond a doubt, noting that the leaf was "reportedly purchased from a convent near Toledo before the late 1950s."[32] The chant on the folio, "Quasi modo geniti infantes," is the Introit for the Mass on Low Sunday (the first Sunday after Easter) and identifies the source for this leaf as a Gradual. The list price of nearly $125,000 USD at the time for this single folio serves as a useful point of reference to illustrate the extraordinary quality of these manuscripts.[33] Shortly after Günther and Ferrini published their catalog, the folio was purchased by a European collector who wishes to remain anonymous.[34]

The ninth leaf has not been recovered, and there is no information on its current location.[35] A conspectus of the nine leaves is given in appendix A.1.

Arthur Rau (1898–1972), the only documented Paris connection, was probably the first owner of the nine leaves in appendix A.1 after they left Spain in 1936. Rau was actually an Englishman by birth, which accounts for the fluent English in the letter of solicitation by "A.R." to the president of the Art Institute

of Chicago in 1958.[36] He was born and educated in London and had intended to enter Oxford University before World War I forced a change in plans. Rau spent 1917 and 1918 in France and, while there, added French to his already fluent English and German. On his return to England he studied "Oriental languages" and picked up at least a reading knowledge of some of them.

Rau's interest in languages was a perfect complement to his early fondness for antique books. After World War I, he began his career in the rare book trade with Maggs Brothers in London and became the manager of their Paris office by the early 1930s. In 1932 he opened an independent rare book store at 130 Boulevard Haussman, just a short walk from the Maggs Brothers' Paris office he had managed.[37] The outbreak of World War II forced Rau's return to England in 1939, where he was a schoolmaster for the next ten years. He returned to Paris in 1949 and continued his work there as a rare book dealer until retiring in 1963. Rau's last years were spent in England (especially in Wensleydale in the Yorkshire Dales) where he remained an active contributor to *The Book Collector*, a quarterly journal devoted to rare books and manuscripts.

Two Divergent Paths

Surprisingly, the possible connection between the nine leaves from a "convent near Toledo" and the Beinecke's Kyriale went unnoticed until July 1994, as the Beinecke contemplated acquiring the leaf that would become its Ms. 794. On July 8, 1994, less than three weeks after Sam Fogg Rare Books and Manuscripts had purchased the leaf from Sotheby's (and prior to the Beinecke's acquisition of the leaf on September 19 that year), Robert Babcock, curator at the Beinecke, received a note from William Voelkle that gives every indication of his having recognized a possible connection—the first time anyone had done so. Voelkle, still curator at the Morgan Library, wrote:

> I look forward to hearing your reaction to the Spanish leaf. . . .
> Enclosed are photographs of the two Morgan leaves, a xerox of the [Norman] Strouse Christmas card, and copies made from various volumes of [Chandler Rathfon] Post's work on Spanish painting that refer to the Gentleman of Cologne.[38]

Why did it take so long for anyone to make the connection? Most likely, it was because the Beinecke's Kyriale and the set of nine related leaves followed two divergent and unrelated paths from their place of origin and into the hands of dealers. Laurence Witten's initial claim that the Kyriale "is said to come from Switzerland" and his subsequent musings over its possible Spanish origins are telling, particularly given that his reassessment came after recalling only *one* other leaf that appeared to be related—one he had given to a private collector in New Haven (see fig. 3).[39] It is also instructive that none of the literature or

correspondence tied to Arthur Rau, Philip Duschnes, William Glazier, or Norman Strouse mentions anything about a large choir book—only separate folios. In sum, Laurence Witten seems to have had an entirely independent connection to the nearly complete Kyriale the Beinecke Library purchased in 1989 (Ms. 710) and to the leaf he had given to an anonymous collector in New Haven. Sources tied to Witten are summarized in appendix A.2.

The text and melody on the leaf owned by the anonymous collector in New Haven, Connecticut (see fig. 3), are from the Introit chant "Ad te levavi" (for the first Sunday in Advent). In fact, they pick up precisely where the identical chant on Morgan M887-1 breaks off (see fig. 5), suggesting that these leaves were once conjuncts in the first opening of a manuscript.[40] There are further correspondences in that the styles of the script, notation, and clef design reflect the work of the same scribe.[41] The styles of illumination are different, but such is the case in the first opening of the Beinecke's Kyriale where the two opening folios were clearly executed by two different artists (see figs. 1 and 2). The differences between the two folios are most readily apparent in the execution of the three angels holding the emblems with the five bleeding wounds.

Precisely how Witten came by his two manuscripts (see appendix A.2) has never been established. His initial claim that the Kyriale "is said to have come from Switzerland" might reflect some connection with a Swiss book dealer named Nicolas Rauch of Geneva. Rauch had worked in Paris at about the same time Arthur Rau was there and must have known him.[42] Later, Witten worked regularly with Rauch, and Rauch, in turn, dealt frequently with an Italian dealer named Enzo Ferrajoli. Ferrajoli worked out of Barcelona, Spain, and was a major supplier of Spanish manuscripts to book dealers in Geneva, Paris, and London.

Had Laurence Witten acquired the Spanish Kyriale and separate leaf from Nicolas Rauch? Furthermore, had Enzo Ferrajoli been the Spanish connection not only for Nicolas Rauch in Geneva, Switzerland, but for Arthur Rau in Paris, France, as well?

We may never know for certain. There is, however, at least one occasion during which Witten, Rauch, and Ferrajoli met with one another in Geneva, Switzerland. That meeting would influence Witten's eventual purchase of the famous and highly controversial "Vinland Map," which the Beinecke Library subsequently acquired in 1965. Initially thought to be the oldest pre-Columbian map showing the New World, the Vinland Map was later proved a forgery.[43] As for Enzo Ferrajoli, his prominent role in the Spanish book trade received unwelcome attention in the 1960s when, according to Witten, "the Spanish government alleged that a large number of books and manuscripts were stolen from the library of the Cathedral of La Seo in Saragossa [Zaragoza]. Enzo Ferrajoli was charged with the alleged felony, and eventually the canons of the cathedral were also charged."[44] The charges of the Spanish government against Ferrajoli and the canons at Zaragoza Cathedral reveal just one of the ways valuable books such

as the Beinecke's Kyriale and its related leaves found their way into the hands of international book dealers.

* * * * *

Regardless of the paths taken, we find ourselves with a nearly complete Kyriale and ten leaves (see appendix A.1 and A.2) from a Gradual, linked to one another by a common emblem of the Five Wounds. Six manuscripts, including the Kyriale, are decorated with an illumination that Chandler Rathfon Post identified as "The Miracle of the Gentleman of Cologne," which he associated with the cult of the rosary. Two of the manuscripts (the Beinecke's Kyriale and Morgan M887-1) include scenes from the life of Hercules that have never been explained. Many of the manuscripts are rumored to have come from a convent near Toledo, but the precise origins have never been determined and remain a mystery to this day.

The Mystery Solved

Why has the mystery surrounding these manuscripts endured for so long? The short answer is simple: chant manuscripts from Renaissance Spain have never received the scholarly attention they deserve in spite of the fact that such volumes contain the melodies that inspired much of the polyphony from Spain's celebrated Golden Age of church music. The Beinecke's Kyriale (Ms. 710) is a case in point. The fact that it puzzled scholars—particularly music scholars—for so long underscores the undue neglect in this area. Indeed, several indicators should have alerted one to a Spanish provenance right away.

First is the size of the manuscript. Although examples of large chantbooks can be found elsewhere, one typically tends to find such enormous tomes of almost exaggerated proportions among Spanish sources. The Beinecke's Kyriale comes across as a more modest example when we consider the collection of two hundred-plus *cantorales* at the former Jeronimite monastery of El Escorial near Madrid. On average, the Escorial's chantbooks measure what must be a record 108 × 75 cm; each comes mounted on four small wheels along the lower edge to make it somewhat easier to manage.[45]

Another distinctive feature is the use of the five-line staff rather than the more common four-line staff for the notation of plainchant. A five-line staff became the norm for Spanish chant manuscripts by the fifteenth century. So, too, is the curious text division found in words such as *a-lme* (as opposed to *al-me*) and in many other places where a consonant is separated from a vowel it would normally accompany in non-Spanish sources. This is a regular feature in manuscripts from Catalonia and Castile.[46]

Scholars comfortable with the Spanish language (which has yet to receive the same emphasis as German, English, French, Italian, and Latin in academic

training) might have noticed the occasional vernacular inscription. For example, tabs sewn onto several folios are written in clear Castilian Spanish: "Gloria de doble mayor" (fol. 34v, Gloria for Double Major Feasts), "Credo de doble comun" (fol. 45, Credo for Double Common Feasts), "Sanctus de apostoles" (fol. 50, Sanctus for Feasts of Apostles), and "Gloria de Angeles" (fol. 62v, Gloria for Feasts of Angels). Throughout the Kyriale, one also finds a corrector's mark that is common in Spanish sources. Initially, the mark resembles a percent sign (%) but is actually the word *ojo*, Spanish for "eye"—an appropriate directive to show that attention is needed at a particular spot in the manuscript.

The most useful indicators, however, are the chants themselves. As signposts that point toward a specific musical-liturgical practice, melodies and texts have the strongest potential to help trace more precisely the origins of any unattributed liturgical manuscript with music. Yet such evidence is often overlooked, as attention is focused on the stylistic characteristics of illuminations or on broad speculation over heraldic emblems.

Evidence of Plainchant

Of the forty-eight liturgical items in the Beinecke's Kyriale (see appendix E), nine are especially important because of the geographical extent of their distribution. First, none is found outside Spanish sources. Second, with the exception of two chants for the Agnus Dei that are concentrated in Burgos, Tortosa, and Tarragona, the majority reflects the Use of Toledo (see appendix A.3). Designation of the *Officia ad missas* (Granada, 1544) as Toledan reflects the fact that the liturgical practices of Toledo were implemented in Granada immediately following the Spanish conquest of this last Muslim stronghold on the Iberian Peninsula in January 1492.[47] Indeed, the *Officia ad missas* commemorates that occasion with a frontispiece depicting the surrender of Granada by Sultan Boabdil (Abu 'abd Allah Muhammad XI) to King Fernando, Queen Isabel, and the powerful Toledan cardinal Pedro González de Mendoza (prelacy 1482–95).

The style of notation in several instances lends further support to a Toledan origin. Throughout the Kyriale, one frequently encounters two peculiar note types: one resembles a *punctus*, or a breve, with a pinnacle pointing down and two tails pointing up; the other resembles a *punctus* with a pinnacle pointing up and two tails pointing down. An example of the first type appears on the opening folio above the word "vir-*gin*-um" (see fig. 1). The two appear in succession at the beginning of the troped Kyrie "Summe deus" on fol. 5 (see fig. 22). These distinctive note shapes appear with marked frequency in Toledan sources. Contemporary writings refer to them as a *tocus* and an *uncus*. As we will see in chapter 6, they were just two of the various ways plainchant was embellished in Toledo during the sixteenth century. Although concordances for

chants in the Beinecke's Kyriale pointed generally toward Toledo, such ornaments in the melodies revealed their intimate bond with Toledan performance practices.

Once such evidence strongly indicated the link with Toledo, further support materialized in ornamentation of another kind. Only then was it apparent that the images of Hercules in the Beinecke's Kyriale and in one of the related Morgan leaves (see figs. 1, 2, and 5) had not been mere whims of the illuminators. Since at least the mid-fourteenth century, Hercules was not only believed to have founded Toledo but was thought to have lived there in an enchanted cave. To this day, residents of the city take pleasure in pointing out the legendary Cueva de Hércules that lies beneath a site once occupied by the church of San Ginés, destroyed in 1840.[48]

The Illuminations Revisited

Like the marginal images of Hercules, the Kyriale's illumination depicting "The Miracle of the Gentleman of Cologne" assumed greater importance once its plainchants had indicated a Toledan origin. Chandler Rathfon Post's observations on the miracle and its ties to the cult of the rosary provided a key starting point. Further investigation uncovered that it had been popular in Spain since the fifteenth century as a foundation myth for the highly influential rosary confraternity established in 1475 by Jakob Sprenger (ca. 1436–95), prior of the Dominicans at Sankt Andreas-Kirche (St. Andrew's Church) in Cologne. The Cologne brotherhood enjoyed enormous popularity fueled by the unprecedented power of the printing press that dispersed its statutes and related propaganda throughout Western Europe. Spanish rosary confraternities on the Cologne model were established by the 1480s, and there, as elsewhere in the world, they were tied almost exclusively to the Dominican Order.[49]

In an unexpected turn, publications tied to the Cologne confraternity shed an interesting light on the emblem of the Five Wounds. Although its most widespread association may be with the Franciscan Order—a reference to the five stigmata that famously marked the founder of the order, St. Francis of Assisi (1181/82–1226)—the iconography of the Five Wounds was also important to the Dominican Order's cult of the rosary. So, too, was the penitential Fiftieth Psalm (Vulgate), which begins "Have mercy on me Lord"—in Latin, "Miserere mei Deus."[50]

The two most important documents published by the rosary confraternity of Cologne in the year after its founding were Jakob Sprenger's statutes for the brotherhood and a scholarly defense of the rosary by Michael Franciscus de Insulis (ca. 1435–1502), a Dominican professor of theology at the University of Cologne. Turning to the popular device of number symbolism as a means of promoting the rosary, Sprenger proposed a mystical union between the prayer's five

iterations of the "Pater noster" (Our Father) and the Five Wounds of Christ. Likewise, Insulis compared the redemptive power of the fifty repetitions of the "Ave Maria" (Hail Mary) to that of the highly revered Psalm 50, the penitential "Miserere." The inscribed emblem of the Five Wounds in the Beinecke's Kyriale and its sister leaves is thus a concise statement reflecting the essential structure of the rosary: five Our Fathers and fifty Hail Marys. The custom of repeating that cycle three times is reflected in the opening folios of the Kyriale and in several of the leaves, where the emblem appears three times in the marginal decoration of each (see figs. 1 and 2).[51]

The rosary emblems and the illuminations depicting "The Miracle of the Gentleman of Cologne" presented the clearest evidence that these Spanish plainchant manuscripts were connected to a rosary confraternity. They formed the basis for christening the set's most complete exemplar, Beinecke Ms. 710, as the "Rosary Cantoral." Given that the chants in the Rosary Cantoral indicated Toledo, Spain, as its place of origin, the confraternity must have been one in that city.

Indeed, local records identify one such brotherhood in Toledo during the sixteenth century. Moreover, they reveal that the brotherhood was tied to the royal Dominican house of San Pedro Mártir (St. Peter Martyr), where it kept a large treasury tapped across two centuries to magnify Our Lady of the Rosary with music for Sunday Masses, processions adorned by music, tapestries, fireworks, and costly altarpieces, among other items. Membership in this rosary confraternity was strictly limited by local statute to artisans of the silk industry—a cornerstone of the Toledan economy and the basis for the brotherhood's extraordinary wealth. Such was their magnanimity that future chroniclers of Toledo would write of the "very eminent chapel of Our Lady of the Rosary" (muy insigne capilla de Nuestra Señora del Rosario) at San Pedro Mártir, served by its "eminent confraternity" (insigne cofradía).[52] Although a lay confraternity had no use for a full set of *cantorales*, the chantbooks would have been fundamental to liturgical practices at the Dominican convent with which they were affiliated.

A Convent "Near Toledo"

All evidence pointed to the wealthy rosary confraternity of Toledo as the driving force behind the Rosary Cantoral and the leaves that were mere traces of what must have been a magnificent set of companion books. It also seemed to indicate that the convent of San Pedro Mártir had been the primary owner of these liturgical instruments. In short, the mystery appeared solved: the Rosary Cantoral and its related leaves had proceeded from San Pedro Mártir, a Dominican convent in Toledo.

But what about the persistent rumor of a "convent near Toledo"?

The answer came in 2000, during a final drive to uncover the smoking gun that is the end to any good mystery—in this case, a *cantoral* of similar size and

design that had survived at San Pedro Mártir. Although the edifice of the convent has survived and now houses the Toledan branch of the University of Castilla–La Mancha, it had been assured that no such *cantoral* had survived there. Between 1835 and 1837, decrees of exclaustration issued under the governmental reforms of Juan Álvarez Mendizábal (1790–1853) (known as the *Desamortización*) led to the dissolution of almost every religious house in Spain. These included San Pedro Mártir de Toledo, from which the friars were unceremoniously expelled on January 28, 1836.[53] Only four religious communities were left intact, and one of those was the Dominican convent of Santo Domingo in Ocaña, a small town not far from Toledo.[54] According to the archivist there, a senior friar named Jesús Santos, it was upon the dissolution of San Pedro Mártir that the convent of Ocaña assumed ownership of a complete set of *cantorales* that had belonged to the Dominicans of Toledo. Their subsequent fate was described in a personal communication dated May 23, 2000: "In the said convent [of San Pedro Mártir] there was a collection of '*cantorales*' that dated from the sixteenth century. The collection was passed over to the convent of Santo Domingo de Ocaña after the *Desamortización* of Mendizábal in 1835 and remained here until the Spanish Civil War (1936–39) during which they disappeared without any clue as to where they went."[55]

Although the Dominicans of Santo Domingo de Ocaña no longer possess any of the *cantorales* that once belonged to San Pedro Mártir, they did manage to preserve some calligraphic letters that were cut out of the manuscripts. However modest, with all that is lost, two of those initials offer the best approximation of a smoking gun that one might hope to find. Each is decorated with a small pen-drawn ribbon containing the incipit to the fundamental text of the rosary: "Ave Ma[ria]" (see fig. 8) and "Ave Maria Gra[tia plena]" (see fig. 9). In the absence of emblems or illuminations or chantbooks, the incipits on those calligraphic initials represent the strongest link between the fragments from the *cantorales* of San Pedro Mártir that were once at Ocaña and the rosary confraternity of Toledo.

The persistent rumor of a "convent near Toledo" was thus put to rest, and so too a mystery that had existed at the convent of Santo Domingo de Ocaña since the days of the Spanish Civil War. The chantbooks it acquired after San Pedro Mártir was dissolved in 1836 had passed through the hands of European dealers in Paris (and possibly Geneva), then into the homes of private collectors, the Beinecke Library, the Pierpont Morgan Library, the Detroit Public Library, and the Getty Museum. Chapter 2 looks at the history of the convent that owned the chantbooks before it fell to government reformers in 1836.

Chapter Two

San Pedro Mártir de Toledo

The history of San Pedro Mártir de Toledo begins with one of the first waves of Dominican friars to arrive in Spain. St. Dominic Guzmán (1171–1221), a native of Caleruega (Old Castile), founded the community of the Order of Preachers just north of the Pyrenees in Toulouse, France, in 1215. The community was initially lodged in the largest of three houses donated in April that year by Peter Seila, a wealthy citizen of Toulouse who made his profession before St. Dominic himself. With the permission of the local bishop, Foulques of Toulouse, the Order subsequently took up residence at the church of St. Romanus and was confirmed on December 22, 1216, by Pope Honorius III (Cencio Savelli, d. 1227). The following years marked the great dispersal of the Order. By May 1220, the month and year of the Order's First General Chapter, the Dominicans had established an international presence with new communities in France, Italy, and Spain.[1]

St. Dominic had visited Spain in 1218. His itinerary traversed the Pyrenees and followed a route that cut through Zaragoza and wended its way southwest toward Toledo. After Zaragoza he stopped in Guadalajara, Brihuega, Madrid, and Segovia. It is unknown whether St. Dominic ever made it to Toledo, but the Toledan archbishop, Rodrigo Jiménez de Rada (b. 1170; prelacy 1210–47), confirmed the gift of a house in Brihuega offered by a local cleric.[2] It is more certain that the first community of Dominican friars was established at Toledo within a decade or so of St. Dominic's missionary work in Spain.

The Dominicans of San Pedro Mártir

Conflicting accounts place the first Dominicans in Toledo as early as 1218 and as late as 1230.[3] By 1230 a small community had taken up residence just outside the city walls in the convent of San Pablo del Granadal. Today, the approximate location would be east of the Puerta Nueva de Bisagra in what is called La Huerta de San Pablo. The convent was modest, built on land acquired for the Dominicans by King Fernando III of Castile (b. 1198; r. 1217–52) in either 1229 or 1230.[4] The friars would live and work there, along the banks of the Tagus River, for just over the next 175 years. On May 11, 1407, the thirteen

friars of San Pablo del Granadal moved into a small collection of houses well within the city walls, adjacent to the parish church of San Román—its name resonant with the first Dominican convent at St. Romanus (St. Romaine) in Toulouse.[5] There the Toledan friars assumed a new advocacy under San Pedro Mártir, a name taken for the venerable St. Peter of Verona (1206–52), a Dominican friar whose defense of the faith won his martyrdom by an assailant's sword in the thirteenth century.[6] On March 10, 1408, the community's relocation to the "houses of San Román" (casas de San Román) was officially authorized by Benedict XIII (Pedro de Luna, 1342–1422/3), a rival pope in Avignon during the Papal Schism that divided Western Christendom between 1378 and 1417.[7] With that, Friar Diego de Hamusco, the last prior of San Pablo del Granadal, formally assumed his duties as the first prior of San Pedro Mártir.[8]

The origins of the Dominican convent of San Pedro Mártir were small but hardly humble. The houses in which the thirteen friars took up residence in 1407 had been donated by a woman who was one of Toledo's greatest benefactors, Doña Guiomar de Meneses (d. 1459).[9] In addition to San Pedro Mártir, Doña Guiomar provided the original properties for two additional institutions in Toledo—El Hospital de la Misericordia in 1445 and the Augustinian convent of discalced nuns known as El Convento de "Las Gaitanas" in 1459.[10] The donation to San Pedro Mártir was made during her first marriage, to the nobleman Alfonso Tenorio de Silva, a governor of the Toledan fief of Cazorla in the Jaén province of Andalucia.[11] The latter two foundations occurred during her second marriage to another nobleman, Don Lope Gaitan. (Hence the popular name "Las Gaitanas" for the Augustinian nuns who inhabited the convent, an appellation that remains to this day).[12] Throughout her life Doña Guiomar maintained a close connection with San Pedro Mártir. When she died on March 8, 1459, she was interred at the Dominican convent along with her second husband, Lope Gaitan, and their daughter Doña Juana.[13] Nominally, like El Hospital de la Misericordia and El Convento de "Las Gaitanas," San Pedro Mártir was the house that Doña Guiomar had built. But its prosperity throughout the fifteenth century and beyond was attributed largely to the Silva family, a dynasty of powerful local aristocrats into which Doña Guiomar had married through her first husband, Alfonso Tenorio de Silva.

San Pedro Mártir and the House of Silva

Toledo in the fifteenth century was an oligarchy governed by local nobles and aristocrats who coalesced around two dominant families: the Silva, named counts of Cifuentes in 1455, and the Ayala, who became counts of Fuensalida in 1470.[14] Neither family was native to Toledo. The Ayala were originally from Álava (in the Basque region of northern Spain), and the Silva were from Portugal. But

both worked assiduously to ingratiate themselves with local power holders and eventually came to dominate Toledo's fickle political system by forging key alliances inside an unstable Spanish government and facilitating local administrative and military initiatives for the royals of Castile.[15]

The Ayala family was the more established of the two, at least chronologically. Its roots in Toledo extended back to Pedro López de Ayala (1332–1407), a historian and poet who served King Pedro I of Castile (b. 1433, r. 1350–69) before shifting his alliance to Pedro's half-brother, Enrique of Trastámara, the man who would depose Pedro and ascend to the throne in 1369 as King Enrique II (d. 1379). Enrique II, the illegitimate son of King Alfonso XI of Castile and his mistress, Leonor de Guzmán, was first in a line of weak Trastámaran kings whose monarchy rested on uncertain grounds. Unable to rely on relatives with more legitimate claims to the throne, they regularly turned to members of the minor nobility for the support they needed to remain in power. In a situation that became typical of the way the Trastámaras needed to conduct business, Pedro López de Ayala was rewarded for his loyalty with a royal appointment as *alcalde mayor* (governor) of Toledo in 1375. Ayala would subsequently serve as principal adviser to the next Trastámaran king, Juan I (b. 1358, r. 1379–90). He ingratiated himself further with Juan's heir, Enrique III (b. 1379, r. 1390–1406), successfully leading the lesser nobility in a conflict against relatives who opposed the legitimacy of his claim. For his continued support Ayala was rewarded again in 1398 with an appointment as chancellor of Castile.[16]

Like the Ayalas, the Silva family was closely tied to the royal house of Castile through its support of the Trastámaran kings. There was a notable difference, however. The Ayalas had chosen the winning side of a battle between Enrique of Trastámara and Pedro I of Castile. In contrast, the Silvas' fortunes derived from a disastrous bid by Juan I, Enrique's son, for the throne of Portugal in the 1380s.[17] The aid to Juan I had come in the form of military support from Arias Gómez de Silva, an ambassador of King Fernando of Portugal to the Castilian court.[18] With the failure of Juan I's campaign, Arias Gómez de Silva, now a traitor to the Crown whose interests he represented, fled Portugal and settled in Toledo. There he married Doña Urraca Tenorio, sister of the Toledan archbishop Pedro Tenorio (prelacy 1377–99).[19] The move was a shrewd one, for now, in addition to the favor of Juan I (and subsequently his son, Enrique III), he garnered the protection of the Toledan archbishop as well. At the start of an exile for treason against his native Portugal, Gómez de Silva wasted little time forging key alliances with the most powerful figures in the Crown and Church of Castile. In doing so, he transformed a precarious existence into the start of a dynasty—the House of Silva—whose fortunes would thrive as long as its favor with those in power was secure.

The first generation of the House of Silva was established in Toledo through Alfonso Tenorio de Silva (d. 1430), born to Arias Gómez de Silva and Urraca Tenorio around the year 1370.[20] Alfonso further established the Silva in Toledo

through his marriage to Doña Guiomar (also known as Genoveva) de Meneses, whose family's roots there extended back to the thirteenth century.[21] Together, they had two children: Juan de Silva (1399–1464), named the first count of Cifuentes in 1455, and María de Silva, who married Pedro López de Ayala "El Sordo" (The Deaf) (d. 1486). Ayala "El Sordo" was named the first count of Fuensalida in 1470 and was the grandson of the Pedro López who had initiated the Toledan line of the Ayala in the 1370s. Thus, by the close of the fifteenth century the Silva had established itself as one of the two most powerful families in Toledo and, on top of that, had married into the other.[22] Alfonso Tenorio de Silva followed his father's example closely, as he fostered important relationships within the city of Toledo. In addition to marrying into the Meneses, an established Toledan family, he continued to gain favor with his uncle, the archbishop Pedro Tenorio, by consistently siding with him in local disputes. He was rewarded for his loyalty with possession of the valuable villas and properties of the Adelantamiento de Cazorla in Jaén province.[23]

As dependent as the Silva family was on the fortunes of the Crown, the end of 1406 presented a major crisis. On December 25 that year, Enrique III, who had continued to favor the Silvas because of Arias Gómez's support of his father's campaign against Portugal, died after a long illness. From that point the Silvas could no longer depend on the Crown's support, since Juan II, Enrique's son and heir apparent, was only eighteen months old at the time. Juan II would not be in a position to assume control of Castile until 1419, and for most of his minority (and in full accordance with the deceased king's will) Enrique's brother Fernando (1380–1416), age twenty-six, took over as co-regent of Castile alongside the widowed Queen Catalina of Lancaster (d. 1420).[24]

The crisis of December 1406 must be at the heart of the foundation of San Pedro Mártir. It cannot be a mere coincidence that within five months of Enrique III's death, the Dominicans of Toledo had moved into the houses Alfonso Tenorio de Silva's wife had donated. Indeed, such a donation would be entirely consistent with the Silvas' practice of networking to gain favor with those in power. In 1407, with the support of the Crown no longer ensured, Alfonso Tenorio de Silva played one of his strongest hands in attempting to secure favor with the Dominicans of Toledo. It was a smart move. For one, the donation came at a time when Friar Alfonso de Cusanza, confessor to the king, was provincial of the Dominican Order (1406–10).[25] A more important factor was Diego de Hamusco, the last prior of San Pablo del Granadal and the first prior of San Pedro Mártir. De Hamusco had taken the habit at San Pablo del Granadal and enjoyed great favor with Enrique III's brother Fernando, co-regent of Castile until Juan II reached his majority in 1419.[26] Thus, by extending his family's generosity to the Dominicans of Toledo under de Cusanza's and de Hamusco's leadership in 1407, Alfonso Tenorio de Silva had likely reestablished some of the critical ties with the Crown of Castile that had been severed upon the death of Enrique III at the end of 1406.[27]

For generations afterward, the Silva family maintained a close connection to San Pedro Mártir and was instrumental in its maintenance and expansion. Their relationship is most clearly reflected in the convent's role as burial place for the main branch of the family, the powerful counts of Cifuentes, beginning with Juan de Silva (1399–1464), the first to receive the title in 1455.[28] Pedro de Silva (ca. 1431–79)—Juan's son by his second wife, Inés de Ribera, and half-brother to the second count of Cifuentes, Alfonso de Silva (1429–69)[29]—was a friar at San Pedro Mártir and later bishop of Lugo (1445), Orense (1447), and Badajoz (1461), where he died in 1479.[30] On March 27, 1447, he remembered his former convent with the donation of a family palace, and thirty years later he ceded a collection of houses that had once belonged to his grandmother, Doña Guiomar de Meneses.[31] The connection persisted through Ana de Silva (d. 1606), the eighth countess of Cifuentes who was the last in direct line of succession. Her final testament provided a foundation for the new conventual church, begun in 1605, which replaced the older one that had stood since the 1490s.[32] In homage to such contributions by the counts of Cifuentes and the Silva family in general, the magnificent grill of the central nave is conspicuously adorned with the heraldic shield of the Silva (a lion rampant), which shares pride of place with the emblem of the Dominican Order.[33]

By current estimates, from 1407 to 1760 or so, the Dominican convent of San Pedro Mártir de Toledo grew from a small collection of houses donated by the wife of Alfonso Tenorio de Silva to a massive complex of twenty-one buildings surrounding four cloisters—a complex that sprawled over 20,000 square meters (just over 215,278 square feet).[34] The House of Silva was the core, the foundation of the convent, but there were other benefactors too. None among them was so prominent as the infamous Inquisitor General Tomás de Torquemada (1420–98).

In September 1490, Torquemada ceded a collection of houses to San Pedro Mártir on behalf of King Fernando and Queen Isabel.[35] Incorporation of the properties was only initially hampered by a public street separating them from the existing body of the convent. The street was simply absorbed wholesale into the complex and transformed into the nave of a new conventual church.[36] To appease neighboring citizens inconvenienced by this acquisition, the Dominicans permitted them free passage into the conventual church during the day.[37]

Prior to construction of the conventual church, which must have begun in late 1490 or slightly afterward, the Dominicans had likely used the neighboring parish church of San Román. In 1408 the friars created a scandal when they petitioned the archbishop for the transfer of San Román into their conventual complex. The petition was refused, but the friars did manage to purchase a section of San Román's cloister, which was adjacent to San Pedro Mártir and would be incorporated into the new conventual church of the 1490s.[38] The building of a conventual church after September 1490 corresponds exactly to the period during which the Rosary Cantoral and its companion books were being

compiled. That momentous event in the history of the convent may be the very occasion that sparked their production.

The inquisitor general had reason to favor San Pedro Mártir with the gift of properties to aid their expansion in 1490. On one hand, there was a family connection through his uncle, Cardinal Juan de Torquemada (1388–1468), a native of Valladolid who had served as prior of San Pedro Mártir following his graduation from theological studies in Paris around 1425.[39] On the other was the demand for more space to accommodate San Pedro Mártir's supporting role to a tribunal of the Spanish Inquisition established in Toledo in 1485. That role would contribute significantly to the convent's growth in size and power during the late fifteenth and early sixteenth centuries.

The Inquisition and San Pedro Mártir

The Spanish Inquisition, established in the late fifteenth century to rout and suppress heresy, remains one of the most vilified legacies of King Fernando and Queen Isabel of Castile.[40] Dubbed the "Catholic Monarchs" by Pope Alexander VI (Rodrigo Borgia, b. 1431; prelacy 1492–1503) in 1494, Fernando and Isabel were both descended from the line of Trastámaran kings through two branches that find a common root in their great-grandfather, Juan I of Castile (d. 1390).[41] Their marriage on October 19, 1469, took place on the eve of an eventful decade. Isabel staked her claim to the throne of Castile following the death of her half-brother Enrique IV on December 11, 1474. This precipitated a civil war between one faction that backed Isabel and another that supported Enrique IV's daughter Juana, widely rumored to be illegitimate. Following a number of clashes, the most famous of which was the Battle of Toro in 1476, the war of succession was eventually resolved in Isabel's favor by 1479.[42]

As Isabel worked to resolve her disputed claim to the throne, she and Fernando also turned their attention to the issue of heresy, possibly as part of a comprehensive effort to bring stability to their realm. In the summer of 1478 they petitioned Rome for permission to establish tribunals of the Inquisition in Castile. Just months later, on November 1, Pope Sixtus IV (Francesco della Rovere, b. 1414; prelacy 1471–84) issued the bull *Exigit sincere devotionis* that granted the Spanish Crown power to appoint and dismiss a limited number of inquisitors on the condition that they be priests over age forty. Fernando and Isabel followed through on September 27, 1480, with the appointments of two Dominican friars, and with this action they formally introduced the Spanish Inquisition.[43] The first *auto de fé* (act of faith) at which sentences were publicly carried out took place in Seville on February 6, 1481, when six people were burned at the stake. A year later, a papal bull authorized an expansion of the tribunals, which resulted in seven more appointments (all of them Domincans) including Tomás de Torquemada, then prior of the Dominican convent of Santa Cruz in

Segovia.⁴⁴ Torquemada became the Spanish Inquisition's first inquisitor general in 1483.⁴⁵ That same year a new tribunal was set up in Jaén and another in Ciudad Real—a temporary seat transferred to Toledo in 1485.⁴⁶

The majority of those targeted by the Inquisition were New Christians who had been forced to convert from Judaism in the wake of pogroms around the turn of the fifteenth century. Such individuals were known then as *confesos* or *marranos* and are now commonly referred to as *conversos*. The Jews of Toledo were greatly affected by mass conversions after widespread anti-Semitic riots during the summer of 1391. The violence began in the south of Spain, in and around Sevilla. Fueled by deep-seeded prejudices and stoked by outspoken anti-Semites such as Ferrán Martínez, archbishop of Écija, it spread north from there, reaching Toledo by June of that year.⁴⁷ In 1411 another outspoken anti-Semite, St. Vincent Ferrer, visited Toledo and forced his way into the synagogue of the Greater Jewish Quarter. There he celebrated Mass and rededicated the temple as a Christian house, known today as Santa Maria la Blanca.⁴⁸

A great number of conversions followed events such as the riots of 1391 and St. Vincent's storming of the temple in 1411. But the established Christian community—the Old Christians—never fully accepted that the *conversos* had embraced Catholicism. Hostilities lingered against them. "Though no longer Jews in religion, they continued to suffer the rigours of antisemitism," Henry Kamen has noted.⁴⁹ In Toledo those sentiments brought new uprisings against local *conversos* during civil unrest in 1449 and 1467.⁵⁰ Thus, when the Inquisition was established there in 1485, it found itself in a city where antagonism toward New Christians had been cultivated for nearly a century after the first spate of mass conversions in 1391. With the edict of expulsion Fernando and Isabel issued on March 31, 1492, the work of the Inquisition intensified. Resident Jews had only four months to receive baptism or leave the Spanish kingdom. From that point, in addition to enforcing Christian orthodoxy among *conversos* from previous generations, the Inquisition was charged with oversight of an entirely new group of mass converts.⁵¹

The first inquisitors of the tribunal at Toledo arrived in April 1485.⁵² To some extent, however, Toledo had already been a part of the tribunal system in Castile. Father Juan de Yarza, prior of the Dominican convent of San Pedro Mártir de Toledo from 1479 to 1503, had been appointed an inquisitor at the tribunal established in Jaén in 1483.⁵³ In May 1485 the Toledan inquisitors preached their first sermon and announced a period of grace—forty days during which *conversos* who had practiced the Jewish faith in secret could come forward to confess and be reconciled to the Catholic Church.⁵⁴ The situation deteriorated quickly after a rumor was planted that the Toledan *conversos* were plotting to kill the inquisitors and seize the city during the upcoming procession of Corpus Christi just days later.⁵⁵ Badly shaken by the public notice of this alleged conspiracy, the *conversos* were given until October to come forward, and the first *auto de fé* followed on February 12, 1486, when as many as 750 heretics accused of

"judaizing" were reconciled to the Church. The spectacle was recorded in great detail by a local chronicler who witnessed the events.

> All the reconciled went in procession, to the number of 750 persons, including both men and women. They went in procession from the church of St. Peter Martyr [San Pedro Mártir] in the following way. The men were all together in a group, bareheaded and unshod, and since it was extremely cold they were told to wear soles under their feet which were otherwise bare; in their hands were unlit candles. The women were together in a group, their heads uncovered and their faces bare, unshod like the men and with candles. Among all these were many prominent men in high office. With the bitter cold and the dishonour and disgrace they suffered from the great number of spectators (since a great many people from outlying districts had come to see them), they went along howling loudly and weeping and tearing out their hair, no doubt more for the dishonour they were suffering than for any offence they had committed against God. Thus they went in tribulation through the streets along which the Corpus Christi procession goes, until they came to the cathedral. At the door of the church were two chaplains who made the sign of the cross on each one's forehead, saying, "Receive the sign of the cross, which you denied and lost through being deceived." Then they went into the church until they arrived at a scaffolding erected by the new gate, and on it were the father inquisitors. Nearby was another scaffolding on which stood an altar at which they said mass and delivered a sermon. After this a notary stood up and began to call each one by name, saying, "Is X here?" The penitent raised his hand and said, "Yes." There in public they read all the things in which he had judaized. The same was done for the women. When this was over they were publicly allotted penance and ordered to go in procession for six Fridays, disciplining their body with scourges of hempcord, barebacked, unshod and bareheaded; and they were to fast for those six Fridays. It was also ordered that all the days of their life they were to hold no public office such as *alcalde* [mayor], *alguacil* [constable], *regidor* [town councillor] or *jurado* [juror], or be public scriveners or messengers, and that those who held these offices were to lose them. And that they were not to become moneychangers, shopkeepers, or grocers or hold any official post whatever. And they were not to wear silk or scarlet or coloured cloths or gold or silver or pearls or coral or any jewels. Nor could they stand as witness. And they were ordered that if they relapsed, that is if they fell into the same error again, and resorted to any of the forementioned things, they would be condemned to the fire. And when all this was over they went away at two o'clock in the afternoon.[56]

Swiftly and fiercely, the sword of the Inquisition swept over Toledo. In 1486 alone, after the initial 750 Toledan *conversos* were reconciled on February 12, another 900 followed on April 2, 750 more on June 11, and yet another 900 on December 10. Those deemed beyond reconciliation were publicly executed by burning. Between 1485 and 1501, an estimated 250 people were "condemned to the fire" as a result of the Toledan tribunals.[57] In a city of 18,000–20,000 people at the turn of the sixteenth century, the impact of the Inquisition was deeply felt.[58]

The Inquisition at Toledo was a major administrative operation that could not have succeeded without the help of the Dominicans at San Pedro Mártir. Strictly speaking, San Pedro Mártir was not the seat of the local tribunal. Its headquar-

ters were initially some rented houses in the parish district of San Justo, and then in the Plaza del Juego de la Pelota, before the inquisitors purchased a building adjoining the church of San Vicente in 1560. It would remain there for the next two hundred years.[59] But for three-quarters of a century (1485–1560) the administrative headquarters of the Inquisition in Toledo were small, itinerant, and unstable—hardly sufficient to handle every aspect of the trials, incarcerations, reconciliations, and executions that were required.

San Pedro Mártir, a community with nearly sixty friars by the middle of the sixteenth century, quickly accommodated the arrival of the Toledan tribunal.[60] The religious and their prior, Juan de Yarza, an inquisitor of Jaén, "worked hard . . . to serve and favor the Holy Office of the Inquisition. For many years, and from the first day that the Holy Office entered Toledo, the convent housed its inquisitors and its jails."[61] That was the account of one historian, the Dominican friar Juan López, in 1613. And beyond that, we have already seen an example of the active role the convent played in the Inquisition's trials and reconciliations. As the convent assumed its prominent role in the activities of the Toledan Inquisition, the pressure on its friars and the limitations of its available spaces grew. These were the circumstances that prompted Inquisitor General Tomás de Torquemada to donate royal houses (and the street that separated them from San Pedro Mártir) in September 1490. As Friar López put it: "For having distinguished themselves in the service of the Inquisition, for the great expense and work with which the friars and convent had favored it, the Catholic Monarchs favored them with the gift of a public street and the main houses located on the other side."[62]

The arrival of the Inquisition contributed significantly to the growth of San Pedro Mártir's wealth, its power, and the friars' attendant expansion of the convent. In addition to receiving properties from the Church and Crown to facilitate its growing role in Inquisition activities, the convent also benefited directly from some of the punishments that were meted out. In 1505 the friars purchased some houses that had been confiscated from a judaizer ten years earlier. And in 1506 they annexed the houses of a local silk weaver condemned for being a wizard (*hechicero*).[63] But other factors were involved in that growth as well, including the establishment of a printing press at least two years before the arrival of the Inquisition.

The Printing Press and Bulls of the Crusade

The stylistic differences between the Rosary Cantoral and its related manuscripts reflect the fact that San Pedro Mártir did not have a proper *scriptorium*. Like the great Cathedral of Toledo and other religious houses there, it too relied on several workshops of scribes, illuminators, and book binders located throughout the city and elsewhere in Castile.[64] By 1483, however, San Pedro Mártir housed

a printing press that may have been the first and was at least one of the earliest in Toledo.

The history of the Toledan press is closely tied to an authorization Fernando and Isabel received from Pope Sixtus IV (and, subsequently, Innocent VIII) to promulgate Bulls of the Crusade against the Moors, particularly against those in Granada—the last Muslim stronghold on the Iberian Peninsula.[65] Bulls of the Crusade were not new to Spain. They had been issued centuries before as a means of rousing Christian men to take up arms during the reconquest of Spain, which by the eleventh century was almost entirely under Muslim rule. In that prolonged effort, Bulls of the Crusade were necessary tools of war, as they incited the faithful to risk life and limb in exchange for spiritual benefits and the remission of sins. For those who could not fight, a monetary contribution to the effort was sufficient to earn partial benefits. To promulgate the bulls, bishops assigned preachers within each diocese to exhort the faithful to make the right choice between good and evil as they hawked the benefits and remissions the bulls promised.[66]

Such was the process in the twelfth century, and things had not changed significantly by the late fifteenth century. One major difference in the 1480s, however, was the use of *buletas*, printed sheets that entitled the bearer to whatever indulgences were purchased. The *buleta* has been compared in some respects to a receipt or proof of purchase.[67] But the ways in which *buletas* were produced and exchanged liken them more to bonds or stock certificates, as they were documents with inherent value. To produce them required authorization from the Crown and meticulous recordkeeping on how many were produced, to what regions they were distributed, the revenues they generated, and how many were returned to the printer. Each preprinted *buleta* was specific about what it cost and what it promised, and it left blanks for the name of the individual to whom it was issued and the date on which that occurred.[68] Once they were purchased they became nontransferable but could be obtained on behalf of others, even the dead. When unused *buletas* were returned to the printer, they were examined, burned, and disposed of by an authorized individual.[69]

For the printer fortunate enough to secure a royal privilege to produce them, the great demand for *buletas* translated into a lucrative enterprise. And for nearly four hundred years (from at least 1483 to 1850) the Dominicans of San Pedro Mártir claimed a lion's share of the business.[70] The most intense period of production was during the decade of war against Granada between 1482 and 1492. But even after the fall of Granada on January 2, 1492, there were various campaigns against the Moors of North Africa, the Turks, and the Protestants.[71] There was always a crusade to be waged, and for each one the press at San Pedro Mártir stood at the ready, enriching the convent in the process. The success of that printing press reflects yet another way the convent profited from its support of the Holy Office. By one of the earliest reliable accounts, the Catholic Monarchs, "in remuneration for such great and important services [to the

Inquisition,] also entrusted them [San Pedro Mártir] with the printing of the Bulls of the Holy Crusade, and every subsequent monarch has confirmed this, right up to the royal privilege granted by King Don Felipe III, Our Lord [r. 1598–1621]."[72]

The printing industry stimulated by the renewed Bull of the Crusade at the end of the fifteenth century coincides with the appearance of the first major book publications in Toledo, Spain. The question remains, however, whether the press at San Pedro Mártir had been used to print any type of material other than *buletas*. There is suggestive evidence to that effect. For instance, the names of two of the earliest printers in Toledo appear on both books and *buletas*. Juan Vázquez, a printer of *buletas* since at least 1484, published the first book printed in Toledo on July 31, 1486: Pedro Jiménez de Préxano's *Confutatorium errorum contra claves ecclessie*.[73] His successor, variously referred to as either Juan or Antonio Téllez, printed a run of *buletas* in 1495 and a medical tract by a Toledan doctor named Julián Gutiérrez, titled *De computatione dierum criticorum*, on March 28, 1495.[74] Téllez might also have been responsible for a series of *buletas* and another tract by Julián Gutiérrez from 1494.[75] These correspondences demonstrate, at the very least, that the earliest printers in Toledo were connected to the production of *buletas* at San Pedro Mártir. In this regard, the Dominican convent is intimately bound to the earliest examples of book production in Toledo, Spain, at the close of the fifteenth century.

Antonio (or Juan) Téllez's immediate successor at the press of Toledo is unknown. But by 1498 the Toledan press was operated by one of the most important figures in the history of printing in Castile—the German-born Pedro de Hagenbach, best remembered for his production of the Mozarabic *Missale mixtum* of Cardinal Francisco Jiménez de Cisneros in 1500 and its complementary Breviary in 1502.[76]

Few details are known of Hagenbach's career in Spain. Before Toledo, he had produced work in Valencia since 1493 and was probably established there several years before, working with Leonardo Hutz under the patronage of Jaume Vila.[77] Hagenbach's move to Toledo is confirmed on April 4, 1498, by the first known publication there that bears his name—a medical tract on the treatment of kidney and bladder stones written by Dr. Julián Gutiérrez (the same author published by Téllez in 1495) and financed by Melchor Gorricio.[78] Hagenbach might also have printed an anonymous legal tract on February 26, 1498, which would place him in the city by the end of 1497.[79] The Mozarabic Breviary, dated October 25, 1502, would have been the last work of his brief period in Toledo. In January 1503, Hagenbach's former patron Jaume Vila was served notice that the late Hagenbach had left him a sum of ten ducats, indicating that the printer must have died in the closing months of 1502.[80]

These few ascertainable details about Hagenbach in Toledo run counter to the enormous impact he had on the history of printing there. Toledo was a relative newcomer to the printing industry in Spain, but it compensated for lost

time through the superior craftsmanship of a seasoned German printer whose work there from 1498 to 1502 brought forth some of the finest incunabula on the Iberian Peninsula and set the standard for sixteenth-century book production in Toledo.[81]

In discussing the benefactors of San Pedro Mártir, we cannot overlook that the Rosary Cantoral itself reflects another important factor in the convent's growth and prosperity: the local rosary confraternity that commissioned it, along with its companion books, around the turn of the sixteenth century.

The Rosary Confraternity of Toledo

The earliest written record of the rosary confraternity of Toledo is an entry in a publication from 1549—the *Summi templi toletani* of Blas Ortiz, a canon at the Cathedral of Toledo. Among the 101 lay brotherhoods Ortiz enumerates, we find a single confraternity of the rosary established in the parish district of San Román. Ortiz notes that the members of this brotherhood, "in the name of the Most Holy Virgin of the Rosary[,] keep a treasury [*aerarium*] in the Dominican convent named San Pedro Mártir." Furthermore, he records the striking fact that "these confraternity members are silk weavers."[82] Ortiz rarely annotated the entries in his conspectus of local brotherhoods, and we are fortunate that he provided so much with regard to this one. He gives us not only the name of the specific institution with which it was associated but also the vocation of its members. The latter is significant in that it reflects on the brotherhood's considerable wealth. Indeed, the silk industry was one of the most lucrative in Spain and a cornerstone of the Toledan economy.[83]

The founding statutes for the rosary confraternity of Toledo have not survived. The diocesan archive does preserve, however, late amendments to their constitution that provide specific information about the city's silk weavers. A brief preamble to the earliest set of amendments, adopted on June 22, 1636, reveals that the revised by-laws (which limited the number of members to seventy-two) were ratified "at the professional house in the parish district of Santo Tomé where the masters of the art of silk hold their meetings; we refer to this confraternity of Our Lady of the Rosary established in the royal convent of San Pedro Mártir."[84] By 1651, restrictions on the number of members must have become a problem. Effective that year, a new law was passed declaring that limits on membership could be imposed only after every silk artisan had been enrolled.[85] Although more liberal in terms of the number of members allowed, the statutes from 1651 still resonate with the earlier charter in limiting participation to "masters of the art of silk." What is more, they resonate with greater clarity, stipulating that "no one will be accepted from any condition or state whatsoever, or for any other cause or reason, unless they are masters of the art of weaving velvet, brocades, damasks, and satins"—all popular varieties of silk products.[86]

There were, however, exceptions to the rule. Indeed, the statutes allowed for some flexibilty when considering applications made by "gentlemen of means and social standing" if the brotherhood believed it would be "honored and profited" by their membership.[87] Such latitude must have been granted at an earlier date, since Francisco de Pisa's notes for his monumental history of Toledo (the first volume of which was published in 1605)[88] recorded these details.

> The royal convent of San Pedro Mártir is of the friars of Saint Dominic—the Order of Preachers—and in it there is a very famous chapel of Our Lady of the Rosary that is much-celebrated and frequently visited by the faithful. In that chapel, Our Lady of the Rosary is remembered very solemnly on one Sunday of each month with a proper sermon and a solemn procession around the church and its cloister. Once a year there is a much more solemn service observed outside of the church with great festivity. There is a very famous confraternity of gentlemen and people of nobility who are in the service of the image of Our Lady, and—beyond what has been mentioned—on every Saturday evening following Compline, many of the devoted come out to this chapel where the rosary is prayed aloud and its mysteries are recited by one of the fathers of San Pedro Mártir.[89]

The Dominican historian Juan López presented more details about the confraternity and its activities in this account from 1613.

> Through the work of the father and master friar Felix de Plaça, prior of the house [of San Pedro Mártir], and of the friar Christobal de Torres (a lector of theology there), the confraternity of Our Lady of the Rosary and the devotion given to her have grown to such a degree so as to have arrived at the level of greatness that can be desired. In this confraternity, there are forty-eight most noble gentlemen.... [All] the nobility of Toledo serve in this holy confraternity of the rosary. They confess and take communion on the first Sunday of every month at the high Mass which serves to edify the whole town, and they take part in processions on those days, accompanying the most holy image of the Virgin of the Rosary, which some carry over their shoulders while others precede her carrying torches. On those days, they always perform the music of the Holy Church [plainchant] as well as consorted music of voices and instruments and they decorate the cloisters with draperies that were made through charitable donations.[90]

Lopez's account offers a sense of the distinction the rosary confraternity of Toledo enjoyed and provides a glimpse of one type of occassion on which the *cantorales* produced for San Pedro Mártir would have been used. The liturgical assignments discernible from surviving exemplars, however, suggest they were used on a more regular basis, from Advent to Pentecost.

Statutes aside, few documents tied directly to the rosary confraternity of Toledo have survived. Among those that have, account books preserved at the Archivo Histórico Nacional in Madrid allow valuable insights into the membership of the rosary confraternity of Toledo and how it favored the convent of San Pedro Mártir. Both books are concerned with an estate left by Alonso de Vivar, a resident of Toledo who died at the end of 1670. Vivar was not a member of the

silk weaving trade—he was one of the exceptions to the rule—but he was clearly a gentleman of means and social standing. As the informative preamble to one of the account books makes clear, he was also an official of the Holy Office of the Inquisition, which, as we have seen, played a key role in the growth and prosperity of San Pedro Mártir in the late fifteenth century.

> Madrid, Archivo Histórico Nacional, Libro 15246, fol. 21
>
> The licentiate Alonso de Vivar, was a commissioner of the Holy Office of the Inquisition and a resident of Toledo, exceptionally devoted to Our Lady of the Rosary whom he served in a most exemplary fashion for more than seventy-six years. He always attended the rosary and prayed it with the community, and visited the image of Our Lady with great frequency, not ever missing a day unless it was on account of illness. For more than thirty years, he paid for processional music on the first Sunday of every month and for the wax that was made into candles for those processions and for the altar of Our Lady. For many years, he also provided for the great fireworks celebration on the first Sunday of October [the traditional feast day of Our Lady of the Rosary]. He provided for the throne, the arch, and the angels for the image of Our Lady, as well as for the draperies, the processional cart, and her very ornate dress and altar frontals along with many other expenses to benefit Our Lady.
>
> Alonso de Vivar had many children, for he was married, and they were taken by God. But Our Lady preserved the life of the commissioner so that he might serve her until the age of more than eighty years. He died on December 28, 1670, on the Feast of the Holy Innocents, between 10 and 11 in the evening, with the serenity and peace of one who is about to see Our Lady—"his mother," as he always called her.
>
> His final testament was drawn up so that after paying out the 1,200 *ducados* he had set aside for the funeral and 3,000 Masses for his soul, the remainder of his estate would go to Our Lady of the Rosary, so that the money may be spent serving her by paying for the candle wax and music used during processions on each Sunday of the month as well as other expenses that are incurred in the service of Our Lady.[91]

The expenses covered by Vivar's endowment were meticulously recorded from 1671 to 1756.[92] Most of them reflect the type of support the late commissioner had offered throughout his life. To cite just a handful of examples: 2,508 *reales* for music on every Sunday between August 1680 and March 1682,[93] 456 *reales* for flowers to adorn the image of Our Lady of the Rosary in October 1687,[94] 300 *reales* for 44 pounds of candle wax in March 1694,[95] and 20 *reales* for hanging up and taking down the draperies in the cloister in April 1720.[96] In December 1696, 219 *reales* were paid for 10.5 reams of paper and the impression of pamphlets on the rosary.[97] (One wonders whether these were printed on the press of San Pedro Mártir.) And in October 1720, 11 *reales* were paid for two dozen rosaries.[98]

Benefactors like Alonso de Vivar provided for regular expenses such as these. But there were extraordinary expenses as well. In May 1701 there is an entry for 165,592 *maravedis* donated and applied to the *retablo* of Our Lady.[99] This, the register noted, was among "other large amounts that have been given as charity from the religious sons of this convent as well as from other people in this city."[100]

The account books at the Archivo Histórico Nacional present some welcome, if unexpected, information about the rosary confraternity of Toledo. In an entry for March 30, 1727, for example, we find that the rosary confraternity paid out 73 *reales* for "litigation with the weavers,"[101] which suggests that a split had occurred between the silk weavers and the noblemen who, together, had once formed the brotherhood. Some outside evidence corroborates that, for as Juan Nicolau Castro has noted, a "Confraternity of Silk Masters" (Cofradía de los Maestros del Arte Mayor de la Seda) erected a separate *retablo* in honor of Our Lady of the Rosary at San Pedro Mártir in 1714.[102] In this light, it appears of no small significance that a second rosary confraternity was established at the parish church of San Ginés by 1716.[103] By then, the noblemen's confraternity of the rosary seems to have retained the allegiance of the convent of San Pedro Mártir, while the silk weavers established a new one at the church of San Ginés. In either case, the convent of San Pedro Mártir was a direct beneficiary not only of the patronage of the Silvas, the Inquisition, and the printing press but also of the munificence of some of the wealthiest Toledans who came together in a brotherhood devoted to Our Lady of the Rosary.

Decline and Exclaustration

By 1760 the Dominican convent of San Pedro Mártir was approaching its zenith. It had grown to the massive proportions that reflected three and a half centuries of sustained growth and patronage by some of Toledo's most distinguished luminaries. Between 1789 and 1799, part of the convent assumed a secondary role as the University of Toledo—a precursor to the building's role today as the Toledan branch of La Universidad de Castilla–La Mancha.[104] The tide would turn abruptly, however, in the nineteenth century. The French would invade and occupy Spain. The Spanish nobility would collapse once again into civil war. And liberal reformers would dissolve almost every religious community in what has become known as *La Desamortización* (The Great Disentailment). All of this occurred by 1850.[105]

San Pedro Mártir suffered two great blows during that time. As French troops stormed Toledo in 1809, the Dominicans assumed a quiet but active role in the resistance, helping to raise and finance a local army. The fear of reprisals, however, forced the community to disperse, and they fled to the south of Spain, carrying with them some of the convent's most valuable objects—including, it appears, the throne Alonso de Vivar had provided for in a lifetime of service to "his mother," Our Lady of the Rosary. The throne was lost in the struggle. According to one account, the friars en route to Andalucia were ambushed by the enemy and stripped of their baggage. "Thus," the account says, "perished the throne of the Virgin of the Rosary, which was a true marvel.[106] In spite of their losses, however, the friars of San Pedro Mártir would be restored to their convent when the French were driven out in 1814.[107]

The outcome was less fortuitous with a second, and final, blow in 1836, when the community of friars was permanently expelled after decrees of exclaustration were issued by the liberal reformer Juan Álvarez Mendizábal (1790–1853) during *La Desamortización*—The Great Disentailment of 1835–37. The aim of the *Desamortización* was to stimulate the economy and empower the lower classes by seizing and redistributing goods and properties, particularly those held in what reformers deemed *manos muertas* (dead hands)—institutions such as churches and religious houses that had accumulated material wealth through acts of charity but did not actively cultivate or distribute that wealth for the benefit of the greater public.[108] The process began in 1835 and reached the convent of San Pedro Mártir on January 28, 1836. A friar of the convent recorded the unceremonious manner in which the community was expelled.

> The keys of the convent and all of its offices were turned in to Don Pasqual Nuño de la Rosa on the very afternoon of the exclaustration. There was not a single formality in the notification or in the surrender of the keys. Mr. Nuño, just introduced himself as an administrator who was authorized to liquidate our holdings, and with another official named Ferrer, simply ordered us to vacate the convent within four hours. The convent was closed that very afternoon.[109]

The friars expelled, San Pedro Mártir was handed over to the Ministry of War and commissioned as a military barracks. The ministers weighed the option of converting it into a training facility for soldiers engaged in the civil unrest of the Carlist War (1832–39) but ultimately rejected the idea because of the deterioration the former convent had suffered as military housing. San Pedro Mártir was then converted into a library and museum—a storehouse, really—for items collected from other suppressed religious houses following the *Desamortización*. In 1846 it became a government-sponsored house for public assistance and social services, and for nearly a century afterward it served the public as an orphanage, shelter, and asylum.[110] Well before then, at some point close to that fateful day, January 28, 1836, the Rosary Cantoral and its companion books were transported safely to the nearby convent of Santo Domingo de Ocaña.

Back at San Pedro Mártir, the start of the Spanish Civil War (1936–39) brought another round of devastation. An emotional account, written in the 1960s by the Dominican friar Manuel María de los Hoyos, reflects the firsthand experience of an individual who lived through "those horrific days in 1936, which even the memory shuns."[111] The inventory of destruction is tragic indeed. None of the sculptures inside the church was spared. Every image in the *retablo* of the high altar, including the image of Our Lady of the Rosary, was either profaned or destroyed. So too were the frescoes of Friar Juan Bautista Maíno (1581–1641), who took religious orders at San Pedro Mártir on July 27, 1614.[112] The destruction at San Pedro Mártir began on July 22, 1936, at the start of the famous Siege of the Alcázar that was a flashpoint in the Spanish Civil War. The

greatest damage, however, took place on the morning of September 11.[113] By the end of September, the Nationalist rebels under Francisco Franco had begun to consolidate their control of Toledo, and on October 1, with that important, symbolic victory in hand, Franco declared himself *generalísimo* and head of state—titles he would retain until his death in 1975.

Amid the turmoil and horror, as history unfolded on the world stage, the *cantorales* of San Pedro Mártir de Toledo were taken from their former safe haven in Ocaña, spirited away to Paris, and, ultimately, placed in the collections that now preserve them—silent witnesses to it all.

Chapter Three

"El Cavaller de Colunya"

A Legend of the Rosary

The illuminators who decorated the Rosary Cantoral lavished special attention on the Virgin Mary, the devotional focus of the rosary. From the very start, her name is crowned and emblazoned in gold leaf and azure, and her likeness dominates the grand initial "R" beginning the Kyrie "Rex virginum amator" (see fig. 1). She also appears prominently in the illuminated initials of five of the related Gradual leaves, including Beinecke Ms. 794 (see fig. 4), Pierpont Morgan Library M887-1 (see fig. 5), and Getty Museum Ms. 61 (see fig. 6).[1] In all, the Virgin's image graces six of the ten surviving manuscripts in the set (see appendix B).

Curiously, Mary's likeness is often at odds with the chant it introduces. As is evident from the liturgical assignments in appendix B, the only chant with any explicit Marian connection is the Kyrie "Rex virginum amator," which, according to the rubric appearing on the first folio of the Rosary Cantoral, was performed "on feasts of the Most Blessed Virgin Mary" (in festivitatibus beatissime virginis marie). Otherwise, "Sacerdos et pontifex"—the original chant on the palimpsest folio Beinecke Ms. 794—bears only a tangential relationship to the Virgin as an antiphon preceding the Magnificat, the Marian canticle performed at the end of Vespers. The Marian connection disappears altogether with the remaining four chants: "Ad te levavi" for the first Sunday in Advent (four Sundays before Christmas), "Judica me deus" for Passion Sunday (the Sunday before Palm Sunday), "Nos autem gloriari" for Maundy Thursday (a feast commemorating the Last Supper on Thursday of Holy Week), and "Quasi modo geniti infantes" for Low Sunday (the first Sunday after Easter).[2]

It becomes readily apparent that any feast that did not command an appropriate image such as the Nativity, the Resurrection, or Pentecost by default received an inhabited initial featuring the "Madonna and Child." The image was common enough in the late Middle Ages and the Renaissance; however, here the Madonna and Child are never alone—they are always accompanied by two men in proximity. While the arrangement of these men differs among exemplars, one figure, armed and dressed as a knight or soldier, invariably stands

while the other, in civilian clothing, always kneels before Mary and her infant Son. Mary's discordant pairings with chants of unrelated themes might be explained by her central role in the rosary, the devotion whose advocacy was the raison d'être for the confraternity that commissioned these chantbooks. But who are the two men who invariably accompany her?

The most obvious answer would be that these men represent specific donors or specific recipients, perhaps both. One thinks here, for example, of works such as Jan van Eyck's famous panel of Canon Joris van der Paele in the company of the Virgin, Child, and St. George from around 1436.[3] At a glance, the initials in the chantbooks for San Pedro Mártir also recall the ubiquitous donor portraits found in Medieval Books of Hours, the often miniscule codices on the other extreme of the "size spectrum." (To offer perspective, the surface area covered by nine average-size Books of Hours would barely exceed the 30 × 30 centimeters occupied by just one of these grand illuminated letters alone.) Upon closer inspection, however, we find several important details that might initially escape the eye. In the characteristic scene shown in the Rosary Cantoral (see fig. 10), the kneeling man with his hands clasped in prayer wears a floral crown. Furthermore, the Virgin and Child each hold a single flower. Every exemplar displaying the "Madonna and Child" has these details in common, and, inconsequential as they may seem, they ultimately provide the keys to understanding the significance of the illuminations that contain them.

The first step toward unlocking the mystery behind the Marian illuminations in these chantbooks was taken by the eminent art historian and Hispanist Chandler Rathfon Post. Responding to the Pierpont Morgan Library in 1959 on a query regarding their recently acquired leaves, he laid to rest any speculation about a donor portrait, noting that the illumination depicted a "very common theme in Spanish painting, the Miracle of the Gentleman of Cologne"—a miracle he affiliated with the cult of the rosary.[4] As we have seen, the "Gentleman of Cologne" is a theme Post had described more than twenty years earlier in his monumental *History of Spanish Painting*:

> The commoner version of the story runs that this gentleman, having slain a friend in a quarrel, was beset by the victim's revengeful brother, who eventually came upon him praying before an altar of the Virgin. The brother noticed, however, that the murderer was not alone but that the Mother of God stood by his side and that roses were issuing from his mouth which she wove into a garland and placed upon his head. The immediate result of the vision was that the avenger desisted from his purpose and was reconciled with his enemy.[5]

The story's basic components are entirely in accord with elements in the illuminations. As is often the case, however, new information leads to more pressing questions. We are left to wonder: What is this miracle? When did it happen? What is the Cologne connection? Why would it appear in chantbooks for the Mass and Office? Post did not venture far in addressing these questions, but

neither did his principal sources. His most important and comprehensive informant, Valeri Serra i Boldú's *Golden Book of the Rosary in Catalonia* (*Llibre d'or del rosari a Catalunya*, 1925), only tentatively sketched possible contexts, never advancing past a guess that the miracle recounted "a very ancient feat, the memory of which, passing from mouth to mouth, underwent great changes and lost many details, among them, the place where it happened, the names of the persons involved, and the year in which it occurred."[6] Serra i Boldú did, however, identify the miracle as "El Cavaller de Colunya"—the Catalan name Post translated into "The Gentleman of Cologne."[7]

The Legend in Devotional Iconography

Beyond a name and the precious few details Post or Serra i Boldú could offer, little has been uncovered about the obscure miracle of "El Cavaller de Colunya" and its ties to the rosary. Yet while largely unknown to us today, in addition to the six illuminations in the chantbooks for San Pedro Mártir, numerous engravings, altarpieces, and individual panels from early Renaissance Spain reflect its popularity among the faithful at one time. Serra i Boldú mentions at least nine instances in which the miracle appears in iconography for Our Lady of the Rosary; Post brought further examples to light.[8] Among those that can be dated and ascribed to a particular place with reasonable certainty, the earliest testament to "El Cavaller de Colunya" in Spain is a remarkable engraving from 1488 by Francisco Domènech, a Dominican friar who entered into theological studies at the convent of Santa Catalina in Barcelona in 1487 (see fig. 11).

Biographical details on Francisco Domènech are scarce. Assuming he entered the convent at age twenty-five or so—not unusual at the time—he was probably born in the early 1460s. Contemporary documents inform us that he was at Santa Catalina until 1489, then transferred shortly afterward to the Dominican house of Valencia, where his residency is confirmed in 1491, 1493, and 1494. The historical record then falls silent.[9] Not long after commencing his studies in Barcelona, Domènech produced a fine engraving measuring about 40 × 30 centimeters to celebrate the rosary and guide its recitation. The base of the image is clearly signed and dated: "F(rater) Franciscus Domenech A(nno) D(ivinae) G(ratiae) 1488."

Domènech fashioned his engraving as an altarpiece for the layperson, something that could be tacked up on a wall or set down on any flat surface to create a makeshift home chapel for the Virgin Mary. It was an aesthetically pleasing object for contemplation that also served as an interactive tool for reciting the rosary. As we shall see in chapter 4, the rosary has undergone (and continues to undergo) many transformations, but the form that was roughly standardized in the last quarter of the fifteenth century comprised three cycles of 50 "Ave Marias" (Hail Marys) plus 5 "Pater nosters" (Our Fathers)—one placed after every decade of "Ave Marias." The entire prayer thus consisted of 150 "Ave

Marias" and 15 "Pater nosters," and one typically kept track of them by manipulating a chain of strung beads that resembled a necklace.

Remembering the words to the short "Ave Maria" and somewhat longer "Pater noster" did not likely present great difficulty for most people.[10] In fact, the serial recitation of these prayers often degenerated into a mindless exercise.[11] But proper recitation of the rosary also called for the pious to meditate on fifteen key events from the lives of Christ and Mary—one at each "Pater noster"—that reflected on the Joyful, Sorrowful, and Glorious Mysteries important to the Catholic faith and fundamental to the rosary. These undoubtedly posed greater challenges, which Domènech's engraving addressed with a picture narrative distributed among three registers in its upper half (see fig. 11). Working through the first 50 "Ave Marias," at each "Pater noster" the faithful needed only to glance at the uppermost register to recall the Joyful Mysteries, labeled here in the Catalan "de gorg" (of Joy). From left to right we see the Annunciation, the Visitation, the Nativity, Christ's Presentation, and the Lost Child Jesus Found in the Temple. The next register cues the Sorrowful Mysteries (de dolor): the Agony in the Garden, the Flagellation, the Crowning with Thorns, the Carrying of the Cross, and the Crucifixion. The lowest register presents the Glorious Mysteries (de Gloria): the Resurrection, Christ's Ascension, the Descent of the Holy Spirit, Mary's Death and Assumption, and the Virgin's Coronation in Paradise.[12]

If the top half of Domènech's print served as a road map through the Mysteries accompanying the 15 "Pater nosters," the lower half provided a central image to help focus the heart and mind during a lengthier journey through the repetitive "Ave Marias." Playing on the Medieval concept of Mary as *hortus conclusus*—the Garden Enclosed[13]—Domènech surrounded the Virgin and Child with a rose nimbus that is nothing other than a rosary icon composed of fifty smaller roses partitioned into decades by five larger ones. The design of the mandorla suggests that manipulating rosary beads was ancillary to proper recitation of the prayer. One might just as easily keep track of "Ave Marias" and "Pater nosters" here by tracing with the eye or perhaps a finger the fifty-plus-five roses encapsulating the Virgin and Christ Child.

This utilitarian image is flanked on either side by dignitaries from the sacred and secular realms. Kneeling on the left is the great Spanish preacher St. Vincent Ferrer (1350–1419) with a banderole reading "Fear God and honor Him!" (Timete deum et date illi [honorem]), the ominous imperative with which he typically began his sermons.[14] Behind St. Vincent, a figure identified as "Innocentius papa octavus"—Pope Innocent VIII (Giovanni Battista Cibò, 1432–92)—carries a banderole reading "Indulgencia" to emphasize the papal authorization of indulgences that were an important force in driving the rosary's popularity.[15] Although nothing identifies the emperor and king receding behind the pontiff, the date of the engraving suggests they are the contemporary Emperor Frederick III (1415–93) and his son, King Maximilian I (1459–1519). This elite congregation is overseen by St. Eulalia, patron saint of Barcelona, and Catherine of

Alexandria—the patron saint of the Dominican house for which Domènech made the engraving. The Virgin Martyrs are shown with their attributes and a banderole reading "Let us crown ourselves with roses" (coronemus nos rosis).

Providing an apposite frame for these images, St. Dominic (1171–1221), St. Thomas Aquinas (ca. 1225–74), St. Peter Martyr (1206–52), and St. Catherine of Siena (1347–80) appear in marginal compartments. Like other figures shown in the engraving, these venerable saints direct their gazes toward the Virgin as they offer flattering salutations to identify her with the symbolic rose and splendor of Christianity: "Hail precious rose! Hail rose without thorns! Hail splendor of the world! Hail rose of the heavens!" (ave rosa speciosa, ave rosa spina carens, ave jubar mundi, ave rosa caelorum).[16]

Immediately to the right of the Virgin, Domènech incorporated an illustration of obvious import. The man kneeling with a rosary in his hands, the flowers emanating from his mouth, the man with a raised dagger behind him (here with a band of armed cohorts), and the blossoms in the hands of Mary and the Christ Child all identify the scene with the miracle Valerio Serra i Boldú called "El Cavaller de Colunya." Two angels bearing a rose garland point to a Latin inscription reading "miraculum militum"—"the miracle of the soldiers"—which at once bolsters Serra i Boldú's Catalan designation as it refines Post's subsequent rendering of the name as "The Gentleman of Cologne." Post's translation is not wrong, but the "militum" in Domènech's engraving suggests that "El Cavaller de Colunya" would be expressed more properly as "The Knight of Cologne."[17]

Whatever one chooses to call it, the angels pointing to the miracle underscore its contemporary significance. So does the fact that while everyone else in the engraving stares intently at the Virgin and Child in the mandorla, these two divine figures direct their attention to the man humbly praying the rosary. Given what we know of the miracle from Post's brief description, they probably look toward the man to catch the roses that exit from his mouth and ascend to the heavens. But even if one did not have the slightest clue about this miracle, the implication conveyed by Mary's attention toward the man clutching the beads in his hands is clear: the Queen of Heaven shows special favor to those who pray the rosary.

While Domènech's engraving can be described generally in practical, utilitarian terms—as a guide for the fifteen Mysteries, as a device to keep track of "Ave Marias," even as a device to help maintain a proper devotional focus—the *miraculum militum* comes across as sheer propaganda. This aspect of propaganda is also found in written versions of the miracle, the earliest of which dates from several decades later.

The Legend in Devotional Writings

The first known written version of the *miraculum militum* came from the Valencian press of Duran Salvaniach (a relocated Frenchman, its seems)[18] almost fifty years

after Francisco Domènech was first documented there. The source is a *unicum*—an anonymous handbook titled *Tract summarily written from the bull, or the confraternity of the psalter or rosary* (*Trellat sumariament fet dela bulla, o cofraria del Psaltiri o Roser*), printed on February 27, 1535. The Biblioteca Colombina in Seville preserves the only known copy, and as with many of the early printed books there, it was first purchased and owned by Ferdinand Columbus (Fernando Colón, 1488–1539), son of the famous seafarer and an ardent bibliophile.[19] While the Valencian tract was known to Serra i Boldú and Post, they focused rather narrowly on the passage relating to the miracle without giving much consideration to its immediate context or probing more deeply into the culture that provided a nurturing and receptive environment. Both are revealing.

The tract presents "The Knight of Cologne" within a broad history of the rosary in which the author reaches back to the period shortly after Christ's death. It was then, we are told, that the devotion was first taught to the apostles, disciples, and friends of Christ by the Virgin Mary herself—a tale without basis in the Holy Scriptures and canonical writings, but one that surely found special favor among the rosary's practitioners.

> In the times during which the Most Holy Virgin Mary lived in this mortal life—after our redeemer Jesus Christ was taken up into the heavens, and after he sent the Holy Spirit to his apostles and disciples, and they received from Mary the license to go forth and preach throughout the world the will and doctrine of Jesus Christ—the Virgin through great love and charity, and through a special prayer, advised and instructed them on how to serve most agreeably, and how to devote themselves most pleasingly to Jesus Christ and to her, saying every day a psalter that is fifteen "Pater nosters" and one hundred fifty "Ave Marias." She also extended this benefit to her own devotees and to the friends and devoted of Jesus Christ her Son. . . . The apostles, disciples, and friends dedicatedly carried out these prayers throughout their lives. And they in turn showed these prayers to their own friends, who formed a confraternity because such was the will of the Virgin Mary. After the Virgin Mary passed from this life and was taken up (fonch assumpta)—carried in body and spirit to heaven—the said devotees continued the aforementioned confraternity, and the Virgin Mary looked upon them with special consolations. And this agreeable service persisted for many years.[20]

For the sixteenth-century Spaniard, the rosary and its confraternity could not have been more venerable. But, as the Valencian tract continues we learn that with the passing of many years ravaged by war and persecution against Christians, it became impossible for the confraternity to endure. So, too, the prayer that Mary had first imparted to Christ's faithful was eventually forgotten.[21] All was not lost, however, for a Carthusian monk named Eloym (Eloym . . . del orde de cartoxa) later restored the holy confraternity in a province near present-day Germany (Alemanya). Eloym had called for Mary's intercession during a plague of "such great mortality that people were dropping dead in the fields and streets."[22] Hearing his petitions, the Virgin appeared to Eloym and told him the pestilence would not abate until her confraternity was reestablished. She proceeded to

instruct him not only on how to do this but also on the way its members should pray each day—"saying one 'Pater noster,' then afterwards ten 'Ave Marias' until reaching the sum of fifteen 'Pater nosters' and one hundred fifty 'Ave Marias.' "[23]

Unlike the apocryphal first rosary confraternity, its second founding rests—albeit precariously—on a few ascertainable facts. "Eloym" is a Valencian stylization of "Eloinus," the Latin name used by Dominic of Prussia (1384–1460), a monk from the Carthusian house at Trier.[24] While no evidence indicates that Dominic ever founded a confraternity, much less in the manner described, the monk certainly played a role in developing the prayer we have come to know as the rosary. Sometime very near 1430, Dominic, along with his prior Adolf of Essen (d. 1439), set to write a work titled *Our Virgin Mary's Rosegarden* (*Unser Jungfrauwen Mariae Rosengertlin*) in which the authors expounded on the symbolism of the rose and a particular devotion called "the rose garland" (*Rosenkrantz*).[25] It was probably no accident that the timing of their essay coincided with the Carthusian Order's propagation of an innovative prayer comprising fifty "Ave Marias," each with an attendant meditation on Christ.[26] Several years later, in his *Book of Experiences* (*Liber Experientiarum*, 1458), Dominic claimed rather boastfully—and erroneously, as it turns out—that he had been the first to compose such Christological meditations for the "Ave Marias." In fact, Cisterican nuns at St. Thomas on the Kyll (about 40 kilometers from Trier) had practiced a similar prayer since at least 1300.[27]

After Eloym's (probably fictional) "second founding," the Valencian tract describes in great detail another miraculous reestablishment of the rosary confraternity, this time in Cologne. Here we find the earliest printed narrative corresponding exactly to the illuminations in the chantbooks of San Pedro Mártir, the engraving by Francisco Domènech—indeed, to every devotional pictograph displaying the mysterious "Knight of Cologne."

> In the city of Cologne there was a man very dedicated to the Virgin Mary who would say her psalter [i.e., rosary] every day. It happened that one day, he had an argument with another man in the city and they came to such blows that the man who prayed the psalter killed the other. The man who was killed had a very valiant brother who was determined to seek revenge. A day came in which the killer wanted to take to the road and, as he did, was spied by his enemy. Upon passing in front of a monastery of Preachers chanting the psalms, he entered the chapel of the Virgin Mary, knelt, and began to say her psalter. As he said it, the enemy waited to kill him. But then, the brother intent on seeking revenge looked and saw that the killer was kneeling before the altar of the Virgin Mary, and before him was a very beautiful and resplendent lady. He also saw that roses were coming out of the killer's mouth, and that this very beautiful lady was taking them and making from them a garland that had one red rose and ten white roses. The garland was in such an order because that was the order in which the roses issued from his mouth. When the garland was finished, the beautiful lady placed it upon the killer's head—all of this was seen by the brother of the dead man who was waiting to kill him. However, the vengeful brother, having seen this, knew it was a great mystery and, turned compassionate by the vision, he laid down his arms and with a very happy countenance came into the path of the other. Upon seeing him, the

offender thought that this man wanted to kill him. But the brother of the dead man most joyfully told him: "Have no fear, for I willingly forgive you for the death of my brother." He then proceeded to embrace him, kiss him, and continued: "I beg your pardon and ask you to reveal the identity of that woman who stood before you making a garland of roses." The other answered that he had not seen a thing. Then the brother of the dead man said: "Tell me what prayer you were saying to the Virgin Mary." The other replied that he was saying her psalter, which is fifteen "Pater nosters" and one hundred fifty "Ave Marias." And then, the brother of the dead man who saw the lady—having recognized that she was the Virgin Mary—very lavishly forgave him for the death of his brother. He then proposed that they say the psalter after which the men parted as good friends. This act immediately became well-known by the people of Cologne.[28]

The emphasis on the immediacy with which the act became known is essential to subsequent events that quickly unfold in the Valencian tract. As midnight approaches the following evening, the Virgin appears once again, this time to the prior of the monastery at Cologne.[29] In a passage obviously designed to evoke the famous call of Moses (Exodus 3–4), the author recounts how the Virgin told the prior to give a public sermon on her psalter the following Sunday.[30] Like the reticent Moses, feeling unworthy and outright fearful that he will be dismissed as a drunk or a madman, the prior asks the Virgin for a sign to bestow credibility upon him before the people.[31] The Virgin agrees, first instructing him to remind his congregation about the recent miracle in which a man turned away from killing another after he saw her "making a garland of roses in which there were fifteen red roses and one hundred fifty white ones."[32] Then she gives the prior two prophecies to reveal. One foretells an odd miracle in which a formless "piece of flesh" (troç de carn) will be transformed into a beautiful boy after being brought by procession to the altar "in that chapel where I appeared to the killer saying the psalter to me" (en aquella capella que aparegue al dit homicida dient me lo psaltiri).[33] The other promises the reluctant prior that three days after these things are revealed, he will pass from this world and enter the Kingdom of Heaven.[34] True to her word, the predictions materialize as described, after which the narrative concludes with a grand apotheosis that people "not only from Cologne, but from all over Germany began to say the psalter or rosary of the Virgin Mary."[35] Shifting abruptly to a didactic mode, the author scrupulously reminds his readers, "that is fifteen 'Pater nosters' and one hundred fifty 'Ave Marias.'"[36]

Once we know the story, it comes as little surprise that "The Knight of Cologne" proved so popular in iconography and propaganda for the rosary and its confraternity. The tale accentuates Mary's bewildering loveliness as it simultaneously promotes the virtues of forgiveness and *fraternitas*. Indeed, not only is a killer absolved of a most grievous crime, but he and the bereaved brother are reconciled with one another and part as good friends—all through the agency of a prayer that ensured the resplendent Virgin's intercession in time of need.

Beyond a welcomed context for "The Knight of Cologne," the extended narrative in the Valencian tract from 1535 provides significant clues to help reconstruct

the cultural milieu in which the miracle took root and blossomed. Most important, the religious house central to the miracle undoubtedly refers to the Dominican convent tied to the church of St. Andrew (Sankt Andreas) in Cologne where Jakob (also James) Sprenger (ca. 1436–95) established a famous rosary brotherhood in 1475. The tract later mentions Sprenger by name—with the Valencian spelling Jaume Sparaguer—and further identifies him as a "doctor in sacred theology and conventual prior of the monastery of Cologne in the province of Germany."[37] Indeed, as we press forward in the tract, we soon realize that the Cologne miracle and all the history preceding it serve as a lengthy preamble to Sprenger's by-laws for the confraternity he established. In broadest terms, then, the Valencian tract detailing "The Knight of Cologne" is essentially an early form of the modern "infomercial" that used the most effective medium available—the printing press—to advance a particular idea of how rosary confraternities should be organized and what they should do.[38]

Sprenger's ideas on the rosary circulated widely in Spain. After the Valencian tract of 1535, his name reappears with various regional spellings—Jaume Speuger, Jacobo Spemger, Jacobo Espenger, and Jayme Specner—in rosary manuals published by the Dominican friars Hieronimo Taix (1556), Francisco Messia (1567), Juan López (1584), and Juan Sagastizabal (1597).[39] References to the confraternity Sprenger founded at Cologne resurface as late as the eighteenth century in a manual by Francisco Sánchez, printed in Spain for distribution in Mexico around 1709.[40] To all appearances, the history of the rosary in Spain and the New World might fairly be characterized as Sprenger's legacy—one heralded as early as 1488 by the *miraculum militum* appearing in Francisco Domènech's engraving for Santa Catalina of Barcelona. Precisely how news of Sprenger's brotherhood reached Spain in such short order remains uncertain. One can imagine it rode the wave of printers from Cologne, Strasbourg, Heidelberg, Ulm, and Nuremberg that flowed into Spain at the end of the fifteenth century to boost a virtually nonexistent press industry at the time.[41] In Toledo, we have seen how Pedro de Hagenbach, arriving by way of Valencia, had fulfilled that role. As for Sprenger himself, the seminal confraternity of 1475 that became his legacy in Spain and the New World was not his last major contribution to Christendom. Around ten years later he would collaborate with Heinrich Kramer (d. 1505) to write an encyclopedic treatise on witchcraft that became one of the most notorious documents of the early Renaissance—their *Hammer of the Witches* (*Malleus Maleficarum*).[42] Sprenger's thoughts turned abruptly from salvation to hellfire.

Medieval Origins of "The Knight of Cologne"

With respect to the fundamentals of "The Knight of Cologne" that eluded Valeri Serra i Boldú in 1925—"the place where it happened, the names of the persons

involved, and the year in which it occurred"—two things are certain: the place was the Dominican church of St. Andrew in Cologne, and the year was 1475. But what about the persons involved? Is there any historical basis for the miracle that might help identify them? The answer appears to be no. This fantastic tale is entirely absent from Jakob Sprenger's printed statutes of 1476—the place where one would most expect to find it.[43] Furthermore, the episode in which the prior at Cologne carried out the Virgin's directives and then died three days later is unfounded, for that prior would have been Jakob Sprenger himself, who occupied the position from 1472 until 1488.[44]

Most telling, however, Valeri Serra i Boldú and Chandler Post—neither of whom made any explicit connection between the miracle and Sprenger's confraternity—cite another version of the story in the sermons of St. Vincent Ferrer (1350–1419).[45] Impossible as it may seem, a tale quite similar to the Cologne miracle had in fact circulated in St. Vincent's lectures around three-quarters of a century before Sprenger established his brotherhood. In a sermon delivered on the twenty-fifth Sunday after Pentecost, St. Vincent expounded on a prayer bearing a marked resemblance to the rosary with this exemplum:

> See here how the prayer is made and then accepted. If done well, this prayer is an aromatic herb, and thus a thing adored, that protects one from spiritual and worldly dangers. We read in the miracles of the Virgin Mary that there was once a devoted merchant who would say certain "Ave Marias" in the morning before he would occupy himself with worldly business. And how many were there? Twelve, in honor of the twelve graces that God had bestowed on the Virgin Mary in accordance with twelve parts of her body.
>
> First, he contemplated her head replete with knowledge—more than that of a prophet, apostle, or any other. And then the merchant would say "Ave Maria." Likewise, after he came to contemplate her eyes, he thought about how many times they had looked upon her Son when He was a child . . . and then he would say "Ave Maria." Likewise he meditated on her ears, how many and what graces had they received in hearing the cries of her Son as they walked from village to village, hungry and thirsty, in the cold, mud, rain, and snow. Then he meditated on her hands, how the Blessed Lady adored her Son . . . and how she would swaddle Him, her hands serving Him thus. Then on her lips, the merchant would think on how many times she had kissed Christ's mouth, His hands, His feet. Then on her bosom, he would think about how her virgin breasts nursed the Son of God. Then on her heart, how it burned with charity. Then on her arms[,] he would think about how they carried her blessed Son. Likewise, he would think upon her virginal womb, how it carried Him for nine months. Then on her legs[,] he would think about how they conducted Him to the temple, and here, and there. Then he would think about all of the perfection in her sacred soul. Then on all of her body; what penitence!
>
> Now listen well. See that one day the merchant missed saying this prayer, and upon realizing it fell to his knees, asked forgiveness, and said the oration, for he adored her. It then happened that this merchant had to walk to the market, and since the route was heavily laden with the danger of thieves, he arranged to go with others who were also walking there. On the day they were to leave, these men came to him in the morn-

ing and awakened him: "Come on, it's time to go." They were in such a hurry that the merchant did not offer the prayer he was accustomed to saying. And see now that as these men were walking they came upon many highwaymen who took hold of them, carried them off into a meadow, and killed all of them except the merchant who had been left behind. Knowing they were going to slit his throat, he turned his heart to the oration and requested that they allow him a favor, that they let him pray. The men responded: "Yes, but be done with it quickly!" "I will," replied the merchant, and he began to say his customary prayer. Just as he began to think on the Virgin Mary—according to what is said—the Virgin appeared along with Saint Catherine who held a plate full of roses, and Saint Agnes with a needle and thread. Upon seeing them the highwaymen were astonished. And then every time the merchant said an "Ave Maria," the Virgin Mary took hold of a rose—she did this for every "Ave Maria"—and she sewed them together in a garland that she placed on the merchant's head. He saw nothing of this but sensed a wonderful fragrance, and then the women disappeared. Then the merchant turned to the highwaymen and said: "Brothers, I have said my prayer, slit my throat." The highwaymen said: "How can we slit your throat?! Who were those incredibly beautiful women who stood with you? You must be a blessed man, and we surrender ourselves to your prayers." Then they returned him to the road along with all of his belongings. I believe that the highwaymen were converted by what they had seen.[46]

Even stripped bare of the vibrant colors of gesture, dramatic pause, and vocal inflection, this written account permits a faded glimpse of the brilliant oratory for which the Valencian preacher was famous. With a rhetorical strategy that surely captivated the popular imagination, St. Vincent cleverly infused spiritual meditations on the graces of the Virgin Mary with the poetics of a lover contemplating his mistress. Most relevant, of course, is the basic plot, with several points of contact with "The Knight of Cologne": a fatal attack prevented by Mary's miraculous intervention, "Ave Marias" transformed into roses, the transformed roses sewn into a garland, and the conversion of would-be assailants. A striking resemblance is also seen on a more subtle level. Here again the faithful protagonist is unaware of the miracle that has just occurred. To recall the relevant passage from the Valencian tract of 1535: asked to identify the woman who stood before him making a rose garland, the man kneeling before her altar "answered that he had not seen a thing" (respos que no havia vist res).

St. Vincent's sermon declares from the start that the exemplum is one "we read among the miracles of the Virgin" (legim en los miracles de la Verge Maria). Thus, whatever St. Vincent might have embellished in his oratory, the basic tale is one he had learned somewhere else. We can only guess where, for there are at least as many possibilities as there are late Medieval documents that transmit similar plots. An almost identical scenario was dramatized in a French miracle play from the Middle Ages called "[The Tale] of a Merchant and a Thief" (De un marchant et un larron).[47] Beyond that, investigating the origins of yet another version of the same plot in Medieval German literature—one in which the characters are a monk and a thief in the woods—the philologist Joseph Dobner

uncovered an impressive miscellany of related stories in German, Latin, French, and even Ethiopic and Arabic sources that circulated from the late-thirteenth to mid-fifteenth centuries.[48] The paper trail is long indeed, tracing a path through the diverse cultures touched by Christian evangelism in the Middle Ages. Looking toward the start of that long and winding road, we find the earliest narrative identified thus far: an exemplum tied to the Cistercian Order called "The Virgin Mary's Chaplet of Roses" (Exemplum de capello rosarum beate virginis). The story appears in a late-thirteenth-century manuscript now at the Bibliothèque Nationale in Paris, France (lat. 18134, fols. 145v–47v).[49]

Rich in detail and replete with biblical references, the Cistercian exemplum begins with a lengthy, vivid account of events preceding the fateful encounter between a monk and a band of thieves in the woods. We are first told about a wealthy widow who raised a son on her own and instilled him with a pious devotion to the Virgin Mary. Among the boy's most reverent acts was a daily ritual in which he collected roses and lilies from the valley. With these he adorned an image of the Virgin in their private chapel, laying wreaths and garlands upon her while repeatedly chanting "Ave Maria." After his mother died and the inheritance passed to him, the boy abided by her counsel to take only what was necessary to live, expending all else in continuous devotion to the Virgin. The boy's relatives—disgruntled by what they perceived as a squandering of the inheritance—arranged for him to enter a nearby Cistercian monastery and conspired to take the money for themselves. This came to pass with no struggle, for much to their surprise and delight the boy happily renounced his worldly possessions to enter the service of God and readily agreed to take up a monastic life.

The tale centers next on the boy's new vocation as a monk at the Cistercian convent. An important turn occurs just after the novice realized that in his new vocation he would no longer have time to collect roses and lilies for the garlands he was accustomed to make for the Virgin. Greatly perturbed at first, he eventually found comfort in a worthy compromise:

> With his mind changed to the fact that he was not a steersman fully in possession of his own will, he brought himself to exchange his customary devotional act of decorating the image of the Blessed Virgin with lilies and flowers for another worthy one, observing and knowing that through the salutation "Ave Maria" he could make a garland for the Blessed Virgin just as he used to out of the roses and lilies. And thus, he would "pluck" for the Blessed Virgin, through all the daily salutations of "Ave Marias," the equivalent of the roses or other flowers he used to connect into a garland in her honor.[50]

The Virgin was pleased by the new devotion. She bestowed heavenly grace upon the young monk, and his esteem grew in the eyes of his Cistercian brothers. In fact, his esteem grew so much that he was soon appointed prior of the

abbey—a promotion that displeased him since now, weighed down by the business of the monastery, he no longer had enough time to observe the Divine Office properly and keep up his habitual prayer to the Virgin. The story nevertheless assures us: "the garland which he was accustomed to make from the 'Ave Marias' was not interrupted in any way whatsoever."[51]

Finally, the exemplum arrives at the heart of the narrative with a climactic confrontation between the good monk and a band of mercenaries in the woods.

> And now it happened one day, that the prior went to a certain place to receive a payment, which, much to his dismay, was a duty of his office. But as he was receiving the money with derision for the task, two thieves were making ready for an ambush. Plotting his death, eager to rob him, and even delighting in the thought of just leaving him half-dead, they took up a position and concealed themselves in a wooded grove through which the monk was accustomed to walk and awaited his coming. The monk, approaching and preoccupied with his customary prayers, came upon the thieves. And they, preparing to attack him, upon looking back, saw next to him a most beautiful young woman adorned by the most precious garments and glittering jewels. This woman—lovely beyond all others—was gingerly and with such delight making a garland out of roses she took from the monk's mouth. When the garland was finished, she laid it upon her head then rose up and vanished into thin air.
>
> The mercenaries who saw this were startled and moved about as if drunk. All sense left them, their hearts were filled with compunction, and they collapsed at the monk's feet, begging his pardon with outstretched arms and copious tears. The monk, frantic and startled by this, asked: "What do you seek, my brothers?" The men responded: "O servant of God, truthful and surely able to lead the way to the Lord, have mercy on us! Pardon the deeds we had begun to commit against you, and tell us about that woman, so venerable and virtuous, whose hand collected the roses that came out of your mouth—the woman who was next to you for such a long time, making a garland with her own hands, and having completed it, then vanished from our eyes!" After relating all that they had seen occur, the men embraced the monk's feet.
>
> The monk, hearing this and contemplating their contrition, which was beyond belief, wonderingly said: "You will tell this vision to no one, but magnify the Lord, because you do not know what you say." The men responded to him: "On the contrary, holy father, we do know what we have said and what we have seen, and our testimony is true—have mercy on us!" The monk then said to them: "What do you wish me to do for you?" And the men answered him: "Holy father, help us, so that we may be worthy to live in your monastery and be received by your abbot in your faith, and there, aided by your prayers, may be worthy enough to blot out the filth of our sins." Then, considering their admirable piety and prayers, the monk said, "Be not afraid; you will be comforted and become strong. Follow me, and I will make you servants of God." He then led the men and presented them to his abbot, to whom they reported all the things they had seen and experienced in order, and to whom they humbly petitioned that they be received among the brethren. Then the abbot, blessing the men and amicably receiving them into the brotherhood of his order, gave thanks to God and his Blessed and Glorious Mother, through whom the souls of these men—which the Devil had endeavored to take away—were restored to God.[52]

Music in *Las Cantigas de Santa María*

At some point near the time "The Virgin Mary's Chaplet of Roses" was copied into the late-thirteenth-century manuscript preserving it, still another version of the same plot was worked into the massive compilation *Las Cantigas de Santa María* (*The Songs of Holy Mary*) at the Spanish court of Alfonso "The Wise" (1221–84), the great king of Castile and León. *The Songs of Holy Mary* comprise 420 musical settings of devotional poems and narratives that praise Mary and recount her miracles. These were collected under Alfonso's supervision between about 1257 and 1283, with many songs possibly composed by the learned king himself. The miracles were compiled from diverse sources—some written, some oral—and while not every one is exclusive to the Iberian Peninsula, all were redacted in Galician-Portuguese.[53] This choice of language is significant, for it is the characteristic idiom used by the Medieval Spanish troubadour—the professional bard-minstrel for whom love was an obsessive theme with endless variations. Indeed, the king meant to fashion for himself precisely that role. As his prologue to *The Songs* tells us:

> That which I desire is to praise the Virgin, Mother of Our Lord, Holy Mary, who is the better part of all creation; and for that reason I wish to be her troubadour from this day and forever hence; and I beg that she will accept me as her troubadour and receive my songs, for through them I wish to reveal the miracles she performed; and from now on I will abandon offering my works to just any lady, attempting to recover in this way all I have wasted on others.[54]

Among the songs this troubadour-king wished to lavish upon his virtuous maiden, one unfolds a plot familiar by now—one in which a faithful protagonist (here a knight) is delivered from his enemies by an apparition of Mary weaving a garland together from the roses that issued from his mouth. Once again, the enemies are converted by the miracle, and once again, the intended victim is unaware of the vision that has just saved him. What is different about this version, however, is that the story takes flight on wings of song. Like most of the *Songs of Holy Mary*, it is set to the musico-poetic form of the *virelai*, a conventional form illustrated here using the first stanza only. The letters "a" and "b" represent two different melodies that set the text; the capital letter "A" represents sections in which the same text recurs with the same melody as a refrain. Corresponding sections are labeled in the score (see ex. 3.1).

De muitas maneiras busca a Virgen esperital	A
carreyras en como guarde os seus de mort' e de mal.	
E de tal razon com' esta, en Proença hua vez	b
amostrou mui gran miragre a Sennor de todo prez	b
contra un seu cavaleiro que tal promessa lle fez	a
que lle guerlanda faria de rosas toda, non, d'al.	
De muitas maneiras busca a Virgen esperital	A
carreyras en como guarde os seus de mort' e de mal.	

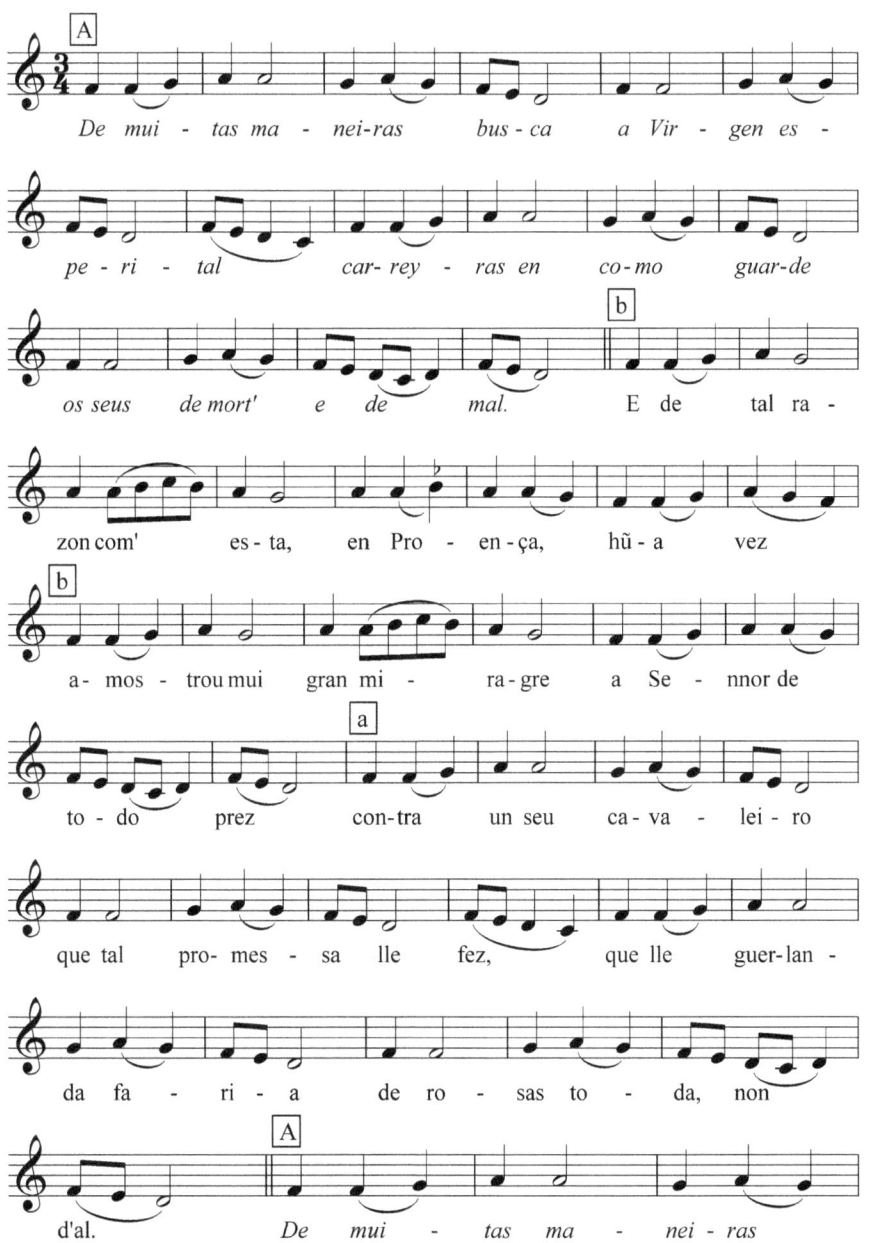

Example 3.1. Cantiga 121, "De muitas maneiras" (*virelai*) from *Las Cantigas de Santa María* (*The Songs of Holy Mary*), thirteenth century.

A translation of the full text is given next to provide a sense of Alfonso's version of the story. For the sake of clarity, it is rendered here in prose with no adherence to the strict *virelai* form. Refrains are indicated at the ends of stanzas, however, to demonstrate how the conventional structure of this musico-poetic form occassionally breaks up the narrative flow. The resultant tension is part of the game, for in the Medieval art of lyrical expression, form was just as important as content and in some cases superceded it.

[Refrain//] The spiritual Virgin looks for many ways to protect her faithful from death and evil.

And for such a reason, the Lady of all glory once revealed a very grand miracle in Provence to a knight (cavaleiro) who made this promise—
that he would make for her a garland entirely of roses, and not of anything else. [R.//]

This would be done every day if he could find them, and, if not, he would say in the place of each rose one "Ave Maria"; and so, with all of the "Ave Marias," he would approximate the garland so that he could meet his obligation. [R.//]

He did this for a very long time, and did not fail to keep his promise in any way because he would make the garlands of roses very well in their season, and he would place them on the Virgin's image, and then, he would commend himself to her, for she never fails her faithful. [R.//]

When he could not find roses, he would pray—as I learned—all of the "Ave Marias" he had promised, and not a single one was missed. And doing this one day, he found himself with his enemies in the middle of a large valley. [R.//]

These enemies were coming very well mounted on horseback. But alas, he was not, as he was riding on a skinny post horse of his. So he dismounted the horse and fell to the ground on his knees. [R.//]

And he said the "Ave Marias," praying from his heart to the Virgin so that she might help him. Then the Virgin came to his aid, and that place where the band of enemies had planned on killing him was seen to be entirely surrounded by a heavenly light. [R.//]

And they also saw a woman making a garland of roses, and the intended victim beside her placing roses on the garland; but the enemies would not approach him, and instead they exclaimed: [R.//]

"Let us turn away from here immediately, as it does not please God that we should want to kill this man, for he is one of his servants."
"And for that reason I advise us, my friends"—said one of the men— "that we leave, for it is a colossal task. . . ." [R.//]

"For us to wage a battle against the Mother of the Lord—that Lady more beautiful than any flower—who we see at the side of this man, who makes the garland with him, and who is his protector. If we were to attack him, we would be dissolved just like salt in water." [R.//]

The men departed; and the knight saw none of this—not even the Lady—nor did he feel the garland that he held in his hand. But in that land of Provence he learned of the miracle after others told him of the Lady who is powerful and assists her faithful. [R.//]

And because of this, if he had loved her before, afterwards he loved her much more; and he told this miracle throughout many lands and, while many praised her, he praised her especially, demonstrating how in times of trouble, she is very loyal to her faithful. [R.//][55]

With the phrase "as I learned" (com' aprendi) in stanza four, we are alerted to the fact that this story (let us call it "The Knight and the Mercenaries") was taken from somewhere else. Possibly it existed as part of an oral tradition; perhaps it was copied from another document. Whatever the case, the story was not new to Alfonso or those who compiled *The Songs of Holy Mary*. It is difficult to say if even the musical setting of the tale is original, for it too might have been part of an oral tradition before being set down for posterity. If anything can be construed as "new" in relation to this song, it may be the set of illustrations preceding the musical setting in the aptly named *Códice Rico* (*Rich Codex*), now preserved at the monastery of El Escorial, near Madrid.[56] Indeed, this contemporary source presents what could be the earliest pictorial rendition of the archetypal plot underlying "The Knight of Cologne," "The Merchant and the Thief," "The Virgin Mary's Chaplet of Roses," and other related tales and exempla. Interestingly, rendered there in the multimedia format of text, image, and song, the edition of "The Knight and the Mercenaries" and its companion stories in the *Rich Codex* very much resemble modern-day Web pages. And we might even extend that comparison to include the interactive capabilities of Internet technology, for another song in that grand compilation describes: "How King don Alfonso of Castile fell ill in Vitoria and had such severe pain that he thought he would die of it. They laid the book of the *Songs of Holy Mary* upon him and he was cured."[57] In the mystical mind-set of the late Middle Ages, our impersonal and largely intangible electronic media might well have paled by comparison.

"The Knight of Cologne": Past and Present

What conclusions can we draw about the legend of "The Knight of Cologne" displayed so prominently in the illuminations of the Rosary Cantoral and its

companion leaves? A legacy of Medieval forebears demonstrates that it was only the latest version of a traditional story about forgiveness, reconciliation, and brotherhood that had been reworked over centuries. Known on the Iberian Peninsula from at least the mid- to late-thirteenth century through *The Songs of Holy Mary* and, later, through the sermons of St. Vincent Ferrer, the archetypal story reentered the consciousness of early modern Spaniards through an apocryphal miracle that purportedly led Jakob Sprenger to establish a new rosary confraternity at Cologne in 1475. Indeed, this might fairly be called a myth—its theme: the vision of the salvific woman.

For the Spanish theologians who essentially turned an old Cistercian exemplum into a founding miracle of Sprenger's confraternity—which required little more than updating a few characters—the lack of any verifiable basis to the story was probably irrelevant. In fact, the associated (and morbidly fascinating) miracle about the piece of flesh transformed into a boy one finds in the Valencian tract from 1535 is just one more instance of a popular old tale revamped for a modern audience. Reportedly another "Cologne miracle" that occurred in the same chapel where Mary appeared to a killer praying her psalter, this is actually a fourteenth-century feat attributed to the famous and much-beloved Black Madonna of Montserrat in northeastern Spain.

> [In the year 1345] a Franciscan brother preaching in this sacred church affirmed as true that in the town of Cervera there was a married woman who continuously prayed to the Virgin of Montserrat, asking for a son. As she persevered in her prayers, in a few days she felt herself conceive. When the hour of birth arrived, what she had borne was taken into the light and the birthing maids found themselves with a piece of flesh in their hands—this without any figure or human form. The devout woman, who had hoped for a beautiful child, became anguished upon seeing what it was, and, although she was in pain, she wrapped the piece of flesh in several cloths and began to call upon the Glorious Lady with many tears. She told the Virgin she had asked for a son and was instead given a piece of flesh. But she held out hope that, in her mercy, the Virgin would transform it into a son, and from this would come glory to her most holy name and the disconsolate parents would rejoice. This said, she unwrapped what she had borne, for she sensed that it was starting to move, and found a perfect and beautiful boy. Everyone was amazed by this and gave many thanks to God and to his most holy Mother.[58]

Cleverly tapping into a collective folk mythology that was an undercurrent in the popular religious culture of early modern Spain, the theologians promoting the cult of the rosary had done nothing more—indeed, *nothing less*—than follow the example of Christ, who taught in parables during his own ministry.[59] These simple, attractive tales provided the Cistercians, Franciscans, Dominicans, and their evangelical brothers further means to preach effectively before a lay public to whom the mysteries of heaven had not been given to understand.

The Weaving Virgin and the Toledan Brotherhood

For all the popularity "The Knight of Cologne" had garnered in Spain during the fifteenth and sixteenth centuries, most of the faithful probably derived little else from the story beyond its attractive proclamation of Mary's salvific power through the rosary and its confraternity. Given the story's didactic and propagandistic aims, that was probably enough. But "The Knight of Cologne" had a unique significance for the rosary brotherhood of Toledo. The reason lies in the miraculous act of weaving performed by the Virgin Mary, for, as we saw in chapter 2, membership in this brotherhood was strictly limited to artisans of the local silk weaving trade. Mary was not only the creator and patroness of the rosary, she was a weaver herself. The double meaning of the illumination is most evident in the Morgan leaf where, upon reinspection, we can now see the Virgin Mary quietly weaving her garland together with a needle and golden thread (see figs. 5 and 27).

The legend of the rosary shown in the grand illuminated initials of the Rosary Cantoral and its companion leaves thus celebrated in one splendid image not only a hallowed aspect of the donors' faith but also a venerable moment in the history of their trade. Its representation is at once a sign of religious conviction and of personal identity—a pictograph rich with meanings that only reveal themselves as we come to understand with greater sympathy the cultural context in which it was created. The multiple layers of meaning are also evident in the recondite emblem of the Five Wounds, to which we turn in chapter 4.

Chapter Four

The Emblem of the Five Wounds

The Rosary Cantoral and its sister leaves share an emblem with five bleeding wounds and the Latin inscription "Miserere Mei"—"Have mercy on me" (see fig. 12). As we saw in chapter 1, the emblem's resemblance to a heraldic shield complicated research on the origins of these manuscripts. One scholar associated the emblem with the Acuña family of Burgos. Others connected the Five Wounds to the stigmata of St. Francis of Assisi and thus a Franciscan house. Those were false leads, of course. Now we know that their place of origin was not Burgos but Toledo. The house to which they were tied was not Franciscan but Dominican. Such are the risks of placing too much faith in a single element of these or any cultural artifacts of similar complexity. But what was the significance of the emblem on these books at the turn of the sixteenth century? A broad consideration of the emblem on these instruments of communal worship sheds light on that question and, interestingly, leads to revelations about one aspect of private devotional life in Toledo—how the rosary was prayed there. This is no mean feat considering the virtually countless ways one might have done so at the time.

But first, given the history of arguments for the emblem's association with the Acuña family and, especially, the Franciscan Order, it is instructive to begin by examining overlooked evidence to the contrary. In some cases, the evidence is found on the manuscripts themselves.

The Five Wounds and the Passion of Christ

Like the pierced heart adopted by the Augustinians and the fleur-de-lis used by the Dominicans, the iconography of the Five Wounds became the regular emblem of the Franciscan Order in fifteenth- and sixteenth-century Spain. Indeed, it was as common there as it would later become in the New World.[1] We find it, for example, at the Observant Franciscan convent of San Juan de los Reyes in Toledo, Spain (1477–95), and at the Franciscan church of San Andrés Calpan near Puebla, México (1540–48). In both instances, five bleeding wounds appear on a shield supported by two angels, the manner fully reminiscent of the emblems in the Rosary Cantoral. A later example appears in a *retablo* of St. Francis in the

early-eighteenth-century church of Santa Cruz de la Cañada near Española, New Mexico.²

The emblem of five bleeding wounds was often incorporated in Franciscan publications as well. One appears on the frontispiece of the *Quadruplicium concionum super evangelia* (*Sermon on the Gospel in Four Parts*) by the Portuguese friar Felipe Diez (1550–1601)—a treatise that was printed in Salamanca, Spain, in 1584 and subsequently circulated in Mexico. The emblem there is divided into three compartments. One shows five bleeding wounds, another shows the three nails that punctured the hands and feet of Christ, and the third displays the intertwined arms of Christ and St. Francis—their palms turned slightly to reveal their wounds. An inscription surrounds all of these images. It quotes from the versicle and response for the Vespers hymn on the Feast of the Stigmatization of St. Francis (September 17): "Signasti Domine servum tuum Franciscum signis redemptionis nostrae"—"Lord, you marked Francis your servant with the signs of our redemption."³

The Franciscan claim on the icon of the Five Wounds was tied to a miraculous event in the life of St. Francis. In September 1224, as he fasted and prayed on La Verna (Alverna), an isolated mountain in the Italian province of Arezzo, a seraph appeared in the heavens and "imprinted the signs of crucifixion upon him, so that he himself seemed to have been crucified. His hands, feet and side were marked by the signature of the cross."⁴ The signature of the cross marked St. Francis for the remaining years of his life, and he thus assumed first place in a line of stigmatics that extends to our own time. The most recent stigmatic of note was Padre Pio da Pietrelcina (1887–1968), a Capuchin Franciscan who was canonized by Pope John Paul II (Karol Wojtyla, prelacy 1978–2005) in 2002.⁵

From St. Francis to Padre Pio, stigmata have created causes célèbres of those who have claimed to bear them. By some counts there have been at least three hundred or so, the majority of them women. The forms of the wounds vary—some appear on the hands, feet, and side; others on the forehead or back—but, in every case recognized by the Roman Catholic Church, the stigmata are vivid outward signs of compassion (in the most literal sense of *compassio* as "suffering with") with Jesus Christ and the wounds he received before and during the Crucifixion.⁶ St. Francis is no exception. Indeed, the versicle and response for the Feast of the Stigmatization ("Signasti Domine") are instructive on this point. The "signs of our redemption" are not the stigmata of St. Francis in and of themselves. The stigmata of St. Francis are only expressions of the true signs in the Wounds of Jesus Christ who, following Christian doctrine, shed his blood for the redemption of humanity. The wounds in the Rosary Cantoral and its related folios must be viewed in the same light. Presupposing that the Five Wounds are the stigmata of St. Francis and jumping to the easy conclusion that the manuscripts must therefore be Franciscan considers the iconography in far too narrow a way.

Narrower still is the idea that the Five Wounds correspond to the Acuña family of Burgos. That notion has taken root not only with respect to the Rosary

Cantoral but also to its related folios, Getty Ms. 61 and Morgan M887-1.[7] The tie with the Acuña family seems to be based on an emblem with five wounds that decorates two manuscripts once connected with the prelacy of Bishop Luis de Acuña of Burgos (1456–95). One is a fifteenth-century *Liber Pontificalis* of Burgos, now at the Biblioteca Nacional in Madrid.[8] The other is a leaf from a fifteenth-century liturgical book at the Cathedral of Burgos.[9] Both display an emblem with five bleeding wounds (each wound has a distinctive almond shape) in the manner of a heraldic device centered in the bottom margin of the folios.[10] But the immediate contexts in which the emblems appear have been overlooked: each is found on a folio that depicts Christ crucified. The perception that the emblems represent a coat of arms is understandable—they look like such devices—but false. The leaf at the Cathedral of Burgos underscores the point because the emblem is displayed inside a monstrance—a vessel that houses and protects the Eucharist, which, in Catholic theology, is the actual presence of the Body of Christ.[11] In sum, the emblems on these leaves are not the coats of arms of Bishop Luis de Acuña but here, too, are signs of Christ's Passion. Similar examples of the emblem in Passion contexts can be seen in the English fifteenth-century *Missal of Abingdon Abbey* (1461) and in a later fifteenth-century English Book of Hours (ca. 1470–80), now at Harvard University's Houghton Library.[12]

Like the emblem in Acuña's manuscripts, the *Missal of Abingdon Abbey*, and the Houghton's Book of Hours, the emblems of the five bleeding wounds in the Rosary Cantoral and its related folios are tied to the Passion of Christ as well. Some of the clearest evidence to that effect is found on two leaves from the set that have been tied erroneously to the Acuña family: Getty Ms. 61 and Morgan M887-1.

Getty Ms. 61

The Getty folio is a Passion leaf through and through (see fig. 6). The driving force in that respect is its chant, "Judica me deus," the Introit for the Mass on Passion Sunday. Our modern liturgical calendar observes Passion and Palm Sunday concurrently on the Sunday before Easter. But prior to the Second Vatican Council (1962–65), Passion Sunday was a separate feast, observed on the fifth Sunday of Lent. It was the first day of a two-week period before Easter called Passiontide that marked the beginning of a time for great solemnity and abstinence.[13] Because the Gospel reading for Passion Sunday concluded with a passage about the Lord going out of the temple and hiding himself (John 8:59), during Passiontide churches customarily veiled their sacred objects from view. The practice of covering paintings, statues, crosses, and other items of comfort for the faithful was established by the seventeenth century and probably took place well before that.[14] A similar practice occurred with a certain prayer, a plea for deliverance that was typically recited just before Mass but omitted after Passion Sunday—"Judica me deus" from Psalm 42 (Vulgate). On Passion Sunday

"Judica me deus" was sung at the Introit but not heard again until Easter.[15] Like the comforting images that were hidden from the eyes, this familiar oration was withheld from the ears of the praying community for the two solemn weeks leading up to the Sunday of Christ's Resurrection.

The emblem of the Five Wounds on Getty Ms. 61 played into this liturgy of abstinence. There the illuminator cleverly foregrounded whatever connections he could find between the emblem and the feast. For one, this representation of the stained cloth (shown bottom center) is unlike any other in the set because the angels displayed on either side are not holding it. Instead, the cloth is tied to the curves of an arch at the opening of a small *aedicula*—a niche to shelter a sacred image or statue. The cloth appears to be concealing something and is thus harmonious with other cloths that would have been hiding devotional images throughout the church from Passion Sunday onward. The illuminator also incorporated brief inscriptions in the empty *aediculae* on the extreme left and right lower margins that are as relevant to the bleeding wounds on the cloth as they are to the occasion of Passion Sunday (see fig. 28). From left to right they read: "Portemus in memoria / Penas et obprobria Christi"—"Let us remember the punishments and indignities of Christ." The phrase was drawn from the second strophe of a thirteenth-century hymn for the Office of the Passion attributed to St. Bonaventura (1221–74).

In passione Domini,	The salvation given to man
Qua datur salus homini,	through the Lord's Passion
Sit nostrum refrigerium	became our consolation
Et cordis desiderium.	And our heart's desire.
Portemus in memoria	Let us remember
Et poenas et opprobria	the punishments and indignities
Christi, coronam spineam,	of Christ; the thorny crown,
Crucem, clavos et lanceam	the cross, the nails, the lance,
Et plagas sacratissimas,	And the most Holy Wounds,
Omni laude dignissimas,	all most deserving of praise;
Acetum, fel, arudinem,	the vinegar, the gall, the reed,
Mortis amaritudinem.	The bitterness of death.
Haec omnia nos satient	All of these things nourish
Et dulciter inebrient,	and sweetly intoxicate us;
Nos repleant virtutibus	Let them fill us with virtue
Et gloriosis fructibus.	And glorious fruits.
Te crucifixum colimus	We worship you, the crucified,
Et toto corde poscimus,	and ask with all our heart
Ut nos sanctorum coetibus	that you bring us into the union
Coniungas in caelestibus.	Of saints in heaven.

> Laus, honor Christo vendito Praise and honor to Christ, given up
> Et sine causa prodito, and betrayed without cause,
> Passo mortem pro populo he suffered death on behalf of the people
> In aspero patibulo. On the bitter cross (gibbet).[16]

The marginal inscriptions on Getty Ms. 61 are thus part of a longer meditation on the Wounds of Christ. We can imagine that the conjuct leaf continued with short inscriptions drawn from the hymn's brief litany of Passion instruments: "the crown of thorns, the cross, the nails and the lance." Or perhaps, in light of the selective quoting (the entire first strophe of the hymn is passed over), the illuminator cut straight to the first two lines of the third strophe: "Portemus in memoria / penas et obprobria Christi / et plagas sacratissimas / omni laude dignissimas" (Let us remember the punishments and indignities of Christ, and the most Holy Wounds, all most deserving of praise). We may never know for certain what additional part of the hymn, if any, the illuminator chose to quote on the conjunct leaf. But the existing fragment from the Office of the Passion is sufficient to confirm that the wounds we are exhorted to remember, the wounds before which the angels pray in the Getty leaf, can only be the Five Wounds of Christ.

Another emblem of the Five Wounds appears to the left of the illumination depicting "The Knight of Cologne." (The illumination itself is an inhabited initial, an enormous letter "I" at the start of the word "Iudica"—"Judica" in modern spelling. The serifs of the "I" are accentuated by sprays of white vine.) The fact that the emblem of Christ's Passion should appear before the incipit of a chant for Passion Sunday seems entirely appropriate. But there is also a marked poignancy in the juxtaposition of the bleeding emblem and the innocent Christ child shown reclining in Mary's arms, more so because the child's face is not turned away or shielded from the Passion image. Indeed, the emblem displaying the wounds of the child's future Crucifixion appears to be within his direct line of sight. The sensitive viewer would perceive in one glance Christ at his cheerful beginning and at his painful end.

Morgan M887-1

Morgan M887-1 (see fig. 5) presents another case of poignant interaction between the subject in its decorated letter (here the "A" of "Ad te levavi") and an image in the margin. The chant on the Morgan leaf, "Ad te levavi," is for the first Sunday in Advent—the start of a period of joyful preparation that leads up to Christmas, the feast celebrating Christ's birth. Temporally, it is at a far remove from the Passion. Advent celebrates the beginning of Christ's humanity, the Passion its end. But here, too, are painful reminders of what is to come. We see at the bottom two angels holding a shield that bears the wounded hands, feet, and Sacred Heart of Christ and is marked by the inscription "Miserere Mei." In the left and right margins, we find the familiar cloths stained by the five bleeding wounds.

The casual observer may not notice that the illuminator placed important representations of Christ's Passion and Resurrection next to these cloths. Directly beneath the blood-stained cloth on the left is a peacock, a symbol of Christ's Resurrection because the peacock's flesh was thought incorruptible.[17] The poignant interplay between letter and margin relates to the image placed directly below the cloth on the right. In the large letter "A" depicting "The Knight of Cologne," the Christ child stands nimbly on his mother's lap, full of life and playing with a finch that has lighted on his finger (see fig. 27). Beneath the wounds in the right margin, however, we find an ominous portent of the Passion—the image of a lifeless finch gripped by a predator owl (see fig. 29). The design of the painting resonates with a print by Martin Schongauer (d. 1491), which arguably served as a model.[18] But its real significance lies in the symbolism of the finch and owl. Like the peacock, the finch was common in Christian art, a symbol of Christ's Passion and Crucifixion.[19] As for the owl, a popular allegorical tradition among Christian writers held that this predator bird represented the Jews who rejected Jesus and pressed Pontius Pilate for his Crucifixion (John 19:1–7). Like the nocturnal owl, the Jews "loved the darkness more than the light" and turned away the Lord who was sent to save them.[20]

The placement of these Christological symbols for the Passion and the Resurrection in such proximity to the five bleeding wounds was neither incidental nor whimsical. They represent serious reflections on what the illuminators saw as the Five Wounds of Christ.

Prophesies of the Five Wounds

The canonical Gospels of Matthew, Mark, Luke, and John reveal precious little about the Crucifixion—the event that produced the Five Wounds. Readers scouring the Vulgate Bible for a narrative on Christ's execution will find only a simple report from each of the Evangelists: "they crucified him" (crucifixerunt eum).[21] The Gospel of John is exceptional in describing a single violent act that corresponds directly to the Five Wounds: "one of the soldiers with a spear opened his side, and immediately there came out blood and water" (John 19:34). But otherwise, the Gospels offer no account of a nailing to a cross that would have pierced the hands and feet of Christ. The cross itself is never described!

The fleshing out of such details was left to exegetes who mined and interpreted Scripture to produce accessible narratives on the Passion and Crucifixion. The most compendious essays were written between the twelfth and thirteenth centuries and were attributed to major theologians such as St. Anselm (d. 1109), St. Bernard of Clairvaux (d. 1153), and St. Bonaventura (d. 1274).[22] St. Anselm's *Dialogus beatae Mariae et Anselmi de passione Domini* (*The Dialogue of Blessed Mary and Anselm Regarding the Passion of the Lord*) presents a good example.

This passage from the *Dialogus* is given from the Virgin Mary's point of view and is duly prefaced by the disclaimer that "none of the Evangelists records this" (nullus evangelistarum scribit).

> When they had arrived at the most ignominious of places, Calvary, where dead dogs and carrion were thrown, they stripped my only son of all his clothes, and I swooned; but taking my head-cloth I bound it about his loins. Thereupon they laid the cross on the ground and extended him upon it and drove in the first nail which was so thick that it filled the wound it caused and no blood could flow. Then they took ropes and dragged the other arm of my son Jesus and drove in a second nail. After this they dragged his feet with ropes and drove in one very sharp nail, and he was so stretched that all his bones appeared, so that the words of the Psalm were fulfilled: they have numbered all my bones.[23]

The end of the passage reveals that writers were not making things up. Their sources were found in the Old Testament on the authority of Christ who had declared to his disciples "that everything written about me in the law of Moses, the prophets, and the psalms must be fulfilled" (Luke 24:44). In this case, as with many other writers (including the Evangelists themselves), the source was Psalm 21—also known as the Passion Psalm, its opening lines paraphrased by Christ as he cried out in the ninth hour: "My God, my God, why hast thou forsaken me?"[24] The Passion Psalm also prefigured the casting of lots for Christ's garments (Psalm 21:19) and, importantly, the nailing to the cross: "they have pierced my hands and my feet; they have numbered all my bones" (Psalm 21:17–18). John's account of the violent piercing of Christ's side is likewise grounded in the Old Testament—a fact John is quick to point out: "these things were done, that the scripture might be fulfilled . . . they shall look on him whom they pierced" (John 19:36–37). Here, John was reflecting on the word of God as written through Zechariah the prophet: "I will pour out upon the house of David, and upon the inhabitants of Jerusalem, the spirit of grace, and of prayers: and they shall look upon me, whom they have pierced" (Zechariah 12:10).

Thus, the infliction of the Five Wounds is found not in the canonical Gospels but in the books that foretold the suffering and death of Jesus Christ—the Old Testament, Hebrew scriptures read through Christian eyes. It becomes clear, then, why Matthew, Mark, Luke, and John needed only to confirm that "they crucified him" (crucifixerunt eum). Everything that related what was to happen had been written. All that remained was their fulfillment, and, with only a few words, the Evangelists report just that.

Beinecke Ms. 794

Images surrounding the emblem of the Five Wounds on Beinecke Ms. 794 (see fig. 4) reveal that the folio's illuminator had an understanding of the Old

Testament's role in telling the story of Christ's Passion and Crucifixion. The figure seated to the left of the Wounds is identified by a gold inscription as the Old Testament prophet Jeremiah. Likewise, the figure on the right is identified as the prophet Zechariah. Both are shown writing and meditating in their respective cells as they turn inward toward the cloth displaying the Five Wounds.

Jeremiah's Lamentations have figured prominently in the Christian liturgy for Holy Week since at least the ninth century. In an earlier phase of the tradition, a reading of the entire book was spread across the three days that constitute the *triduum sacrum*—the Thursday, Friday, and Saturday of Holy Week that recall, respectively, the Last Supper, the Crucifixion, and the Easter Vigil. The lengthy readings would normally take place during the first Nocturn of Matins. Later, they were shortened to include only select passages.[25] The readings are from the Old Testament, but in the season of Passiontide their association with Christ's suffering is made explicit. Then as now, to the Christian faithful the Lamentations of Jeremiah are prophetic writings fulfilled in the person of Jesus Christ.

So too, as we have seen, are scriptural passages from the Book of Zechariah. Whereas Jeremiah's Lamentations reflect on the general theme of suffering (Passion), excerpts from Zechariah provide more concrete references to the future actions and sufferings of Christ. There is, for example, the prophesy of Christ's entry into Jerusalem on Palm Sunday (Matthew 21:5 and John 12:14–15): "Lo, your king comes to you; triumphant and victorious is he, humble and riding on a donkey" (Zechariah 9:9). And there is the piercing of Christ's side in the Gospel of John (19:34)—the fulfillment of Zechariah 12:10.

The images of Jeremiah and Zechariah are directly related to the emblem of the Five Wounds on Beinecke Ms. 794 because the leaf itself has nothing to do with the Passion.

As we saw in chapter 1, Beinecke Ms. 794 is a palimpsest. The original chant, "Sacerdos et pontifex," is an antiphon preceding the Magnificat at Vespers on the feast commemorating the birth of a confessor bishop. That chant was erased and replaced by the current chant, which serves a completely different purpose in a different part of the liturgy. The new chant is "Intret in conspectu tuo"—the Introit for the Mass of two or more martyrs outside of Paschal time (the period between Easter and Pentecost). The large initial "S" of "Sacerdos" was left untouched to preserve the illumination of "The Knight of Cologne," with the result that the current incipit reads (somewhat awkwardly) "SIntret." The changes in music and text suggest that the leaf was transplanted from one liturgical book to another, since the original chant ("Sacerdos et pontifex") is one we would expect to find in an Antiphoner while the new chant ("Intret in conspectu") is typically found in a Gradual. In other words, Beinecke Ms. 794 lived a liturgical "double life" of sorts. It originally formed part of a choir book for the Divine Office but was extracted at some point and sewn into a choir book with chants for the Mass Proper.

In neither life, however, did this leaf have any connection to the liturgy of the Passion. The images of Jeremiah and Zechariah were thoughtfully placed there as ornaments to the Five Wounds of Christ's Passion. Any uncritical association of the emblem on this leaf with a bishop of Burgos or the Franciscan Order misses centuries of exegetical writing that grew out of seeds prophets such as Jeremiah and Zechariah had planted.

The Cult of the Five Wounds

The iconography of the Five Wounds in the Rosary Cantoral tapped into a cult of devotion that was popular among individuals from diverse social and educational backgrounds. In the mid-fifteenth century, laypeople wore crudely drawn amulets depicting the Five Wounds as protective devices against everything from evildoers to uncontrolled bleeding.[26] About two hundred years earlier, St. Edmund of Canterbury (d. 1240) washed the Five Wounds of his crucifix with wine and water as he lay on his deathbed. After blessing them with a sign of the Cross, he drank from the moistened wounds, pronouncing the words of Isaiah 12:3: "You shall draw waters with joy out of the Savior's fountains."[27] And just over a century before that, King Alfonso of Portugal gave praise to Christ for an important victory over the five Moorish kings on the plains of Ourique in 1139 by incorporating emblems of the Five Wounds into his new kingdom's coat of arms.[28] (Vestiges of those emblems mark the Portuguese flag to this day.) It is perhaps for that reason that, many centuries later, King Philip II of Spain (1527–98), who was born to a Portuguese princess and acquired the kingdom of Portugal in 1580, made what may seem to us a rather odd request for his burial. For the benefit and protection of his soul in the afterlife, Philip ordered (at great expense) that the keel of a wrecked Portuguese ship be transported from Lisbon to his palace-monastery of El Escorial (near Madrid) for the purpose of fashioning for himself a proper coffin. The name of the ship: *Cinco Chagas*—The Five Wounds.[29] This was—literally—a protective amulet fit for a king.

Philip II's request might not have been so unusual after all. Final testaments by sixteenth-century Spaniards reveal that cycles of Masses dedicated to the Five Wounds of Christ were often requested of religious houses for the benefit of departed souls. These cycles typically consisted of five Masses performed on five consecutive days and often concluded with one Psalm that had been assigned to each Mass, taken in this sequence: Psalm 20 ("Domine in virtute tua"), Psalm 33 ("Benedicam dominum"), Psalm 53 ("Deus in nomine"), Psalm 67 ("Exsurgat deus"), and Psalm 108 ("Deus laudem meam").[30]

The final testaments do not specify the Mass, but it was likely a votive Mass of the Five Wounds known as the *Missa Humiliavit* (from the first word of the Mass Introit). The *Missa Humiliavit*, which became popular during the fourteenth century, was attributed to St. John the Evangelist, allegedly revealed to Pope

Boniface II (530–32) by the archangel Raphael, and subsequently granted indulgences by John XXII (1316–34) and Innocent VI (1352–62). If recited five times, it promised to restore health to the living and release the souls of the dead from purgatory. The early history of the *Missa Humiliavit* is uncertain. The Mass might stem from the earliest known liturgical celebrations of the Five Wounds by the Benedictine monks of Fritzlar in Thuringia during the fourteenth century.[31]

The popularity of the *Missa Humiliavit* is well documented by manuscripts that have survived in churches throughout Western Europe. The Cathedral of Toledo owns two copies, both from the fifteenth century.[32] And these are just two instances of the broader cult of the Five Wounds that bubbled to the surface there. In the early sixteenth century the image of the Five Wounds was incorporated into the emblems of two Toledan confraternities dedicated to the body of Christ: the Cofradía del Corpus Christi (Confraternity of the Body of Christ) and the Cofradía del Santissimo Sacramento (Confraternity of the Most Holy Sacrament).[33] The emblem of the latter bears a close resemblance to the device adopted by a third Toledan confraternity around 1500, one dedicated to the popular cult of the rosary.

The Five Wounds and the Rosary

What purpose did the Five Wounds serve within the cult of the rosary? There, as in other contexts, they represented the promise of salvation made possible through Christ's death on the Cross. That is why St. Edmund imbibed from the wounds on his crucifix, why Philip II built a coffin from the *Cinco Chagas*, why the *Missa Humiliavit* was prayed over five days, and why the laity wore protective amulets displaying the Five Wounds. To understand their meaning in the rosary cult more precisely, however, we need to review the prayer itself—specifically, the form of the prayer promoted by the rosary confraternity founded at Cologne in 1475. That is the rosary described in the Spanish legend of "The Knight of Cologne" during the late fifteenth century and the form of the prayer most Catholics would recite until the dawn of the twenty-first century.[34]

To review: the basic form of the rosary still most familiar today follows a straightforward pattern of 3 sets of 50 "Ave Marias" (Hail Marys) divided into decades by 5 "Pater nosters" (Our Fathers). At each "Pater noster" the faithful also meditate sequentially on 1 of 15 Mysteries recalling 5 Joyful, 5 Sorrowful, and 5 Glorious events in the lives of Christ and Mary. Thus the full sequence is composed of 150 "Ave Marias," 15 "Pater nosters," and a systematic rehearsal of the 15 Mysteries.

But that was not always the case. One scholar who surveyed prayerbooks from about 1475 to 1550 was overwhelmed by the "bewildering array of rosaries" she found, noting that two or three different versions might appear in a single

book.³⁵ A popular German tract titled *Von dem Psalter und Rosenkranz unser lieben Frauen* (*Concerning the Psalter and Rosary of Our Beloved Virgin*), published in seven editions between 1483 and 1502, underscores her observation. It instructs the reader on six different methods of recitation, then adds, almost too casually, "if none of the six above-mentioned ways pleases you, or if you should have greater devotion by another method, take it for your own."³⁶ There were theoretically as many different versions of the rosary as there were people who prayed it.

Jakob Sprenger was aware of that diversity when he founded the rosary confraternity of Cologne in 1475. His statutes for the brotherhood, published in 1476, demonstrate that from its inception the organization aimed to promote a single form of the rosary. The regulations make it clear that every member "should pray three rosaries each week" and, furthermore, that the rosaries should equal "three times fifty 'Ave Marias' and three times five 'Pater nosters.'" To illustrate, Sprenger provided the metaphorical description Spaniards would adopt in the legend of "The Knight of Cologne" (see chapter 3): "after ten white roses one should insert a red rose, representing the 'Pater noster.'" And on that "Pater noster," Sprenger continued, "one should think on the rose red blood of Jesus Christ that God the Father willed to be poured out for our sake."³⁷

Sprenger's idea of tying the "Pater nosters" of the rosary to the Passion of Christ had a precedent in the writings of Alanus de Rupe (ca. 1428–75), a Dominican friar who founded the Confratria Psalterii Domini Nostri Jesu Christi et Mariae Virginis (Confraternity of the Psalter [Rosary] of Our Lord Jesus Christ and the Virgin Mary) at Douai, France, in 1470. Alanus's brotherhood in Douai (just over 320 km southwest of Cologne) was an important precursor to Sprenger's more famous confraternity.³⁸ Indeed, it may be more than a coincidence that the Cologne confraternity was founded on the very day Alanus de Rupe died— September 8, 1475, the feast of the Nativity of the Virgin Mary.³⁹ Alanus's statutes for the Douai brotherhood are less rigid than Sprenger's in that he suggests two methods of praying the rosary. But one of those methods made a clear impression on Sprenger. Alanus claimed that if one prayed 150 "Ave Marias" daily and marked off every 10 of those with a "Pater noster," the total number of "Pater nosters" recited in a year (15 × 365) would equal 5,475—the total number of wounds Christ received on his body during the Passion.⁴⁰ Alanus cites St. Bernard as the source for his number, but he could easily have cited several others. Bernard (or someone writing under his name) was just one of many exegetes who had tackled the issue of precisely how many wounds Christ had received during the Passion.⁴¹

Sprenger thus drew on Alanus's idea of linking the "Pater nosters" of the rosary with the Passion of Christ. And when he took that one step further, connecting the Passion of Christ with the red rose, he tapped into a Christian tradition that stretched back at least as far as St. Bonaventura (d. 1274), who had compared Christ's Passion to "a bleeding rose" in the *Vitis Mystica*. A more immediate precedent could be found in the anonymous fifteenth-century *Nürnberger*

Garten, an allegorical work for the laity that described Christ as a rosebush "decorated with the beautiful red roses of his holy wounds."[42] In the wake of Sprenger's association of the red rose, the Passion, and the "Pater noster," European printers literally engraved the idea into popular culture. One work from before 1500 shows St. Dominic, the Virgin Mary, and the Christ child surrounded by a rosary in which five blossoms (the "red roses") marking the five "Pater nosters" bear the pierced hands, feet, and Sacred Heart of Christ.[43]

Sixteenth-century Spaniards were aware of the connection between the "Pater nosters" of the rosary and the wounds of Christ. A passage from the 1535 edition of the Valencian *Trellat sumariament* (which presents the earliest narrative for "The Knight of Cologne," see chapter 3) resonates with Alanus's statutes for the brotherhood at Douai: "The fifteen 'Pater nosters' [are recited] in reverence of all of the wounds that Jesus Christ received on his sacred body for the redemption of human nature. If fifteen 'Pater nosters' are recited each day, at the end of the year the number of 'Pater nosters' recited [will equal] the number of Christ's Wounds."[44] The frontispiece for a subsequent edition, published in 1546, also reflects the connection between the roses of the "Pater noster" and the Passion (see fig. 13).[45] There we see a rosary before the instruments of the Passion and—at its very center—an emblem of the Five Wounds of Christ. Spanish missionaries took that strategy one step further in their evangelization of the New World. When the rosary was taught to natives of Mexico, it was called *teocuitlaxuchicozcatl* (golden flower necklace) after the Nahuatl word *teocuitlaxochitl*—an indigenous golden flower whose center, according to one Jesuit writer in 1640, resembled the Five Wounds.[46]

The connection between the Five Wounds and the rosary was known in Toledo by the early sixteenth century. In 1513 Juan de Villaquirán, a printer in Toledo between 1512 and 1524, published a philosophical work by Bartolomé de Castro, the *Questiones logicae*, that has nothing to do with the rosary but includes relevant iconography on its frontispiece (see fig. 14).[47] The haphazard arrangement of the images, their differences in size, and the careless alignment suggest a rush job. Villaquirán—probably working against a deadline—apparently did not want to waste time having a new frontispiece engraved for the *Questiones*, so he used whatever attractive images he had lying around the press. Most of the images he cobbled together for the *Questiones* show moments from the lives of Christ and Mary, although there is neither rhyme nor reason to their arrangement. Reading clockwise from the top left corner, we see the Annunciation to Mary, the Holy Family in a manger, the annunciation to the shepherds, the Epiphany, the raising of Lazarus, the Circumcision, the Crucifixion, the Visitation, and the Nativity of Christ.

Imbedded within this cycle, however, are three images of the rosary. Two are centered along the top of the frontispiece. The one on the left shows a rosary with the pierced hands and feet of Christ nestled into the large rose blossoms where the "Pater nosters" should go. At its center is an emblem with instruments of the Passion. Next to it is a rosary of a similar design, again displaying the pierced hands

and feet of Christ at the "Pater nosters." In the center, a crown of thorns surrounds the pierced Sacred Heart of Christ. Finally, along the bottom of the frontispiece, right next to the Crucifixion, is a rosary surrounding the emblem of the Five Wounds. The design there is virtually identical to the emblem appearing on the frontispiece of the Valencian *Trellat sumariament* published in 1546 (see fig. 13). The images Villaquirán cobbled together for Bartolomé de Castro's *Questiones* in 1513 suggest that the press at Toledo had printed a work related to the rosary before then. Perhaps some of those images were also reused when Villaquirán published Fernando de Morales's *Salterio y rosario de nuestra señora* (*Psalter and Rosary of Our Lady*) in 1515—a work that, unfortunately, has been lost.[48]

The emblems in the Rosary Cantoral were thus derived from a well-established tie between the Five Wounds of Christ and the five "Pater nosters" of the rosary—an association that ultimately goes back to the form of the rosary promoted by Jakob Sprenger's confraternity at St. Andrew's in Cologne since 1475. More to that point, *three* emblems of the Five Wounds appear on each opening folio of the Rosary Cantoral (see figs. 1 and 2) and on several of the related leaves (see, for example, figs. 3, 5, and 7).[49] Their significance derives from Sprenger's exhortation that, each week, confraternity members should pray *three* full cycles of the rosary—including its "three times five 'Pater nosters' . . . on which one should reflect on the rose red blood of Jesus Christ."[50] Those indoctrinated in the symbolic language of the rosary would have seen in the Rosary Cantoral's emblems of the Five Wounds a perfect complement to the legend of "The Knight of Cologne" in its large illuminated letter.

They also would have perceived as much in the emblem's inscription of "Miserere Mei"—another reflection of the rosary as promoted by the Cologne brotherhood and prayed in Toledo.

Miserere Mei and the Rosary of Cologne

In addition to specifying that each member should pray "three times five 'Pater nosters'" each week, Sprenger also required "three times fifty 'Ave Marias'" for a reason he made explicit: so the total number of 150 "Ave Marias" each week would equal the 150 Psalms of David.[51] The idea of linking the recitation of 150 "Ave Marias" with the Psalms did not originate with Sprenger. The form of the rosary he codified for the Cologne brotherhood in 1475 recalls the much older tradition of the Marian Psalter, which dates back to the early twelfth century. In its early stage, the Marian Psalter consisted of 150 antiphons about the Virgin Mary, each prefacing one of the Davidic Psalms. The antiphons eventually broke away from their attendant Psalms and became 150 independent stanzas honoring the Virgin Mary and Christ.[52] The *Psalterium Beatae Mariae Virginis* (*Psalter of the Blessed Virgin Mary*) by Engelbert (ca. 1250–1331), abbot of the Benedictine monastery of Admont in the duchy of Styria (southern Austria–northern

Slovenia), exemplifies the latter trend. The first three stanzas are given here as representative of the form.

Ave, rosa, flos aestive,	Hail, rose, flower of summer,
O Maria, lucis vivae	O Mary, light of life
Suave habitaculum	Gentle dwelling place
Lumen vivum ex te luxit	The living light comes forth from you
Lumen vitae quod reduxit	The light of life that returns
In hoc mortis saeculum.	In this age of death.

Ave, rosa aestivalis,	Hail, rose of summer,
Nulla umquam rosa talis	Not ever had such a rose
In hoc mundo splenduit,	Blossomed in this world.
Ut est notum Gabrieli	Just as it was known to Gabriel,
De te sola lumen caeli	Of you alone, light of heaven,
Homo nasci voluit.	Did man wish to be born.

Ave, rosa, flos vitalis,	Hail, rose, flower of life,
Creatura aestivalis,	Creation of summer,
Felix o prodigium,	Happy, O portent
Quod cum Deus fabricaret,	That should have been made by God;
Hoc intendit, ut monstraret	This He intended, to demonstrate
Grande artificium.[53]	In great skill.

Jakob Sprenger's aim to establish a single form of the rosary that consisted of 150 "Ave Marias" reflects again the strong influence of Alanus de Rupe, one of whose motivations in founding his brotherhood at Douai had been to promote a rosary that utilized the 150 repetitions of *Aves* characteristic of older Marian Psalters such as Engelbert's *Psalterium*. The competition was stiff. Among the vast number of rosaries then in circulation, this longer version of the prayer had especially lost ground to a Carthusian rosary consisting of only 50 repetitions of the "Ave Maria," each followed by a short clause on the life of Christ.[54] The short, 50-*Ave* rosary was promoted with great success by monks of the Carthusian Order during the first half of the fifteenth century.[55] As we saw in chapter 3, Dominic of Prussia (1384–1460), a monk of the Carthusian house at Trier, had even tried to take credit for the prayer in his *Liber Experientiarum* (1458). Such was its popularity by then. What made the Carthusian rosary so attractive was its economy: a compact form that seamlessly merged 50 meditations on the life of Christ into a litany-like recitation of the "Ave Maria."[56]

> Hail Mary, full of grace, the Lord is with you. Blessed are you among all women and blessed is the fruit of your womb Jesus who you conceived at the annunciation of the angel by way of the Holy Spirit.
> Hail Mary, full of grace, the Lord is with you. Blessed are you among all women and blessed is the fruit of your womb Jesus with whom you visited St. Elizabeth after he was conceived.

> Hail Mary, full of grace, the Lord is with you. Blessed are you among all women and blessed is the fruit of your womb Jesus who you—a virgin in body and spirit—brought to light with joy.[57]

The longer form of the rosary that Alanus de Rupe favored and Jakob Sprenger promoted would eventually prevail. Over five hundred years later, practicing Catholics would be most familiar with Sprenger's "Cologne model" of three weekly rosaries totaling 150 "Hail Marys" and 15 "Our Fathers." Thus, for more than half a millennium, justification for the number of "Ave Marias" was grounded in the 150 Psalms of David, whose recitation occupied the greater part of the day in convents and monasteries throughout the world. When Pope John Paul II introduced the 5 "Mysteries of Light" that added 50 "Ave Marias" and 5 "Pater nosters" on October 16, 2002, the parallel with the 150 Psalms was broken.[58] But until then the rosary had been a layperson's Psalter. It was a religious exercise through which one participated vicariously in the work of a religious house where the full book of 150 Psalms was chanted on a weekly basis.[59] It is undoubtedly for that reason that the protagonist in "The Knight of Cologne" is prompted to recite his rosary upon passing a Dominican convent where the friars are chanting their Psalter.[60] Ironically, from a purely historical perspective, when the numerical parallel between the "Ave Marias" and the Psalms was broken, the modern rosary became less connected with the work of the Church. It ceased to be the layperson's Psalter.

To reestablish a rosary of 150 "Ave Marias" today, one would probably need an individual like Michael Franciscus de Insulis (1435–1502). After Jakob Sprenger's statutes, de Insulis's *Determinatio quodlibetalis facta colonie* (*Result of the Theological Disputations Made in Cologne*) was the most important document published on the Cologne confraternity in 1476. De Insulis was a Dominican professor of theology at the University of Cologne and possibly a former student of Alanus de Rupe at Douai. His *Determinatio* originated as a series of lectures given in defense of the rosary in December 1475. They were collected and published the next year, apparently at Sprenger's request.[61] Unlike the populist writings of de Rupe and Sprenger, the *Determinatio* presents its arguments on behalf of the Cologne rosary in a polished academic narrative that mines Scripture along with other canonical literature for its strident defense of the prayer against detractors. With Alanus de Rupe and Jakob Sprenger, Michael Franciscus de Insulis formed part of a Dominican triumvirate whose works on the rosary circulated widely. Hieronimo Taix testified to their influence in Spain, citing all three in his compendious history of the rosary from 1556.[62]

Like Sprenger, de Insulis was concerned with promoting the legitimacy of the Cologne rosary: 50 "Ave Marias" and 5 "Pater nosters" recited three times each week to yield 150 of the former and 15 of the latter. To that end, de Insulis took great pains to show how the Cologne confraternity "was founded on a certain number of salutations" (hec fraternitas est sub certo salutationum instituta

numero) and that "this number should not lack mystery" (hic numerus non careat misterio).[63] Numbers matter, and to prove it de Insulis presents his arguments against the background of a well-worn dictum of Solomon that God had created all things in measure, number, and weight (Wisdom 11:21).[64] He begins by citing various examples including the *three* visitors that appeared to Abraham (Genesis 18:2), Christ's Resurrection on the *third* day, the *seven* virtues, and the *twelve* articles of faith, among others. He then focuses on the set of numbers most relevant to the Cologne rosary: "three times fifty or one hundred fifty" (de triplici quinquagena sive centum et quinquaginta).[65]

De Insulis is fully in line with Jakob Sprenger and Alanus de Rupe in his discussion of the number 150, which he relates to the Psalms of David.[66] Distinctive, however, is his passionate defense of the number 50—the number of "Ave Marias" in one cycle of the rosary. "The number of fifty salutations is not lacking mystery," de Insulis tells us.[67] To explain why, he draws on a variety of examples from Scripture. He likens, for instance, the 50-cubit width of Noah's ark (Genesis 6:15) to the breadth of Mary's charity. The Jubilee Year—the 50th year of a 50-year cycle described in Leviticus 25—get its due as well. On that year the Lord ordered that all property be restored, debts forgiven, and bound laborers set free. Thus, argues de Insulis, it is no surprise that Mary, who restored to man those things that Eve had taken away, should be honored by the number 50. De Insulis also mentions the prominence of the number 50 in the construction of the Tabernacle of Moses (Exodus 26) and the Temple of Solomon (1 Kings 7)—sanctuaries of the Holy Covenant, which, according to Medieval exegetes, prefigured the Virgin Mary, whose womb carried the Son of God.[68] De Insulis concludes his discourse on the number 50 with a passage of primary importance to understanding the emblem of the Five Wounds in the Rosary Cantoral.

> It should not be left out that the psalm of mercy and the remission of sins which is extolled above all others is the fiftieth, that is MISERERE MEI DEUS to which David came . . . as the greatest of sinners but was worthy to hear the voice of God through Nathan the prophet: "the Lord has transferred your sin away from you." Also, according to the New Testament, on the fiftieth day the Holy Spirit descended upon the apostles, among whom the Virgin was present. It is no wonder then if we should associate with the number fifty she who is the Mother of Mercy—she through whom our sins are relieved—and she through whom the law of grace is infused in our hearts.[69]

Psalm 50, the fourth of seven psalms regarded as "penitential," was indeed "extolled above all others" in the late Middle Ages and the Renaissance. Just around the time the Rosary Cantoral was being compiled (or was about to be compiled), the fiftieth Psalm had surged into public view as the basis for a widely disseminated meditation written by the Dominican preacher Girolamo Savonarola (1452–98) as he awaited execution in Florence, Italy, on May 23, 1498. Whether it was David, Savonarola, or the average layperson, Psalm 50

(widely known as the "Miserere") was the psalm of choice for the most desperate of circumstances.[70] The full text is given here:

> [1]Unto the end, a psalm of David, [2]when Nathan the prophet came to him after he had sinned with Bethsabee.
> [3]Have mercy on me [Miserere mei], O God, according to thy great mercy. And according to the multitude of thy tender mercies blot out my iniquity.
> [4]Wash me yet more from my iniquity, and cleanse me from my sin.
> [5]For I know my iniquity, and my sin is always before me.
> [6]To thee only have I sinned, and have done evil before thee: that thou mayst be justified in thy words and mayst overcome when thou art judged.
> [7]For behold I was conceived in iniquities; and in sins did my mother conceive me.
> [8]For behold thou hast loved truth: the uncertain and hidden things of thy wisdom thou hast made manifest to me.
> [9]Thou shalt sprinkle me with hyssop, and I shall be cleansed: thou shalt wash me, and I shall be made whiter than snow.
> [10]To my hearing thou shalt give joy and gladness: and the bones that have been humbled shall rejoice.
> [11]Turn away thy face from my sins, and blot out all my iniquities.
> [12]Create a clean heart in me, O God: and renew a right spirit within my bowels.
> [13]Cast me not away from thy face; and take not thy holy spirit from me.
> [14]Restore unto me the joy of thy salvation, and strengthen me with a perfect spirit.
> [15]I will teach the unjust thy ways: and the wicked shall be converted to thee.
> [16]Deliver me from blood, O God, thou God of my salvation: and my tongue shall extol thy justice.
> [17]O Lord, thou wilt open my lips: and my mouth shall declare thy praise.
> [18]For if thou hadst desired sacrifice, I would indeed have given it: with burnt offerings thou wilt not be delighted.
> [19]A sacrifice to God is an afflicted spirit: a contrite and humbled heart, O God, thou wilt not despise.
> [20]Deal favourably, O Lord, in thy good will with Sion; that the walls of Jerusalem may be built up.
> [21]Then shalt thou accept the sacrifice of justice, oblations and whole burnt offerings: then shall they lay calves upon thy altar.

The first two verses allude to the sin of adultery, but the nature of King David's offense is actually far worse. The backstory is given in 2 Samuel 11–12. Briefly, Bathsheba is a beautiful woman whom David spies from his rooftop while she is bathing. He learns that she is the wife of Uriah the Hittite, a soldier in his army. Unable to suppress his lust, David sends for Bathsheba, lies with her, and they conceive a child. David conspires with the commander of his army (also his nephew) to have Uriah killed in battle, then takes the widow Bathsheba as a wife. Not surprisingly, all of this greatly displeases the Lord, who sends Nathan the prophet to rebuke David for his sins. Nathan tells David of the horrible and embarrassing consequences that await him in life for having committed adultery and murder. Frightened and humbled, David repents for having offended God: "I have sinned against the Lord"—a phrase that resonates in verse six of the

Psalm. The voice of God, through Nathan, then replies "that the Lord has transferred your sin away from you" (2 Samuel 12:13), the line paraphrased by de Insulis in his passage on Psalm 50.

Psalm 50, the "Miserere," was linked to the Passion of Christ by a peculiar story from the thirteenth century known as the "rood legend," a popular history concerning the wood of the Cross. According to that legend, David had composed the "Miserere" as penance for his sins under the very tree that provided the wood for the Holy Cross. "David," one version holds, "after the great sin that he had committed, began to weep under that holy tree in penance for the sin that he had committed, saying to the Lord, *Miserere mei deus etc.*"[71] The inscription "Miserere Mei" is thus entirely reconcilable with the image of the Five Wounds that appears on the Rosary Cantoral and its companion manuscripts. It too is a Passion image of sorts. But given the context in which the emblems appear, that does not seem to be what the illuminators had in mind. Like Jakob Sprenger and Michael Franciscus de Insulis, they were thinking in terms of numbers: the Five Wounds represented the 5 "Pater nosters." The inscription "Miserere Mei" represented the 50 "Ave Marias." And the 3 iterations of both on each of the opening leaves of the Rosary Cantoral stood for the customary 3 cycles that yielded the 150 "Ave Marias" and 15 "Pater nosters" of the rosary of Cologne. This was the rosary as it was prayed in Toledo—a glimpse into the life of private devotion.

The Emblem of the Rosary Confraternity of Toledo

The emblem of the Five Wounds on the Rosary Cantoral and its sister leaves might be fairly characterized as the corporate logo of the Toledan rosary confraternity that commissioned them: a distinctive mark representing a diverse assembly of people united by a shared instrument of devotion to the Virgin Mary. As such, it invites comparison with an emblem adopted by a rosary confraternity founded around the turn of the sixteenth century at the religious house of Santo Domingo in Zaragoza, about 386 km (roughly 240 miles) northeast of Toledo. Their detailed statutes note how a chapel within the conventual church was identified by "the emblem of the confraternity of Our Lady of the Rosary which is seven red roses."[72]

Here again, we get a peek into a regional private devotion. The seven red roses were probably adopted there because of the Seven Joys of the Virgin that were especially celebrated in northeastern Spain, particularly in nearby Catalonia and Aragón. A ballade from the *Llibre Vermell* (*Red Book*), a collection of music compiled for pilgrims to the famous Black Madonna at the Benedictine monastery of Montserrat (in Catalonia) during the late fourteenth century, presents a good example of a rosary-like prayer that combines seven recitations of the "Ave Maria" with meditations on her seven joys: the Annunciation, the Nativity, the Adoration of the Magi, the Resurrection of Christ, the Ascension of Christ, the Descent of the Holy Spirit, and the Coronation of the Virgin (see ex. 4.1).[73]

76 THE EMBLEM OF THE FIVE WOUNDS

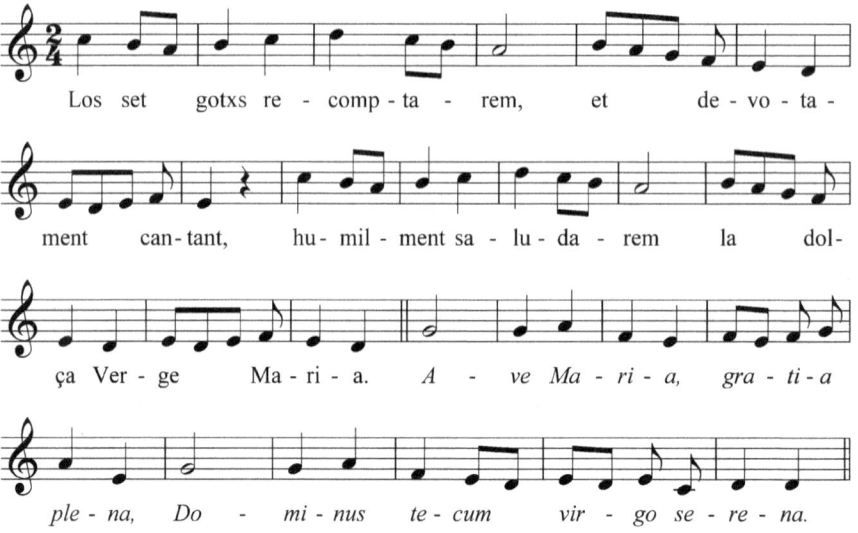

Example 4.1. "Los set goytx" (ballade, round dance) from *El Llibre Vermell de Montserrat*, fourteenth century.

According to the manuscript, the pilgrims were to sing this ballade as they performed a round dance that would have looked very much like the ring of *putti* gathered in the lower right corner of the first opening in the Rosary Cantoral (see fig. 2). The musico-poetic structure suggests an interactive liturgy in which a monk would have sung the more complex narrative on the joys, followed by the pilgrims' refrain of "Ave Maria" (given in italics here) as they danced their round.

Los set goytx recomptarem	I shall tell of the seven joys
et devotament cantant	and sing in devotion.
humilment saludarem	I shall humbly praise
la dolça Verge Maria	the sweet Virgin Mary
Ave Maria Gracia plena	Hail Mary full of Grace
Dominus tecum Virgo serena	may the Lord be with you, serene Virgin.
Ave Maria Gracia plena	*Hail Mary full of Grace*
Dominus tecum Virgo serena	*may the Lord be with you, serene Virgin*
Verge fos anans del part	Virgin, you came forth
pura e sens falliment	pure and without fault
en lo part e' pres lo part	in labor, and after labor
sens negun corrumpiment	without corruption
Lo Fill de Deus, Verge pia	The Son of God, pious Virgin

de vos nasque verament	was truly born of you.
Ave Maria Gracia plena	*Hail Mary full of Grace*
Dominus tecum Virgo serena	*may the Lord be with you, serene Virgin*
Verge tres reys d'Orient	Virgin, three kings from the East
cavalcan ab gran coratge	rode with great courage,
ab l'estrella precedent	following the star,
venegren al vostr' ebitage	and came to your dwelling place.
Offerint vos de gradatge	They offer you gifts
aur et mirre et encenç	of gold and myrrh and incense.
Ave Maria Gracia plena	*Hail Mary full of Grace*
Dominus tecum Virgo serena	*may the Lord be with you, serene Virgin*
Verge stant dolorosa	Virgin, being in sorrow
per la mort del Fill molt car	for the death of your very dear Son
romangues tota joyosa	your joy returned
can lo vis resuscitar	when you saw him rise again.
A vos Mare piadosa	To you pious Mother
primer se volch demostrar	did he first reveal himself
Ave Maria Gracia plena	*Hail Mary full of Grace*
Dominus tecum Virgo serena	*may the Lord be with you, serene Virgin*
Verge lo quint alegrage	Virgin, the fifth joy
que'n agues del Fill molt car	that you had of your very dear Son
estant al Munt d'Olivatge	was that on the Mount of Olives
al cell lo'n vehes puyar	when you saw him ascend to Heaven
On aurem tots alegratge	We should all be filled with joy
si per nos vos plau pregar	if you should deign to pray for us
Ave Maria Gracia plena	*Hail Mary full of Grace*
Dominus tecum Virgo serena	*may the Lord be with you, serene Virgin*
Verge quan foren complits	Virgin, when the days
los dies de Pentacosta	of Pentecost were completed,
ab vos eren aunits	you were together with
los apostols et decosta	the apostles and others
sobre tots sens nuylla costa	upon which—with no exception—
devallè l'Esperit Sant	the Holy Spirit descended.
Ave Maria Gracia plena	*Hail Mary full of Grace*
Dominus tecum Virgo serena	*may the Lord be with you, serene Virgin*
Verge .l derrer alegratge	Virgin, the last joy
que'n agues en aquest mon	—which you did not have in this world—
voster Fill ab gran coratge	was when your Son with great courage
vos muntà al cel pregon	took you up into the heavens
on sots tots temps coronada	where for all time you are crowned
Regina perpetual	as the perpetual Queen
Ave Maria Gracia plena	*Hail Mary full of Grace*
Dominus tecum Virgo serena	*may the Lord be with you, serene Virgin*

Tots donques nos esforcem	Let us all strive
en aquesta present vida	in this present life
que peccats forgitem	to free our sin from
de nostr' anima mesquina	our wretched souls
E vos dolçe Verge pia	and you, gentle pious Virgin
vuyllats nos ho empetrar	help us in this
Ave Maria Gracia plena	*Hail Mary full of Grace*
Dominus tecum Virgo serena[74]	*may the Lord be with you, serene Virgin*

Unlike the Zaragozan emblem of seven red roses, which tapped into a regional cultural stream, the emblem of the Toledan rosary confraternity was modeled after an ideology developed elsewhere and imported as part of a broader campaign to establish a particular form of the rosary among competing versions. Should the original statutes for the Toledan confraternity ever be found, they would undoubtedly bear the emblem of their rosary of choice: the Five Wounds and the inscription "Miserere Mei" that stand for the 5 "Pater nosters" and the 50 "Ave Marias" of the rosary of Cologne.

The emblem of the Five Wounds and the illuminations displaying "The Knight of Cologne," properly understood, reflect the foreign influences on the rosary as practiced in Toledo. But another element of decoration in the Rosary Cantoral presents an important vestige of a "homegrown" tradition as well. Chapter 5 addresses that point as it relates to the iconography of Hercules—a figure intimately connected to the city of Toledo, Spain.

Chapter Five

Hercules and Albrecht Dürer's Das Meerwunder

Among the many classical and pagan subjects that proliferated in the secular and religious arts of late Medieval and Renaissance Spain, few rival the popularity of Hercules.[1] His likeness appears throughout the Iberian Peninsula on the facades of universities, palaces, and cathedrals and in the ornamental work of *retablos* and choir stalls.[2] The lavishly decorated Rosary Cantoral demonstrates that the famous hero of antiquity was also incorporated into such intimate spaces as the marginalia of Spanish chantbooks for the Mass. The first opening of the manuscript (see figs. 1 and 2) depicts Hercules wrestling the Libyan giant Antaeus (see fig. 15) and battling the dragon in the garden of the Hesperides (see fig. 16)—legendary feats carried out in the far reaches of the Western world, often identified with Spain and its surroundings.[3] Curiously, nestled between these two scenes from the life of Hercules is a splendid border painting modeled after Albrecht Dürer's (1471–1528) *Das Meerwunder* (The Sea Monster), an engraving from ca. 1498 (see figs. 17 and 18).[4]

The use of Dürer's engraving as a model is significant. We saw in chapter 1 that it provides a useful *terminus ante quem non* for the compilation of the Rosary Cantoral. But it also raises a challenging interpretive issue, for the subject of Dürer's print has been much debated by scholars. His only known reference to the engraving is a diary entry of November 24, 1520, where he recorded that a *Meerwunder* was sold, along with an assortment of other artworks, at Antwerp for eight florins. Unfortunately, Dürer's reference is fleeting, his thoughts apparently preoccupied by a sea monster of another sort. No sooner does his diary mention the engraving than it turns to ruminations on a great whale that had washed ashore on the coast of Zierikzee—one so large that citizens entertained the guess that "it could not be cut in pieces and boiled down for oil in half a year."[5]

Given the absence of any authoritative commentary beyond a name (and a very general one at that), the iteration of *Das Meerwunder* in the Rosary Cantoral presents a valuable opportunity. If we have a reasonable understanding of the context in which it appears, this border painting might provide what has been lacking thus far with respect to Dürer's engraving: a contemporary reading or interpretation

of its enigmatic subject. This chapter will address that issue. But before considering the meaning of the vignette on *Das Meerwunder* in the Rosary Cantoral, it is first necessary to know the significance of the Hercules iconography that frames the image derived from Dürer's engraving. The particular relevance of these images is underscored by the fact that similar paintings from the life of Hercules appear in the lower border of the companion leaf, Pierpont Morgan Library M887-1 (see fig. 5), which has two contrasting images of the pagan hero engaged in battle—here, too, with the Hesperian dragon. As we shall see, the feats of Hercules that appear in the marginalia of these Spanish manuscripts are indeed important reflections of the rich culture in which the chantbooks existed. A proper understanding of their significance also sets the stage for discovering the meaning of the image after Dürer's *Meerwunder* in the Rosary Cantoral.

Hercules in Spain

Why was Hercules so popular in Spain? His widespread representation there, particularly in religious contexts, is partly explained by the great esteem he enjoyed throughout Europe as a personification of virtue, even a prefiguration of Christ.[6] With trepidation—one might say "at arm's length"—Dante Alighieri (1265–1321) suggested in his *Inferno* a parallel between the recursive journeys of Christ and Hercules into the Underworld.[7] Elsewhere, an anonymous contemporary of Dante—variously identified as a mysterious friar minor named Chrétien le Gouays or the renown poet and musician Philippe de Vitry, bishop of Meaux (1291–1361)—more boldly interpreted the Hercules and Alcmena of Ovid's *Metamorphoses* as Christ and the Virgin Mary in the *Ovide moralisé*.[8] Later, in the sixteenth century the celebrated Pierre de Ronsard (1524–85) hailed mighty Hercules as another Christ in his *Hymne de l'Hercule Chrestien*, where he made no fewer than eighteen comparisons between the two.[9]

During the fifteenth century it was the widely known *Los doze trabajos de Hércules* (1417) of Enrique de Villena (1384–1434) that most strongly suggested Hercules's identification with a virtuous, Christ-like warrior on the Hispanic peninsula.[10] The two feats represented in the Rosary Cantoral are among the twelve Villena recounted, and my paraphrases from relevant chapters in the 1499 edition present clear case studies of how a pagan figure such as Hercules might be given an *interpretatio christiana* appropriate for sacred contexts such as chantbooks for the Mass.[11]

Garden of the Hesperides: Villena, *Doze trabajos*, chapter 4

Historia nuda: In his fourth Labor, Hercules retrieved the golden apple from the garden of King Atlas of Libya. The gates of the Libyan garden were guarded by the Hesperides—the three daughters of Hesperus, brother of King Atlas. The tall tree in the middle of the garden, where the golden apples grew, was guarded by a large fierce

dragon that "was wrapped around the trunk of that tree" (estava embuelto en aquel tronco de aquel arbol) (see especially fig. 5). Delighted and moved by the continuous supplications and sweet words of Hercules, the Hesperides granted him passage into the garden. Not lingering on any of the lesser trees, Hercules advanced directly to the precious tree at the center. Undaunted by the dragon guarding the apples, he battled and defeated the beast, took the rich apple, and presented it to Eurystheus, King of Argos.

Declaración: Libya should be understood as our dry and sandy humanity, which is nevertheless disposed to producing marvelous fruits. The wise man is represented by Atlas, ruler of Libya, who planted there a garden of trees, which we should interpret as the diverse sciences bearing excellent fruits of wisdom. The tallest tree in the middle of the garden is that of Philosophy, which bears the greatest and richest fruit. Access to its fruit is difficult, however, for the tree of Philosophy is guarded by a watchful dragon that stands for "artful deceit" (sotileza). The garden itself was guarded by the Hesperides—three maidens who represent intelligence, memory, and eloquence. Hercules, a man desirous of learning, overcame these obstacles. He gained access to the garden by demonstrating his mastery of intelligence, memory, and eloquence; then—not lingering on any of the lesser sciences—[he] proceeded forthwith to Philosophy, the cradle of Wisdom. Having overcome his own roughness through continuous labor, he gained access to the golden apple of Philosophy and made that precious fruit available to those in the region who desired to learn.

Verdad: King Atlas of Libya was wise and learned in all branches of knowledge. Realizing that all of the sciences in this part of the world were unregulated, he imposed order on them through certain rules and principles (these represented by the walls of the garden). The pure arts and sciences in the garden were accessible only through the agreement of intelligence, memory, and eloquence, and the highest science of Philosophy was watchfully guarded by formidable disputations, which could only be won through proper work. Hercules, disposed toward gaining knowledge, went to Libya and, after demonstrating his mastery of intelligence, memory, and eloquence, passed into the garden of knowledge. Not lingering on the primitive arts he went directly to the science of Philosophy, defended by the academic disputations of Atlas himself, who Hercules eventually overcame through his persistent efforts. Having gained the precious fruit of philosophical wisdom, Hercules communicated what he had learned to King Eurystheus and, in turn, enlightened those people of his land who had been steeped in ignorance.

Aplicación: The application of this Labor is directed to the religious estate whose members should apply themselves diligently to acquiring knowledge so that they can reveal and explain the secrets of Holy Scripture. Their lives should be dry and arid as Libya through chastity and penitence. So too they should be kings over their dry bodies, masters over sensuality, and dead to the world and its temporal life. Before all else, the religious should tend to planting a garden of pure, virtuous knowledge without blemish—like gold—and this should be a garden of divine understanding enclosed by the reason and intelligence entrusted to the three powers of the spirit: to *Understanding*, which meditates upon divine works, to *Memory*, which remembers the benefits of these works, and to *Will*, which enacts their justice and principles. The tree in the center of this garden is metaphysical doctrine; the religious must surpass the dragon guarding this tree and make its theological fruit understandable. They must present divine truths before kings and enlighten the people by showing them the path of light and truth (carrera de salud).[12]

Antaeus: Villena, *Doze trabajos*, chapter 9

Historia nuda: In his ninth Labor, Hercules wrestled the Libyan giant Antaeus, who renewed his strength whenever he touched the ground, the source of his power. Hercules defeated the giant by holding him aloft (thus preventing him from regaining his strength) and proceeded to strangle him in his arms.

Declaración: Antaeus represents the flesh, which is susceptible to dangerous vices, represented here by the earth. The story is set in Libya because vices of the flesh—which are obstacles to learning—manifest themselves to a greater extent in hot climates. The virtuous man of learning (represented by Hercules) wrestles and overcomes the pleasures and delights of the flesh, holding such desires at a distance from the dangerous vices that empower them.

Verdad: Antaeus was a rich and powerful king of Libya—full of vices and completely given to earthly and carnal things—who ruled tyranically and annihilated the great and learned men of his realm, leaving the land in great turmoil and utter chaos. To remove the king from power, Hercules arrived in Libya with his fleet and a league of virtuous knights and engaged the opposing forces in a lengthy battle. Each time Hercules seemed to gain the advantage, Antaeus retreated to his fortifications, recuperated from the abundant provisions that had been produced by the land, and returned with his strength renewed. Ultimately, Hercules placed himself between Antaeus and his provisions with the result that Antaeus—now unable to regain his strength—was overwhelmed and defeated.

Aplicación: The application of this Labor is directed especially to teachers of theology. A knowledgeable and virtuous teacher must make his students fearful of carnal affections, which are obstacles to learning. Following the example of Hercules, he should impose himself between the student and the source of his vices, occupying him instead with exercises, virtuous works, and scholarly deeds. "Thus he will kill and be victorious over the carnal giant Antaeus, who is interpreted as being against God." (Así matará et vencerá el carnal gigante Antheo que es interpretado contrario de Dios.)[13]

Thus did Villena instruct his contemporaries not only on the classical tales and historical deeds of the great Hercules but also on their implicit moral imperatives and fitting applications to modern Spanish society. Of course, the publication of *Los doze trabajos* as late as 1499 raises the question whether it had provided the impetus toward incorporating scenes from the life of Hercules into the Morgan leaf and the Rosary Cantoral. And, to be sure, the *aplicaciones* directed toward the religious estate and teachers of theology seem especially appropriate exhortations to the Dominicans of San Pedro Mártir de Toledo, for this Order could claim a long line of distinguished theologians stretching from its founder and namesake, the Spaniard St. Dominic Guzmán (1171–1221), to Girolamo Savonarola (1452–98).[14] Ultimately, we can only wonder whether any specific connection existed between the images in the chantbooks for San Pedro Mártir and Villena's *Los doze trabajos*. But the association need not be so direct, for, while the Hercules paintings in these Spanish chantbooks reflected a measure of Christian morality and rectitude, they also projected a sense of place as civic icons commemorating Hercules's historical role as a founding father of Toledo.

Hercules in Toledo

Conceptions of the historical role Hercules played on the Iberian Peninsula extend back at least to the thirteenth century in the chronicles of the Toledan Archbishop Rodrigo Jiménez de Rada (1210–47) and King Alfonso "The Wise" (1221–84), which recount the demigod's founding of such glorious cities as Barcelona, Cádiz, Coruña, and Sevilla.[15] By the mid-fourteenth century, Toledo had a Herculean tradition of its own. The anonymous *Crónica general de 1344*, commissioned by Don Pedro Alfonso, count of Barcelos, presents the earliest mention of a house built there by Hercules himself—a looming, magnificent, round palace of multicolored stone situated over four large metallic lions.[16] According to the *Crónica general*, "When the great Hercules passed through Spain and placed in her all of those things that the world knows, he built in Toledo a house so artful and with such mastery that we would not be able to tell you either how it was built or through what intelligence."[17] The account goes so far as to declare that an inscription within the edifice read: "When Hercules built this house the era was at four thousand and six years."[18] A Toledan "house of Hercules" (casa de Ércoles) also appears in the fifteenth-century *Crónica Sarracina* (1430) of Pedro del Corral, who recorded a more chronologically specific inscription: "When Hercules built this house, the era of Adam was at three thousand and six years."[19]

By the sixteenth century some writers had begun to supplant the house of Hercules with a cave in which the hero supposedly lived after settling Toledo. An account from 1549 by Blas Ortiz (ca. 1485–1552) recounts, "A good part of the Spanish lands attribute the foundation of this city to the Libyan Hercules, who passed through the interior of Spain after killing Geryon. The proof would seem to be the cave of Hercules built here below the church of San Ginés, since, if the city had been founded earlier, in no manner would the famous Hercules have inhabited the cave."[20] The belief that Hercules had founded Toledo was current earlier on—that is, in the late fifteenth and early sixteenth centuries—for a skeptical Ortiz referenced the critical observation of Lucio Marineo Sículo (1444?–1536) —royal historian to Queen Isabel—who noted, "Regarding the founder of Toledo, I can affirm nothing with certainty; although there is no one who does not imagine that it was founded by Hercules."[21] In spite of all skepticism, however, the story was resilient and appeared again in the first printed history devoted exclusively to Toledo—the *Hystoria, o descripción dela imperial cibdad de Toledo* (1554) by Pedro de Alcocer. Alcocer also mentions the Cueva de Hércules but attributes its discovery and name to the Greek astrologer and black magician (nigromantico) Ferecio, who dedicated the cave to Hercules and taught the surrounding inhabitants to make sacrifices to him, as well as to other pagan gods.[22]

While Sículo, Ortiz, and Alcocer acknowledged a widespread belief in the local cave of Hercules, their tendency was to characterize the stories surrounding it as fancies of the popular imagination. But at least one member among

Toledan society's learned elite had his interest sufficiently aroused to prompt a more serious investigation into the matter. Pedro Salazar de Mendoza's (d. 1629) *Crónica del gran cardenal de España, don Pedro Gonçalez de Mendoça* (Toledo, 1625) recounts in gripping detail a preliminary exploration of the "cave of Hercules" ordered by Cardinal Juan Martínez Silíceo (1486–1557) in 1546. It is evident in this passage that the cave was already thought to exist beneath the church of San Ginés (the claim Blas Ortiz would reiterate three years later):

> In the year fifteen hundred and forty-six, Cardinal Juan Martínez Silíceo wished to study [the cave], and, to this effect, he ordered it cleaned and prepared. Several men entered it with a provision of food and drink, along with lanterns and guidelines that they were laying for their return. They found the cave very cool and damp [because] it was summer. Having entered at morning, they came out as it was beginning to darken. The men swore that after walking about a half-league between Levante and Setentrion (although it seemed to them more like four leagues because of the task with which they were charged) they bumped into some statues. These appeared to be of bronze, and stood on an altar. On bumping into them, one fell with such a noise that it frightened them. Moving on ahead, they encountered a rush of water which they could not pass for lack of proper equipment. This torrent brought great fear upon them because of the force with which it flowed. The men returned from that point, penetrated by the cold and dampness, and became ill. Almost all of them died.[23]

Cardinal Silíceo would not be the last person to launch an expedition into the Cueva de Hércules. Subsequent studies in the nineteenth and twentieth centuries of a cave near the site formerly occupied by the church of San Ginés— destroyed in 1840—have determined that the presumed "cave of Hercules" was, in fact, a depository for an elaborate subterranean Roman hydraulic system that channeled water from the Tagus River into the center of town.[24] But for the citizens of Toledo, from at least the mid-fourteenth century, the legends of Hercules that surrounded the ruins of this marvelous feat of Roman engineering were proof enough to claim a special affinity with the ancient settler of Spain. To be sure, its existence entitled the great Castilian city to count itself among those Hercules had directly founded. Thus did Toledo join a handful of privileged communities that could boast the virtuous Hercules as a cultural and civic icon.

This important connection between Hercules and Toledo was not lost on the artists who illuminated the Rosary Cantoral and the companion Morgan leaf. Indeed, with respect to the latter (see fig. 5), not only are there two representations of Hercules and the Hesperian dragon, but next to each of these are several *putti* assembled with evident curiosity and trepidation outside the opening of a cave of some sort. The unsuspecting mind will almost certainly gloss over these caves. But to the informed observer, the intent is clear. The Morgan leaf pays homage not only to Hercules himself; it goes one step further, recording for posterity semblances of his fantastic local dwelling place: the physical

monument that intimately connected generations of Toledan citizens with the classical hero of antiquity and founding father of Spain.

Albrecht Dürer's *Das Meerwunder*

The readily identifiable paintings of Hercules and Antaeus (see fig. 15) and of Hercules and the Hesperian dragon (see fig. 16) are not the only profane images found on the opening folios of the Rosary Cantoral. As we have seen, the artist who rendered these miniatures also incorporated a splendid border painting (see fig. 17) modeled after Albrecht Dürer's *Das Meerwunder—The Sea Monster* (see fig. 18)—from ca. 1498.[25] Comparisons between Dürer's engraving and the border painting in the Rosary Cantoral reveal an illuminator sensitive to the religious context of his work. For example, the breasts of the woman riding the sea monster have been conspicuously reduced and her hips modestly covered by a light veil. So, too, the voluptuous nudes shown bathing in the background of Dürer's engraving have been rendered in the chantbook as cherubic maidens. Otherwise, many details were retained faithfully—the city in the background, the man shown running downhill, and the sea monster depicted as a horned, piscine man with a flowing beard.

Dürer was well-known and highly regarded in Spain, as elsewhere in Europe. Ferdinand Columbus (1488–1539)—who, as we have seen, owned one of the earliest written sources for "The Knight of Cologne" (see chapter 3)—was one of his most avid collectors.[26] Dürer features prominently in his inventory of at least 3,204 prints, and Columbus was especially scrupulous about recognizing authenticity and attribution with respect to his work, often noting directly on the print itself, "es vere de Alberto" ([this] is truly by Albrecht).[27] Given his popularity, it might not surprise us to find Dürer represented in the marginal art of a Toledan chantbook. Access to model prints was likely not a problem, for they could probably be had at any of the major art fairs that took place in Valladolid or Medina del Campo, among other places.[28] Also recall in this regard that San Pedro Mártir was host to the recently arrived printing industry of Spain and, furthermore, that a German expatriate, Pedro de Hagenbach, is documented there from the waning years of the fifteenth century until the last quarter of 1502 (see chapter 2). Yet the central question with respect to the appearance of *Das Meerwunder* in the Rosary Cantoral remains: What is this particular image doing in this particular context?

Arriving at a reasonable understanding of what *Das Meerwunder* communicated to the artist who incorporated this image into the Rosary Cantoral requires coordination of the scant details left by Dürer himself—namely, the fleeting reference to a *Meerwunder* sold at Antwerp in 1520—the evidence of contemporary iconography and literature, and the particular context in which the painting appears. The task is complicated by the conflicting interpretations of scholars

challenged by the engraving. Some scarcely merit consideration, such as Jesús María González de Zárate's strong but baseless claim that Dürer had titled the work *Great Oceanus*.[29] But others can be compelling, and they exercise no small influence in the effort to arrive at a contextually sensitive reading of the image in the Rosary Cantoral. Prompted in part by the curious pairing of two decorative scenes in an anonymous Italian engraving from the early sixteenth century (see fig. 19), Fedja Anzelewsky has raised the question whether Dürer's *Das Meerwunder* and his roughly contemporary *Pupila Augusta* were originally planned as complementary works in an abandoned project that aimed to depict Venus Urania and Venus Vulgaris—the heavenly Venus and her more earthly counterpart.[30] The anonymous Italian engraving joins an image strikingly similar to Dürer's *Meerwunder* with what appears to be the more familiar depiction of Venus Anadyomene, or Venus rising from the sea—a subject famously rendered by Sandro Botticelli (1444/45–1510) around 1484.

To read the image of *Das Meerwunder* in the Rosary Cantoral as a representation of Venus seems entirely appropriate on several fronts. For one, not unlike the Virgin of the Immaculate Conception, Venus (a Roman appropriation of the Greek goddess Aphrodite) had emerged *sine macula* out of a sea that foamed from the castrated genitals of Uranus, a god personifying the heavens.[31] But more important in this context, Venus was the ancient mother of the red rose, which was often incorporated among her devices in the visual arts of the Middle Ages and the Renaissance.[32] What is more, the twelfth-century writer Albricus described one attribute in particular, a garland of red and white roses—"rosis candidis et rubeis sertum gerebat in capite ornatum"[33]—that finds a significant parallel in the legend of "The Knight of Cologne," depicted in the Kyriale's large illuminated letter. As we saw in chapter 3, the fabled garland of redemption woven by the Virgin Mary was one in which every ten white roses—representing the "Ave Marias" of the rosary—were punctuated by a red rose standing for the "Pater noster."[34] If we ventured to interpret the figure on the sea monster as Venus, her pairing with Hercules in the Rosary Cantoral may not be unique. Chandler Rathfon Post has called attention to figures he tentatively identified as Hercules and Venus in the decoration of a panel from the Valencian school, which, interestingly, also depicts the Virgin of the Rosary and the legend of "The Knight of Cologne."[35]

Venus thus presents an attractive possibility. To identify the subject as this pagan goddess, however, fails to explain why the manuscript's artist retained the running man shown in the background of Dürer's engraving. Furthermore, aside from the maritime setting, there is nothing inherently suggesting Venus in the rendering of *Das Meerwunder* found in the Rosary Cantoral. While the illuminator altered certain details of the landscape and even the headdress of the nude subject, there is no indication of any effort to incorporate the iconography—roses, doves, swans, a mirror, Cupid, or the three Graces—that typically identifies Venus.[36] For similar reasons, it is equally doubtful that Dürer sought to render Venus in the model engraving the artist himself would later call *Meerwunder*.

Indeed, in three "Venus works" attributed to Dürer—among them the thematically similar *Venus Riding on a Dolphin* (W.330), from 1503—she is unambiguously identified by her companion, Cupid.[37] In sum, however attractive initially, Venus does not seem a likely prospect for the subject of the painting in the Rosary Cantoral or, for that matter, of the Dürer engraving that inspired it.

That said, while this particular Hellenic-become–Roman goddess does not bear our scrutiny, more broadly considered, there is little question about the classical overtones that resonate in Dürer's engraving and in the derivative painting in the Rosary Cantoral. Given the overall design and date of *Das Meerwunder* (ca. 1498), it appears that Dürer was inspired by the "Triton and Nereid" theme prominent in Roman sculpture, which he likely encountered just a few years earlier during his first Italian journey (1494–95).[38] To this point, the Metropolitan Museum of Art in New York owns a marble lunette that is strikingly consonant with Dürer's principal subject (see fig. 20).

In light of the pronounced classical influence, art historians have considered a wide range of myths from the ancient world as possible subjects of *Das Meerwunder*, among them the abduction of Amymone, Glaucus and Scylla, Nessus and Deianira, Perimele and Achelous, Syme and Triton, and Syme and Glaucus. None has yielded a compelling interpretation.[39] Fedja Anzelewsky has suggested that Dürer's *Das Meerwunder* might also be an antique representation of a contemporary German story, such as that of Langobard Queen Theudelinde's abduction by a sea monster. Notably, a verse rendition of Theudelinde's abduction appeared in 1472 under the title "Das Meerwunder" in a Germanic legends cycle compiled by Kaspar von der Rhön at Nuremberg. In 1552 the same story also became the subject of a prose version and Meisterlied by Hans Sachs (1494–1576).[40] As Anzelewsky concedes, however, von der Rhön and Sachs both described the sea monsters in their stories as "hairy like a bear with the wings of a bat"—"behaart wie ein Bär und mit Fledermausflügeln"—key elements, it would seem, but neither reflected to any extent in Dürer's engraving.[41] Arguing essentially the inverse of Anzelewsky's theory of a classicized modern tale, Erwin Panofsky proposed that the subject of *Das Meerwunder* was "one of those anonymous atrocity stories which, though ultimately of classical origin, were currently reported as having taken place in recent times and in a familiar environment."[42] In this case, Panofsky seemed especially compelled by a fifteenth-century Italian tale describing a Triton that stole children and young girls off the coast of Dalmatia—that is, until it was defeated by a horde of local washerwomen.[43]

Taking a step back from these sundry interpretations, we might marvel at the various meanings one can find in *Das Meerwunder*. This might frustrate us, yet it stands to reason. For however much one might wish to idealize Dürer as a creator of art, he was fundamentally invested in the business of selling prints in a competitive market environment. He had just opened his Nuremberg workshop in 1495 at age twenty-four, and *Das Meerwunder* would have been among the first

major projects to emerge from his nascent entrepreneurial spirit.[44] As such, we can well imagine that its delicious ambiguity was the result not only of a creative artistic mind but also of an astute business sense. In *Das Meerwunder* Dürer successfully fashioned an aesthetically pleasing image that was precisely what it needed to be: many different things to many different people. What, then, did this multivalent print say to the artist who decorated the Rosary Cantoral?

Hercules and the Sea Monster

While debates over the subject of *Das Meerwunder* fall short of reaching a consensus, most observers tend to agree on two things: (1) the strong classical influence that permeates the engraving and (2) the general theme of an abduction scenario. Accordingly, given the Hercules motif in the Rosary Cantoral and his significance to the city of Toledo, we might ask: Did Dürer's *Meerwunder* suggest to the illuminator some apposite event from the life of the classical hero—one involving an abduction and (of course) a sea monster?

That question might seem far-fetched today given our modern conception of Hercules—one fostered by B movies, television serials, and the canonical "Twelve Labors" memorized in secondary school—but the classical world would have seen it otherwise. Gudrun Ahlberg-Cornell has shown, for example, the extent to which the theme of "Hercules and the Sea Monster" was featured in Attic black-figure vase paintings of the sixth and fifth centuries BCE. We may find it suggestive with respect to the horned, piscine man in Dürer's engraving that Ahlberg-Cornell describes the popular motif as "easily identifiable due to the characteristic shape of the monster, with the human upper part of the body fixed to a compound of a serpent and/or a fish."[45] More to the point, the sea monster is also typically characterized by a long, flowing beard and, in one Attic red-figure *stamnos*, by a horn protruding from its forehead (see fig. 21).

The mythological background for "Hercules and the Sea Monster" in Attic vase painting is uncertain—the sources are many and varied. A few centuries later, however, the literary arts provide an interesting manifestation of the theme, one that may (or may not) be related to the Attic paintings. In *The Library* of Apollodorus (fl. 140 BCE), we learn of Hercules's rescue of Hesione, daughter of the Trojan king Laomedon, from a sea monster that abducted citizens off the coast of Troy. As we might expect, the brave and virtuous Hercules arrives in time to spare Hesione, slaying the beast in the process. But the deed comes at a very dear price, as it sets into motion a sequence of events that ultimately brings about the destruction of Troy:

> [Desiring] to put the wantonness of Laomedon to the proof, Apollo and Poseidon assumed the likeness of men and undertook to fortify Pergamum [the Trojan citadel] for wages. But when they had fortified it, he would not pay them their wages. Therefore

Apollo sent a pestilence, and Poseidon a sea monster, which, carried up by a flood, snatched away the people of the plain. But as oracles foretold deliverance from these calamities if Laomedon would expose his daughter Hesione to be devoured by the sea monster, he exposed her by fastening her to the rocks near the sea. Seeing her exposed, Hercules promised to save her on condition of receiving from Laomedon the mares which Zeus had given in compensation for the rape of Ganymede. On Laomedon's saying that he would give them, Hercules killed the monster and saved Hesione. But when Laomedon would not give the stipulated reward, Hercules put to sea after threatening to make war on Troy.[46]

It is certain that Hercules's Trojan exploits were well-known in the Middle Ages and afterward. Indeed, they figure prominently among the hero's twenty-seven "great deeds" (grandes fechos) recounted in Alfonso "The Wise"'s late-thirteenth-century *General estoria*, an ambitious attempt at a comprehensive history of the world that was never completed.[47] Just a few chapters prior to the description of the hero's passage to Africa and encounter with Antaeus (chapter 417), the Alfonsine chroniclers relate the story of Hercules's crushing defeat of Troy, where we are first introduced to King Laomedon and his daughter Hesione (chapter 404). Elsewhere in the *General estoria*—namely, in its lengthy exposition on the history of Troy (chapters 437–621)—the chroniclers describe in greater detail Laomedon's broken agreements with Apollo and Neptune (Poseidon), his reneged promise of horses to Hercules in exchange for Hesione's rescue, and, again, the ensuing destruction of the great city.[48]

Apart from Alfonso's *General estoria*, an important source for the story of Hercules and Hesione at Troy during the late Middle Ages and the Renaissance was the *Genealogie deorum* of Giovanni Boccaccio (1313–75). Arguably the most popular mythological handbook in Spain and elsewhere until the mid-sixteenth century, Boccaccio's *Genealogie* circulated widely and survives today in numerous Latin, Italian, and Spanish sources.[49] An early-fifteenth-century Castilian translation was once kept in the chapter library of the Cathedral of Toledo.[50]

Like the twenty-seven *grandes fechos* of Hercules in Alfonso's *General estoria*, the Labors enumerated by Boccaccio in book thirteen of his *Genealogie* go well beyond the customary twelve. As Boccaccio contended, "Almost everybody affirms that the principal labors [of Hercules] were only twelve, though I will find that there were thirty-one, even if they are not equal."[51] Among these, he included the wrestling match with the Libyan Antaeus (Labor 12), the battle with the Hesperian dragon (Labor 14), and, significantly, the rescue of Hesione and subsequent destruction of Troy: "In the twenty-first Labor [Hercules] liberated Hesione, the daughter of Laomedon, from a sea monster as described above in the section regarding Laomedon. In the twenty-second Labor he destroyed Troy as fully described in the section regarding Laomedon."[52] Boccaccio's cross-references to the fuller discussion on the Trojan king undoubtedly point to book six, chapter six, of the *Genealogie*, where we find this narrative:

Laomedon, the king of Troy, was the son of Ilion as Homer writes in the *Iliad* [20.236]. The ancients say that this Laomedon wanted to surround Ilion [Troy] with walls and he arrived at an agreement with Apollo and Neptune wherein they would build the walls and he would observe an oath for recompense. After they finished the walls and saw that what Laomedon had promised was not forthcoming, Neptune inundated all of Troy with waters and Apollo sent a pestilence. Distressed by these things, Laomedon consulted an oracle concerning a remedy and it was the oracle's answer that each year a maiden should be exposed to a sea monster. This was bravely being done by the Trojans, and finally the fortune fell upon Hesione, who was the daughter of Laomedon. While she was bound to the sea ledge awaiting the monster, Hercules came and Laomedon made a pact with him in which it was agreed that if Hercules freed his daughter from the sea monster, then Laomedon would give him some horses of divine origin which he was known to possess. Nevertheless, after Hercules had freed the maiden Laomedon was not forthcoming with what had been promised. And because of these things, or as others have it, because he was prohibited by Laomedon from entering the port of Troy as he searched for the lost child Hylas, Hercules arrived with many troops, conquered Troy, killed Laomedon, and plundered all that was in the city.[53]

As with Enrique de Villena and others who presented historical interpretations of the Hercules myth, Boccaccio likewise elaborated on the basic story:

> These things having been said, we shall see what is meant by this fiction. They maintain, in effect, that in Troy there was money reserved for the sacrifices of Neptune and Apollo, which Laomedon—after having made an oath that he would not only restore the money spent on building the city walls, but that he would also make a gift from his own abundant riches to the reserves for the aforementioned sacrifices—did not want to return the borrowed money to those who reclaimed it. Then there came afterward an inundation and, after it was not sufficiently evaporated by the sun (as should occur), the air, infected by the putrefection of the waters, caused an epidemic. Given that the elements of water and sun were seen to pertain to Neptune and Apollo, it was believed that these calamities were sent by them in retribution for deceiving the gods through perjury. I suppose it is possible that maidens were exposed to a monster in response to the words of an oracle, given that the devil would often deceive them in this way. I believe this story has other well-founded opinions. Laomedon's sons and daughters were many, although only Priam would succeed him in his kingdom.[54]

Beyond its inclusion in Alfonso's *General estoria* and Boccaccio's *Genealogie deorum*, a few other sources underscore the popularity—and the currency—of Hesione's rescue from a sea monster during the fifteenth and sixteenth centuries. Two circulated in Italy, both devoted exclusively to Hercules: Coluccio Salutati's (1331–1406) *De laboribus Herculis* (1406) and Lilio Gregorio Giraldi's (1479–1552) *Herculis vita* (1539).[55] In each compendium we find not only the rescue of Hesione but also the stories of Hercules wrestling Antaeus and battling the Hesperian dragon. Closer to home—at the end of the sixteenth century—all three reappear in Juan Pérez de Moya's *Philosophia secreta* (Madrid, 1585), where the author presents not only the basic story of Laomedon and Hesione at

Troy but also extensive historical and allegorical interpretations of the tale.[56] The essence of Pérez de Moya's historical reading is clearly derived from the version in Boccaccio's *Genealogie deorum*, although the author enriched his discussion with citations from the *Polyhistor* of C. Julius Solinus (third century CE) and the *Aeneid* of Virgil (70–19 BCE). Pérez de Moya's allegorical interpretation, however, revealed yet another dimension of the story:

> Through Laomedon's perjury against Apollo and Neptune, we find the portrait of an ungrateful man who in time of need turns to God with grand supplications and promises, and, once he obtains what he wants, does not remember Him. For this, he deserves the punishment of being inundated by waters that take away all of his property, leaving him in the misery that is ascribed to Laomedon. What is more, the act of lying to Hercules reflects that whoever is ungrateful to God is also an ingrate to men. In sum, the ancient sages exhort Religion and Truth in our contracts through this fable.[57]

Thus did Pérez de Moya find in the story of Hesione a rich and timeless allegorical lesson to instruct his contemporaries' moral and spiritual lives. Early in the previous century Enrique de Villena had seized upon the stories of Hercules and Antaeus, and of Hercules and the Hesperian garden, to exhort teachers and theologians to defeat the giant of carnal vices and bring the golden fruit of metaphysical doctrine to those who walk in darkness. In a similar vein, Pérez de Moya mined from the depths of a fable the moral imperative to keep Religion and Truth in agreements made between honorable men and their God.

Hercules, Hesione, and the Population of Spain

The prominence of the story of Hercules, Hesione, Laomedon, and the sea monster at Troy during the Middle Ages and the Renaissance brings much to bear on the image of *Das Meerwunder* that appears in the Rosary Cantoral. For the painting rendered there arguably presents yet another iteration of the tale: a pictorial adjunct to the narrative accounts spanning the history from *The Library* of Apollodorus to the *Philosophia secreta* of Juan Pérez de Moya. Whatever Dürer's intentions in creating *Das Meerwunder* (see fig. 18), it is clear how elements in the engraving might have suggested this Trojan episode from the life of Hercules. The illuminator plausibly read the woman atop the sea monster as Hesione, the man running toward her as the distraught Laomedon, and the city behind them as ill-fated Troy. To fortify that supposition, it is telling that the manuscript artist "color coded" a significant bond between the man in the background and the nude on the sea monster by selecting an expensive royal azure for both the man's overcoat and the younger woman's gold-embroidered turban (see fig. 17). Through the medium of this rich pigment and its gold ornament, the artist painted for the viewer a picture of two closely related individuals from the highest rank of society whose lives were being torn assunder by a sea monster. To add another observation

regarding the identity of the woman in particular, it is intriguing that while Juan Pérez de Moya's *Philosophia secreta* (1585) came too late to have been a direct source of inspiration, the author's expositions on Hercules's encounters with Antaeus, Hesione, and the garden of the Hesperides follow one another there in direct sequential order—that is, in the precise arrangement of what can be read as corresponding images in the Rosary Cantoral.

To read the art as such would seem plausible, but it raises a nagging question: Why would the artist have chosen to highlight Hesione instead of her more famous rescuer? A clue to the answer might lie in the history of ancient Spain outlined by Pedro de Alcocer's *Hystoria, o descripción dela imperial cibdad de Toledo* (1554), in which Hercules figures prominently. In fact, Alcocer acknowledges not only one but two founding fathers of that name—one Libyan, another Greek—who were at the forefront of two distinct Spanish generations:[58]

> The fifth generation [of Spaniards] was that of the Libyan Hercules—or the Egyptian—son of the aforementioned Osiris [of the fourth generation] who shortly after him came to Spain with many people against the aforementioned Gerions [Africans of the third-generation Gerion], with whom there was a battle in which they were defeated and killed, and whose bodies were entombed on the island of Cádiz according to Philostratus in the life of Apollonius [of Tyana].[59] The ninth generation of people consisted of many other Greeks, who, in addition to those already mentioned, came to Spain, where they populated many cities (according to Justinus, Strabo, Pliny, Titus Livius, and many other writers). The first among them was the Greek Hercules, who with other corsairs [cossarios]—his companions—came from the island of Colchis and arrived in Spain after stealing the treasures of King Aeëtes. Here (according to Strabo [*Geography*, 3.1.7], who cites Timosthenes) he built and populated a city, named Heracleia, which is also called by the other name of Calpe, from the name of a mountain upon whose foundation he built it. The Moors later gave it the name Gibraltar. Hercules left some of his companions in this place and he returned to his ships without it being known [sin que se sepa] that he entered more deeply into the interior of Spain. Not much later, Teukro [Teucer] the son of Telamon, King of Aegina, also came to Spain, and he settled with his companions in Galicia.[60]

The grandness of Hercules's roles as described by Alcocer overshadows two important allusions in his brief narrative on the ninth generation. The first, with its references to "Colchis" and the "treasures of King Aeëtes," points to the famous legend of Jason and his capture of the Golden Fleece—an expedition in which Hercules took part, according to the well-known *Argonautika* of Apollonios Rhodios (b. ca. 295 BCE) and the later version by Gaius Valerius Flaccus (fl. 1 CE).[61] Oddly, the rhetoric here is such that the lead role of Jason (who is never mentioned) is upstaged—indeed, usurped—by Hercules.[62] But if Alcocer conspicuously overplays Hercules's role with respect to the Argonautic voyage, he decidedly underplays it in the more obscure allusion to the event flagged by the reference to "Teucer the son of Telamon"—the Prince of Aegina who reportedly settled Galicia in northwestern Spain. Part of what is alluded to

here is nothing other than the rescue of Hesione, for that was the event directly responsible for the birth of Teucer, the son of Telamon and Hesione. Perhaps this more difficult reference was not lost on Alcocer's more learned contemporaries. According to Boccaccio's widely known *Genealogie deorum*, Teucer—Alcocer's princely pioneer of northwestern Spain—was the fruit of a union that came about after Hercules rescued Hesione, destroyed Troy, killed Laomedon, and turned his daughter over to Telamon.[63] The consequences of these actions would carry further still, since, according to Alcocer, Teucer was only the first in a long line of refugees to reach Spain in the aftermath of Troy's destruction. The tenth generation of Spaniards listed in the *Hystoria* was composed of the vanquished and displaced Trojans who had come to settle and populate the northern Spanish provinces of Cantabria and Asturias.[64]

As we unpack the mythical elements in Alcocer's history of Toledo and the early population of Spain, it becomes increasingly apparent that, as the mother of Teucer and a catalyst in Hercules's destruction of Troy, the unfortunate Hesione played an important, albeit passive, role in developing the internal map of Spain. Indeed, it is precisely in such a "supporting role" that she seems to have been cast by the illuminator who decorated the Rosary Cantoral. In paying homage to the feats of Hercules—an early resident of Toledo and one of Spain's founding fathers—the artist also saw fit to recognize the Trojan princess he had rescued: a hapless maiden who might fairly be described as a "founding mother" of Spain. Hesione and her near-sacrifice and rescue by Hercules had consequences for the settlement and population of Spain; as such, she can serve alongside her rescuer as an appropriate civic icon. With respect to Albrecht Dürer's *Das Meerwunder*, then, whatever debates might continue over the enigmatic *intentio auctoris*, the Rosary Cantoral may allow us to garner some idea about the intentions of the reader on the part of one Toledan illuminator working near the turn of the sixteenth century. It would seem that the artist saw in Dürer's *Das Meerwunder* a "Sea Monster," to be sure, but one that had figured into the feats of Hercules and his once-famous rescue of Hesione at Troy.

The iteration of *Das Meerwunder* in the Rosary Cantoral thus assumes a more logical place among the Hercules iconography that frames it on either side. More broadly considered—like its surrounding Herculean imagery, the emblems of the Five Wounds discussed in chapter 4, and the illuminated letter featuring "The Knight of Cologne" discussed in chapter 3—the image of Hesione and the sea monster (see fig. 17) can also be viewed as part of the grand iconographic scheme designed to project a semblance of identity and a sense of place on behalf of the rosary confraternity that commissioned the book and so, too, for the Dominicans of San Pedro Mártir who chanted from this richly—and meaningfully—decorated cultural artifact from Renaissance Spain. The musical prayers themselves have much to reveal about the culture of Toledo at the turn of the sixteenth century. They will form the basis of discussion in chapter 6.

Chapter Six

Roses for the Blessed Virgin

The Music

The musical prayers in the Rosary Cantoral find their visual counterparts in the roses that were painted into the margins of the manuscript (see fig. 1). At first, like the marginal images of Hercules, they seem inconsequential. But given the opportunity to survey the related leaves Beinecke 794, Morgan M887-1, and the folio last owned by Günther and Ferrini (see figs. 4, 5, and 7), we notice that the rose is a recurring motif—something fundamental to the iconographical program of these *cantorales*. The basis for its inclusion, of course, is the rosary to which the Toledan confraternity devoted itself, in particular its representation in "The Knight of Cologne" as a garland of roses. At the heart of that miracle is a clever metaphorical device—the notion of "Ave Marias" and "Pater nosters" transformed into roses—that allows the faithful to visualize the abstract idea of prayer. As the story goes, the prayers offered to the Virgin are transformed into roses, which she, in turn, plucks from the air and weaves into a garland of redemption.

The texts in the Rosary Cantoral and its companion books are prayers too; indeed, prayers made all the more fragrant by the melodies that carry them. Like the spoken prayers of the "Ave Maria" and "Pater noster" in "The Knight of Cologne," they too rise toward the heavens—but on wings of song. This chapter takes a closer look at some of these roses for the Blessed Virgin, especially the exceptional ones that—to push the metaphor slightly further—are a cut above the garden variety. Just as the art in this manuscript preserves revealing vestiges of currents in Toledan culture around the turn of the sixteenth century, so too do the chants—decoration not for the eyes but for the ears.

Like the rosary itself—which consists largely of unvaried repetitions of "Ave Marias" and "Pater nosters"—the principal body of chants in the Rosary Cantoral is composed of the most quotidian and repetitive prayers of the church year: the Kyrie, Gloria, Credo, Sanctus, and Agnus Dei. Remarkably, however, most of these are richly ornamented by tropes. This is unusual in a manuscript from around 1500, since tropes are broadly understood as textual or musical

additions to chants of the Mass that flourished from the ninth to twelfth centuries but gradually fell out of fashion afterward.[1] They are thus distinctly late Medieval creations. Yet the Rosary Cantoral transmits twenty-two tropes for the Mass Ordinary: thirteen for the Kyrie, one for the Gloria, five for the Sanctus, and three for the Agnus Dei (see appendix C.1).

As is evident, most of these tropes have been inventoried previously. But nine are unaccounted for in the basic scholarly literature and survive only in Spanish sources.[2] Seven are simple textual additions to preexisting melismas for the Kyrie and Sanctus (Osanna). These are widely known as *prosulae* and, perhaps less so, as the type of trope specifically designated *melogene*. The remaining examples are *logogene* tropes. That is, they involve newly composed (or derived) melodies as well as added texts.[3] The following sections will examine these in turn.

Melogene Tropes for the Kyrie

The earliest concordances for the seven Spanish *melogene* tropes in the Rosary Cantoral reflect dates of origin ranging from the twelfth to sixteenth centuries. There are five for the Kyrie (see appendix C.2).

Among the Kyrie tropes, "Kyrie cunctipotens domine" and "Kyrie summe rex" are the most venerable. Both are found in twelfth-century manuscripts with Aquitanian notation—one in Montserrat 73, the other in Salamanca 2637—that rank among the earliest sources to record extensive use of Roman-Carolingian chant in Spain. This is the variety of chant widely known today as Gregorian. The Aquitanian notation in Monsterrat 73 and Salamanca 2637 reflects the industry of southern French clerics who helped introduce Gregorian chant into Spain after the Roman liturgy was officially adopted at the Council of Burgos in 1081. This replaced the Old-Hispanic rite (also known as "Visigothic" and "Mozarabic") that has garnered the attention of most scholars who have worked on Spanish chant.[4] Unfortunately, the precise origins of these manuscripts have not been firmly established. Montserrat 73 originated either in the south of France (Toulouse) or just across the Pyrenees in northeastern Spain (diocese of Urgell).[5] Salamanca 2637 might have originated at the Benedictine monastery of Santo Domingo de Silos (about 55 km southeast of Burgos) where French clerics, bishops, and cardinals were noted in attendance at the dedication of the monastery's romanesque church on September 29, 1088.[6]

The specific origins of Montserrat 73 and Salamanca 2637 might be debated. But it remains clear that they circulated in the regions where southern French clerics had assisted their northern Spanish counterparts in adopting a new rite, its chants, and the tropes that were fashionable at the time. The reiteration of "Kyrie cunctipotens domine" and "Kyrie summe rex" in the Rosary Cantoral around 1500 demonstrates the extent to which Spaniards continued to chant

the melodies of the Roman rite in the manner in which French clerics had first introduced them—tropes and all. Indeed, "Kyrie cunctipotens domine" appears as late as 1544 in a chantbook printed for use in southern Spain. Significantly, the two oldest tropes in the Rosary Cantoral find more direct antecedents in Toledo 35-10, a Gradual copied in the early thirteenth century for use at the cathedral.[7] "Kyrie cunctipotens domine" also appears in the fourteenth-century Toledan Gradual, Madrid 1361.[8] These are vestiges of Toledo's "French connection" that extends back to 1086—the year the Cluniac Bernard de la Sauvetat assumed his position as the city's first archbishop after its recapture from the Muslims in 1085. On December 18, 1086, Bernard officially introduced the new Roman-Carolingian rite at Toledo in the company of other French clerics who would help him implement the new observance throughout the diocese.[9]

In light of the early appearances of "Kyrie cunctipotens domine" and "Kyrie summe rex" in the twelfth-century manuscripts Montserrat 73 and Salamanca 2637, and given their subsequent inclusion in Toledan manuscripts from the thirteenth and fourteenth centuries (one of which uses Aquitanian notation), it seems reasonable to suggest that these tropes had graced the chants Bernard helped implement during his prelacy. The question remains open, however, as to whether these tropes were Aquitanian in origin or Spanish compositions after southern French models. The chants that set these texts in the Rosary Cantoral shed little light on the issue. On one hand, the melody for "Kyrie cunctipotens domine" is rare and found only in Spanish sources (see ex. 6.1).[10] On the other, the chant for "Kyrie summe rex" is a French melody that first appears in eleventh-century manuscripts from Moissac and Narbonne.[11]

Example 6.1. "Kyrie cunctipotens domine" (untroped verse), Rosary Cantoral, fol. 13.

The origins of the remaining three Kyrie tropes are less ambiguous by comparison, with the preponderance of evidence suggesting they are later Spanish compositions. "Xpriste patris genite" first appears in the fourteenth-century Toledan Gradual Madrid 1361. The chant setting it there and in all subsequent sources (including the Rosary Cantoral) is a melody that has been identified only in Spanish manuscripts (see ex. 6.2).[12]

"O pater immense" and "Pater excelse" are evidently very late accretions to the trope repertory. Indeed, the Rosary Cantoral is the earliest source for both

Example 6.2. "Xpriste patris genite" (untroped verse), Rosary Cantoral, fol. 24v.

texts.[13] "O pater immense" appears next in a choral manual of Seville printed in 1539.[14] The next concordance for "Pater excelse" is in a chantbook printed in 1544 for use in Granada, where the musical-liturgical practices of Toledo were introduced immediately after Christian forces retook this last Muslim stronghold on the Iberian Peninsula in 1492.[15]

"Pater excelse" is an interesting text assigned to the Saturday Mass for the Virgin Mary and bears a close relationship to the well-known "Spiritus et alme"— a Marian trope for the Gloria that is also included in the Rosary Cantoral (fol. 30v–33).[16] A comparison of the trope elements added to each prayer reveals the clear parallel constructions between them:

Kyrie "Pater excelse" (fols. 9–11)	Gloria "Spiritus et alme" (fols. 30v–33)
	Spiritus et alme orphanorum paraclite
	Primo genitus marie virginis matris
	Ad mariam gloriam
Pater excelse mariam preparans eleyson	Mariam sanctificans
Iesu benigne mariam consecrans eleyson	Mariam gubernans
Spiritus alme mariam obumbrans eleyson	Mariam coronans

The similar texts "Spiritus alme" and "Spiritus et alme" might be dismissed as fairly common references to the Holy Spirit, the third person of the Trinity. But it is hard to overlook the three parallel constructions of present active participles that take Mary as their direct object: "mariam preparans" / "mariam sanctificans"; "mariam consecrans" / "mariam gubernans"; "mariam obumbrans" / "mariam coronans." Furthermore, the melodies setting the Kyrie and Gloria in the Beinecke's Kyriale (Melnicki 27 and Bosse 23) have traditionally been linked with Marian Masses and appear in the modern Vatican Edition as the first two chants of an Ordinary cycle designated specifically "For Feasts of the Blessed Virgin" (Kyrie IX, Gloria IX).[17] All evidence suggests that the text "Pater excelse" is a very recent Spanish composition designed specifically to complement the Gloria "Spiritus et alme."

Melogene Tropes for the Sanctus (Osanna)

The two tropes for the Osanna of the Sanctus (see appendix C.3) are *unica*. Unfortunately, both have come down to us as fragments. The first of these is the concluding versicle of a trope that reads "Ómnes vírgines sánctum quóque

flámen. Ámen." The rest was lost when seven of the preceding folios were excised from the manuscript. Enough of the text remains, however, to discern a coarse attempt at hexameter.[18] The versification is significant because while hexameter is the most common meter found in Sanctus tropes, it is usually applied to the first section of the chant and rarely to the Osanna concluding the prayer. Indeed, only three other instances of hexameter in Osanna tropes have been documented: "Hostia pro miseris," "Plebs tibi mente pia," and "Spiritus alme fovens."[19] The first two appear in twelfth- and thirteenth-century manuscripts from southern France (Toulouse) or northern Spain (Huesca, Tortosa, Urgell).[20] "Spiritus alme fovens" is found in a manuscript that originated in Catania around the mid- to late twelfth century.[21] The "Omnes virgines" fragment in the Rosary Cantoral provides sufficient evidence to identify a fourth example of this rare design. The chant itself matches the end of a Sanctus melody in only one other Spanish source: the *Officia ad missas* printed in Granada in 1544, where it is assigned to the Saturday Mass of the Virgin Mary (see ex. 6.3).[22] The inelegant verse "Omnes virgines" arguably formed part of a Spanish composition after a French model.

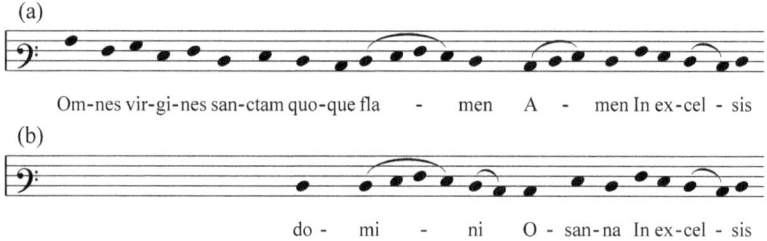

Example 6.3. (a) "Omnes virgines," Rosary Cantoral, fol. 77; (b) Marian Sanctus, *Officia ad missas* (Granada, 1544), fol. 214v.

We find a similar case with the second "new" Osanna trope in the Rosary Cantoral, which is barely legible in an erasure on fols. 78–79v. The melody for the base Sanctus is a variant of Thannabaur 53, which has been identified only in Spanish sources from Toledo, Tortosa, and Tarragona.[23] According to the rubric preceding the main chant, the erased trope "Osanna salvifica . . . rex angelorum" was performed on feasts of double rank and on Sundays.[24] Although a concordance for this particular text has not been found, the incipit places it among two other "Osanna salvifica" chants known thus far: "Osanna salvifica concinentes" and "Osanna salvifica tuum plasma." The latter was fairly widespread in northern Spain and southern France.[25] The trope "Osanna salvifica concinentes," however, appears only in the early-fourteenth-century Toledan Gradual, Madrid 1361 (fol. 190).[26] These tropes are distinctive in

immediately juxtaposing the words "Osanna" and "salvifica," and they belong to a broader subcategory of Sanctus tropes that play on a concept going back to the writings of St. Jerome (ca. 340–420) and St. Isidore of Seville (ca. 560–636) in which the word "Osanna" is interpreted as an elision of the Hebrew "osi" (save) and "anna" (we pray to you).[27]

A "Compound Trope" for the Agnus Dei

The most extensive trope in the Rosary Cantoral is also the most fascinating. Unlike the simple textual additions seen thus far, the troped Agnus Dei on fols. 81v–83 involves new texts that have been added to new melodies. Thus, they are *logogene* tropes.[28] The rubric preceding the base chant assigns it to double major feasts and feasts of the Blessed Virgin.[29] Most unusual is the patchwork of three distinct *logogene* tropes that have been cobbled together to create an extended musical-poetic form that might be fairly designated a "compound trope." The layout of the manuscript indicates that the three trope elements would sequentially follow a performance of the full Agnus Dei with the concluding "Dona nobis pacem" repeated upon their completion (see ex. 6.4). The trope elements are transcribed and labeled A, B, and C in appendix C.4, where concordances are provided for each.

The first element of this "compound trope" is the rare "O Jesu salvator" (A). Until now, it was thought to have been transmitted solely by the famous *Las Huelgas* manuscript compiled in the fourteenth century for the Cistercian convent of Santa María la Real de Las Huelgas in Burgos, Spain.[30] The setting in *Las Huelgas* is for three voices and appears in a section dedicated to tropes for the Agnus Dei (fols. 18–21). The Rosary Cantoral provides an especially important source because it is the only known complete setting of "O Jesu salvator" in plainchant. It is clear from the musical transcription that the new melody was derived from the base chant, an embellished version of Vatican Agnus Dei IX (Schildbach 114). The iterations of "O Jesu salvator" in the Rosary Cantoral and the *Las Huelgas* codex reveal no direct correlations. Both testify, however, to a more extensive use of this trope in Spain than previously suspected.

The melody for the second trope element, "Crimina tollis" (B), was also modeled after the base Agnus Dei melody in the Rosary Cantoral (Schildbach 114). The text in this case is more widespread in German, French, and Spanish sources.[31] The last element, however, returns us to a more unusual example. "Ave maria celi regina" (C) is melodically distinct from the preceding two tropes and is not derived from the base Agnus Dei chant. The text is rare and unknown outside of the Toledan Rosary Cantoral and two other sources that come from northeastern Spain (Tortosa, Tarragona).[32] The earliest concordances for the text and melody in the Rosary Cantoral are found in the thirteenth-century manuscript Tortosa 135 (see ex. 6.5).

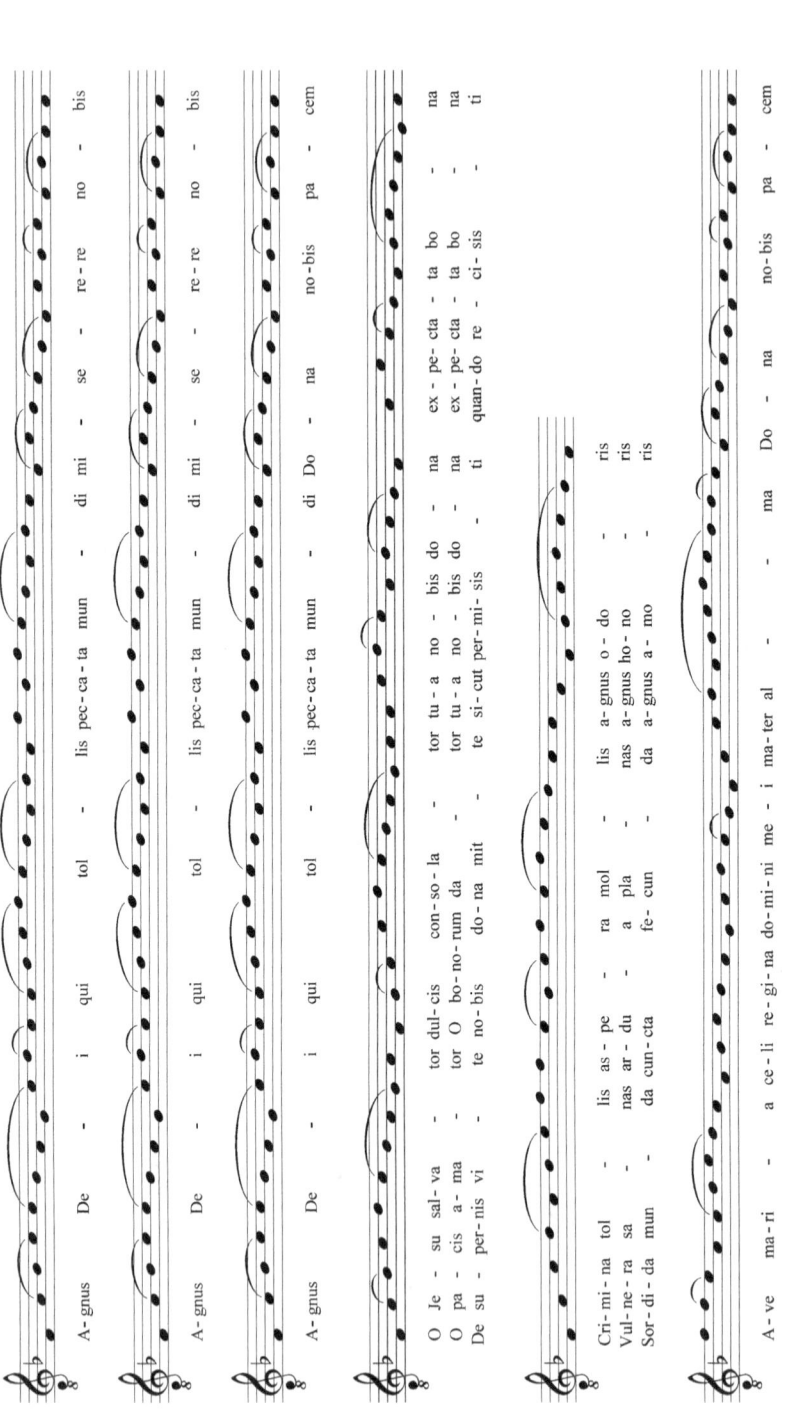

Example 6.4. "Compound trope" for the Agnus Dei, Rosary Cantoral, fols. 81v–83.

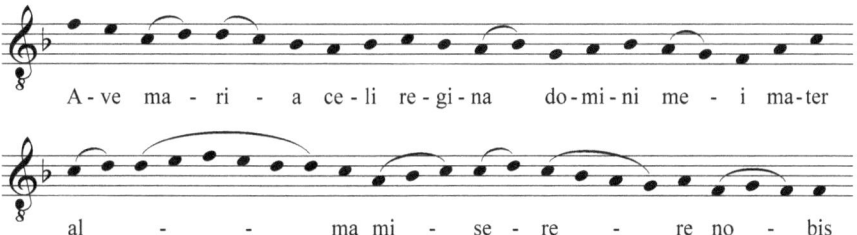

Example 6.5. "Ave maria celi regina," Tortosa, Biblioteca Capitular, Ms. 135, fol. 35.

The contents of Tortosa 135 suggest that the manuscript was compiled for use at the cathedral of Tortosa (about 150 km south of Barcelona) between 1228 and 1264, most likely very close to the year 1254.[33] The region and relatively early date make it difficult to tell with certainty whether the trope is French or Spanish in origin. The evidence favors Spanish, but—as with every other trope surveyed here—it was ultimately inspired by the late Medieval troping practices of southern France.

Ornamented Plainchant in Toledo

Plainchant in Toledo is greatly indebted to late Medieval Aquitaine. But Toledan plainchant was unique in one respect—the particular manner in which it was performed. Modern musicians rarely give a second thought to the diversity of plainchant melodies, performance practices, and, above all, the sensitivity with which chant should be performed—a pause here, an inflection there. Typically, when one hears plainchant performed at all, more often than not as the intonation to a polyphonic Gloria or Credo on the concert stage, the listener is subjected to a lifeless, perfunctory warbling of a text that is inherently passionate and meaningful: "Glory to God in the Highest" (Gloria in excelsis deo)— "I believe in one God" (Credo in unum deum). But whether we are talking about a religious house or a concert stage, plainchant today is performed with a numbing monotony directly at odds with the celebration of the word it should be.

To the contrary, chant in Toledo was recognized in the sixteenth century for the lively manner in which it was performed. A few writings have survived to give some sense of what it might have sounded like.[34] The evidence comes down in the music itself as well. The Rosary Cantoral is a case in point.

An anonymous sixteenth-century treatise titled *Arte de melodía sobre canto lano y canto d'organo* (*The Art of Melody Concerning Plainchant and Polyphony*) is one important indicator of the distinctive style of plainchant performance in Toledo.[35] It describes, among other things, eight major ornamental figures "through which the singing of plainchant was made more sweet"—a style the writer claims hearkened

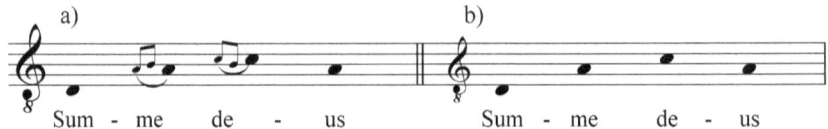

Example 6.6. (a) Kyrie "Summe deus" (incipit), Rosary Cantoral, fol. 5, with the *tocus* and *uncus*; (b) "Summe deus" (incipit) without the *tocus* and *uncus*.

back to the "most ancient cantories of the Mozarabic Mass in Toledo and its church."[36] Among the eight notational symbols are two that appear repeatedly throughout the Rosary Cantoral. These can be seen in succession over the incipit to the Kyrie "Summe deus" on fol. 5 (see fig. 22). The first (over "Summe") is a bent note with two tails pointing up. The second (over "deus") is a bent note with two tails pointing down. According to *The Art of Melody*, these were known, respectively, as a *tocus* and an *uncus*. "The *tocus*," the treatise says, "is a figure like a breve with two plicas pointing upward and it was invented to signal that the voice should be repelled upward and then return to the same point in the melody."[37] Alternatively, "[T]he *uncus* is a figure like a breve with two plicas pointing downward and it was invented to repel the voice downward then return to the same point."[38] *The Art of Melody* goes on to say that the two were collectively referred to as an "estrunto" in Toledo[39]—a word undoubtedly related to the modern Castilian *estruendo*, meaning a sudden noise or disruption.

These two notes—the *tocus* and the *uncus*—were the equivalents of what musicians would call "double grace notes" today. Based on the description in *The Art of Melody*, we can derive some idea of what the friars at San Pedro Mártir heard when the text "Summe deus" was chanted. To illustrate, it is transcribed here, first with the *estrunto* (ex. 6.6a) and then without it (ex. 6.6b).

Estruntos appear throughout the Rosary Cantoral: as ornaments to a melody with several repeated notes (ex. 6.7a), as an ornament to enliven an upper or lower neighbor (ex. 6.7b), as the decoration to a cadence (ex. 6.7c), or—as we have seen in the Kyrie "Summe deus"—as ornamental notes to help fill the empty spaces of successive leaps in a melody.

Other methods of adorning plainchant were not exclusive to Toledo. For example, the Rosary Cantoral contains instances of mensural chant, which can be found throughout Europe.[40] Contrary to the notion of plainchant as freeflowing and unmeasured, mensural chants are chants that were performed with a rhythmic lilt and sometimes a steady beat. One good example is a chant for the Gloria inserted into the Rosary Cantoral at a later date (see fig. 23), probably in the early seventeenth century. The chant is an *unicum* insofar as no corresponding melody has been discovered thus far. It is preceded by the sign for *tempus imperfectum*, indicating that the chant would have been performed in a moderate duple meter (see ex. 6.8).

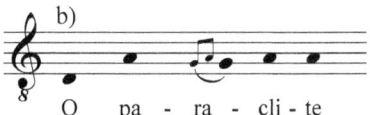

Example 6.7. Various uses of *estrunto* in the Rosary Cantoral: (a) ornamenting a monotonous melodic line, fol. 1v; (b) ornamenting a lower neighbor, fol. 2v; (c) ornamenting a cadence, fol. 4v.

In addition to being mensural, the tune is also much more diatonic than older chants tend to be; here there is a marked bent toward the melodic minor. Notably, the scalar melody with its occasional leap is more idiomatic of keyboard music than of the voice, suggesting that this particular chant was neither monophonic nor "a cappella" but perhaps the internal line of some polyphonic Gloria for the organ that accompanied it.[41]

This Gloria aside, two instances in the Rosary Cantoral certainly involved the interaction of plainchant and polyphony. They are considered next.

Two Ornaments of Renaissance Polyphony

The chants of the Rosary Cantoral are important testaments to the extraordinary degree to which late Medieval troping practices had endured in Toledo, Spain, even at the dawn of the early modern period. But its art and music also make clear that it was very much a product of High Renaissance sensibilities. Its opening folios (see figs. 1 and 2), illuminated in the new Ghent-Bruges fashion, incorporate images inspired by a late-fifteenth-century miracle of the rosary (see fig. 10) and a masterwork by Albrecht Dürer (see fig. 17). We find musical counterparts to these in two polyphonic compositions transmitted by the Rosary Cantoral—one by a celebrated Renaissance composer and another that followed

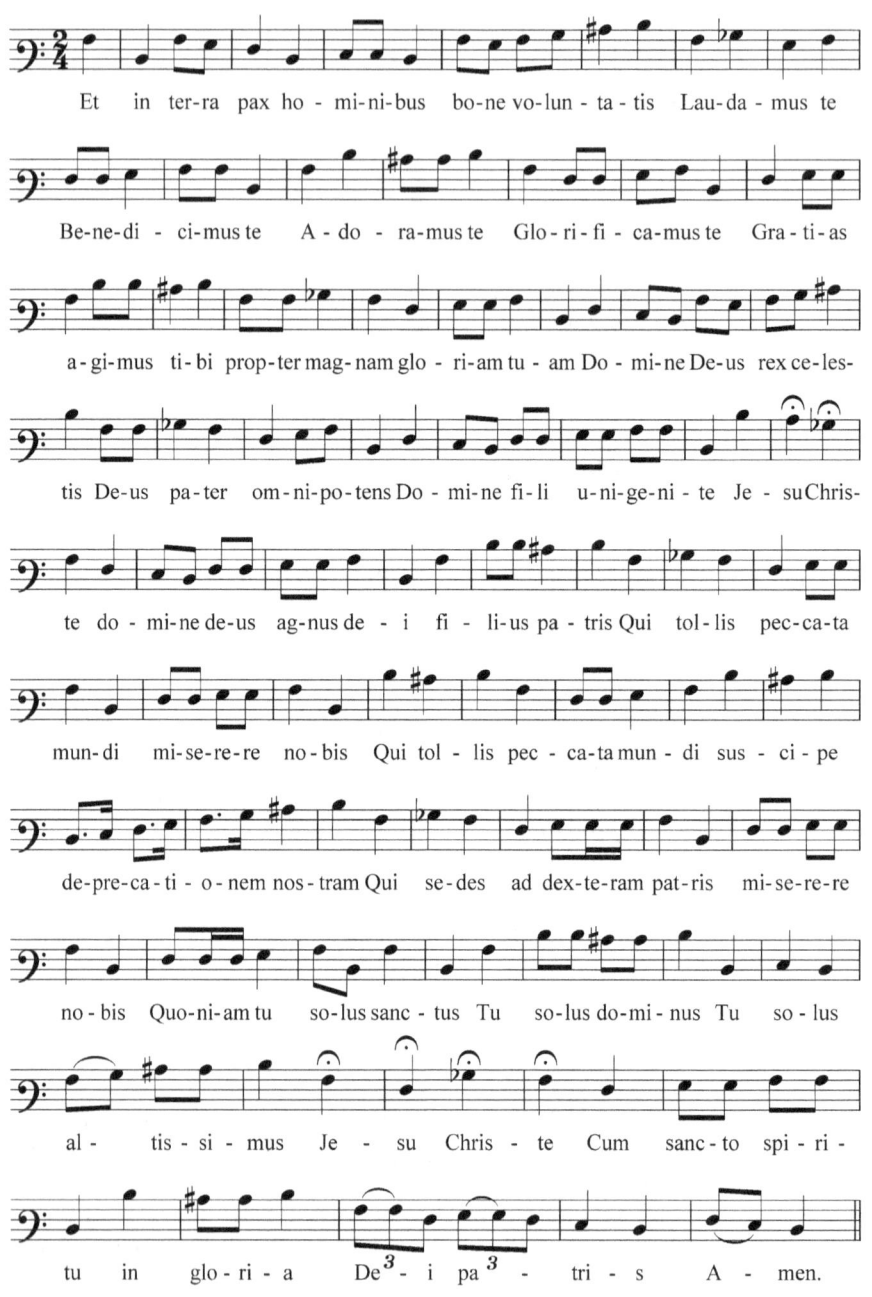

Example 6.8. Transcription of a mensural chant for the Gloria, Rosary Cantoral, fols. 54–55v.

a celebrated Renaissance tradition. Like the mensural chant for the Gloria examined earlier, both were probably inserted in the early seventeenth century.

The first of these is a four-part "Et incarnatus est" from the Credo of the *Missa sine nomine* by Josquin Desprez (ca. 1455–1521).[42] This was introduced into the manuscript at some point after its initial compilation and is, at present, the only Josquin Mass material preserved in manuscript form in an American library. It appears on fol. 99 with a clear attribution to "Jusquin"—a spelling frequently encountered in Spanish sources (see fig. 24).[43] The second polyphonic fragment is also a later addition. It appears on 101v and is untexted and unattributed (see fig. 25). As my transcription shows, however, this too was included as a polyphonic "Et incarnatus est" (see ex. 6.9a). Indeed, the alto voice paraphrases the "Et incarnatus est" of a Credo for the Virgin Mary that appears earlier in the Kyriale (see ex. 6.9b).[44] The paraphrase of this Marian Credo helps explain why there is only enough polyphony to accommodate the text up to "ex Maria Virgine," rather than the more customary "et homo factus est" as seen in the Josquin excerpt.

What makes this anonymous fragment so remarkable is that the two lower voices were clearly derived from the famous "L'homme armé" tune (see ex. 6.10) that inspired at least thirty-five polyphonic Masses between 1450 and 1600.[45]

L'homme, l'homme, l'homme armé, l'homme armé
L'homme armé doibt on doubter, doibt on doubter,
On a fait partout crier
Que chascun se viegne armer
D'un haubregon de fer
L'homme, l'homme, l'homme armé, l'homme armé
L'homme armé doibt on doubter, doibt on doubter

The man! The man! The armed man! The armed man!
The armed man should be feared! He should be feared!
Everywhere the cry has gone out,
That everyone should arm himself
With a hauberk of iron.
The man! The man! The armed man! The armed man!
The armed man should be feared! He should be feared!

This Rosary Cantoral's polyphonic fragment on "L'homme armé" represents a new and previously unknown Spanish Mass on this famous tune. It does not correspond to any *L'homme armé* Mass identified thus far and is rather ambitious in setting the "A section" of the tune in the tenor while the "B section" unfolds simultaneously in the bass.[46] (Compare the sections labeled accordingly in examples 6.9a and 6.10.) The paraphrase of the Marian Credo (see ex. 6.9b) in the alto voice evidently forced a compromise of the signature ascending fourth that begins "L'homme armé." To avoid leaping into a major second between the alto and tenor on the downbeat of m. 2, the composer substituted a contrapuntally correct, but much less satisfying, B-flat for the C-natural that should otherwise have been there.

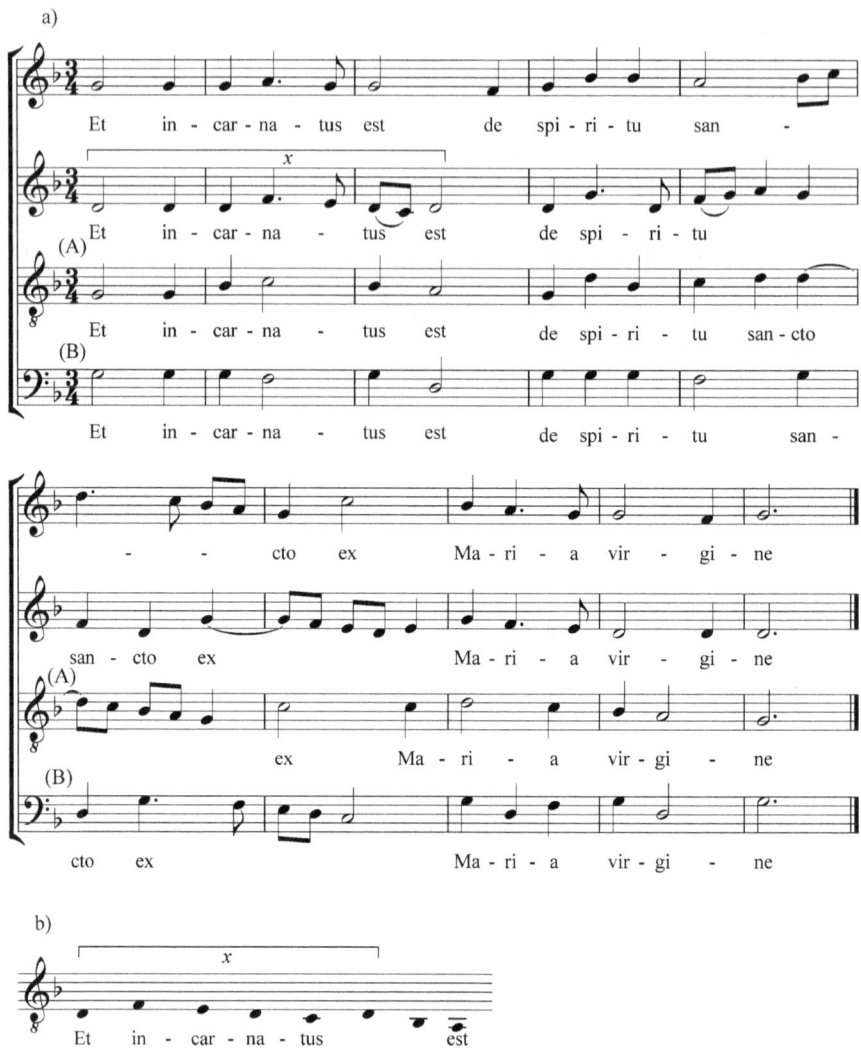

Example 6.9. (a) Anonymous, "Et incarnatus est" on "L'homme armé," Rosary Cantoral, fol. 101v [text underlay added]; (b) "Et incarnatus est" of a Marian Credo, Rosary Cantoral, fol. 64v.

These fragments of polyphony provide valuable new concordances for music by Josquin and for music based on "L'homme armé," but, more broadly considered, such settings of the "Et incarnatus est" are not unusual in Hispanic chant sources. In fact, they are rather common, as this section of the Credo was the

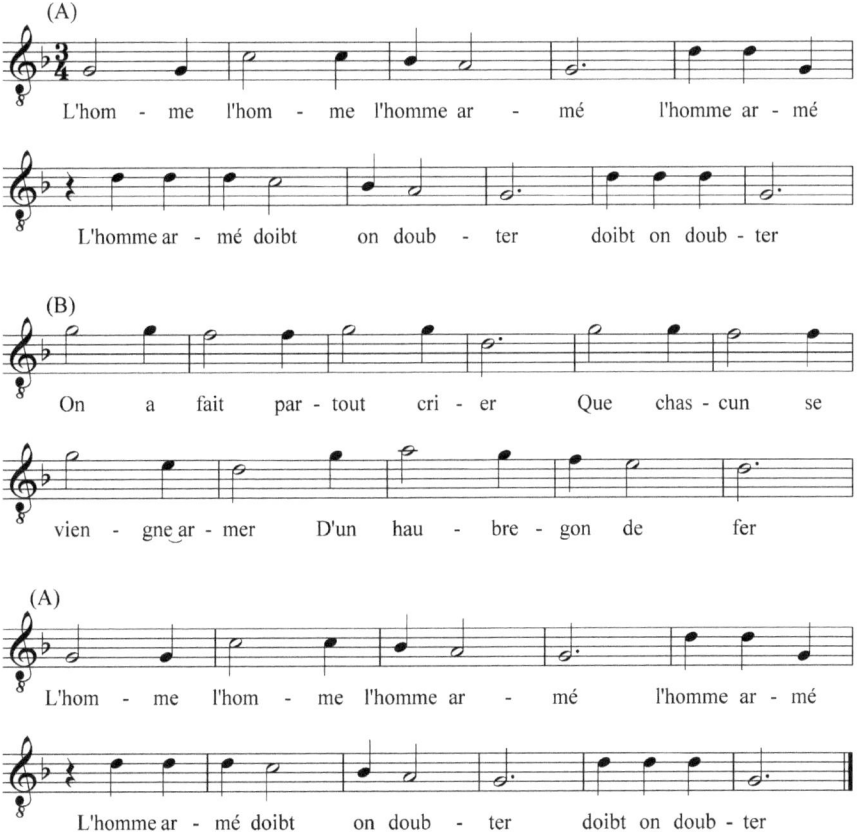

Example 6.10. Anonymous, "L'homme armé."

only part of the Mass Ordinary typically performed in polyphony during the seasons of Advent and Lent in Spain and in territories subject to its rule.[47]

The effect of chant suddenly blossoming into polyphony is quite dramatic from a purely musical standpoint. But it also illustrates the magnitude of a central tenet of the Credo and, indeed, of the Christian faith—the fundamental idea of the Word made Flesh: "Et incarnatus est de spiritu sancto, ex Maria Virgine, et homo factus est" (And he was made flesh by the Holy Spirit, through the Virgin Mary, and became man).[48] In such instances as we find in the Rosary Cantoral, the "Et incarnatus est" is literally fleshed out by additional singers who create a polyphonic texture that vividly captures the sense of the phrase. Upon its conclusion, the performance reverts to plainchant. A Kyriale now at King Philip II's (1527–98) palace-monastery of San Lorenzo del Escorial (42 km northwest

of Madrid, Spain) provides a more modest example of the practice with a polyphonic "Et incarnatus est" derived from the appropriate section of the "Credo Cardinalis" (Vatican Credo IV).[49] Here the chant is "fleshed out" by means of straightforward faburden and an added bass line to complete the four-part texture that was more customary for the period (see ex. 6.11).[50] The very simplicity of this texture suggests that polyphony was probably often improvised at the "Et incarnatus est," even if only with three voices (that is, as strict faburden without the added bass line). Insertions of more complex polyphony, such as the fragments found in the Rosary Cantoral, might have been substituted for simple faburden at the "Et incarnatus est" on especially grand occasions.[51]

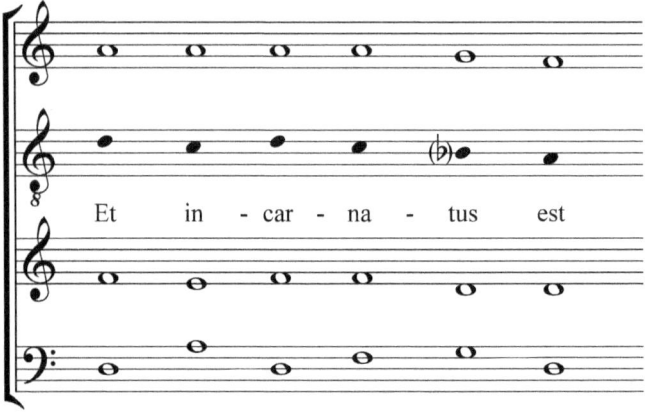

Example 6.11. Polyphonic "Et incarnatus est" (incipit), El Escorial, Cantoral 210, fol. 86v.

Like the tropes that embellish the Kyrie, Gloria, Sanctus, and Agnus Dei, the two polyphonic fragments for the "Et incarnatus est" brought a special element to the Credo chants of the Rosary Cantoral. They represent another way the artists, scribes, and musicians who compiled this magnificent chantbook around 1500 had endeavored to create something extraordinary out of the Ordinary for the friars of San Pedro Mártir de Toledo.

The Armed Man and the Virgin: A Case of Musical Misprision

We understand now the reason for the polyphonic settings of the "Et incarnatus est" in the Rosary Cantoral. But of all the settings, why these two in particular? The explanation lies in the illumination of "The Knight of Cologne" seen in the first opening of the manuscript (see fig. 10). More specifically, the selection of

these particular musical settings by Josquin and on "L'homme armé" reflects a creative misreading of the image—a case of musical misprision.

The excerpts, judging from the script, were copied into the manuscript very close to the turn of the seventeenth century—a time when the legend of "The Knight of Cologne" had fallen out of memory. In the 1570s another miracle of the rosary took center stage by storm, almost completely supplanting "The Knight of Cologne," by then almost a hundred years old. The new miracle was much grander in scope, dealing with a key victory for Christianity in one of the greatest naval battles ever fought—the Battle of Lepanto in 1571.

Since the mid-1560s the Turkish navy had been mounting attacks in the eastern Mediterranean, with all indicators pointing to a massive and sustained assault on Western European interests there. At particular risk was the republic of Venice, which lost the island of Cyprus in the summer of 1570. To confront the Turkish threat, a coalition of willing European states formalized a Christian union on May 20, 1571. Designated the "Holy League," the alliance was composed principally of Spaniards and Italians and backed by the recently elected Pope Pius V (Michele Ghisleri, b. 1504, papacy 1566–72), a religious of the Dominican Order. On the morning of Sunday, October 7, 1571, under the command of King Philip II's half-brother Don Juan of Austria (1545–78), the Holy League's fleet of around two hundred galleys confronted an evenly matched Turkish navy in the strait between the Gulfs of Patras and Corinth, then called Lepanto. The casualties were heavy on both sides, but at day's end the Christian fleet had scored a decisive victory.[52]

The aftermath was as important for the Christian world as the victory itself. For one, Pope Pius V began to entertain the idea of continuing an offensive drive that would retake the Holy Land and Constantinople, the Christian capital of the East that had fallen to Turkish forces in 1453.[53] These were pipe dreams that never came to pass, but one consequence of Lepanto remains to this day: the Feast of the Holy Rosary.

Few modern Catholics realize that the celebration of this feast on October 7 every year is in commemoration of the Holy League's victory at Lepanto. Pius V had attributed the victory to the rosary and its confraternity. In 1573 his successor, Pope Gregory XIII (Ugo Buoncompagni, b. 1502, papacy 1572–85), established an anniversary Mass of the Rosary on the first Sunday of October 1573. Spaniards kept it as a double feast with nine lessons.[54] The role of the rosary in this great victory for Christianity soon became a subject of lore. In his *Libro en que se trata de la importancia y exercicio del santo rosario* (*Book on the Importance of the Holy Rosary and How to Pray It*), published in 1584, the Dominican friar Juan López wrote that the feast of the rosary was offered "in memory and in perpetual gratitude of the miraculous victory that the Lord gave to his Christian people that day against the Turkish armada."[55] López went on to say that it was "most piously believed that the Lord brought about that great favor to Christianity through the merits of the Virgin and through the prayers of confraternity members throughout the Christian world who were in their usual processions, praying for the Church on that very Sunday, and at that very hour."[56]

Pius V saw the victory at Lepanto in 1571 as confirmation of the rosary's power. He buttressed that notion by citing what, until then, had been just one among many stories about the prayer's early history: that St. Dominic had received it directly from the hands of the Virgin Mary as he struggled to counter the Albigensian heresy in southern France during the thirteenth century.[57] Like the feast that commemorates the Christian victory at Lepanto, the story of St. Dominic as progenitor of the rosary persists to this day. Given Lepanto's magnitude in the annals of Christianity, the legend of "The Knight of Cologne" simply paled by comparison and faded from view. However, the magnificent illumination preserving a vestige of its former popularity in the Rosary Cantoral did not. Confronted with such glorious iconography depicting a knight fully dressed with his armor and sword, it is not surprising that a creative individual was prompted to include a polyphonic "Et incarnatus est" on "L'homme armé"—The Armed Man—in this chantbook.

The tradition of writing Masses on "L'homme armé" had not abated during the sixteenth century. Prominent composers, including Cristóbal de Morales (d. 1553) and Giovanni Pierluigi da Palestrina (d. 1594), wrote not just one such Mass but two.[58] An echo of the melodic profile in the *altus* of Palestrina's *Missa quarta (L'homme armé à 4)*, published in 1582, appears in the *superius* of the Credo fragment on "L'homme armé" in the Rosary Cantoral (see ex. 6.12). This suggests that the composer of the anonymous fragment knew Palestrina's Mass and had sampled a line for his own setting. The sampling (if it is indeed that) suggests a *terminus post quem* of 1582 for its composition.

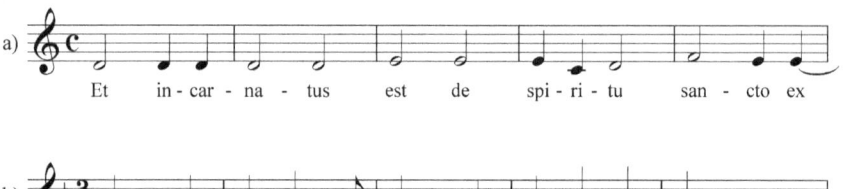

Example 6.12. (a) *Altus* from the "Et incarnatus est" by Giovanni Pierluigi da Palestrina, *Missa quarta* (*L'homme armé*), 1582; (b) *Superius* from the anonymous "Et incarnatus est" on "L'homme armé," Rosary Cantoral, fol. 101v [text underlay added].

Be that as it may, a knight in the opening illumination of the Rosary Cantoral had spurred someone (either a composer or a compiler) to think of music appropriate for an Armed Man. It appears that he gave ample thought to the Virgin in the picture as well. Although settings of the "Et incarnatus est" section typically

accommodate the text up to "et homo factus est" (and he was made man), the "L'homme armé" fragment in the Rosary Cantoral has only enough music to conclude with the text "ex Maria Virgine" (through the Virgin Mary). The result is a setting that emphasizes not only the idea of the Word made Flesh but also of Mary as the portal of Christ incarnate. Beyond that, moreover, Mary is a protector of her devoted—an idea also reflected in this polyphonic setting.

Mary as protector is best exemplified in the visual arts by the *Madonna della Misericordia*, typically shown protecting the faithful huddled beneath her large outstretched mantel.[59] Mariners regularly prayed the "Ave Maria" (Hail Mary) and the "Ave Stella Maris" (Hail Star of the Sea) to invoke Mary's protection against perils at sea—a tradition surely not lost on the fleet of the Holy League engaged in battle at Lepanto.[60] Indeed, it might have been that very tradition that nudged Pius V to credit the rosary prayer for the League's victory. In any event, the composer of the Rosary Cantoral's unattributed "Et incarnatus est" on "L'homme armé" reflected the idea of Mary as protector with a clever stroke: by setting the concluding words "Maria Virgine" to the segment of the Armed Man tune that corresponds to "d'un haubregon de fer"—a hauberk of iron (ex. 6.13). As the well-known text for "L'homme armé" goes: "the cry has gone out that everyone should arm themselves with a hauberk of iron." Thus, the anonymous composer, through an intertextual reference, musically encoded Mary as that hauberk—a protective garment of chain mail that is indispensable in warfare—and in the metaphorical battles of life.[61]

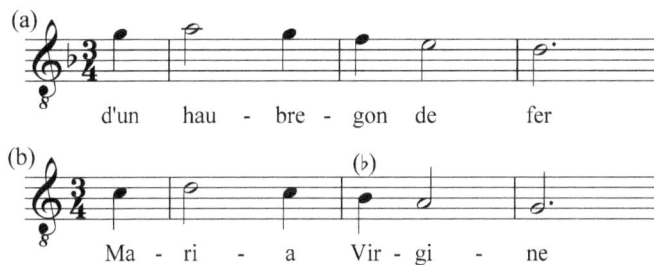

Example 6.13. (a) melodic segment corresponding to "d'un haubregon de fer" in "L'homme armé"; (b) melodic segment corresponding to "Maria Virgine" in the anonymous "Et incarnatus est" on "L'homme armé," Rosary Cantoral, fol. 101v.

The musical highlighting of "Maria Virgine" with a recognizable melodic segment from "L'homme armé" finds a direct parallel in the exquisite rendering of Mary's name in gold leaf and azure six times throughout the manuscript. One instance appears in the Kyrie for feasts of the Blessed Virgin on the opening folio of the Rosary Cantoral (see fig. 1). Three others appear on folio 32v, in the Marian "Spiritus et alme" trope for the Gloria (see fig. 26).[62] In light of these musical and

iconographical emphases, it should not escape notice that Mary is highlighted in the Rosary Cantoral's "Et incarnatus est" from Josquin's *Missa sine nomine* as well. In fact, this setting is the only instance among all of the "Et incarnatus est" sections attributed to Josquin that has a striking—indeed, startling—simultaneous cross-relation on the word "Maria." The clash happens in m. 14 between the B-flat in the *superius* and the B-natural in the tenor (see ex. 6.14). Up until that moment the

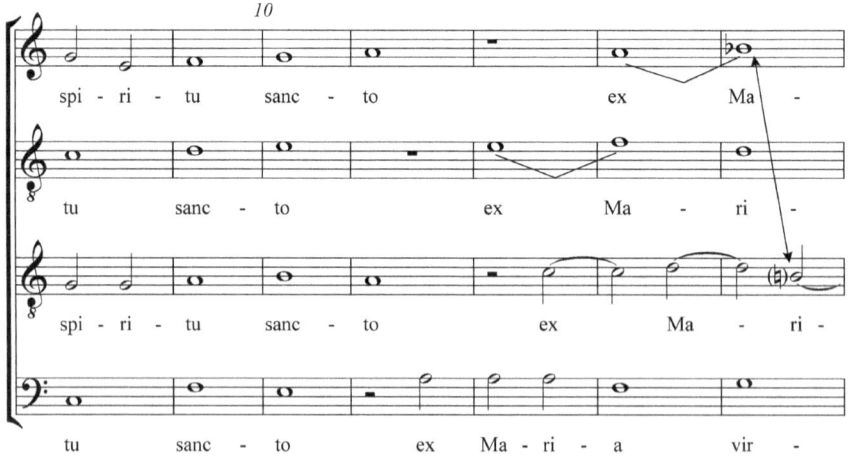

Example 6.14. Josquin Desprez, "Et incarnatus est" of the *Missa sine nomine*, Rosary Cantoral, fol. 99.

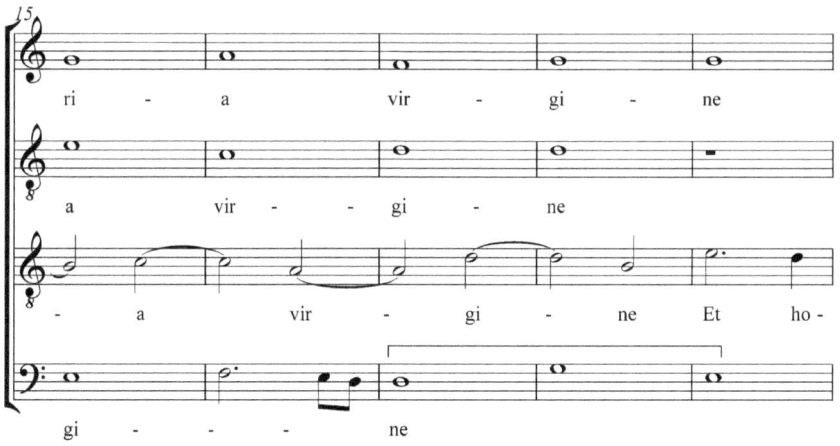

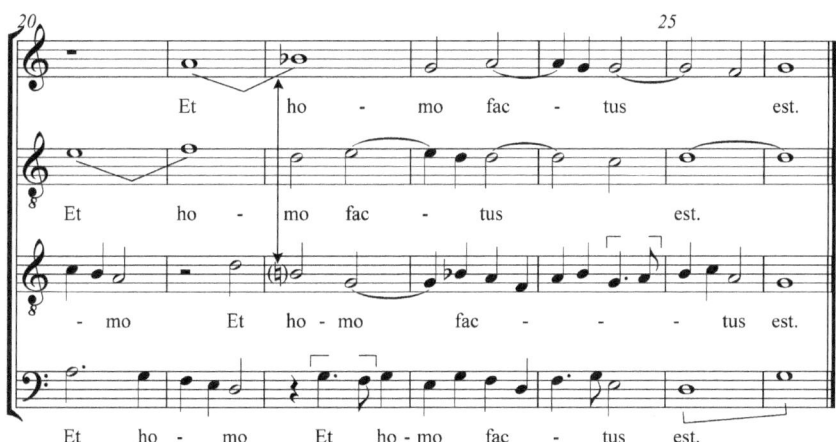

Example 6.14. (*continued*)

music unfolds harmoniously, with the masterful handling of notes that marks Josquin as a model of perfection in music composition.[63]

Josquin's works were much admired in Spain, perhaps nowhere more so than in Toledo.[64] Toledo Cathedral preserves what may be the richest collection of Josquin's Masses and motets in Spain.[65] The Masses were copied into beautifully

decorated choir books between 1542 and 1557 during the time of chapelmasters Andrés de Torrentes (1539–45 and 1547–53), Cristóbal de Morales (1545–47), and Bartolomé de Quevedo (1553–62).[66] The *Missa sine nomine* was among those. It was copied into the choir books of Toledo Cathedral during the prelacy of Archbishop Juan Martínez Silíceo (1546–57).[67] The inclusion of the "Et incarnatus est" from this Mass in the Rosary Cantoral is another reflection of Josquin's popularity in Toledo. Yet, one wonders: of all the glorious music attributed to Josquin that *might* have been included in the Rosary Cantoral, why *this* selection from the unremarkable *Missa sine nomine*—literally, "The Mass without a Name"?

The memorable clash highlighting "Maria" may be the answer. The unattractive, dissonant clash on Mary's name makes her stand out, to be sure. But the clash also represents the turning point of an important—and symbolic—musical process happening in the upper two voices (*superius* and *altus*). These voices proceed in exact canon at the fourth between mm. 1–11 (see ex. 6.14). That canon proceeds smoothly up until mm. 12–14, where it begins to break down—that is, unless the B-natural that should happen in the *superius* is changed to a B-flat right at the word "Maria." The same change is required in the *superius* of m. 22 at the word "homo"—meaning "man." Musically speaking, what we have is a change from a perfect, unadulterated canon to an imperfect, compromised canon that can only proceed if certain modifications are made to the notes. It is significant that the change from a perfect to an imperfect canon happens precisely at the word "Maria" and is reiterated at the word "homo." Indeed, Josquin musically interprets the text here to reflect the Christian belief that Mary is the portal through which God the Son left the perfection of Heaven and became man in an imperfect world. No other reason adequately explains why a master composer of Josquin's time would allow such a disagreeable sound on the name of the Blessed Virgin. If Josquin could speak to us today, he might explain his method thus: it is through Mary that the perfect becomes imperfect, the celestial becomes human.[68]

* * * * * *

Like the rich collection of iconography it preserves, the music in the Rosary Cantoral reveals much about the cultural influences, tastes, and artistic modes of expression particular to the society that created and used it. As we have seen, this is a volume that embraced a Medieval past, with its numerous *prosulae* and tropes, as well as the Renaissance vogue for "L'homme armé" and Josquin Desprez. Furthermore, it allowed a glimpse into how Toledans in the late sixteenth century interpreted (or misinterpreted) the Virgin and Armed Man in the illumination featuring "The Knight of Cologne" after that legend of the rosary had fallen from memory—replaced by a new miracle in 1571 that involved armed men and the Virgin who protected them.

Chapter 7 will conclude with another look at "The Knight of Cologne" that has resurfaced in several of our discussions thus far, this time focusing on its meaning around the year 1500. Leaving behind its subsequent misreading toward the end of the sixteenth century, the chapter will take a closer look at what this story about a weaving Virgin meant for early members of the rosary confraternity of Toledo. But as with all readings of "The Knight of Cologne," there is a backstory. In this case, that story has to do with the nature of the Toledan confraternity and the complex dynamics that framed its patronage of the Dominican convent of San Pedro Mártir, the issues to which we turn next.

Chapter Seven

The Confraternity of Toledo and Its Patronage

This concluding chapter revisits the rosary confraternity that was such an important factor in the growth and prosperity of San Pedro Mártir. It focuses in particular on the brotherhood's lavish patronage of the Dominican convent. Earlier, we gained a sense of what that patronage entailed—altarpieces, Masses, processions, and chantbooks, among other luxury items, over several centuries (see chapter 2). This time we will come to terms with the broader question of why that system of patronage existed. The question is pressing because the exorbitant generosity of the Toledan brotherhood, and even its composition, were marked departures from standards promoted for rosary confraternities at the time. Examining that issue requires some context. Thus we begin with an essential overview of the confraternity Jakob Sprenger founded at Cologne in 1475 and the Spanish brotherhoods that were modeled after it. Then we will focus on what was so extraordinary about the rosary brotherhood of Toledo, particularly in light of the silk weavers who were its members, and the tensions that arose when the Inquisition arrived in Toledo in 1485. Rosary brotherhoods were generally geared toward assisting the souls of the faithful in the afterlife. But, as we shall see, the confraternity of Toledo was more concerned with the precarious temporal world.

Membership in the Confraternity of Cologne

The illumination depicting "The Knight of Cologne" and the emblem of the Five Wounds reflect the degree to which the rosary confraternity of Toledo drew its inspiration from the famous brotherhood Jakob Sprenger founded at St. Andrew's Church of the Dominican convent at Cologne in 1475. But it was also different in a fundamental way. In stark contrast to the Toledan confraternity, which admitted only members of the silk weaving trade and persons of wealth and status, Sprenger's brotherhood was fiercely egalitarian in terms of who could join. In a word: everybody. Sprenger's printed statutes of 1476 for his Cologne confraternity are explicit about the fact that any man or woman,

regardless of social status, was free to become a member. Indeed, the Cologne brotherhood especially embraced the poor and despised individual. Sprenger noted, "as the Holy Scriptures say, the prayers of this same person are more welcome and more pleasing to God than those of the rich and respected one."[1] To enroll, all a person had to do was sign his or her first and last names into a registry and indicate whether he or she was single, married, clergy, or a layperson. The only major obligation incumbent upon each member was to pray three rosaries a week—a total of 150 "Ave Marias" and 15 "Pater nosters."[2]

The payoff for enrolling was attractive. In exchange for signing on, the person received the spiritual benefits of all prayers offered up by confraternity members throughout the world—that is, as long as members were not neglectful about offering their own rosaries. Furthermore, four times a year, on the Marian feasts of the Purification (February 2), Annunciation (March 25), Assumption (August 15), and Nativity (September 8), the Dominicans of Cologne offered a Matins service with nine lessons, a sung Mass, and a service for the dead "to help the poor souls of the persons who died while members of the brotherhood."[3] These Masses and services were special perquisites. As Sprenger noted: "Many people are departing from this life for whom, unfortunately, little good is being done after their deaths. The person who joins this brotherhood may protect himself from neglect of his soul."[4] Here we see an underscoring of Sprenger's egalitarian bent. Indeed, the Masses and services promised through the rosary confraternity of Cologne were otherwise a luxury only the wealthy could afford, since they normally required either an endowment to pay for them or a charitable donation (such as a chapel or an altarpiece) to merit such attention for the soul.

Spanish Rosary Confraternities

Spanish rosary confraternities of the fifteenth and sixteenth centuries typically followed Sprenger's model. Their statutes reflect a solidarity with the founder of the Cologne confraternity in at least one of three ways: by including the miracle of "The Knight of Cologne," mentioning Jakob Sprenger's name, or reproducing some version of the Cologne statutes. Sprenger's name is probably the most enduring of the three. "The Knight of Cologne" gradually falls out of memory, and statutes evolve over time to suit changing needs. But as we have seen, Sprenger's name and references to the confraternity he founded extend into the eighteenth century (see chapter 3). The earliest printed statutes in the Valencian *Trellat sumariament* (1535)—which also presents the earliest written narrative of "The Knight of Cologne"—are explicit about their connection to the Cologne confraternity. They promise members the spiritual benefits of rosary prayers offered throughout the world, "especially those by the brothers and sisters in the city of Cologne, where this holy institution had its origins."[5]

Spanish brotherhoods were tied without exception to religious houses of the Dominican Order, were accessible to every man and woman who wanted to become a member, and cost nothing to join. Those points were especially elaborated upon in rosary manuals published during the sixteenth century. The Dominican friar Diego de Ogea's *Short Instruction on the Devotion, Confraternity, Indulgences, and Miracles of Our Lady's Rosary* (1589) reflects the norm in stating that "no confraternity of the rosary whatsoever can be founded in any place without the particular license of the General of the [Dominican] Order."[6] On the issues of membership and accessibility, the first ordinance of the *Trellat sumariament* (1535) has it that "any person of whatever condition, or dignity, whether man or woman, can enter and be enrolled in this confraternity without price or fee."[7] Francisco Messia, in 1567, heaped extravagant praise on the singularity of that trait. The rosary confraternity counted among its members "popes, prelates, emperors, and kings; princes and barons; monks and canons; gentlemen and commoners; men and women; rich and poor." And this, Messia continued, "is something not found in other confraternities, given that one will so often be of clerics, another of laymen, another of noblemen, and another, finally, of laborers, with each one of the professions having its own designated confraternity." It was an honorable thing that "the confraternity of the rosary embraces everything and everyone, because it is in the service of the Mother who protects and shelters all people as the universal protector."[8]

The rosary confraternity of Cologne and the brotherhoods it inspired in Spain were thus universal, all-embracing—indeed, *catholic* in the strictest sense. The promise of salvation—through the rosary, through the corporate prayers of its members, and through the association with the Dominicans who prayed for them—was available to everyone who wanted it.

Confraternities of the Elite

The confraternity statutes that were printed and widely circulated throughout Spain reflect an ideal promoted by the Dominican Order. At the local level, however, the precious few statutes that have survived from the sixteenth century reveal varying degrees of compliance.[9] In some cases rosary confraternities strayed far and wide from the egalitarian principles Sprenger had forged for the brotherhood.

One example is an early-sixteenth-century rosary confraternity founded at the Dominican convent of Zaragoza in northeastern Spain. Its ordinances indicate that members were charged an annual fee to compensate the friars for twelve recited Masses throughout the year, a Vespers service and high solemn Mass with sermon on the principal feast day, and an annual Requiem Mass for departed members.[10] In addition to the set fee—and, literally, banking on the frailties of human nature—the Zaragoza confraternity also generated funds and needed materials through a wide array of punitive fines imposed on its members.

Arriving at Mass after the Gospel had been read or taking the name of the Lord or the Virgin in vain during chapter meetings would incur a monetary fine. (So would the failure to report someone who had committed such offenses.)[11] Refusing to surrender sidearms (daggers and swords) during chapter meetings would cost a pound of wax, which would be used for procession candles.[12] Not being properly attired on feast days would cost an *arroba* (11–16 kg) of oil.[13] Infractions and fines were recorded into a book by a notary throughout the year. The infractions would be read aloud at a designated meeting where each offender was required to surrender a personal item of value that would not be returned until all fines were paid in full.[14]

The statutes of Zaragoza show that in addition to providing for the spiritual well-being of its members, the rosary confraternity there acted as a burial society for its brothers and their children, offered material assistance to members who had fallen into difficult times or poverty, and encouraged members who were doctors or surgeons to extend their services charitably to others in the sodality. Membership thus carried social benefits that made the investment of enrolling attractive. From a strictly practical point of view, enrollment in this confraternity entitled an individual to protective benefits not unlike those offered by insurance companies today.[15] Then as now, however, such privileges were available only to those who could afford them.

At La Coruña in the northwest corner of Spain, the ordinances of a rosary confraternity from 1574 reflect a middle ground—a sliding scale of fees that were nonetheless required from those who wished to participate. To meet the cost of wax and other expenses incurred during Masses offered on behalf of its members, the brotherhood required "from rich persons, or persons of wealth one *real*; from people of lower society or lesser means a half *real*. Poor widows or poor wretches need pay nothing."[16] Members of the brotherhood were sent out to collect donations from the public every Wednesday, on the first Sunday of each month, and on feast days of the Virgin Mary. Those who refused the duty of collecting donations were charged a penalty of two *reales*.[17] Likewise, those who refused to pay the specified sum were denied processional candles.[18] Although the stakes were lower compared to the brotherhood at Zaragoza, participation in the rosary confraternity of La Coruña still came at a price.

In cases where ordinances have disappeared, the account books of rosary confraternities can be helpful not only in determining the types of fees required but also in reconstructing their activities. An instructive example is the late-sixteenth-century financial register of a brotherhood founded at Mohedas de la Jara, a town on the far western border of Toledo Province near Talavera de la Reina. There we learn that on the Feast of the Nativity (September 8) in 1598, 175 *reales* were paid to one Julio Gutiérrez for a bull that was run on that occasion.[19] On the same feast in 1599, 4 *reales* were paid to a drummer (tamborilero) who had performed (most likely in a procession), and just over 120 *reales* were paid to minstrils brought in from the nearby town of Guadalupe.[20] An additional

17 *reales* were spent to pay for their transportation and the travel of other musicians accompanying them, 40 *reales* on food provided for the entertainers, and 24 *reales* more for the *comedia* in which they performed.[21] Details on the *comedia* are wanting, but one might imagine it was didactic fare along the lines of the highly popular "El rosario perseguido" (The Persecuted Rosary), which exalted the devotion and its brotherhood.[22] The tenor of such works is exemplified in this excerpt, a lament by Lucifer on the apparition of the Virgin Mary to St. Dominic: "Today Dominic was visited by Heavenly Mary whom God preserved from sin and she left him, this adversary of mine, with the greatest charge to create a holy confraternity of the rosary. This is my affliction and affront, this is the cause of my restlessness, and this is what I fear more than the eternal fire that torments me."[23]

The confraternities of La Coruña and Mohedas de la Jara probably reflect something close to the norm in terms of the financing required for such organizations. This is an issue neither Sprenger nor his immediate followers addressed directly. But revenues were necessary to cover expenses related to the general maintenance of chapels, equipment, and devotional accessories such as candles. To address the matter, Pope Leo X (Giovanni de Medici; b. 1475, papacy 1513–21) included a statement in his bull on the rosary from 1520 (*Pastoris aeterni*) that opened the door for confraternities to accept charity from members if given of their own free will.[24] Even in this light, however, the rosary confraternity of Zaragoza is an extreme case that falls well outside the ordinary. Its statutes—beautifully presented in an illuminated parchment manuscript—paint the picture of an exclusive brotherhood that catered to society's more privileged. The revenues raised through annual fees and fines for infractions of every sort reflect an elite club that stood to benefit not only from the brotherhood's spiritual rewards but also from the material support and services made available through the confraternity.

The rosary brotherhood of Toledo is another example of a confraternity of the elite. As we saw in chapter 2, membership in the Toledan brotherhood was restricted to artisans of the lucrative silk trade, with occasional exceptions made for individuals of wealth and means. Some of the details bear repeating, as they are relevant to our discussion here. One is the statement in Blas Ortiz's *Summi templi toletani* (1549), which records the earliest explicit reference to the particular composition of the rosary confraternity of Toledo: "these confraternity members are silk weavers."[25] Another is the brief preamble to the brotherhood's revised by-laws in 1636, where it is noted that the newly edited statutes were approved "at the professional house in the parish district of Santo Tomé where the masters of the art of silk hold their meetings; we refer to this confraternity of Our Lady of the Rosary established in the royal convent of San Pedro Mártir."[26] The same by-laws make the exception for "gentlemen of means and social standing" so long as the confraternity is "honored and profited" by their membership.[27]

Many details about the rosary confraternity of Toledo are wanting. But the fact that its membership was primarily composed of local silk weavers opens an

important window into who they were and what had motivated their generous support of the Dominicans at San Pedro Mártir. For in Toledo, as elsewhere in Spain, the silk weaving trade was dominated by members of the *converso* (New Christian) population—the very segment of society against which the Inquisition had set itself.[28] Thus, when the Holy Office arrived in Toledo in 1485, the local silk trade was severely impacted by the scrutiny of the Inquisition during its most zealous period.

Conversos in Toledo

Toledo's large *converso* population endured some of its greatest trials in the last quarter of the fifteenth century. *Conversos* were looked upon with suspicion by the established Christian community—the "Old Christians"—and scorned by the small community of Jews that remained in Toledo until its expulsion in 1492.[29] The Holy Office did not have jurisdiction over the Jews of Toledo, but it wasted no time in taking advantage of existing prejudices. Upon its arrival in 1485, inquisitors pressured local rabbis to create a network of Jewish spies to denounce *conversos* who had lapsed into judaizing—covertly engaging in Jewish rites or practices. Christians swore an oath to help the Inquisition in its work.[30]

Through such means and circumstances, living conditions for the suspect community deteriorated rapidly. After the discovery of judaizers at Toledo's Jeronimite monastery of La Sisla, the prior and four other monks were implicated and burned at the stake in 1486 and 1487.[31] This was followed in 1490 with public burnings of Jewish sacred texts confiscated from the *converso* community.[32] And as threatening as those developments were, few things could have compared to the widely publicized execution on November 16, 1491 of a group of Jews and *conversos* from the neighboring town of La Guardia. The cohort had been condemned for kidnapping, torturing, and crucifying a young boy from Toledo, allegedly for the purpose of creating a spell that would thwart the work of the Inquisition.[33] (The sentences were carried out in Ávila that year because of a pestilence in Toledo.)[34]

Some of the punitive measures were less dramatic but very stressful on the *converso* population's financial resources. Indeed, to some contemporary observers it seemed that money was all the inquisitors were really pursuing. That issue is debatable, but there is no question about the inadequate financing of the Inquisition.[35] The Holy Office had no fixed source of income from the Church or Crown, and in its early stages the Spanish Inquisition had to generate revenues by its own activities. Given those circumstances, the inquisitors of Toledo were particularly aggressive in confiscating properties, imposing fines, and collecting commutations—punishments that had been commuted to a cash payment. In 1497 the Toledan Inquisition acknowledged receiving 6.5 million *maravedis* from dispensations alone, and by 1538 the situation became such that one Toledan *converso* wrote Emperor Charles V: "Your Majesty should above all provide that the

expenses of the Holy Office do not come from the property of the condemned, because it is a repugnant thing if inquisitors cannot eat unless they burn."[36]

Prosecutions brought against suspected judaizers in Toledo were especially frequent between about 1485 and 1530.[37] And in this hostile environment, the impact on the local silk industry was especially heavy. Not only was it closely tied to the *converso* population, but as one of Toledo's leading market sectors, a large portion of the city's wealth was concentrated there as well. Thus, the silk trade must have presented a lucrative target for an institution such as the Holy Office, which, as one scholar aptly put it, "was left to fend for itself."[38]

Toledan Silk Weavers and the Inquisition

The Inquisition arrived in Toledo at a time when the local silk trade had just begun to thrive. It steadily grew throughout the sixteenth century and would eventually constitute the core of the Toledan economy. By 1533 the vast majority of business transactions in Toledo involved the silk trade in some form or fashion.[39] Few statistics are available for the earliest period, but we can extrapolate its strength in numbers from the fact that in 1562 there were 423 master silk weavers who formed part of a guild under the advocation of Our Lady of the Rosary.[40] By then, this brotherhood represented one of the largest guilds in Toledo and was certainly one of the most profitable. It is clear, moreover, that the silk trade was already strong in the last quarter of the fifteenth century. Some of the most compelling evidence comes from the activity of the Inquisition against its practitioners.

Although documents tied to the early history of the Inquisition at Toledo are scarce, a few important witnesses to its activities have survived. The most critical regarding its scrutiny of the local silk industry is a list of *conversos* reconciled by the Holy Office in 1495.[41] The document records a list of penalties that were commuted to cash payments in the first quarter of 1495 "for the sustenance and necessities of the Office of the Holy Inquisition, to pay the expenses that were incurred in the war with Granada [1482–92], and for the war we hope to wage against the Moors abroad, along with other works."[42] The importance of this document stems not only from the fact that it is one of few papers to have survived from the early history of the Toledan tribunal but also from the remarkably detailed information it preserves. The notaries did not list specific crimes—those were probably kept in a separate volume—but they did record in detail the names of the condemned (and in some cases the names of their children, grandchildren, and spouses) and the amount to which their penalty was commuted. Most important, they also specified the professions of the condemned along with the parish districts in which they lived.

The evidence that emerges from tribunal records is revealing, particularly if we bear two things in mind. First, the convent of San Pedro Mártir, where the confraternity was established and where it kept its treasury, is in the parish

district of San Román. Second, the masters of the art of silk are documented to have had their business office in the parish district of Santo Tomé, Toledo's old Jewish Quarter where one can still visit the synagogues of Santa María la Blanca and El Transito. Of twenty-one parish districts in the city of Toledo, Santo Tomé ranked third in terms of cash payments extracted from its residents, whose penalties in 1495 were commuted to a total of 446,100 *maravedis*.[43] When we look strictly at the number of condemned individuals per parish, however, we find that Santo Tomé ranked first, with 310, and that it was followed in this regard by none other than San Román, where the number of heretics and apostates with commuted sentences was 235.[44]

Furthermore, when the focus is placed squarely on the silk industry (see appendix D), of sixty-three penalized individuals who had ties to the Toledan silk trade, those from the districts of Santo Tomé (with seventeen listed) and San Román (with eleven) comprised 44 percent of the total number. And narrowing the focus even further, scrutiny of various subgroups within the silk industry itself reveals that the two designations appearing most frequently are *texedor de seda* (silk weaver) and the more general *sedero* (silk master), which could have included silk weavers, among others. (Each designation appears sixteen times.) In most cases, the condemned were silk masters and their spouses; in a few others, they were their offspring. But in every instance the commuted sentence effected a redistribution of wealth from the collective earnings of the lucrative silk trade to the Church and its activities.

In chapter 2 we saw the extent to which San Pedro Mártir had prospered as a result of the Inquisition. Inquisitor General Tomás de Torquemada donated royal houses to the convent in 1490, and the Catholic Monarchs had conferred the right to publish lucrative Bulls of the Crusade in remuneration for the convent's support of the Inquisition's activities. Now the degree to which the silk industry played an unwitting role in the Inquisition's prosperity becomes evident. In 1505 the convent incorporated some houses that ten years earlier had been seized from the *converso* Diego Gómez, who was tried and condemned for judaizing. In a cruel twist of fate, the houses were converted into the Inquisition's jails.[45] The following year the convent annexed the houses of a silk master named Manuel Sánchez, who had been condemned for practicing sorcery.[46] In sum, all evidence suggests that the silk trade of Toledo was rife with accused judaizers, and the Inquisition was quick to capitalize on that fact.

Patronage of the Toledan Confraternity

The adverse relationship between the Inquisition and the Toledo silk trade provides a framework for reconsidering the exclusive membership of the city's only rosary confraternity and the patronage it lavished on San Pedro Mártir. In light of the frequency with which local silk artisans were persecuted for judaizing, one

would suspect that the silk trade was perceived as a "heretic industry" of sorts. Whether it was actually heretical stands beside the point, for perception was all that mattered; even the slightest suspicion was enough to invite scrutiny. To that end, the Inquisition encouraged the faithful to denounce anyone who commited a range of suspicious activities. These could include anything from wearing fine clothes on Saturdays, to placing their hands on their children's heads without making the sign of the cross, to refusing to eat salt pork, rabbits, snails, or fish without scales, or even to preparing stews on Friday—any custom the popular mind associated with Judaism.[47] As a result, the agendas of tribunals were often driven by prejudices and social discord within local communities. Denunciations were rampant as a means of getting even with enemies and advancing self-interests. Witnesses had nothing to lose: the identities of accusers were always protected, and the costs of prosecuting cases were borne by the Inquisition.[48]

In a judicial system that relied as heavily as the Inquisition did on community involvement, the importance of how one was perceived cannot be overstated. But perception worked both ways—one could be seen as either a heretic or a good Christian. Thus, given the circumstances, the relationship between the silk weavers of Toledo, who assembled in the name of the rosary, and the convent of San Pedro Mártir must have been defined in no small part by an interest to curry favor with the Dominicans who played such an influential role in the Inquisition's administration. For an industry so closely associated with the local *converso* community, it was undoubtedly just as important to curry favor with the broader public by projecting the image of a brotherhood passionately devoted to Christian ideals.

The evidence is circumstantial, to be sure, but it strongly suggests that the silk weavers of Toledo had been motivated by risks of suspicion and persecution to seek refuge beneath the protective mantle of the Virgin of the Rosary. Of all lay brotherhoods—and there were at least one hundred in Toledo by 1549—there could not have been a more prudent or obvious choice.[49] The Dominicans were the most outspoken advocates of the rosary and its confraternity, but perhaps more important, the instrument itself was a weekly, systematic rehearsal of the basic prayers and Mysteries of the Christian faith. The recitation of the rosary was thus a potent countermeasure to heresy. Its fundamental prayers—the "Ave Maria" and the "Pater noster"—were key in that regard. Indeed, by the 1540s Toledan inquisitors were testing accused heretics on the basic tenets of the Catholic faith by asking them to recite the "Ave Maria," "Pater noster," Apostle's Creed, "Salve Regina," and Ten Commandments in Castilian.[50]

In the sixteenth and seventeeth centuries, the use of the rosary as a defense against heresy became widespread. The case of late-sixteenth-century Brazil is representative. There, in 1586, missionaries were instructed "to create Confraternities of the Rosary for Indians and Africans in order to encourage piety and sound doctrine among new converts."[51] The status of the rosary as a

protective device against heresy and heretics remains with us today, as Catholics rehearse the story of St. Dominic receiving the rosary from the Virgin to combat the Albigensians in the thirteenth century. That story, as we saw in chapter 6, drew special emphasis following the victory of the Holy League against the Turkish infidels at Lepanto—a victory against heretics that was attributed to the prayers of rosary confraternities who were in procession on the first Sunday in October 1571.

Advocation of the rosary was one way the silk weavers might have sought to raise their profile as honest and devout Christians. Patronage of the Dominican convent of San Pedro Mártir was another. The latter was important since the favor of the Dominicans, whose support of the local tribunal was crucial, would have been imperative for anyone seeking an intervention in a conflict that involved the Holy Office. Chantbooks, altarpieces, endowed Masses, and other luxury items were expensive, to be sure. But the extraordinary expenses they entailed were a certain bargain compared with the penalties that could be imposed by the Inquisition. Those could range from simple fines, to the confiscation of goods and properties, to life sentences of wearing shameful penitential garments, and, in extreme cases, to "relaxation" by fire.[52] What is more, the stigma of condemnation could be far worse than the material cost. Although one might conceivably escape debt, one would never fully blot out the transgression itself. As Henry Kamen has noted: "Infamy was beyond doubt the worst punishment imaginable in those times. In the ordinary criminal courts, humiliating punishments that brought public shame (vergüenza) and ridicule were feared more than the death sentence, since they ruined one's reputation for ever in the local community and brought disgrace on all one's family and relatives."[53]

Fines collected from the children and grandchildren of silk masters in 1495 (see appendix D) reflect the hereditary responsibility for crimes against the church that affected the Toledo silk trade. Monetary punishments and sullied reputations were passed along from one generation to the next in such a way that any trade or industry with too many blighted souls among its ranks could soon find its business interests severely compromised. By the turn of the sixteenth century, the silk weavers of Toledo likely found themselves in just that predicament. Their celebration of the rosary and patronage of the Dominican convent of San Pedro Mártir must be viewed against those circumstances. For only then does one realize that their activities were geared not only toward reaping spiritual rewards in the hereafter but also toward preserving their interests and quality of life in the temporal world—in the here and now.

Although not donor portraits in the strictest sense, the recurring images of "The Knight of Cologne" (see fig. 10) in the Rosary Cantoral and its companion manuscripts served in one respect as a reminder to the friars of San Pedro Mártir that the silk weavers of Toledo had furnished them with these books for the Mass and Office. That was more certainly the case with the emblem of the

confraternity that marks every surviving exemplar—the emblem of the Five Wounds and the inscription "Miserere Mei," which together create a symbolic representation of the rosary itself. It seems more significant now that these are generally displayed on white cloths that may represent the silk weavers' handiwork (see fig. 12). Just as the images of Hercules and Dürer's *Das Meerwunder* projected a sense of place through civic iconography (see chapter 5), these images of the "The Knight of Cologne" and the Five Wounds projected a semblance of the brotherhood's trade and, more important, their concomitant identification with Christian ideals. That was kept in sight, and therefore in mind, every time the friars opened a book to celebrate the liturgy.

The Knight of Cologne Revisited

Assembled around the turn of the sixteenth century, the Rosary Cantoral and its companion books mark the earliest identifiable stage of charity from a confraternity whose role in the development of San Pedro Mártir extended into the eighteenth century (see chapter 2). The historical circumstances of the period during which they were compiled (probably between 1490 and 1510 or so, see chapter 1) invite a final look at the iconography that provided the first major break toward uncovering the cultural context of these manuscripts—the illumination depicting "The Knight of Cologne" (see fig. 10). As we saw in chapter 3, the miracle of "The Knight of Cologne" had a double resonance with the silk weavers of Toledo. It was at once a miracle related to the founding of the first rosary confraternity in Cologne and a miraculous act of weaving by the Virgin Mary herself. "The Knight of Cologne" is not the only example of a weaving miracle attributed to the Madonna. Alfonso's *Cantigas de Santa María* (*Songs of Holy Mary*) describes a curious marvel in which the Virgin created (through the agency of silkworms) a cloth of such beauty that the silk weaver for whom it was made invited all "to see how the Mother of God could weave with miraculous skill."[54] Holy Mary, Mother of God was not only the creator and patroness of the rosary, she was a weaver herself. Thus, for the silk masters of Toledo, the illuminations featuring "The Knight of Cologne" in at least six of the chantbooks compiled for San Pedro Mártir celebrated in one splendid image both the hallowed tradition of their devotional instrument and a miraculous moment in the history of their profession as well.

But beyond that, "The Knight of Cologne" is also a story about conversion and reconciliation. Indeed, the miracle is as much about the conversion of the knight who wanted to seek revenge as it is about the killer who was protected by an apparition of the weaving Virgin. So are many of the stories after which it was modeled. In the earliest prototype for "The Knight of Cologne," the thirteenth-century Cistercian exemplum titled "The Virgin Mary's Chaplet of Roses," particular emphasis is given to the conversion of the mercenaries who wanted to

rob the prior and leave him for dead. Not only is the prior spared by an apparition of the Virgin Mary, but the mercenaries are converted in a dramatic way, begging the prior to allow them to enter the Cistercian Order. The prior honors their wishes, and the story ends with the benediction of an abbot who welcomes them into religious life: "the abbot, blessing the men and amicably receiving them into the brotherhood of his order, gave thanks to God and his Blessed and Glorious Mother, through whom the souls of these men—which the Devil had endeavored to take away—were restored to God."[55] Likewise, St. Vincent Ferrer, preaching on the twenty-fifth Sunday after Pentecost, closed his sermon on the merchant saved from certain death with a line about the fate of his would-be attackers: "I believe that the highwaymen were converted by this miracle."[56] This was not a mere afterthought for Ferrer, a master of rhetoric and delivery. Rather, he was driving a point home—the Virgin not only protects her faithful; so powerful is she that even the most vile among us can be converted.

Conversion—the theme is at the heart of "The Knight of Cologne" in the Rosary Cantoral. And with that understanding, the miracle's full significance to the rosary confraternity of Toledo becomes evident. Its meaning is couched in the history of the rosary, in the profession of silk weaving, and in the crisis the Inquisition had galvanized for the *conversos* of Toledo upon its arrival in 1485. The last of these is imbedded at the broadest and deepest layer of the cultural history that gave rise to the Rosary Cantoral and its related *cantorales*. But at least one trace of that layer has risen to the surface: St. Paul—Christianity's most famous convert—is shown pointing directly to the miracle of "The Knight of Cologne" in the illumination of Beinecke Ms. 794 (see fig. 4).[57] There he is clearly labeled with a banderole reading "San Pablo." Above him, appropriately, is St. Andrew—the patron saint of the Dominican church in Cologne where Jakob Sprenger founded his brotherhood in 1475 (see fig. 30).

If the Rosary Cantoral is the most complete and beautifully preserved of the magnificent chantbooks that once belonged to San Pedro Mártir, it would be fair to say that the single Beinecke leaf is the most humble, even the least attractive. Art historians and musicologists alike passed it by without much of a second thought, and with good reason: the decoration is crude and the music not particularly interesting. But there, in synoptic form, encoded in the images of St. Andrew, St. Paul, and the miracle of "The Knight of Cologne," are the answers to critical questions about the origin and cultural context of these artifacts from early Renaissance Toledo. It seems fitting that the original chant on this palimpsest, "Sacerdos et pontifex," was performed as an antiphon for the Magnificat (Luke 1:46–55). For here at the end, to paraphrase that great Marian canticle, the most humble is exalted (Luke 1:52).

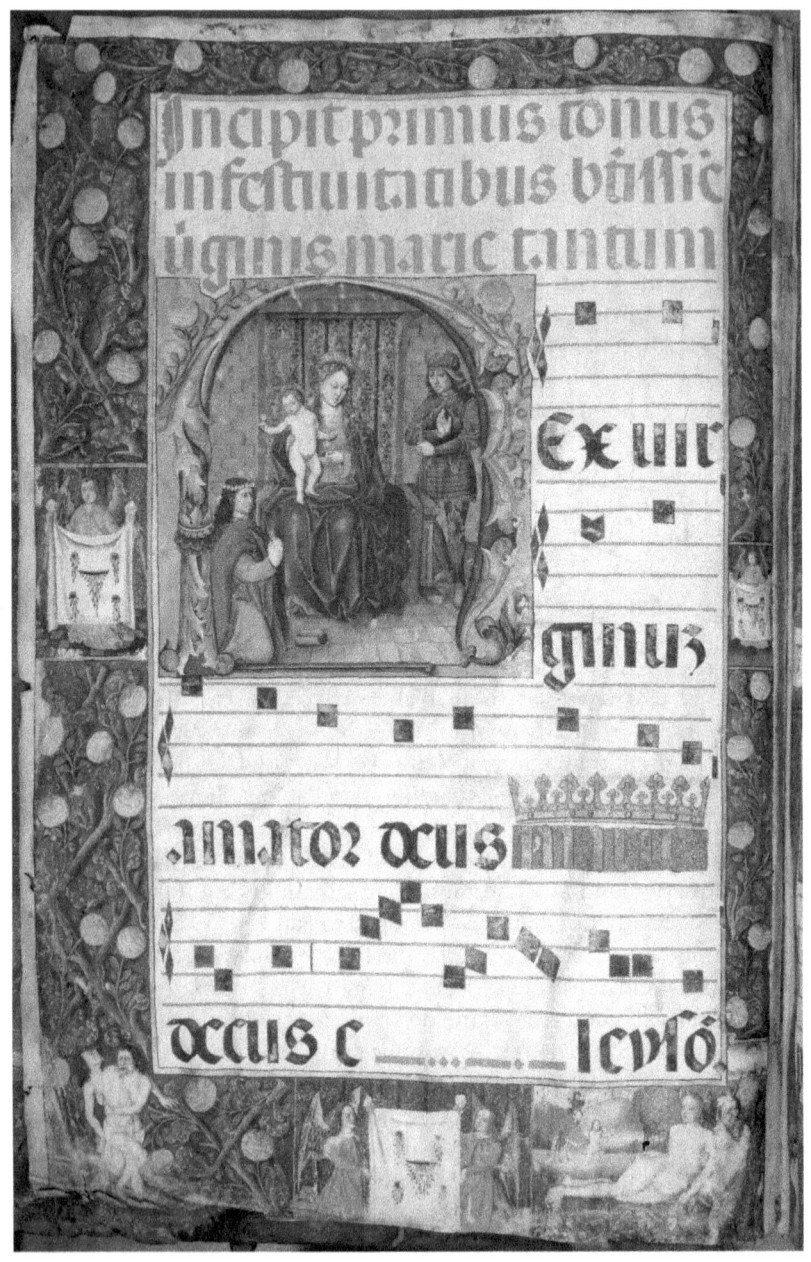

Figure 1. The Rosary Cantoral (Kyriale of San Pedro Mártir, Toledo, ca. 1490–1510). New Haven, CT, Yale University, Beinecke Rare Book and Manuscript Library. Ms. 710, fol. 1v.

Figure 2. The Rosary Cantoral (Kyriale of San Pedro Mártir, Toledo, ca. 1490–1510). New Haven, CT, Yale University, Beinecke Rare Book and Manuscript Library. Ms. 710, fol. 2.

Figure 3. Leaf from a Gradual of San Pedro Mártir, Toledo, ca. 1490–1510. New Haven, CT. Private collection, courtesy of the owner.

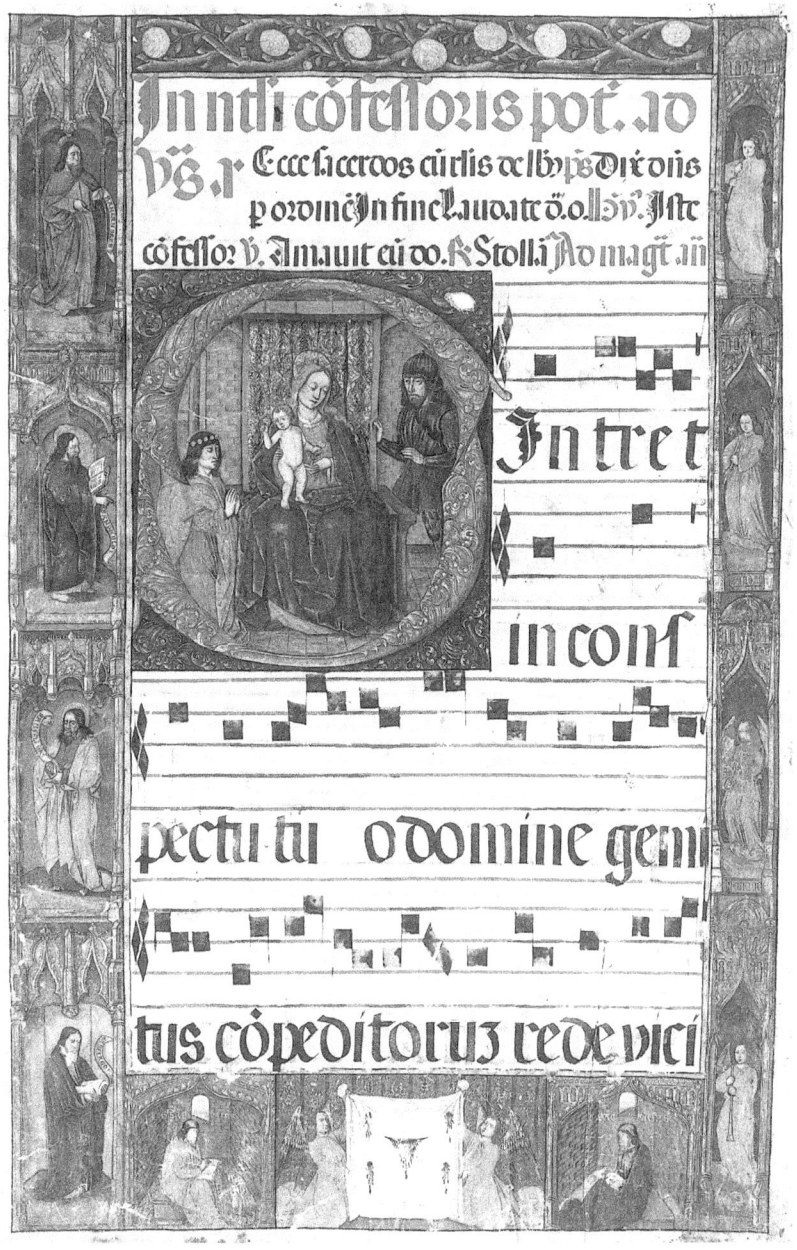

Figure 4. Leaf (palimpsest) from a Gradual (originally from an Antiphoner) of San Pedro Mártir, Toledo, ca. 1490–1510. New Haven, CT, Yale University, Beinecke Rare Book and Manuscript Library. Ms. 794.

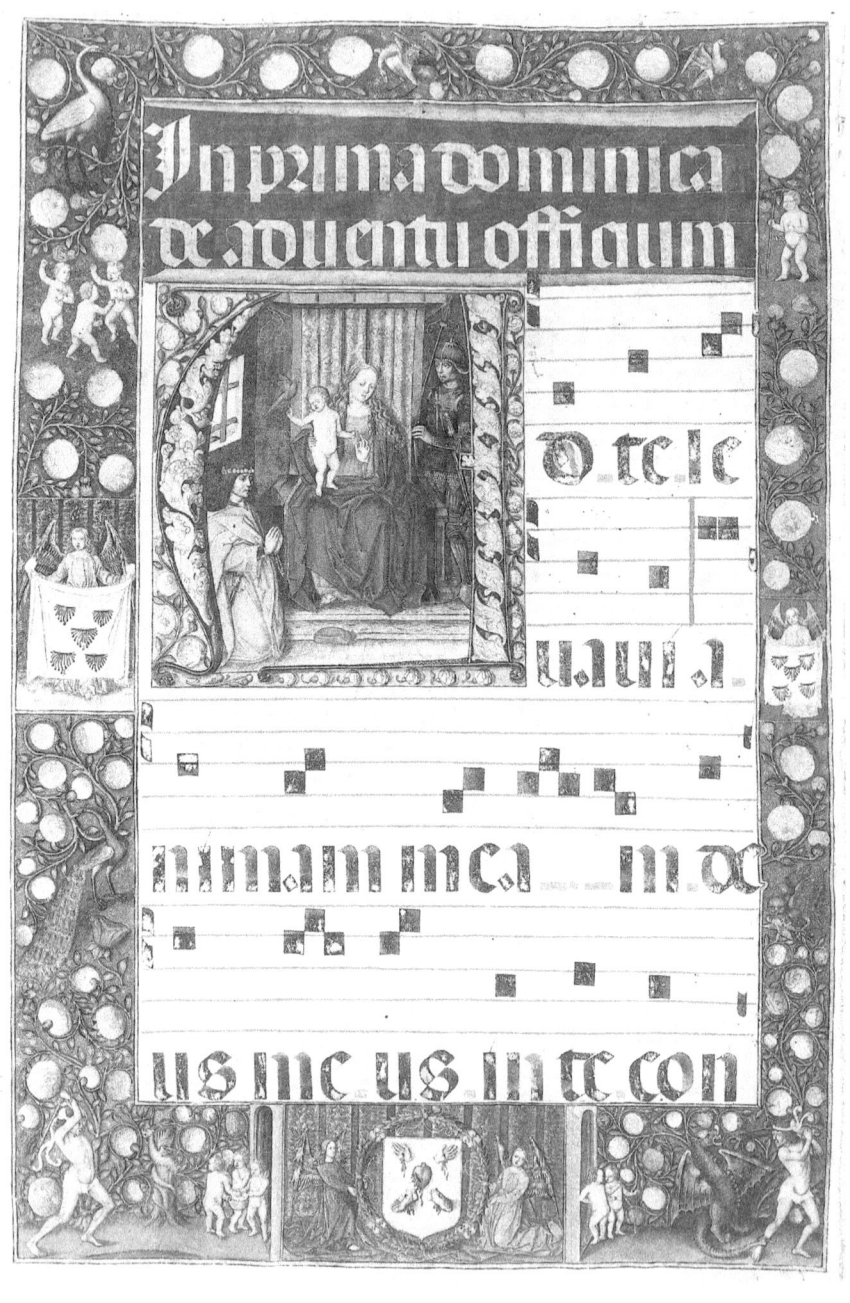

Figure 5. Leaf from a Gradual of San Pedro Mártir, Toledo, ca. 1490–1510. New York, NY, the Pierpont Morgan Library. Ms. M887-1.

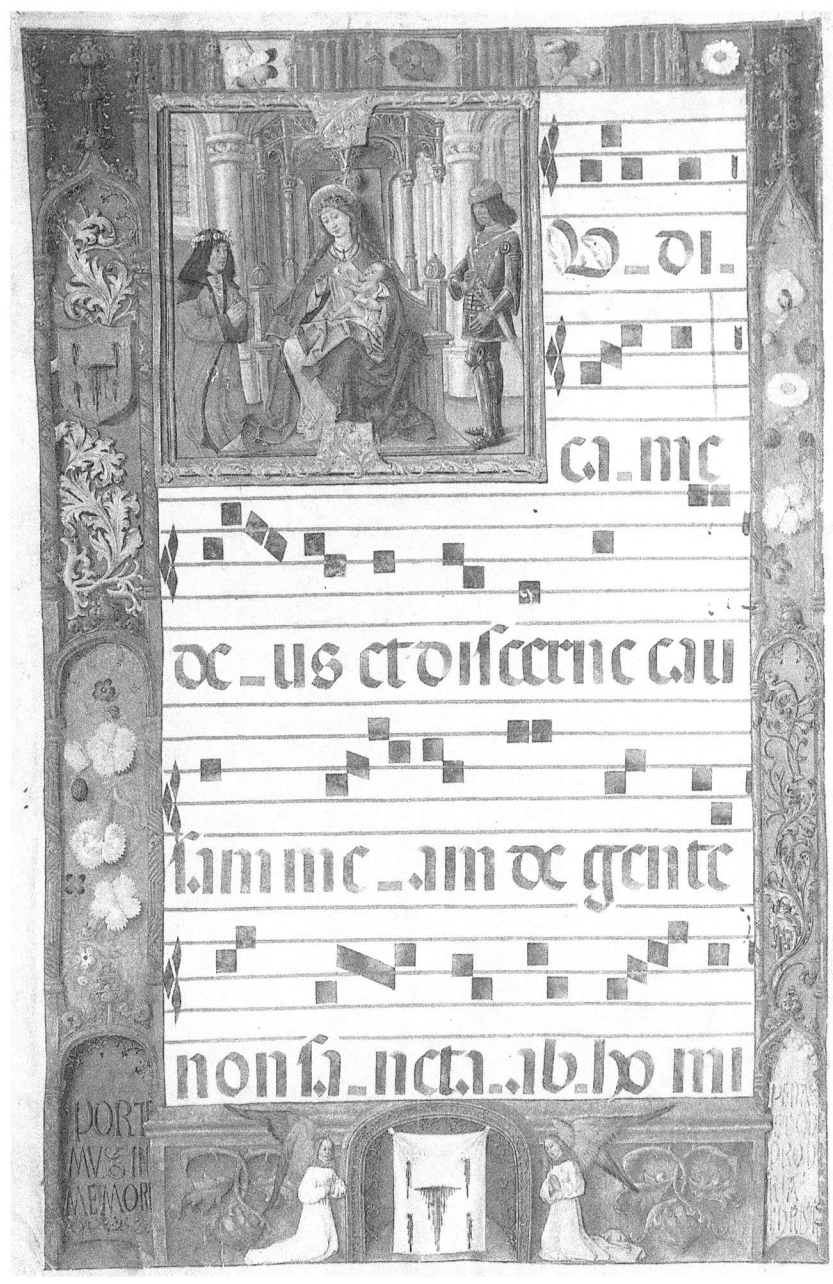

Figure 6. Leaf from a Gradual of San Pedro Mártir, Toledo, ca. 1490–1510. Los Angeles, CA, the J. Paul Getty Museum. Ms. 61 (95.MH.50).

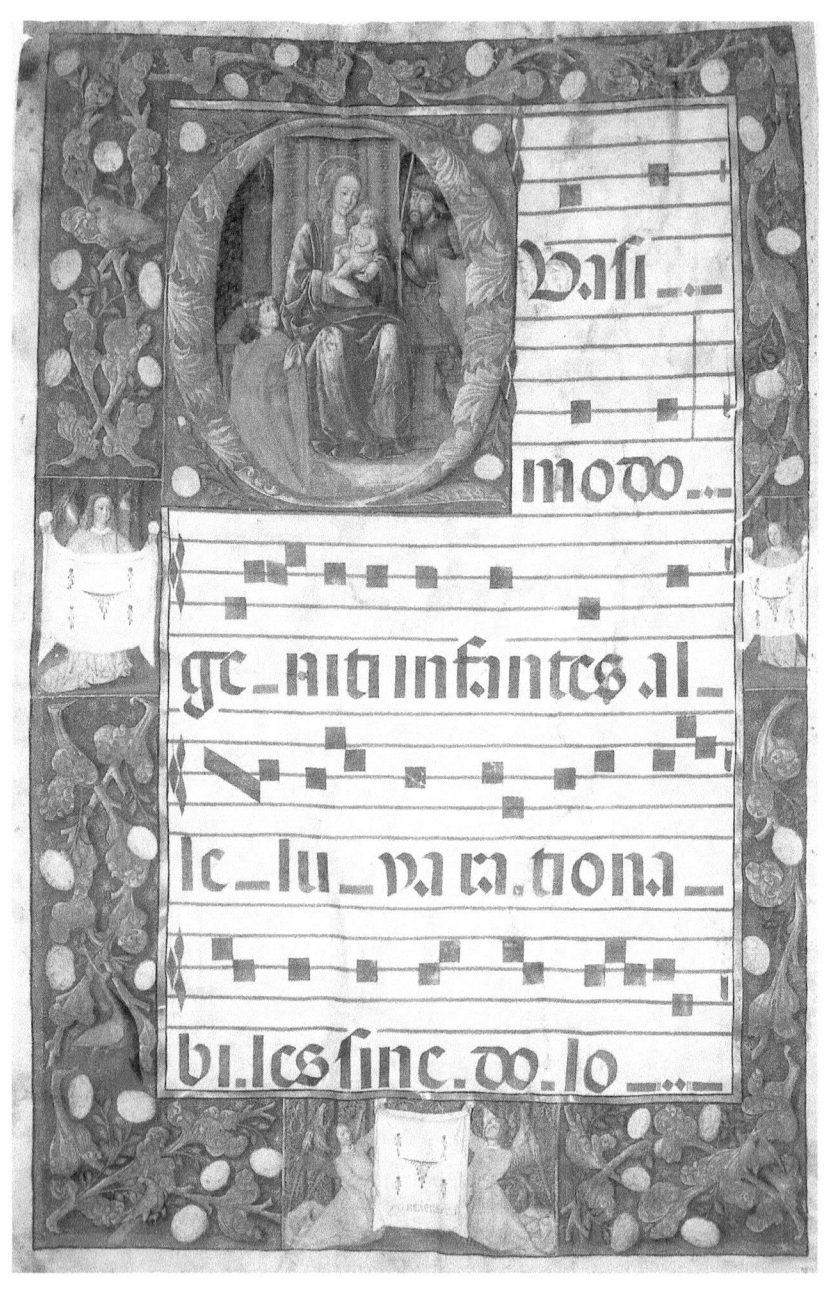

Figure 7. Leaf from a Gradual of San Pedro Mártir, Toledo, ca. 1490–1510. Private collection, courtesy of Dr. Jörn Günther, Antiquariat, Hamburg.

Figure 8. Fragment from a sixteenth-century *cantoral* of San Pedro Mártir, Toledo, with "Ave Ma[ria]." Ocaña (Spain), Convento de Santo Domingo, s.n.

Figure 9. Fragment from a sixteenth-century *cantoral* of San Pedro Mártir, Toledo, with "Ave Maria Gra[tia plena]." Ocaña (Spain), Convento de Santo Domingo, s.n.

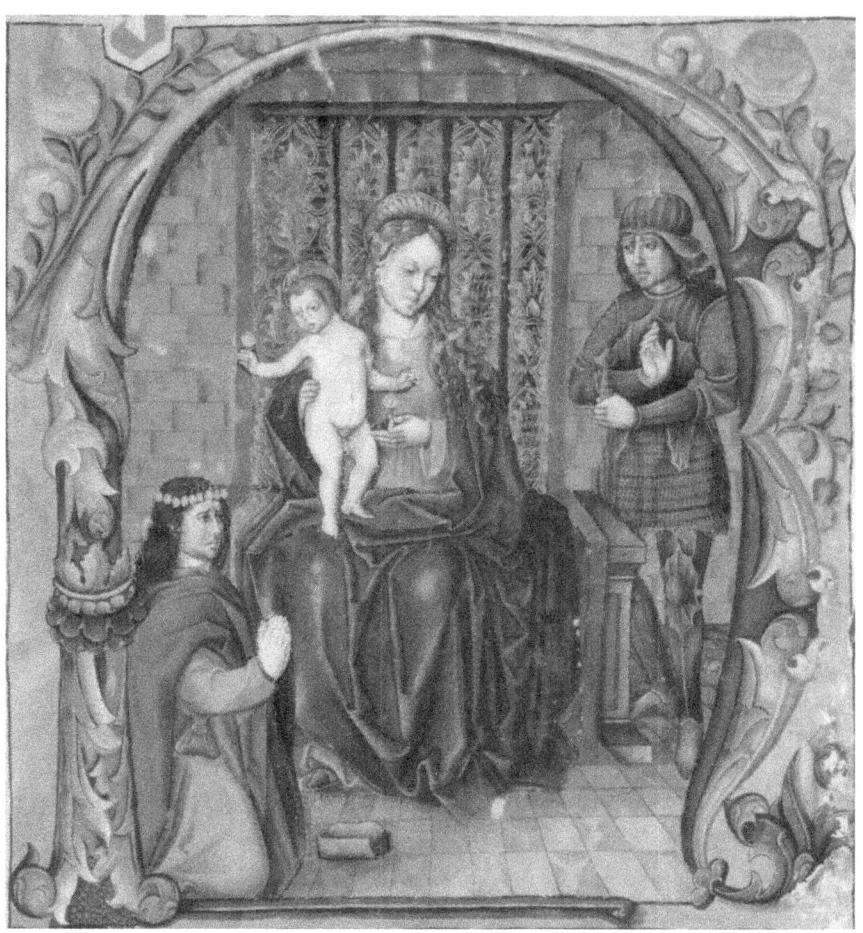

Figure 10. Inhabited initial "R" with the Madonna and Child ("El Cavaller de Colunya"). The Rosary Cantoral (Kyriale of San Pedro Mártir, Toledo, ca. 1490–1510). New Haven, CT, Yale University, Beinecke Rare Book and Manuscript Library. Ms. 710, fol. 1v (detail).

Figure 11. Francisco Domènech (Spanish, b. ca. 1460, d. aft. 1494), *The Fifteen Mysteries and the Virgin of the Rosary* (1488). Engraving. 16 × 12 in. (40.6 × 30.5 cm). The Metropolitan Museum of Art, 1957 (57.526). Image © The Metropolitan Museum of Art.

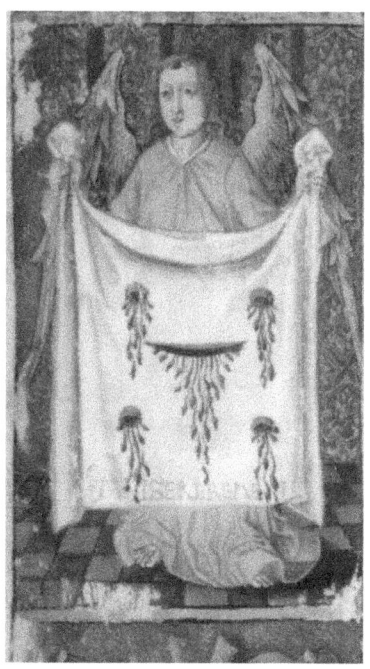

Figure 12. Confraternity emblem of the Five Wounds with the inscription "Miserere Mei." The Rosary Cantoral (Kyriale of San Pedro Mártir, Toledo, ca. 1490–1510). New Haven, CT, Yale University, Beinecke Rare Book and Manuscript Library. Ms. 710, fol. 1v (detail).

Figure 13. Frontispiece. Anonymous, *Trellat sumariament fet dela bulla o confraria del psaltiri o roser*. Valencia, 1546. Barcelona, Biblioteca de Catalunya, Top. 6-VI-39.

Figure 14. Frontispiece. Bartolomé de Castro, *Questiones logicae*. Toledo, 1513. Madrid, Biblioteca Nacional, R/3355.

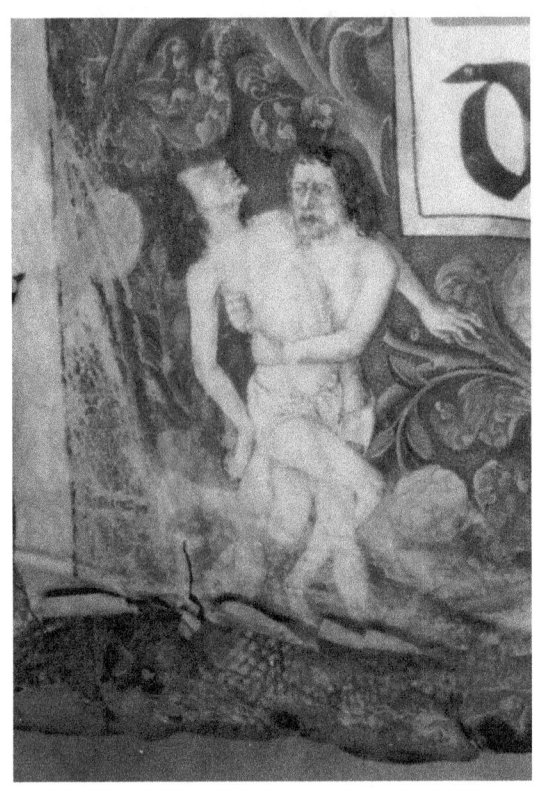

Figure 15. Hercules and Antaeus. The Rosary Cantoral (Kyriale of San Pedro Mártir, Toledo, ca. 1490–1510). New Haven, CT, Yale University, Beinecke Rare Book and Manuscript Library. Ms. 710, fol. 1v (detail).

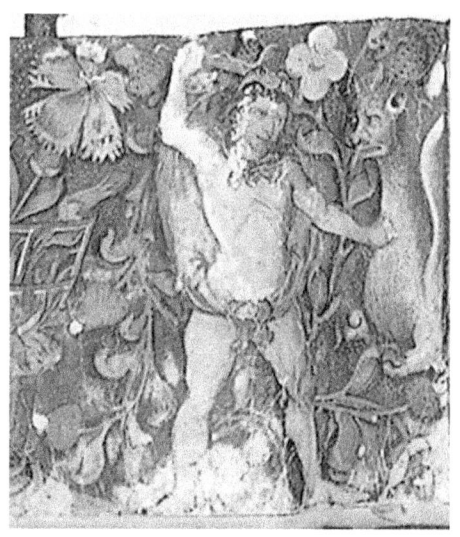

Figure 16. Hercules and the Hesperian dragon. The Rosary Cantoral (Kyriale of San Pedro Mártir, Toledo, ca. 1490–1510). New Haven, CT, Yale University, Beinecke Rare Book and Manuscript Library. Ms. 710, fol. 2 (detail).

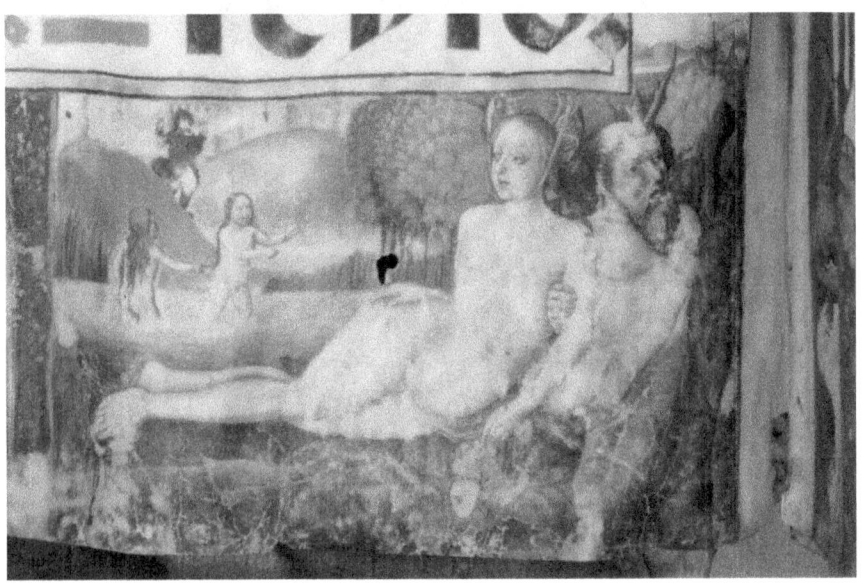

Figure 17. Border painting after Albrecht Dürer's *Das Meerwunder* (The Sea Monster). The Rosary Cantoral (Kyriale of San Pedro Mártir, Toledo, ca. 1490–1510). New Haven, CT, Yale University, Beinecke Rare Book and Manuscript Library. Ms. 710, fol. 1v (detail).

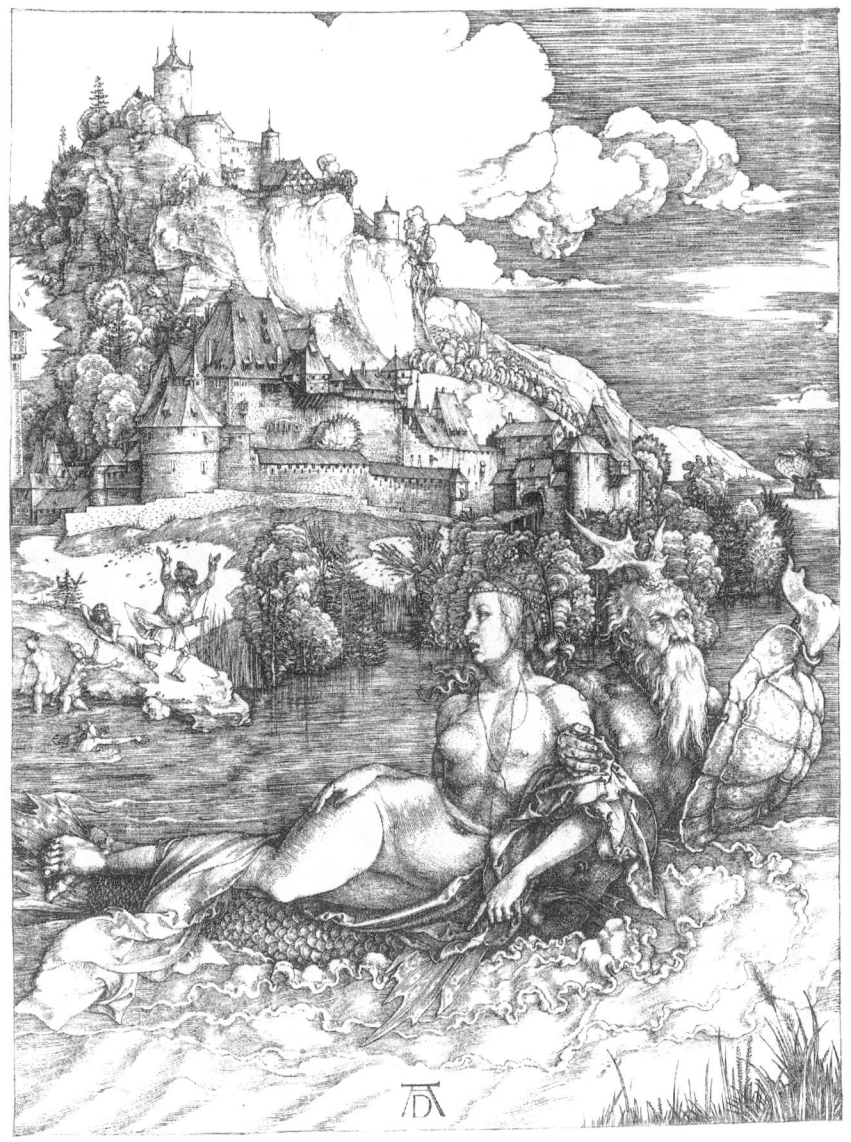

Figure 18. Albrecht Dürer, *Das Meerwunder* (The Sea Monster), ca. 1498. New Haven, CT, Yale University Art Gallery, Fritz Achelis Memorial Collection. Gift of Frederic George Achelis, B.A. 1907.

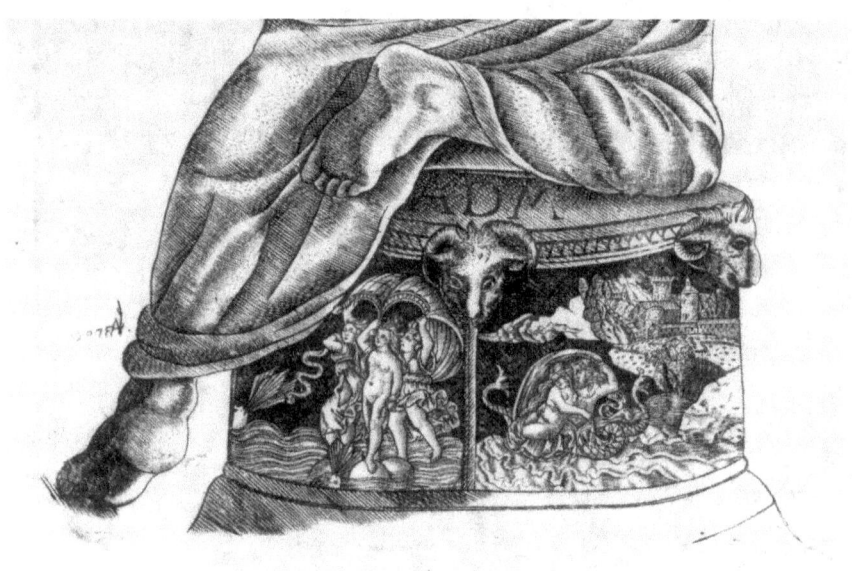

Figure 19. Maenad (detail of base). Engraving by Meister FA. 1507. Hind.1 Photo: Volker-H. Schneider. Kupferstichkabinette, Staatliche Museen zu Berlin, Berlin, Germany. Bildarchiv Preussischer Kulturbesitz / Art Resource, NY.

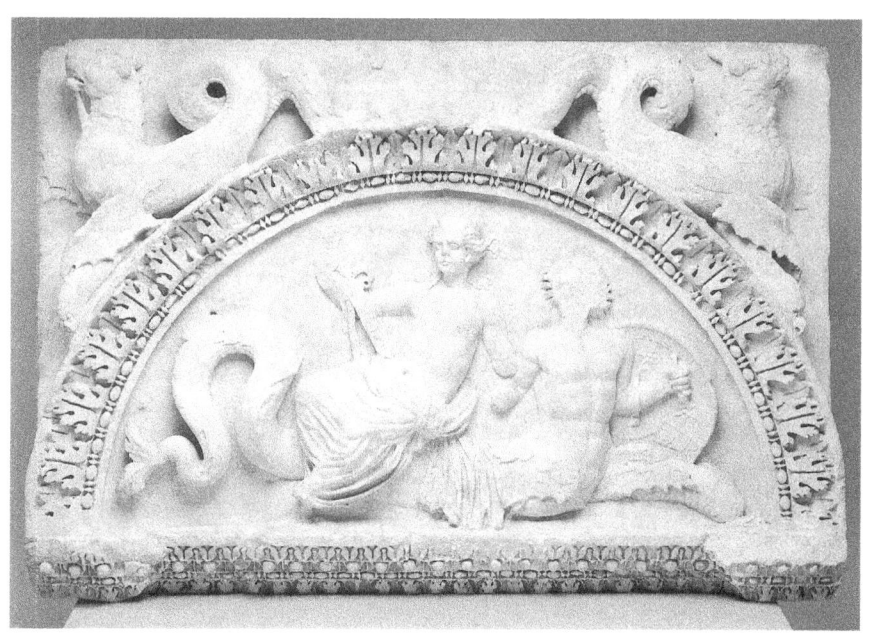

Figure 20. Roman, *Relief with lunette showing Nereid riding on a Triton* (Mid-Imperial, Trajanic period, first quarter of second century AD), marble, overall: 46 1/2 × 69 in. (1118.1 × 175.3 cm.). The Metropolitan Museum of Art, Classical Purchase Fund, 1993 (1993.11.2). Image © The Metropolitan Museum of Art.

Figure 21. Attic red-figure *stamnos* by Oltos as painter and Pamphaios as potter. London, British Museum, E 437.

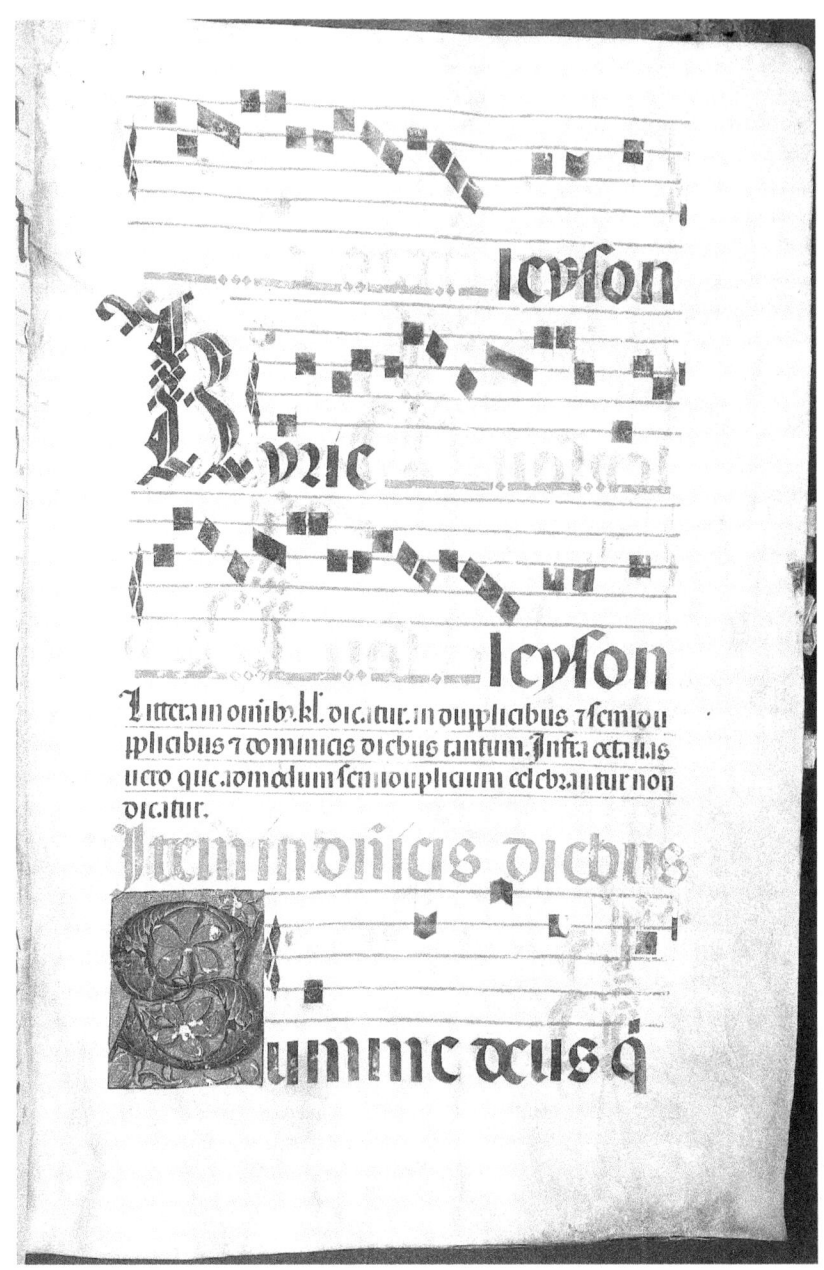

Figure 22. An ornamental *tocus* and *uncus* in succession over "Summe deus." The Rosary Cantoral (Kyriale of San Pedro Mártir, Toledo, ca. 1490–1510). New Haven, CT, Yale University, Beinecke Rare Book and Manuscript Library. Ms. 710, fol. 5.

Figure 23. Mensural chant for the Gloria. The Rosary Cantoral (Kyriale of San Pedro Mártir, Toledo, ca. 1490–1510). New Haven, CT, Yale University, Beinecke Rare Book and Manuscript Library. Ms. 710, fol. 54.

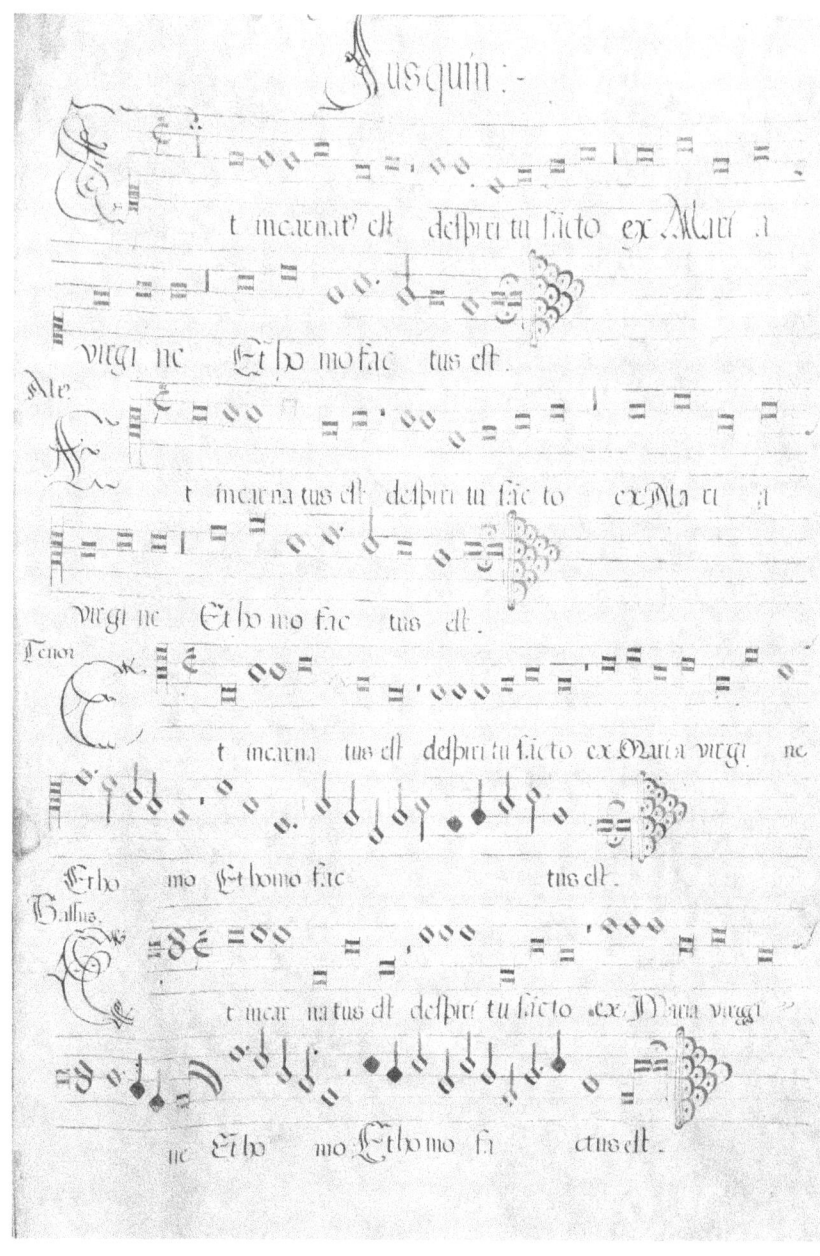

Figure 24. Josquin Desprez, "Et incarnatus est" from the *Missa sine nomine*. The Rosary Cantoral (Kyriale of San Pedro Mártir, Toledo, ca. 1490–1510). New Haven, CT, Yale University, Beinecke Rare Book and Manuscript Library. Ms. 710, fol. 99.

Figure 25. Anonymous, "Et incarnatus est" on "L'homme armé." The Rosary Cantoral (Kyriale of San Pedro Mártir, Toledo, ca. 1490–1510). New Haven, CT, Yale University, Beinecke Rare Book and Manuscript Library. Ms. 710, fol. 101v.

Figure 26. The name Mary (Mariam) highlighted in the Gloria trope "Spiritus et alme." The Rosary Cantoral (Kyriale of San Pedro Mártir, Toledo, ca. 1490–1510). New Haven, CT, Yale University, Beinecke Rare Book and Manuscript Library. Ms. 710, fol. 32v.

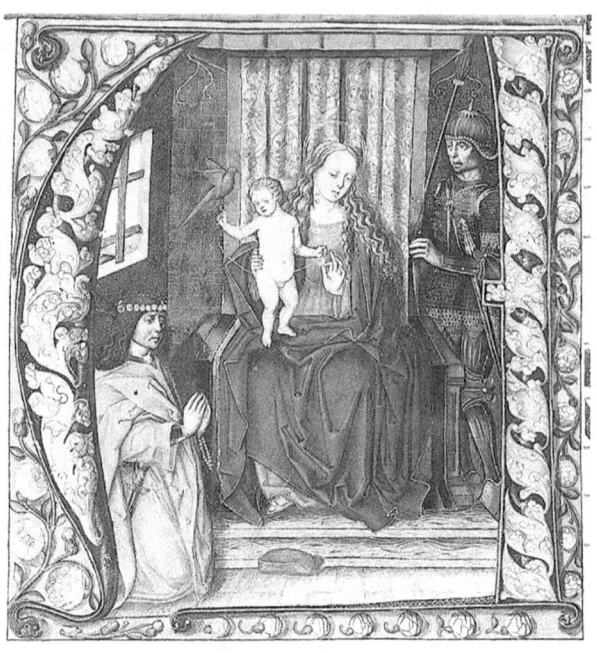

Figure 27. Inhabited initial "A" with the Madonna and Child ("El Cavaller de Colunya"). Leaf from a Gradual of San Pedro Mártir, Toledo, ca. 1490–1510. New York, NY, the Pierpont Morgan Library. Ms. M887-1 (detail).

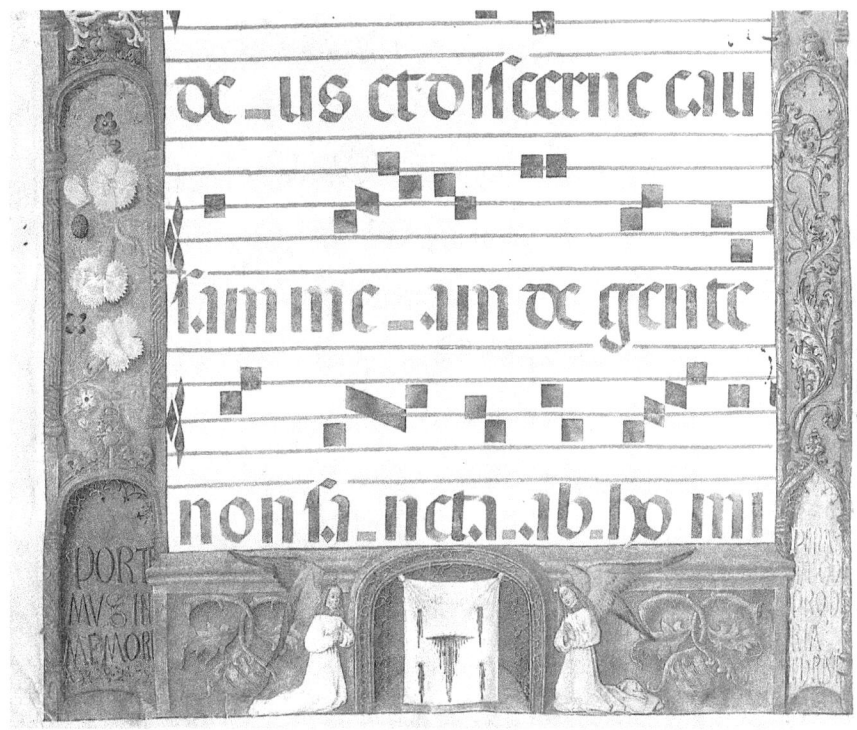

Figure 28. Inscriptions "Portemus in memoria" (left) and "Penas et obprobia Christi" (right) from the Office of the Passion. Leaf from a Gradual of San Pedro Mártir, Toledo, ca. 1490–1510. Los Angeles, CA, the J. Paul Getty Museum. Ms. 61 (95.MH.50) (detail).

Figure 29. Lifeless finch gripped by predator owl (after Martin Schongauer?). Leaf from a Gradual of San Pedro Mártir, Toledo, ca. 1490–1510. New York, NY, the Pierpont Morgan Library. Ms. M887-1 (detail).

Figure 30. St. Andrew (above) and St. Paul pointing to "The Knight of Cologne" ("El Cavaller de Colunya"). Leaf (palimpsest) from a Gradual (originally from an Antiphoner) of San Pedro Mártir, Toledo, ca. 1490–1510. New Haven, CT, Yale University, Beinecke Rare Book and Manuscript Library. Ms. 794 (detail).

Epilogue

The end of chapter 7 reflected on the richness of meaning in just a handful of icons on a single leaf of vellum: the image of "The Knight of Cologne" along with its adjunct images of St. Paul and St. Andrew. The idea of such heavily weighted icons is not lost on us today. At least, it shouldn't be. We point and click on libraries of information stored behind images every day. Indeed, our computer screens are strewn with them. Like the image of "The Knight of Cologne," Albrecht Dürer's *Das Meerwunder*, or the emblem of the Five Wounds, every icon is a link to some part of our cultural memory.

As a society, whether we are musicologists, art historians, religious scholars, bankers, teachers, lawyers, or whatever, we have never been more disposed to understand and appreciate illuminated music manuscripts than we are now. Sound odd? Think about it. Not since the age of illuminated manuscripts in the Middle Ages and the Renaissance have human beings interacted so intimately with sounds, images, and texts accessible through the written page. In their case it was vellum or parchment; in ours it is electronic screens. Click on any news Web site, such as that for CNN or *The New York Times*, for instance, and you will be transported to a place that gives the text to a story, a collection of images (some of which are related to the story, others that are not), corporate logos as markers of identity, and even soundclips. Every one of these finds a parallel in the texts, illuminations, emblems, and music in the Rosary Cantoral. It would be interesting to see a scholar come across a digital file of today five hundred years from now. What would he or she make of that Web site as a cultural artifact?

With a little prodding, it becomes easier to see parallels in the modes of cultural production—how the illuminated chantbook of yesteryear is not unlike the creative Web site of today. More challenging, perhaps, are questions regarding whether all of the intricate details and histories behind the images, texts, and music in the Rosary Cantoral discussed throughout this book were actually comprehended by those who "interfaced" with them (to borrow an apposite term). My guess is no—at least, not entirely. But such is the nature of cultural artifacts, even those designed to project a semblance of identity. Take something as quotidian as the U.S. dollar bill. In the United States, citizens recognize the dollar bill as a currency particular to the country without paying much attention to the myriad symbols that adorn it, all of them meaningful and representative of the people who

exchange it every day.¹ Although few may notice or care to understand the meaning of individual symbols—the thirteen arrows, the thirteen stars, the thirteen steps on the pyramid, for instance—they are viewed in toto as a projection of American identity. Thus, it comes as no surprise that when a certain business in the United States recently began accepting foreign currency for its goods, there was an uproar.² Likewise, the emblem of the Five Wounds was widely recognized in Toledo as a marker of identity for its local rosary confraternity. I suspect, however, that the average "man on the street" would have been hard-pressed to explain precisely why.

So too, the Toledan friars chanting Aquitanian texts and melodies from the Rosary Cantoral probably thought about it as much as any American singing "The Star-Spangled Banner" at a baseball game ponders the origins of that tune in a mid-eighteenth-century English gentleman's club.³ Yet change the language of the anthem, as some Hispanic Americans did in 2006, or stray too far from an "acceptable" performance, as Jimi Hendrix did at Woodstock in 1969, and there will be trouble.⁴ In spite of its English origins, "The Star-Spangled Banner" is a marker of American identity in every way that Toledo's Aquitanian chants were markers of theirs.

And what about Hercules and his enchanted cave? Toledans probably rehearsed that story in much the same way Texans talk about Davy Crockett and his feats at the Alamo—a topic with which Euhemerus would have had a field day!⁵ Depending on one's point of view, that argument of making and rehearsing myths could extend to any one of our world religions today. Without belaboring the point any further, it suffices to say that we are surrounded by symbols and cultural artifacts with which we identify. In many cases we cannot sufficiently explain how or why. Yet each one of those artifacts has a history, and with enough digging we can sometimes find its root.

When I began my study of the Rosary Cantoral about ten years ago, the big question was pretty simple: Where had this manuscript come from? In the course of answering that question, it became clear that, while determining its origins was of import, there was much greater value in coming to terms with it as a rare witness to music, art, and liturgy in early Renaissance Toledo. In spite of all the documentary lacunae, as far as cultural artifacts go, one could hardly have hoped for better. Not only is it eminently attractive as a physical object, its rituals and meaning are couched in some of the deepest layers of social history. I hope some of those layers have been brought out to the reader in these chapters.

But now, reflecting back on the journey at its end, I have come to see the Rosary Cantoral as something more. As I worked on unlocking its secrets and coming to terms with its cultural content, the world changed. Suddenly, and violently, on the morning of September 11, 2001, we were plunged into a new world that is much closer to the environment that gave rise to this chantbook than we had previously known. In the paranoia of the years that ensued, as I wrote about the *conversos* in Toledo, I noticed startling parallels in the rash of hate crimes, racial profiling, and suspicion levied against Arab Americans and

Muslims in the United States. Once again, perception is the key. Thus, when Keith Ellison, the first Muslim elected to the United States Congress, took the ceremonial oath of office with his hand placed on the Quran on January 4, 2007, it was widely publicized that the Quran had been borrowed from the United States Library of Congress and that it had once belonged to Thomas Jefferson, the revered third president of the United States who is popularly credited as the author of the Declaration of Independence.[6]

Centuries-old documents of rosary propaganda, dutifully photocopied in 1999 and 2000 and filed away in boxes for future reference, also came to life, sometimes ominously so, as I happened across Web sites posted on the Internet (our modern counterpart to the late-fifteenth-century printing press) that exhorted all faithful Christians to pray the rosary to defeat the Muslim threat in a "post-9/11" world. According to one site, maintained by These Last Days Ministries in Lowell, Michigan: "The Rosary defeated the Muslims at the Battle of Lepanto. . . . In this year 2006, let us pray the Rosary continuously till the Muslim terrorists are defeated again."[7] Elsewhere, the organization exhorts its followers to "Join the Rosary Crusade today to stop terrorism" and to "Save America the Rosary way."[8]

As These Last Days Ministries waged a new crusade and helped revive dormant prejudices from their seat in Lowell, the large Arab American community of Dearborn, Michigan, about 140 miles southeast of Lowell, took a more positive approach. Dearborn boasts what may be the largest Arab American population in the United States. It seems fitting, then, that there, on May 5, 2005, the Arab American National Museum officially opened its doors. Touted as the nation's first museum devoted to Arab American history and culture, the 38,500-square-foot building was placed in the heart of downtown Dearborn, right across from City Hall.[9] Planning for the museum had begun prior to September 11, 2001, but its goal of "bringing the voices and faces of Arab Americans to mainstream audiences . . . to dispel misconceptions about Arab Americans and other minorities" can only have intensified after that.[10] What cultural artifacts will survive from that museum five hundred years hence? What will future cultural historians say about them, or the museum they belonged to, or the circumstances faced by the people who made them, or even those who thought it was important to foreground the Arab American contribution to U.S. cultural history at the dawn of the twenty-first century?

Throughout this book, I have sought to characterize the Rosary Cantoral as a cultural artifact—a historian's valuable witness to the past. At least that is how I saw it on the evening of September 10, 2001. After that, its greatest value, perhaps its true meaning as an object of history, came to the fore as a monument to how little things have changed. Like the story of "The Knight of Cologne," which was an updated version of an archetypal story that spanned centuries, the story of the Rosary Cantoral is only a surface manifestation of a timeless tale—one not so much about cultural artifacts themselves as about the prejudices and outright oppression that sometimes create them.

Appendices

Appendix A: Details Regarding the Mystery of the Rosary Cantoral and Its Related Leaves

A.1: Nine Leaves Connected to Arthur Rau

1. Detroit, Detroit Public Library, Burton Historical Collection
 Gradual leaf
 Incipit: Nos autem gloriari
 Liturgical assignment: Introit for the solemn evening Mass on Maundy Thursday
 Illumination: Large inhabited initial "N" depicting the "Miracle of the Gentleman of Cologne"; emblems with five bleeding wounds and inscription "MISERERE MEI"
2. Los Angeles, J. Paul Getty Museum, Ms. 61
 Gradual leaf
 Incipit: Judica me deus
 Liturgical assignment: Introit for the Mass on Passion Sunday
 Illumination: Large inhabited initial "J" depicting "Gentleman of Cologne"; emblem with five bleeding wounds and inscription "MISERE MEI" [*sic*]
3. New Haven, Yale University, Beinecke Rare Book and Manuscript Library, Ms. 794
 Palimpsest. Gradual leaf. Originally from an Antiphoner
 Incipit: Intret in conspectu tuo; originally Sacerdos et pontifex
 Liturgical assignment: Introit for a Mass of Two or More Martyrs out of Paschal time. Originally the antiphon preceding the Magnificat
 Illumination: Large historiated initial "S" depicting "Gentleman of Cologne"; emblems with five bleeding wounds and inscription "MISERERE MEI"

4. New York, Pierpont Morgan Library, M887-1
 Gradual leaf
 Incipit: Ad te levavi
 Liturgical assignment: Introit for the first Sunday in Advent
 Illumination: Large inhabited initial "A" depicting "Gentleman of Cologne"; two bas-de-page with scenes from the life of Hercules; emblems with five bleeding wounds and inscription "MISERERE MEI"
5. New York, Pierpont Morgan Library, M887-2
 Gradual leaf
 Incipit: Resurrexi et adhuc tecum
 Liturgical assignment: Introit for the Mass on Easter Sunday
 Illumination: Large inhabited initial "R" depicting the Resurrection; emblems with five bleeding wounds and inscription "MISERE MEI" [*sic*]
6. Jörn Günther and Bruce P. Ferrini, *Overlooking the Ages: A Private Exhibition of Illuminated Manuscripts, Miniatures and Printed Books* (October 1999), Cat. #28
 Gradual leaf
 Incipit: Quasi modo geniti infantes
 Liturgical assignment: Introit for the Mass on Low Sunday
 Illumination: Large inhabited initial "Q" depicting "Gentleman of Cologne"; emblem with five bleeding wounds and inscription "MISERERE MEI"
7. Last documented at the home of Norman Strouse, 1986
 Gradual leaf
 Incipit: Spiritus domini
 Liturgical assignment: Introit for the Mass on Whit Sunday (Pentecost)
 Illumination: Large inhabited initial "S" depicting the descent of the Holy Spirit; emblems with five bleeding wounds and inscription "MISERERE MEI"
8. Location unknown. Images deposited at Morgan and Beinecke
 Gradual leaf
 Incipit: Puer natus est
 Liturgical assignment: Introit for the Mass on Christmas Day
 Illumination: Large inhabited initial "P" depicting the Nativity; emblem with five bleeding wounds and inscription "MISERERE MEI"
9. Unrecovered leaf

A.2: Two Manuscripts Connected to Laurence Witten

1. New Haven, Yale University, Beinecke Rare Book and Manuscript Library, Ms. 710
 Kyriale. 103 fols. See the conspectus of chants and polyphony in appendix E.

Illumination: Fol. 1v–2, large inhabited initial "R" depicting "Gentleman of Cologne"; emblems with five bleeding wounds and inscription "MISERERE MEI," images from the life of Hercules, border painting after Albrecht Dürer's *Das Meerwunder*
2. New Haven, private collection
 Gradual leaf
 Text: [con]fido non erubescam [Incipit: Ad te levavi]
 Liturgical assignment: Introit for the first Sunday in Advent
 Illumination: Emblems with five bleeding wounds and inscription "MISERERE MEI"

A.3: Spanish Tropes and Melodies in the Rosary Cantoral (Beinecke Ms. 710)

1. Fol. 9 [Kyrie]
Pater excelse mariam preparans eleyson
Iesu benigne mariam consecrans eleyson
Spiritus alme mariam obumbrans
 1544 Granada, *Officia ad missas cantandum in festivitatibus sanctorum per annum secundum consuetudinem romane curie: atque etiam de novo additis juxta usum sancte granatensis ecclesie* (fol. 9) [Toledo]
2. Fol. 13 [Kyrie]
Kyrie cunctipotens domine miserator eleyson
Xpriste verbum caro factum de virgine eleyson
Kyrie te celebrantibus una in te sperantibus eleyson
 12 c. Montserrat, Biblioteca del Monasterio, Ms. 73 (fol. 7v) [Urgell? Toulouse?]
 13 c. Toledo, Biblioteca Capitular, Ms. 35-10 (fol. 117v) [Toledo]
 14 c. Madrid, Biblioteca Nacional, M. 1361 (fol. 180v) [Toledo]
 1544 Granada, *Officia ad missas* (fol. 198v) [Toledo]
3. Fol. 17v [Kyrie]
Kyrie summe rex glorie sideream regens arcem potenter eleyson
Criste veteris macule purgator ade verbi gena eleyson
Kyrie sancte spiritus vivifice aspirans supplici tue promptus familie eleyson
 12 c. Salamanca, Biblioteca Universitaria, Ms. 2637 (fol. 266v) [Silos?]
 13 c. Toledo, Biblioteca Capitular, Ms. 35-10 (fol. 177v) [Toledo]
 14 c. Madrid, Biblioteca Nacional, M. 1361 (fol. 181v) [Toledo]
4. Fol. 20 [Kyrie]
O pater immense dux noster mitissime eleyson.
Xpriste deus verbum patris qui mundi reatus clementer pertulisti eleyson

O paraclite alme ab utroque spiritus lux prefulgens procedens eterne nosterque consolator eleyson.

 1539 Sevilla, *Manuale chori romanum noviter compilatum super omnia alia completissimum* (fol. 194v) [Sevilla]

 1544 Granada, *Officia ad missas* (fol. 100) [Toledo]

5. Fol. 24v [Kyrie]

Xpriste patris genite tocius gloria vite eleyson

Dextra paterna ream revoca miserando choream eleyson

Amborum flamen confer de more juvamen eleyson

 14 c. Madrid, Biblioteca Nacional, M. 1361 (fol. 182v) [Toledo]

 15 c. Toledo, Biblioteca Capitular, Ms. 52-14 (fol. 38v) [Toledo]

 16 c. Santo Domingo de Silos, Biblioteca del Monasterio, s.n. (fol. 60v) [Silos]

6. Fol. 77 [Sanctus] Melodic fragment

 1544 Granada, *Officia ad missas* (fol. 214v) [Toledo]

7. Fol. 79v [Sanctus] Melody designated "de angeles"

 1707 Madrid, Biblioteca Nacional, Ms. 18724/51 ("Ordo missae del misal mixto Mozarabe") [copied in Toledo]

 1789 Madrid, *Manual procesional para el uso de la provincia de San Joseph de Franciscos Descalzos en Castilla la Nueva* [Madrid]

8. Fol. 82 [Agnus Dei]

O Iesu salvator dulcis consolator tua nobis dona expectata bona

O pacis amator o bonorum dator tua nobis dona expectata bona

De supernis vite nobis dona mitte sicut permisisti quando recessisti

 14 c. Burgos, Monasterio de las Huelgas, s.n. (fol. 18) [Burgos]

9. Fol. 83 [Agnus Dei]

Ave maria celi regina domini mei mater alma

 13 c. Tortosa, Biblioteca Capitular, Ms. 135 (fol. 35) [Tortosa]

 14 c. Barcelona, Biblioteca del Orfeò Català, Ms. 1 (fol. 9) [Tarragona]

Appendix B: The Chantbooks of San Pedro Mártir

The Rosary Cantoral. New Haven, Yale University, Beinecke Rare Book and Manuscript Library, Ms. 710
 Kyriale: 103 folios
 Illumination: Fol. 1v–2, large inhabited initial "R" depicting Madonna and Child ("El Cavaller de Colunya"); border paintings with scenes from the life of Hercules, another based on Albrecht Dürer's *Das Meerwunder* (1498); emblems with Five Wounds and inscription "Miserere Mei"
Separate folios
1. Detroit, Detroit Public Library, Burton Historical Collection
 Gradual leaf
 Incipit: Nos autem gloriari
 Liturgical assignment: Introit for the solemn evening Mass on Maundy Thursday
 Illumination: Large inhabited initial "N" depicting the Madonna and Child ("El Cavaller de Colunya"); emblems with Five Wounds and inscription "Miserere Mei"
2. Los Angeles, J. Paul Getty Museum, Ms. 61
 Gradual leaf
 Incipit: Judica me deus
 Liturgical assignment: Introit for the Mass on Passion Sunday
 Illumination: Large inhabited initial "J" depicting Madonna and Child ("El Cavaller de Colunya"); emblem with Five Wounds and inscription "Misere Mei" [*sic*]
3. New Haven, private collection
 Gradual leaf
 Text: [con]fido non erubescam [Incipit: Ad te levavi]
 Liturgical assignment: Introit for the first Sunday in Advent
 Illumination: Emblems with Five Wounds and inscription "Miserere Mei"
4. New Haven, Yale University, Beinecke Rare Book and Manuscript Library, Ms. 794
 Palimpsest. Gradual leaf (originally from an Antiphoner)
 Incipit: Intret in conspectu tuo. Originally Sacerdos et pontifex

Liturgical assignment: Introit for a Mass of Two or More Martyrs out of Paschal time. Originally antiphon preceding the Magnificat
Illumination: Large inhabited initial "S" depicting Madonna and Child ("El Cavaller de Colunya"); emblems with Five Wounds and inscription "Miserere Mei"

5. New York, Pierpont Morgan Library, M887-1
Gradual leaf
Incipit: Ad te levavi
Liturgical assignment: Introit for the first Sunday in Advent
Illumination: Large inhabited initial "A" depicting Madonna and Child ("El Cavaller de Colunya"); border paintings with scenes from the life of Hercules; emblems with Five Wounds and inscription "Miserere Mei"

6. New York, Pierpont Morgan Library, M887-2
Gradual leaf
Incipit: Resurrexi et adhuc tecum
Liturgical assignment: Introit for the Mass on Easter Sunday
Illumination: Large inhabited initial "R" depicting the Resurrection; emblems with Five Wounds and inscription "Misere Mei" [*sic*]

7. Jörn Günther and Bruce P. Ferrini, *Overlooking the Ages: A Private Exhibition of Illuminated Manuscripts, Miniatures and Printed Books* (Hamburg: Jörn Günther, 1999), Cat. #28
Gradual leaf
Incipit: Quasi modo geniti infantes
Liturgical assignment: Introit for the Mass on Low Sunday
Illumination: Large inhabited initial "Q" depicting Madonna and Child ("El Cavaller de Colunya"); emblem with Five Wounds and inscription "Miserere Mei"

8. Last documented at the home of Norman Strouse, 1986
Gradual leaf
Incipit: Spiritus domini
Liturgical assignment: Introit for the Mass on Pentecost
Illumination: Large inhabited initial "S" depicting the descent of the Holy Spirit; emblems with Five Wounds and inscription "Miserere Mei." Image on file at Beinecke and Morgan

9. Location unknown
Gradual leaf
Incipit: Puer natus est
Liturgical assignment: Introit for the Mass on Christmas Day
Illumination: Large inhabited initial "P" depicting the Nativity; emblem with Five Wounds and inscription "Miserere Mei." Image on file at Beinecke and Morgan

Appendix C: Details Regarding Music and Texts in the Rosary Cantoral

C.1: A Conspectus of Tropes in the Rosary Cantoral

Kyrie

Rex virginum amator (fol. 1v)
 Text: AH 8, RH 17533; Melody: Vatican IV, Melnicki 18
Cunctipotens genitor deus (fol. 3v)
 Text: AH 4, RH 4128; Melody: Vatican IV, Melnicki 18
Summe deus (fol. 5)
 Text: AH 24, RH 19673; Melody: Vatican ad lib. II, Melnicki 161
Rector cosmi pie (fol. 7)
 Text: AH 53, RH 32762; Melody: Vatican ad lib. III, Melnicki 198
Pater excelse mariam (fol. 9)
 Text: ———; Melody: Vatican IX, Melnicki 27
Kyrie fons bonitatis (fol. 11)
 Text: AH 5, RH 6429; Melody: Vatican II, Melnicki 48
Kyrie cunctipotens domine (fol. 13)
 Text: ———; Melody: Prado I
Rex magne domine (fol. 15)
 Text: AH 11a; Melody: Melnicki 124
Kyrie summe rex (fol. 17v)
 Text: ———; Melody: Vatican ad lib. IV, Melnicki 94
O pater immense dux noster (fol. 20)
 Text: ———; Melody: Melnicki 97
Iesu redemptor omnium (fol. 22)
 Text: AH 14, RH 9616; Melody: Melnicki 64
Xpriste patris genite (fol. 24v)
 Text: ———; Melody: Prado III
Xpriste deus decus (fol. 27)
 Text: AH 37, RH 24398; Melody: Vatican VI, Melnicki 47

Gloria

Spiritus et alme (fol. 30v)
 Text: RH 19312; Melody: Vatican IX, Bosse 23

Sanctus (Osanna)

Clangat cetus iste letus (fol. 50)
 Text: AH 378, CT 15, RH 36204; Melody: Vatican VIII, Thannabaur 116
Celeste preconium (fol. 53)
 Text: AH 314, CT 10, RH 3414; Melody: Vatican IV, Thannabaur 49 (var.)
[. . .] Omnes virgines (fol. 77)
 Text: ———; Melody: ———
Osanna salvifica [. . .] rex angelorum (fol. 78)
 Text: ———; Melody: Thannabaur 53 (var.)
[Clangat hodie] fragment (fol. 81)
 Text: AH 341, CT 16, RH 36206; Melody: Thannabaur 112

Agnus Dei

O Iesu salvator (fol. 81)
 Text: CMA 12701; Melody: Schildbach 114
Crimina tollis (fol. 82v)
 Text: AH 453, RH 3979; Melody: Schildbach 114
Ave maria celi regina (fol. 83)
 Text: ———; Melody: Schildbach 3 (var.)

Notes

Key:
AH = Clemens Blume and Guido M. Dreves, eds. *Analecta hymnica medii aevi*, vol. 47, *Tropen des Missale im Mittelalter* (Leipzig: O. R. Reisland, 1905).
CMA = Hans Walther, *Carmina medii aevi posterioris latina*, vol. 1, *Initia carminum ac versuum medii aevi posterioris latinorum* (Göttingen: Vandenhoeck & Ruprecht, 1959).
CT = Gunilla Iversen, *Corpus troporum*, vol. 7, *Tropes de l'ordinaire de la messe: Tropes du Sanctus* (Stockholm: Almqvist & Wiksell International, 1990).
RH = Ulysse Chevalier, *Repertorium hymnologicum. Catalogue des chants, hymnes, proses, séquences, tropes en usage dans l'église latine depuis les origines jusqu'à nos jours*, 6 vols. (Louvain and Brussels, 1892–1921).
Bosse = Detlev Bosse, *Untersuchung einstimmiger mittelalterlicher Melodien zum "Gloria in excelsis deo,"* Forschungsbeiträge zur Musikwissenschaft 2 (Regensburg: Gustav Bosse Verlag, 1955).
Melnicki = Margareta Melnicki, *Das einstimmige Kyrie des lateinischen Mittelalters*, Forschungsbeiträge zur Musikwissenschaft 1 (Regensburg: Gustav Bosse Verlag, 1955).

Prado = German Prado, *Supplementum ad kyriale ex codicibus hispanicis excerptum* (Paris: Desclée & Socii, 1934).

Schildbach = Martin Schildbach, *Das einstimmige Agnus Dei und seine handschriftliche Überlieferung von 10. bis zum 16. Jahrhunderts* (Erlangen-Nürnberg: J. Hogl, 1967).

Thannabaur = Peter Josef Thannabaur, *Das einstimmige Sanctus der römischen Messe in der handschriftlichen Überlieferung des 11. bis 16. Jahrhunderts*, Erlanger Arbeiten zur Musikwissenschaft 1 (Munich: Walter Ricke, 1962).

Vatican = See corresponding chants in *Liber Usualis* (1953; repr., Great Falls, MT: St. Bonaventura, 1997).

C.2: Spanish Kyrie Tropes in the Rosary Cantoral (arranged chronologically)

1. Fol. 13
Kyrie cunctipotens domine miserator eleyson
Xpriste verbum caro factum de virgine eleyson
Kyrie te celebrantibus una in te sperantibus eleyson
 Melody: Prado, *Supplementum*, I.
 12 c. Montserrat, Biblioteca del Monasterio, Ms. 73 (fol. 7v)
 13 c. Toledo, Biblioteca Capitular, Ms. 35-10 (fol. 117v)
 14 c. Madrid, Biblioteca Nacional, M. 1361 (fol. 180v)
 1544 Granada, *Officia ad missas* (fol. 198v)[1]

2. Fol. 17v
Kyrie summe rex glorie sideream regens arcem potenter eleyson
Criste veteris macule purgator ade verbi gena eleyson
Kyrie sancte spiritus vivifice aspirans supplici tue promptus familie eleyson
 Melody: Vatican Kyrie ad libitum IV (Melnicki 94)
 12 c. Salamanca, Biblioteca Universitaria, Ms. 2637 (fol. 266v)
 13 c. Toledo, Biblioteca Capitular, Ms. 35-10 (fol. 177v)
 14 c. Madrid, Biblioteca Nacional, M. 1361 (fol. 181v)

3. Fol. 24v
Xpriste patris genite tocius gloria vite eleyson
Dextra paterna ream revoca miserando choream eleyson
Amborum flamen confer de more juvamen eleyson
 Melody: Prado, *Supplementum*, III.
 14 c. Madrid, Biblioteca Nacional, M. 1361 (fol. 182v)
 15 c. Toledo, Biblioteca Capitular, Ms. 52-14 (fol. 38v)
 16 c. Santo Domingo de Silos, Biblioteca del Monasterio, s.n. (fol. 60v)

4. Fol. 20
O pater immense dux noster mitissime eleyson
Xpriste deus verbum patris qui mundi reatus clementer pertulisti eleyson

O paraclite alme ab utroque spiritus lux prefulgens procedens eterne nosterque consolator eleyson.
> Melody: Melnicki 97
> 1539 Seville, *Manuale chori* (fol. 194v)[2]
> 1544 Granada, *Officia ad missas* (fol. 100)

5. Fol. 9
Pater excelse mariam preparans eleyson
Iesu benigne mariam consecrans eleyson
Spiritus alme mariam obumbrans
> Melody: Vatican Kyrie IX (Melnicki 27)
> 1544 Granada, *Officia ad missas* (fol. 9)

C.3: Spanish Osanna Tropes in the Rosary Cantoral

1. Fol. 77
Omnes virgines sanctum quoque flamen, Amen.
In excelsis.
> 1544 Granada, *Officia ad missas* (fol. 214v)

2. Fol. 78
Osanna salvifica [. . .] rex angelorum
Spes [. . .] [. . .] salus perfectorum
In huius solennio de sudantem chorum
Clementer constitue sub spe salvandorum
Errantes retifica rectos fac constantes
Huius sancti precibus salvate laudantes
In mundi naufragio rege navigantes
Ne mergantur fluctibus te glorificantes
In excelsis.
> Thannabaur 53 (var.)

C.4: Elements of a Compound Trope for the Agnus Dei

Element A

O Iesu salvator dulcis consolator tua nobis dona expectata bona
O pacis amator o bonorum dator tua nobis dona expectata bona
De supernis vite nobis dona mitte sicut permisisti quando recessisti
> Text: CMA 12701; Melody: Schildbach 114
> 14 c. Burgos, Monasterio de las Huelgas, s.n. (fol. 18)

Element B

Crimina tollis aspera mollis agnus odoris
Vulnera sanas ardua planas agnus honoris
Sordida munda cuncta fecunda agnus amoris
 Text: AH 453, RH 3979; Melody: Schildbach 114

Element C

Ave maria celi regina domini mei mater alma
 Text: ———; Melody: ———
 13 c. Tortosa, Biblioteca Capitular, Ms. 135 (fol. 35)
 14 c. Barcelona, Biblioteca del Orfeò Català, Ms. 1 (fol. 9)

Notes

Key:
AH = Blume and Dreves, eds. *Analecta hymnica*, vol. 47.
CMA = Walther, *Carmina medii aevi*, vol. 1.
RH = Chevalier, *Repertorium hymnologicum*.

Appendix D: Individuals with Ties to the Silk Trade Rehabilitated by the Inquisition in 1495

(mrs = maravedis)
1. Santo Tomé (17 total)
 Alonso de Toledo, silk weaver (1), and Beatris Rodriguez, his wife (2) 500 mrs
 Anton Gutierres, silk spinner, son of Juan Gutierres (3) 500 mrs
 Alonso de Cordova, silk master (4), and Marialvares, his wife (5) 4,000 mrs
 Françisco Gutierres, silk merchant (6), and Aldonça de Madrid, his wife (7) 1,000 mrs
 Juan de Cuenca, silk master (8), and Catalina Ponce, his wife (9) 10,000 mrs
 Leonor Alvares, wife of Pero Manuel, silk weaver (10) 500 mrs
 Pedro Portugues, silk weaver (11), and Elena, his wife (12) 500 mrs
 —Children and Grandchildren of Those Condemned in Santo Tomé—
 Ana Rodrigues, wife of Juan de Villalva, silk master, daughter of the graduate in medicine (bachiller de medeçina) (13) 600 mrs
 Arias, son of Diego Lopez, *texillero*[1] (14) 300 mrs
 Juan, son of Pedro Rodrigues Carranque, silk weaver, at the house of Françisco de Yllescas (15) 300 mrs
 Teresa Jarada, wife of Juan Gutierres, silk weaver (16) 600 mrs
 Ynes Alvares, wife of Lope de Cuellar, silk spinner, daughter of Pedro de Castañeda (17) 300 mrs
2. San Román (11 total)
 Christoval, fruit vendor; Ysabel Lopes, his wife, who was the wife of Alonso *texillero*(1) 1,000 mrs
 Elvia Ramires, wife of Ro[drigo] de Toledo, silk master (2) 300 mrs
 Garçia de Toledo, silk master (3) 500 mrs
 Juan de Cordova, silk master (4), and Catalina Gonçales, his wife (5) 7,500 mrs

Rodrigo de Santiago, silk merchant (6) 3,500 mrs
Ynes Lopez, wife of Diego Lopez, *texillero* (7) 300 mrs
—Children and Grandchildren of Those Condemned in San Roman—
Alonso de Yliescas, silk spinner (8) 300 mrs
Fernando de Toledo, son of Pedro Rodrigues Carranque, silk weaver (9) 300 mrs
Françisco, his brother (10) 300 mrs
Maria Alvares, wife of Luys de Toledo, silk weaver (11) 600 mrs

3. Santa Leocadia (8 total)
 Diego de la Rua, silk weaver (1), and Teresa Nuñez, his wife (2) 500 mrs
 Lope de Cuellar, silk weaver (3), and his wife, the daughter of a condemned person (4) 400 mrs
 Lope de Toledo, silk weaver (5), and Aldonça Rodrigues, his wife (6) 2,000 mrs
 —Children and Grandchildren of Those Condemned in Santa Leocadia—
 Alonso de Toledo, enameler (esmaltador), son of Diego Lopes *texillero* (7) 300 mrs
 Leonor Nuñez, wife of Alonso de Segovia, silk weaver (8) 600 mrs
4. San Nicolás (6 total)
 Alonso de Toledo, son of Diego Lopez, silk master (1) 3,500 mrs
 Juan de Sevilla, silk tintor (2) 500 mrs
 Juan de Toledo, silk master (3), and Catalina Alvares, his wife (4) 1,000 mrs
 —Children and Grandchildren of Those Condemned in San Nicolas—
 Arias de Montenegro, silk weaver (5), and Ynes Alvares, his wife (6) 1,200 mrs
5. San Juan de la Leche (5 total)
 Alonso de Alcaras, silk master (1), and Elvira Dias, his wife (2) 25,000 mrs
 Anton de Villalva, silk master (3) 7,500 mrs
 Juan Sorge, jeweler and silk master (4), and Ysabel Alvares, his wife (5) 2,000 mrs
6. San Vicente de Toledo (4 total)
 Diego Xemis, silk master (1), and Elvira Gonçales, his wife (2) 6,000 mrs
 —Children and Grandchildren of Those Condemned in San Vicente—
 Bartolome de Hermosylla, silversmith, son of Go[nzalo] *texillero* (3), and his wife (4) 4,500 mrs
7. Santa Maria Magdalena (2 total)
 Françisco Lopez, silk master (1), and Ynes Ramires, his wife (2) 3,000 mrs
8. Santa Justa (2 total)
 Pedro de Sevilla, silk master (1), and Beatris Garcia, his wife (2) 2,000 mrs
9. Santa Olalla (2 total)
 Pero Cartuxo, silk master (1), and Teresalvares [Teresa Alvares], his wife (2) 3,000 mrs

10. San Andrés (1 total)
 —Children and Grandchildren of Those Condemned in San Andres—
 Gonzalo, silk weaver, son of Nicolas d'Esquivas (1) 3,000 mrs
11. San Cristóbal (1 total)
 Catalina Gutierres, wife of Manuel de Toledo, silk weaver (1) 300 mrs
12. San Ginés (1 total)
 Mençia Gonçales, wife of Juan Martines Cota, silk spinner (1) 500 mrs
13. San Miguel (1 total)
 Pedro de Toledo, silk master (1) 6,000 mrs
14. San Salvador (1 total)
 —Children and Grandchildren of Those Condemned in San Salvador—
 Françisco de Toledo, silk weaver, son of Diego Jarada (1) 300 mrs
15. San Soles (1 total)
 —Children and Grandchildren of Those Condemned in San Soles—
 Mayor de Teva, wife of Diego de Talavera, silk weaver (1) 300 mrs
16. San Antolin
 none
17. Santiago del Arrabal
 none
18. San Justo de Toledo
 none
19. San Lorenzo
 none
20. San Marcos
 none
21. San Pedro
 none

Appendix E: A Conspectus of Chants and Polyphony in the Rosary Cantoral

Gathering I, fols. 1–8 [recto of fol. 1 is blank]
 1. Fol. 1v Rex virginum amator deus marie decus [Kyrie 1]
 2. Fol. 3v Cunctipotens genitor deus omni creator [Kyrie 2]
 3. Fol. 5 Summe deus que cuncta creas [Kyrie 3]
 4. Fol. 7 Rector cosmi pie devotis subveni [Kyrie 4]
Gathering II, fols. 9–16
 5. Fol. 9 Pater excelse mariam preparans [Kyrie 5]
 6. Fol. 11 Kyrie fons bonitatis pater ingenite [Kyrie 6]
 7. Fol. 13 Kyrie cunctipotens domine miserator [Kyrie 7]
 8. Fol. 15 Rex magne domine quem sancti adorant [Kyrie 8]
Gathering III, fols. 17–24
 9. Fol. 17v Kyrie summe rex glorie sideream regens [Kyrie 9]
 10. Fol. 20 O Pater immense dux noster mitissime [Kyrie 10]
 11. Fol. 22 Iesu redemptor omnium tu theos ymon [Kyrie 11]
 12. Fol. 24v Xpriste patris genite tocius gloria vite [Kyrie 12]
Gathering IV, fols. 25–32
 13. Fol. 27 Xpriste deus decus in euo cum patre [Kyrie 13]
 14. Fol. 29v Gloria. Spiritus et alme [Gloria 1]
Gathering V, fols. 33–40
 15. Fol. 33 Gloria [Gloria 2]
 16. Fol. 36 Gloria [Gloria 3]
 17. Fol. 39v Patrem omnipotentem [Credo 1]
Gathering VI, fols. 41–48
 18. Fol. 44v Credo in unum deum [Credo 2]
Gathering VII, fols. 49–53
 19. Fol. 50 Sanctus. Clangat cetus iste letus [Sanctus 1]
 [. . .] dat et a morte nos defendat
 (continued trope from missing folios)

20. Fol. 52v Sanctus. Celeste preconium sonet vox [Sanctus 2] (trope incomplete)

Gathering VIII, fols. 54–55

21. Fol. 54 Et in terra pax [Gloria 4]

Gathering IX, fols. 56–60

22. Fol. 56 Patrem omnipotentem [Credo 3]

Gathering X, fols. 62–69 [missing fol. 61]

23. Fol. 62 [. . .] damus te. Benedicimus te [Gloria 5] (this continues a chant from the missing folio)

24. Fol. 64v Patrem omnipotentem [Credo 4]

[Missing fols. 70–76]

Gathering XI, fols. 77–78

25. Fol. 77 [. . .] omnes virgines sanctum quoque flamen [Sanctus 3] (this continues a trope from the missing folios)

26. Fol. 77 Sanctus [Sanctus 4] (erased trope, Osanna salvific [. . .])

Gathering XII, fols. 79–84

27. Fol. 79v Sanctus [Sanctus 5] ([. . .] pere promissa, from the trope Clangat hodie vox nostra)

28. Fol. 81v Agnus dei [Agnus 1] (includes the tropes O Iesu salvator, Crimina tollis, and Ave Maria celi regina)

29. Fol. 83v Agnus dei [Agnus 2]

30. Fol. 84v Agnus dei [Agnus 3]

Gathering XIII, fols. 85–88

31. Fol. 85v Agnus dei [Agnus 4]

32. Fol. 86 Victime paschali laudes[1] [Sequence 1, Easter]

33. Fol. 89 [. . .] inaudito seculis [Sequence 2, Pentecost] (this is a fragment from the sequence Sancti spiritus)

Gathering XIV, fols. 89–92

34. Fol. 89 Veni sancte spiritus[2] [Sequence 3, Pentecost]

35. Fol. 92v Asperges me[3] [Antiphon 1, Asperges]

Gathering XV, fols. 93–95

36. Fol. 93v Vidi aquam[4] [Antiphon 2, Asperges]

37. Fol. 95 O Ioachim sancte coniunx[5] [Tract 1, St. Joachim]

38. Fol. 95v Beatus vir qui timet[6] [Tract 2]

Gathering XVI, fols. 96–101

39. Fol. 97v Qui seminant in lachrimis[7] [Tract 3]

40. Fol. 99 Josquin Desprez, "Et incarnatus est" in four parts [Credo 5] (from the *Missa sine nomine*)

41. Fol. 99v Desiderium anime eius tribuisti ei[8] [Tract 4]

42. Fol. 101v Unattributed, four-part polyphony "Et incarnatus est" from an unknown Mass on "L'homme armé"[9] [Credo 6]

Gathering XVII, fols. 102–111
 43. Fol. 102 Te deum patrem ingenitum[10] [Tract 5, Holy Trinity]
 44. Fol. 104 Emite spiritum tuum[11] [Tract 6, Holy Spirit]
 45. Fol. 105v Benedicite dominum omnes angeli[12] [Tract 7, Guardian Angels]
 46. Fol. 107 Veni sponsa christi[13] [Tract 8, Nativity of a Virgin]
 47. Fol. 109v Celi confidunt in domino[14] [Tract 9, Dedication of a Church]
 48. Fol. 111 Ave maria gratia plena (incomplete)[15] [Tract 10]

Notes

Introduction

1. "Recent Acquisitions Briefly Noted. The Witten Purchase," *Yale University Library Gazette* 64, nos. 3–4 (April 1990): 176–90.
2. Fols. 36v, 39v, 81v, 83v, 84v, 86, 92v, and 93v.
3. Fols. 1v, 2v, 32, and 32v.
4. *Graduale . . . iuxta ritum sacrosanctae romanae ecclesiae cum cantu, Pauli V. pontificis maximi iussu reformatio . . . ex typographica Medicea* (Rome, 1614–15). For an overview of various adjustments to the liturgy in the sixteenth century, see *The New Grove Dictionary of Music and Musicians*, 2nd ed. (2001), s.v. "Plainchant, §10: Developments from 1500 to 1800 (i) Tridentine reforms."

Chapter One

1. Witten, "A Giant Choir Book c. 1525." New Haven, CT, Yale University, Beinecke Rare Book and Manuscript Library, acquisition file for Ms. 710.
2. Witten to Robert Babcock, Southport, CT, August 9, 1989. Beinecke, acq. 710.
3. See these letters in ibid.: Lynette Bosch to Craig Wright, Cortland, NY, August 22, 1990; Robert Stevenson to Craig Wright, Los Angeles, CA, September 17, 1990; and Josefina Planas to Craig Wright, Bellaterra (Barcelona), November 26, 1990. I am grateful to collector Javier Krahe, Prof. Anna Muntada Torrellas, and Prof. Ismael Fernández de la Cuesta for sharing with me their thoughts on the manuscript's provenance in May and October 1999.
4. Sider to Craig Wright, New York, September 14, 1990. Ibid.
5. Bosch to Craig Wright, Cortland, NY, August 22, 1990. Ibid.
6. "Una altra anomalia que jo observo en aquest Kirial és la contradicció entre l'emblema i la representació del donant. L'emblema és religiós . . . i hem d'atribuir-lo a un convent o monestir; però la presència del donant ens obliga a atribuir-li l'emblema que prolifera a l'orla del full on és ell representat, de manera que la perplexitat és insoluble: o el donant no té escut (cosa inadmissible), o el llibre és fet a iniciativa de la comunitat religiosa (i aleshores no té sentit la presència del donant)." Riera to Craig Wright, Barcelona, August 16, 1990. Ibid.
7. "Només afegiré, per acabar, que si algun dia vostè m'escriu dient que ha arribat a la conclusió que el Kirial procedeix d'un taller de falsaris de llibres miniats, del segle XIX o XX, no en tindré cap sorpresa." [I would only add, to conclude, that if one day you were to write me saying you had arrived at the conclusion that the Kyriale came from a workshop of forged illuminated books, from the nineteenth or twentieth century, I would not be the least surprised.] Riera to Craig Wright, Barcelona, August 16, 1990. Ibid.

8. Ibid. All material related to Beinecke Ms. 794 is included here.

9. John Russell, "Morgan Library Gets Rare Manuscript Collection," *New York Times*, May 9, 1984.

10. Fredrick B. Adams Jr. *Ninth Report to the Fellows of the Pierpont Morgan Library, 1958 & 1959* (New York: Pierpont Morgan Library, November 1959), 32–34.

11. Ibid., 33.

12. Chandler Rathfon Post, *A History of Spanish Painting*, 14 vols. (Cambridge, MA: Harvard University Press, 1930–66).

13. Post to John Plummer, Cambridge, MA, May 25, 1959. New York, Pierpont Morgan Library, acquisition file for M887.

14. Post, *History of Spanish Painting*, vol. 7, pt. 1, *The Catalan School in the Middle Ages* (Cambridge, MA: Harvard University Press, 1938), 260.

15. Post to Plummer, 1959. Morgan, acq. M887.

16. The image consulted is filed in Beinecke, acq. 710.

17. Duschnes to Mabel L. Conat, New York, NY, June 11, 1959. Detroit, MI, Detroit Public Library, acquisition file for "Spanish Antiphonal Leaf" in the Burton Historical Collection. I thank Peter Gulewich for providing copies of the letter and description in a personal communication, September 21, 1999.

18. Ibid.

19. Rivera to Brewer, Toledo, Spain, January 21, 1962. Now deposited in Morgan, acq. M887.

20. Brewer to Herbert Cahoon (chief of the reference department at the Morgan), Detroit, MI, November 2, 1962. Ibid.

21. Bruce Lambert, "N. H. Strouse, Chairman, 86, of Ad Agency," *New York Times*, January 23, 1993.

22. Shaffer to William Voelkle, St. Helena, CA, March 29, 1986. Morgan, acq. M887.

23. Shaffer to Voelkle, St. Helena, CA, April 8, 1986. Ibid.

24. Norman Strouse to Shaffer, St. Helena, CA, 1986. Ibid.

25. Strouse Christmas card, 1961. Now deposited in Beinecke, acq. 710.

26. "Manuscripts. 39. Leaf from a Gradual with an initial *I* with *The Virgin and Child with the Gentleman from Cologne and a Soldier*," *The J. Paul Getty Museum Journal, Including Acquisitions/1995* 24 (1996): 6, 109–10.

27. Sotheby's, *Western Manuscripts and Miniatures* (London, June 21, 1994), 59.

28. Philip C. Duschnes, *Medieval Miniatures and Illumination*, cat. no. 174 (New York: Philip C. Duschnes, 1965), 16.

29. A.R. to Graff, n.p., June 2 1958. Now deposited in Morgan, acq. M887.

30. Duschnes to Conat, June 11, 1959.

31. A negative is deposited in Morgan, acq. M887; a color photograph in Beinecke, acq. 710.

32. Jörn Günther and Bruce P. Ferrini, *Overlooking the Ages: A Private Exhibition of Illuminated Manuscripts, Miniatures and Printed Books* (Hamburg: Jörn Günther, October 1999), #28.

33. Ibid.

34. Personal communication from Katharina Georgi, assistant to Dr. Jörn Günther, Antiquariat, Hamburg, Germany, February 14, 2006.

35. A clue regarding its current location may be found in Norman Strouse's Christmas card from 1961. One of the few differences between this card and the card he mailed in 1986 is the specific indication that two of the leaves are "in a private collection in Ohio." Strouse, Christmas card, 1961. Now deposited in Beinecke, acq. 710.

36. Except where noted, the biographical information on Arthur Rau comes from his obituary published in "News & Comment," *The Book Collector* 22, no. 1 (Spring 1973): 86–89.

37. "Arthur Rau. Rare Old Books," advertisement, *New York Times*, September 18, 1932. The Maggs Brothers' Paris office was initially at 140 Boulevard Haussman. See the Maggs' Brothers Web site: http://www.maggs.com/about/history.asp.

38. Voelkle to Babcock, New York, NY, July 8, 1994. Beinecke, acq. 710.

39. One might suspect that this is the ninth leaf of the set once connected to Arthur Rau (see appendix A.1)—the leaf whose current location is unknown. No documentary evidence supports that supposition, however. Furthermore, unlike every other folio in the set connected with Rau, the New Haven leaf is devoid of any large illuminated initial and is indeed a more modest example.

40. The chant that reads across Morgan M887-1 (see fig. 5) and the New Haven leaf (see fig. 3) is given here. The slashes dividing the word "confido" indicate where the Morgan leaf ends and the New Haven leaf takes over: "Ad te levavi animam meam deus meus in te con // fido non erubescam neque irrideant me inimici mei et enim universi qui expec[tant non confundentur]." The break in the text is also reflected in the music notation. The *custos* at the end of the Morgan leaf indicates the precise note (f) at which the New Haven leaf continues with the chant.

41. This is particularly noticeable in the letters "t, e, a, v" and in the consistent use of the uncial "d" with its characteristic fat loop and nearly horizontal ascender. Both leaves also use a distinctive backsloping C-clef and a similar design in the notation of the *custos* (slightly bowled with a hairline ascender). One might note the different uses of a single-story "s" in one leaf (Morgan M887-1, see fig. 5, at "deus meus") and a two-story "long s" in the other (New Haven, see fig. 3, at "universi"), but these two forms are often found together in manuscripts prepared by the same scribe. The latter is usually adopted as a space-saving measure. Both appear, for example, on the opening folio of the Rosary Cantoral (see fig. 1, at "festivitatibus" and "decus eleyson").

42. Nicolas Rauch was born in Russia to Swiss parents and was orphaned during the 1917 Revolution. After escaping to Switzerland, he began a career in the book trade by working in his grandfather's bookshop, then ventured out on his own in Paris during the 1920s. In the early 1930s, he worked for the Maggs Brothers' Paris branch and later became a partner with the Bridel firm in Lausanne. He died in Geneva on September 19, 1961, at age sixty-six. From the obituary published in "Commentary," *The Book Collector* 11, no. 4 (Winter 1962): 416–19.

43. Laurence Witten, "Vinland's Saga Recalled," in *Proceedings of the Vinland Map Conference*, ed. Wilcomb E. Washburn (Chicago: University of Chicago Press, 1971), 4–5.

44. Ibid., 10.

45. See the descriptions in Vicente Rabanal, *Los cantorales de El Escorial* (Escorial: Monasterio de El Escorial, 1947), and Samuel Rubio, *Las melodías gregorianas de los "libros corales" del monasterio del Escorial: Estudio crítico* (El Escorial: Ediciones Escurialenses, Real Monasterio del Escorial, 1982). This impressive collection still awaits a comprehensive study. I am grateful to Friar Jafet Ortega, OSA, for facilitating my access to these manuscripts.

46. Andrew Hughes, "Medieval Liturgical Books in Twenty-Three Spanish Libraries: Provisional Inventories," *Traditio: Studies in Ancient and Medieval History, Thought, and Religion* 38 (1982): 370. Hughes addresses the issue with regard to manuscripts from the Catalan region; I have regularly seen this trait in my extensive study of chant manuscripts in and around Castile.

47. Francisco Bermudez de Pedrazas, *Historia eclesiastica, principios, y progresos de la ciudad, y religion catolica en Granada* (Granada, 1638), fols. 169v–171, 172–173v, describes the surrender of Granada and the subsequent installation of Toledan musical-liturgical practices.

48. See chapter 5.

49. See chapters 3 and 7.

50. All biblical references are to the Vulgate. English translations have been drawn or adapted from the Douay-Rheims Bible, American ed. (Baltimore, MD: John Murphy, 1899), accessed online at http://biblegateway.com.

51. See chapter 4.

52. Francisco de Pisa, *Descripción de la imperial ciudad de Toledo, y historia de sus antiguedades, y grandeza, y cosas memorables que en ella han acontecido* (1605; facs. Madrid: Villena Artes Gráficas, 1974), 57. See chapters 2 and 7 for more on the Toledan rosary confraternity.

53. See chapter 2.

54. Friar Manuel González, OP, of the Convento de San Pedro Mártir in Madrid (there is no connection with the Toledan house) informed me in a personal communication on April 7, 2000, that the four communities allowed to remain were the Dominicans of Ocaña and the Augustinians of Valladolid, Burgos, and Montuedo (Navarra).

55. "En dicho convento había una colección de 'cantorales' del siglo XVI, que después de la 'desamortización de Mendizaval' en 1835, pasaron al convento de Santo Domingo de Ocaña. Aquí estuvieron hasta la pasada Guerra Civil Española (1936–1939) en que desaparecieron sin que sepa a donde fueron a parar." Friar Jesús Santos, OP, Convento de Santo Domingo de Ocaña, Spain, in a personal letter, May 23, 2000.

Chapter Two

1. William A. Hinnebusch, OP, *The History of the Dominican Order*, vol. 1, *Origins and Growth to 1500* (Staten Island, NY: Alba House, 1966), 39–87.

2. Ibid., 60.

3. José Barrado, OP, "El convento de San Pedro Mártir. Notas históricas en el V centenario de su imprenta (1483–1983)," *Toletum: Boletín de la Real Academia de Bellas Artes y Ciencias Históricas de Toledo* 18 (1985): 184–91.

4. Ibid., 191.

5. Ibid., 195.

6. On St. Peter Martyr, see the popular account by Jacobus de Voragine, *The Golden Legend: Readings on the Saints*, trans. William Granger Ryan, vol. 1 (Princeton, NJ: Princeton University Press, 1993), 254–66.

7. María Paloma López del Álamo and Fernando Valdés Fernández, "Arqueología del sitio," in *San Pedro Mártir el Real, Toledo*, ed. Ángel Alcalde and Isidro Sánchez (Ciudad Real: Universidad de Castilla–La Mancha, 1997), 118.

8. Barrado, "El convento," 195, n, 36.

9. Sixto Ramón Parro, *Toledo en la mano, ó descripcion histórico-artística de la magnífica catedral y de los demas célebres monumentos*, vol. 2 (1857; facs. Toledo: Instituto Provincial de Investigaciones y Estudios Toledanos, 1978), 57.

10. Ibid., 110–11, 402–3.

11. Ibid., 57–58.

12. Ibid., 402 n. 1.
13. Ibid., 66. Mario Arellano García and Ventura Leblic García locate the heraldic shields corresponding to Doña Guiomar, Lope Gaitan, and Doña Juana in the hollow of a second altar in the nave on the epistle side of the conventual church. See their "Estudio sobre la heráldica toledana," *Toletum: Boletín de la Real Academia de Bellas Artes y Ciencias Históricas de Toledo* 19 (1986): 271, 272, figs. 9–12.
14. Linda Martz, *A Network of Converso Families in Early Modern Toledo: Assimilating a Minority* (Ann Arbor: University of Michigan Press, 2003), 5.
15. Ibid., 10–13.
16. J. N. Hillgarth, *The Spanish Kingdoms, 1250–1516*, vol. 2, *1410–1516, Castilian Hegemony* (Oxford: Clarendon, 1978), 206–7; Lynette M. F. Bosch, *Art, Liturgy, and Legend in Renaissance Toledo: The Mendoza and the Iglesia Primada* (University Park: Pennsylvania State University Press, 2000), 66–67.
17. See Hillgarth, *Spanish Kingdoms*, vol. 1, *1250–1410, Precarious Balance* (Oxford: Clarendon, 1976), 394–99.
18. On the nature of the support and its rewards, see María Begoña Riesco de Iturri, "Propiedades y fortuna de los condes de Cifuentes: la constitución de su patrimonio a lo largo del siglo XV," *En la España Medieval* 15 (1992): 140–41.
19. Ibid., 138–39.
20. Ibid., 139.
21. Salvador de Moxó, *Los antiguos señoríos de Toledo* (Toledo: Instituto Provincial de Investigaciones y Estudios Toledanos, 1973), 149.
22. See Martz, *Network of Converso Families*, 7, 10–11.
23. Riesco de Iturri, "Propiedades," 143.
24. Hillgarth, *Spanish Kingdoms*, vol. 1, 405–8; vol. 2, 301.
25. Barrado, "El convento," 194. Barrado identifies Cusanza as confessor to Juan II, but given his tender age it seems more likely that Cusanza had served his father, Enrique III.
26. Ibid.
27. Historians attempting to understand the motive behind the move from San Pablo del Granadal to San Pedro Mártir in May 1407 have concentrated exclusively on the friars' point of view. The most common explanation has been that the friars of San Pablo del Granadal found conditions at the edge of the Tagus River unsanitary. José Barrado has expanded that view to include reasons of security, prestige, convenience, and the favor certain Dominicans enjoyed with the royals. (See Barrado, "El convento," 194–95.) These suggest a desire by the Dominican community to move, but they do not adequately explain why the move happened when it did. By expanding our scope slightly to consider the dire straits confronting the Silvas at the end of 1406, we can see that those circumstances must have been the motivating factor. The Dominicans had a desire to move, but the Silvas had the reason to make it happen.
28. Martz, *Network of Converso Families*, 6; Parro, *Toledo en la mano*, vol. 2, 62.
29. José Carlos Gómez-Menor Fuentes, "Datos documentales sobre la rama toledana de los Silvas," *Toletum: Boletín de la Real Academia de Bellas Artes y Ciencias Históricas de Toledo* 17 (1985): 225.
30. Barrado, "El convento," 183.
31. López del Álamo and Valdés Fernández, "Arqueología del sitio," 122; Ricardo Izquierdo Benito, "Historia de un singular edificio toledano," in *San Pedro Mártir el Real, Toledo*, ed. Ángel Alcalde and Isidro Sánchez (Ciudad Real: Universidad de Castilla–La Mancha, 1997), 17. Izquierdo Benito mistakenly refers to Doña Guiomar as Pedro de Silva's mother.

32. Izquierdo Benito, "Historia," 21, credits "la Condesa de Cifuentes," which must be Ana de Silva, the only woman in line of succession. See Martz, *Network of Converso Families*, 7.

33. There are twelve iterations of the Silva coat of arms, which alternate with the shield of the Dominican Order. Arellano García and Leblic García, "Estudio," 274.

34. Izquierdo Benito, "Historia," 15; López del Álamo and Valdés Fernández, "Arqueología del sitio," 113; and the diagrams reflecting accretions to the convent between 1407 and 1760 in Mario Muelas Jiménez and Agustín Mateo Ortega, "La rehabilitación" in *San Pedro Mártir el Real, Toledo*, ed. Ángel Alcalde and Isidro Sánchez (Ciudad Real: Universidad de Castilla–La Mancha, 1997), 136–43.

35. Izquierdo Benito, "Historia," 18; López del Álamo and Valdés Fernández, "Arqueología del sitio," 122.

36. The conversion of the street into the central nave is apparent in comparing the diagrams for 1407 and 1490 in Muelas Jiménez and Mateo Ortega, "La rehabilitación," 136–37.

37. Julio Porres Martín-Cleto, *Historia de las calles de Toledo*, vol. 2 (Toledo: Diputación Provincial, 1971), 239.

38. López del Álamo and Valdés Fernández, "Arqueología del sitio," 118. A comparison of the diagrams for 1407 and 1490 in Muelas Jiménez and Mateo Ortega, "La rehabilitación," 136–37, shows that the section from San Román's adjacent cloister became the northern wall of the conventual church built at San Pedro Mártir in the 1490s.

39. Benzion Netanyahu, *The Origins of the Inquisition in Fifteenth Century Spain*, 2nd ed. (New York: New York Review Books, 2001), 422.

40. In the following paragraphs I have relied especially on Henry Kamen, *The Spanish Inquisition: A Historical Revision* (New Haven, CT: Yale University Press, 1997); Cecil Roth, *The Spanish Inquisition* (1964; repr. New York: W. W. Norton, 1996); and ibid.

41. J. H. Elliott, *Imperial Spain, 1469–1716* (New York: St. Martin's, 1967), 65; Hillgarth, *Spanish Kingdoms*, vol. 2, 350, fig. 2.

42. Elliott, *Imperial Spain*, 5–12. Hillgarth, *Spanish Kingdoms*, vol. 2, 335–65, presents a more nuanced account.

43. Netanyahu, *Origins of the Inquisition*, 920; Kamen, *Spanish Inquisition*, 44–45.

44. Kamen, *Spanish Inquisition*, 47.

45. Hillgarth, *Spanish Kingdoms*, vol. 2, 426; *The Catholic Encyclopedia* (1907–1914), s.v. "Tomás de Torquemada."

46. Kamen, *Spanish Inquisition*, 47–48.

47. Ibid., 10–11; Martz, *Network of Converso Families*, 21.

48. Martz, *Network of Converso Families*, 21; Netanyahu, *Origins of the Inquisition*, 186–87; Pedro de Alcocer, *Hystoria o descripción de la imperial cibdad de Toledo* (1554; facs. Toledo: Instituto Provincial de Investigaciones y Estudios Toledanos, 1973), fol. LXX.

49. Kamen, *Spanish Inquisition*, 11.

50. Martz, *Network of Converso Families*, 24–36. The Toledan uprisings of 1449 and 1467 are discussed in Netanyahu, *Origins of the Inquisition*, 296–327, 768–93.

51. Kamen, *Spanish Inquisition*, 20, 28.

52. Martz, *Network of Converso Families*, 61.

53. Barrado, "El convento," 197–98.

54. Martz, *Network of Converso Families*, 61.

55. See Netanyahu, *Origins of the Inquisition*, 1155–64.

56. As translated in Kamen, *Spanish Inquisition*, 207–8.

57. Ibid., 60.

58. On the population of Toledo, see Martz, *Network of Converso Families*, 3, 65–66.
59. Julio Porres Martín-Cleto, "Las casas de la Inquisición en Toledo," *Toletum: Boletín de la Real Academia de Bellas Artes y Ciencias Históricas de Toledo* 20 (1986): 125.
60. See Francisco de Pisa, *Apuntamientos para la segunda parte de la "Descripción de la imperial ciudad de Toledo,"* transcribed with notes by José Gómez-Menor Fuentes (Toledo: Instituto Provincial de Investigaciones y Estudios Toledanos, 1976), 57 n. 14.
61. "Trabajaron mucho los religiosos de este convento en servir y favorecer al Santo Oficio de la Inquisición, la qual estuvo muchos años con sus cárceles, y inquisidores dentro desta casa, desde el primero dia que el Santo Oficio entró en Toledo." Juan López, OP, *Tercera parte de la historia general de Sancto Domingo, y de su Orden de Predicadores* (Valladolid: Francisco Fernández de Córdova, 1613), 161. There, López cites "a document by Tomás de Torquemada, Inquisitor General, written in Toledo on September 12, 1490" [una escritura de Fray Tomás de Torquemada inquisidor general, fecha en Toledo à doze de Setiembre de 1490] that must relate to the donation of royal houses to San Pedro Mártir that month.
62. "Que por averse señalado en servir à la Inquisición, por la mucha costa y trabajo con que los frayles y convento la avian favorecido, les hizieron merced los reyes católicos de una calle pública y de unas principales cases que avia de la otra parte." Ibid., 161–62. See also n. 61 above.
63. Izquierdo Benito, "Historia," 20.
64. See Bosch, *Art, Liturgy, and Legend*, 135–37; Anna Muntada Torrellas, *Misal Rico de Cisneros* (Madrid: Real Fundación de Toledo, 2000), 41.
65. Barrado, "El convento," 200.
66. Joseph F. O'Callaghan, *Reconquest and Crusade in Medieval Spain* (Philadelphia: University of Pennsylvania Press, 2003), 1–2, 177–78; Ramón Gonzálvez Ruiz, "Las bulas de la catedral de Toledo y la imprenta incunable castellana," *Toletum: Boletín de la Real Academia de Bellas Artes y Ciencias Históricas de Toledo* 18 (1985): 13–14.
67. Norman Housely, *The Later Crusades, 1274–1580: From Lyons to Alcazar* (Oxford: Oxford University Press, 1992), 302, 313. Housely notes the ways the "Bula de la Cruzada" was abused for profit in the sixteenth century.
68. See the reproduction from 1483 in Cristóbal Pérez Pastor, *La imprenta en Toledo: Descripción bibliográfica de las obras impresas en La Imperial Ciudad desde 1483 hasta nuestros días* (1887; facs. Valencia: Librerías "París-Valencia," 1994), 3.
69. Barrado, "El convento," 204–5. This information corresponds to records for the year 1592.
70. See ibid., 200–210; Pérez Pastor, *La imprenta*, xi–xix; Gonzálvez Ruiz, "Las bulas," 157–65.
71. See Housely, *Later Crusades*, 291–321.
72. "Y también en remuneración de tan grandes y importantes servicios les confiaron y encomendaron la impresión de las Bulas de la Santa Cruzada, y todos los reyes sus sucessores se la han confirmado hasta que el Rey Don Felipe III, Nuestro Señor les dió su priviligio real sobre esto." López, *Tercera parte*, 162. According to Izquierdo Benito, "Historia," 22, King Philip III granted San Pedro Mártir the royal privilege on October 7, 1609.
73. Gonzálvez Ruiz, "Las bulas," 144–45; Pérez Pastor, *La imprenta*, 6–7.
74. Gonzálvez Ruiz, "Las bulas," 154.
75. Pérez Pastor, *La imprenta*, 9–10.
76. *Missale mixtum secundum regulam beati Isidori dictum Mozarabes*, Toledo, January 9, 1500; *Breviarium secundum regulam beati Hysidori*, Toledo, October 25, 1502. See Pérez Pastor, *La imprenta*, 16–17, 23–24.

77. Jesúsa Vega González, *La imprenta en Toledo: Estampas del Renacimiento, 1500–1550* (Toledo: Instituto Provincial de Investigaciones y Estudios Toledanos, 1983), 26; Pérez Pastor, *La imprenta*, xx. The earliest suspected collaboration between Hagenbach and Hutz is *De imitatione Christi et de contemptu mundi, splanat de latí per Miquel Pereç* [Miguel Pérez], published in Valencia on February 16, 1491. The first attributed work is *Furs nous del regne de Valencia e capitols ordenades per lo rey don Ferrando II. en la cort general de Oriola. 31 jul 1488*, published by Hagenbach and Hutz for Jaume Vila on September 6, 1493. See *Catálogo general de incunables en bibliotecas españolas*, ed. Francisco García Craviotto, vol. 1 (Madrid: Ministerio de Cultura, 1989), 479–80, 396. Hagenbach and Hutz are thought to have collaborated on at least ten incunabula between 1491 and 1495. *Catálogo general*, vol. 2 (1990), 455.

78. *Cura de la piedra y dolor de la yjada y colica rreñal*, published in Toledo on April 4, 1498. See Pérez Pastor, *La imprenta*, 11–12.

79. *Leyes del estilo: y declaraciones sobre las leyes del fuero*, published in Toledo on February 26, 1498. The publisher is not indicated, but the book bears Hagenbach's characteristic stamp of the Virgin investing St. Ildephonsus with a chasuble. See Pérez Pastor, *La imprenta*, 10–12. Vega González, *La imprenta*, 26, also presumes that Hagenbach was in Toledo by the end of 1497.

80. Vega González, *La imprenta*, 26 n. 1.

81. Pérez Pastor, *La imprenta*, xx. Vega González, ibid., 29, notes that Hagenbach's types and ornaments remained in use, with only a few innovations, by successors Juan de Villaquirán and Nicolás Ganzini de Piedemonte.

82. Blas Ortiz, *Summi templi toletani perquam graphica descriptio; Blasio Ortizio iuris pontificii doctore eiusdem templi canonico toletanaeque diocesis vicario generali autore* (Toledo: Juan de Ayala, 1549), fol. CXLVI, "In parochia sancti Romani . . . 24. Titulo Sanctissimae Virginis del Rosario, huius confratres telarum sericearum textores sunt, habent aerarium in coenobio Sancti Dominici, cui titulus Sancti Petri Martyris est."

83. See Julián Montemayor, "La seda en Toledo en la época moderna," in *España y Portugal en las rutas de la seda: Diez siglos de producción y comercio entre oriente y occidente*, Comisión Española de la Ruta de la Seda (Barcelona: Universitat de Barcelona, 1996), 120–32.

84. "en la casa del oficio que es en la parrochial santo tome donde haçen sus juntas y cabildo los maestros del arte de la seda que es esta cofradía de nuestra señora del rosario sita en el conbento de san pedro martyr el real." Toledo, Archivo Diocesano, Sección Cofradías y Hermandades, Legajo To. 25, Expediente 5, 1636 (Convento de San Pedro Mártir, Cofradía de Nuestra Señora del Rosario, "Presentación de las constituciones para su aprobación"), fol. 2.

85. Ibid., Expediente 2, 1651 (Convento de San Pedro Mártir, Cofradía de Nuestra Señora del Rosario, "Presentación de ordenanzas para su aprobación"), fol. 2.

86. "hordenamos que en esta hermandad y cofradia non sea reçibido por cofrade ninguna persona que sea de ninguna condición ni estado por alguna causa ni raçon salbo los maestros del arte del texer tercios pelos y brocados y damascos y rasos[.]" Ibid.

87. "Otrosi hordenamos que puedan ser recibidos por cofrades y hermanos algunos caballeros de estado y renta si el cabildo los quisiere y consintiere y que el tal caballero non se puede reçibir sin ser mandado por nuestro cabildo lo qual queremos que sean reçibidos a causa que la cofradía sea mas honrada y aprobechada[.]" Ibid., fol. 3v.

88. Francisco de Pisa, *Descripción de la Imperial Ciudad de Toledo, y historia de sus antiguedades, y grandeza, y cosas memorables que en ella han acontecido* (1605; facs. Madrid: Villena Artes Gráficas, 1974).

89. "El real monasterio de San Pedro Mártir es de frailes de Santo Domingo, Orden de Predicadores, en el cual hay una muy insigne capilla de Ntra. Sra. del Rosario muy celebrada y frecuentada de fieles, en que se hace memoria de ella muy solemnemente en un domingo cada mes, con sermón particular y solemne procesión alrededor de la iglesia y claustro y una vez al año más solemne fuera de la iglesia con grande acompañamiento. En servicio de esta imagen hay una insigne cofradía de caballeros y gente noble, y demás de esto en cada sábado de la semana por la tarde, después de completas, acuden muchas personas devotas a esta capilla donde se reza en voz alta y se declaran los misterios del SS. Rosario por uno de los padres del dicho convento." Pisa, *Apuntamientos*, 57.

90. "Por industria del padre maestro fray Felix de Plaça, prior desta casa, y del presentado fray Christoval de Torres (siendo lector de teologia della) ha creçido tanto la cofradia y devocion de N. Señora del rosario que ha llegado à la grandeza y devocion que se puede dessear. Ay en esta santa hermandad 48, cofrades cavalleros nobilissimos. . . . [Toda] la nobleza de Toledo, sirven en esta santa cofradia del rosario, confesando, y comulgando todos los primeros domingos de cada mes, à la missa mayor con edificacion de todo el pueblo, y acompañan en la procession esos dias, à la santissima imagen, llevandola sobre sus ombros, y yendo delante con hachas todos ellos. Para estos dias traen siempre la musica de la santa Iglesia, la de vozes y instrumentos, y cuelgan el claustro con colgaduras que de limosnas se han hecho." López, *Tercera parte*, 163.

91. "El licenciado Alonso de Vivar commisario del sancto officio dela inquisicion vecino que fue de Toledo singularissimo devota de Nuestra Señora del Rossario a quien sirvio con mucho exemplo mas de sesenta y seis años asistiendo siempre al Rossario y reçandole con la communidad y visitando a Nuestra Señora con mucha frequentaçion sin que faltase dia sino es por enfermedad tan sençia y pormas de treinta años pago la musica de las proçessiones de los primeros Domingos del mes y cera que se gastaba en dichas proçessiones y altar de Nuestra Señora y por muchos años grande fiesta de polvora el primero Domingo de Octubre. Hiço el trono y arco y angeles de Nuestra Señora y la colgadura y carro y su vestido muy rico y frontales y otros muchos gastos en servicio de Nuestra Señora y haviendo tenido muchos hijos, que fue casado se los llevo Dios y al dicho commisario lo conservo Nuestra Señora para que la sirviese hasta edad de mas de ochenta años y murio a veinte y ocho de Diciembre de mil seisçientos y setenta dia de pasqua de los innoçentes entre diez y onçe de la noche con una serenidad y sosiego como para ir a ver a Nuestra Señora su ama que assi la llamaba siempre, tenia hecho ser su testamento zerrado que despues de mil y docientos ducados que dexo de mandas y pagado su funeral y tres mill missas dexo por heredera universal destos sus bienes a Nuestra Señora del Rossario para que la renta se gastasse en su servicio de çera y musica en las processiones de cada domingo del mes y demas gastos para el culto y asistençia del servicio de Nuestra Señora y la haçienda y renta que dexo se pondra eneste libro." Madrid, Archivo Histórico Nacional, Libro 15246, fol. 21 ("Recibo general de la hacienda de Ntra. Sra. del Rosario. A. 1671–1730").

92. Ibid.; along with Madrid, Archivo Histórico Nacional, Libro 15296 ("Libro de las memorias de Ntra. Sra. del Rosario. A. 1731–1763").

93. "Musica. En 4 de março de 1682 pagamos dos mill quinientos y ocho reales de la musica de los domingos. Pagamos desde el mes de agosto de 1680 hasta el primero del março de 1682 inclusive." Madrid, Archivo Histórico Nacional, 15246 ("Recibo"), fol. 61.

94. "Flores. Este dia pagamos quatro cientos y cinquenta y seis reales de los ramos que se pusieron en las jarrillas del trono de nuestra señora." Ibid., fol. 62v.

95. "Zera. En 16 de Marzo de 1694 pagamos trescientos Reales de quarenta y quatro libras de zera." Ibid., fol. 65.

96. "Colgar claustro. En este dia pagamos veinte reales de colgar y descolgar del claustro por el mes de abril." Ibid., fol. 84v.

97. "Libritos. Este dia pagamos dos cientos y diezinuebe reales de diez resmas y media de papel, y ympression de ellas y libritos de ofrecimiento del rosario." Ibid., fol. 66v.

98. "Rosarios. En este dia pagamos once reales de dos dozenas de rosarios." Ibid., fol. 85.

99. "ciento y sesenta y cinco mill quinientos y noventa y dos maravedis—los quales nos consta hauerse gastado en el retablo[.]" Ibid., fol. 69v.

100. "otras grandes cantidades que han dado de limosna asi los religiosos hijos deeste conuento como personas de esta ciudad." Ibid., fol. 69v–70.

101. "Pleito, texedores. Este dia pagamos sesenta y tres reales del pleito con los texedores." Ibid., fol. 95.

102. Juan Nicolau Castro, "La capilla de la Virgen del Rosario y otras obras del siglo XVIII en el monasterio de San Pedro Mártir," *Anales toledanos* 26 (1989): 303.

103. Toledo, Archivo Diocesano, Cofradías y Hermandades, Legajo To.13, Expediente 36 (Parroquia de San Ginés, Hermandad de Nuestra Señora del Rosario, "Presentación y aprobación de ordenanzas").

104. Izquierdo Benito, "Historia," 24.

105. Manuel María de los Hoyos, OP, *Registro historial de nuestra provincia* (Madrid: Selecciones Gráficas, 1967), 239, 241. The extensive damage to numerous religious houses in Spain during the French occupation is reported in Manuel Herrero, *Historia de la provincia de España de la Orden de Predicadores desde la muerte del Rmo. Quiñones hasta la expulsión de los franceses*, bk. 2 of Justo Cuervo, OP, *Historiadores del convento de San Esteban de Salamanca*, vol. 3 (Salamanca: Imprenta Católica Salmanticense, 1915), 700–777. San Pedro Mártir is discussed in chapter XXXVIII, 764–66.

106. "En la Guerra de la Independencia fue este monasterio uno de los mejor librados, mirando al edificio. Gracias a la acción de los Dominicos, se aquietó el ánimo del vecindario, que llevaba trazas de repetir los excesos acaecidos en Valencia. Uno de los más exaltados llegó a manifestar a un religioso: 'Padre, dos días hace que no como por no desamparar lo comenzado, pero me retiraré porque usted así me lo aconseja.' Decidida la Imperial Ciudad a crear un lucido cuerpo de tropa de caballería, echó mano de este convento para la organización y la compra de los animales. Público este fervor patriótico de los Dominicos y temiendo las represalias de los invasores, que se acercaban a la ciudad, se dispersó la comunidad. Algunos, llevando las preciosidades de la casa, se dirigieron a la región andaluza, mas fueron sorprendidos en el camino por el enemigo y despojados de su equipaje. Así pereció el trono de la Virgen del Rosario, que era una verdadera maravilla." Recounted in Hoyos, *Registro historial*, 239. The source for this story is not cited, but a similar account appears in Herrero, *Historia de la provincia*, 764.

107. Hoyos, *Registro historial*, 241.

108. The effects of the *Desamortización* in Toledo are discussed more fully in Julio Porres Martín-Cleto, *La desamortización del siglo XIX en Toledo* (Toledo: Diputación Provincial, 1965).

109. "las llaves del Convento y de todas sus oficinas, fueron entregadas todas en la misma tarde de la exclaustración a D. Pasqual Nuño de la Rosa, sin que procediese formalidad alguna tanto en la notificación, como en la entrega de dichas llaves; pues solo se presentó dicho Señor Nuño, como Administrador que era de los arbitrios de armortización, con un oficial llamado Ferrer, y sin otra formalidad nos mandaron que en el término de 4 horas desocupáramos el Convento, quedando este cerrado en la misma tarde." Letter dated December 15, 1839, from Juan José Sandoval to the provincial supervisor. Transcribed in ibid., 429.

110. Rafael del Cerro Malagón, "Siglo y medio de uso civil," in *San Pedro Mártir el Real, Toledo*, ed. Ángel Alcalde and Isidro Sánchez (Ciudad Real: Universidad de Castilla–La Mancha, 1997), 54–56, 58.

111. "aquellos terroríficos días de 1936, de los que hasta el recuerdo huye." Hoyos, *Registro historial*, 241.

112. *The Dictionary of Art*, ed. Jane Turner (New York: Grove Dictionaries, 1996), s.v. "Maino, Fray Juan Bautista."

113. The destruction is recounted in Hoyos, *Registro historial*, 241–42.

Chapter Three

1. The striking differences in style and quality from one exemplar to the next reflect the fact that San Pedro Mártir did not have a proper *scriptorium* (see chapter 2). Like the great Cathedral of Toledo and other religious institutions in the city, it too relied on several workshops of scribes, illuminators, and book binders located throughout the city and elsewhere in Castile. See Lynette M. F. Bosch, *Art, Liturgy, and Legend in Renaissance Toledo: The Mendoza and the Iglesia Primada* (University Park: Pennsylvania State University Press, 2000), 135–37; Anna Muntada Torrellas, *Misal Rico de Cisneros* (Madrid: Real Fundación de Toledo, 2000), 41.

2. Assignments for these standard feasts of the church year can be found in *Liber Usualis* (Tournai: Desclée & Co., 1953; repr. Great Falls, MT: St. Bonaventura, 1997), 318, 408, 569, 654, 778, 809, 878, 1162, 1173.

3. For relevant discussions, see Carol J. Purtle, *The Marian Paintings of Jan van Eyck* (Princeton, NJ: Princeton University Press, 1982), 85–97; Bret Rothstein, "Vision and Devotion in Jan van Eyck's *Virgin and Child with Canon Joris van der Paele*," *Word & Image* 15, no. 3 (1999): 262–76.

4. Post to John Plummer, Cambridge, MA, May 25, 1959. The letter is preserved in the acquisition file for New York, Pierpont Morgan Library, M887.

5. Chandler Rathfon Post, *A History of Spanish Painting*, vol. 7, pt. 1, *The Catalan School in the Middle Ages* (Cambridge, MA: Harvard University Press, 1938), 260. Post's use of the word "murderer" is misleading. Murder is a premeditated crime, and—as we shall see in my later exposition of the story—the death that resulted from the quarrel described here occurred in the heat of the moment.

6. "Creiem que es tracta d'un fet de molta antiguitat, la memòria del qual, passant de boca en boca, havia sofert grans transformacions i havia perdut molts detalls, entre altres, el lloc on succeí, els noms de les persones que hi intervingueren, l'any en què passà." Valeri Serra i Boldú, *Llibre d'or del rosari a Catalunya* (Barcelona: Edició Privada, 1925), 22.

7. "Generalment se'n diu 'del Cavaller de Colunya' i nosaltres també hem acceptat aquesta denominació, que té valor de moneda corrent" (Generally the miracle has been called "El Cavaller de Colunya," and we have also accepted this name, which is of current use). Ibid. See also Post, *History of Spanish Painting*, vol. 7, pt. 1, *Catalan School* (1938), 260, 263, 501–3; vol. 8, pt. 1, *The Aragonese School in the Late Middle Ages* (1941), 185–86; vol. 9, pt. 2, *The Beginning of the Renaissance in Castile and Leon* (1947), 825–27; vol. 11, *The Valencian School in the Early Renaissance* (1953), 314–15.

8. See Serra i Boldú, *Llibre d'or*, plates XXII, XXIV, XXVI, XXIX, XXXI, XXXII, XXXIV, XXXVI, as well as the images on 251 and 253. See also n. 7 for references to examples identified by Post.

9. This biographical sketch is based on José María Coll, OP, "Dos artistas cuatrocentistas desconocidos (Pablo de Senis y Fr. Francisco Doménech)," *Analecta sacra tarraconensia* 24 (1951): 141–44. Coll speculates that Domènech was probably a native of Valencia insofar as his repeated assignments to the convent there did not carry any particular mission and were otherwise handled rather casually.

10. Modern versions of these prayers are well-known among the faithful. "Ave Maria": Hail Mary, full of grace, the Lord is with thee. Blessed art thou among women and blessed is the fruit of thy womb Jesus. Holy Mary, Mother of God, pray for us sinners now and at the hour of our death. "Pater noster": Our Father who art in heaven, hallowed be thy name. Thy kingdom come, thy will be done, on earth as it is in heaven. Give us this day our daily bread, and forgive us our trespasses as we forgive those who trespass against us. And lead us not into temptation, but deliver us from evil.

The text of our modern Hail Mary evolved over several centuries. Its basic form—"Hail Mary, full of grace, the Lord is with thee. Blessed art thou among women, and blessed is the fruit of thy womb"—was established by the twelfth century. The name "Jesus" was added by the fourteenth century. The concluding phrase—"Holy Mary, Mother of God, pray for us sinners now and at the hour of our death"—was popular by the sixteenth century. A version of this last phrase (in which "Holy Mary, Mother of God" was followed by the added salutation "Mother of grace and mercy") was known in Florence in the mid-fourteenth century. See Anne Winston-Allen, *Stories of the Rose: The Making of the Rosary in the Middle Ages* (University Park: Pennsylvania State University Press, 1997), 2; Gabriele Roschini, *Maria santissima nella storia della salvezza* (Isola del Liri: Pisani, 1969), 4:232–33. The "Hail Mary" is based on Gabriel's angelic salutation in Luke 1:28 and Elizabeth's cry of joy during Mary's visitation in Luke 1:42. On the "Our Father," also known as "The Lord's Prayer," see Matthew 6:9–14 and Luke 11:1–4.

11. On this issue and the clever exempla created to address it, see Winston-Allen, *Stories of the Rose*, 136.

12. German and Italian rosary confraternities played key roles in shaping and establishing these fifteen meditations during the 1480s. Domènech's Barcelona engraving, from 1488, is among the first to substitute the Coronation of the Virgin for the Last Judgment as the final meditation. See ibid., 57, 65–80.

13. The basis for this popular religious typology is the Song of Songs 4:12. For a general discussion of the association between the Song of Songs and Mary, see Anne E. Matter, *"The Voice of My Beloved": The Song of Songs in Western Medieval Christianity* (Philadelphia: University of Pennsylvania Press, 1990), 151–77. An excellent discussion of the *hortus conclusus* in particular is Stanley Stewart, *The Garden Enclosed: The Tradition and the Image in Seventeenth-Century Poetry* (Madison: University of Wisconsin Press, 1966). Winston-Allen, *Stories of the Rose*, 89–98, presents a good overview of Mary as the "garden enclosed."

14. The signature phrase is noted in Roch Chabás, "Estudio sobre los sermones valencianos de San Vicente Ferrer, que se conservan manuscritos en la Biblioteca de la Basílica Metropolitana de Valencia," *Revista de archivos, bibliotecas y museos* 3rd ser., 6, no. 6 (1902): 4.

15. André Duval observes in *Dictionnaire de Spiritualité* 13 (1988), s.v. "Rosaire," 954, that the word *indulgentia* appears in forty-nine of fifty-four papal bulls issued approving the rosary during the century spanning the pontificates of Sixtus IV (Francesco della Rovere, 1414–84) and Gregory XIII (Ugo Buoncompagni, 1502–85).

16. Subsequent to my study of Domènech's print at the Biblioteca Nacional in Madrid (Sala Goya, INV 42364), I learned of two useful articles that should be mentioned here:

Isidro Rosell y Torres, "Estampa española del siglo XV grabada por Fray Francisco Domenec," *Museo español de antiguidades* 2 (1873): 445–64; and Guy C. Bauman, "A Rosary Picture with a View of the Park of the Ducal Palace in Brussels, Possibly by Goswijn van der Weyden," *Metropolitan Museum Journal* 24 (1989): 135–51.

17. The Catalan *cavaller*, like the Spanish *caballero*, can mean "knight," "horseman," or "gentleman." My reading of "knight" finds agreement in Bauman, "A Rosary Picture," 135–51.

18. The colophon is signed "Mosen Duran Salvaniach *Frances*" (my emphasis).

19. Seville, Biblioteca Colombina, 14-2-7(10). For a list of printed books, see *Biblioteca colombina: Catálogo de sus libros impresos* (Seville and Madrid, 1888–1948); Archer M. Huntington, ed., *Catalogue of the Library of Ferdinand Columbus, Reproduced in Facsimile from the Unique Manuscript in the Columbine Library of Seville* (New York, 1905). For a more specialized inventory of musical sources, see Catherine Weeks Chapman, "Printed Collections of Polyphonic Music Owned by Ferdinand Columbus," *Journal of the American Musicological Society* 21, no. 1 (1968): 33–84.

20. "En lo temps que la sacratissima verge Maria vivia en aquesta mortal vida apres que Jesu Christ redemptor nostre sen fonch pujat al cel e hac trames lo sanct esperit als seus apostols o dexebles, e aquells prenent licencia de ella per anar a preycar per lo mon la voluntat e doctrina de Jesu Christ: e per lo semblant a tots los amichs e devots de Jesus Christ son fill e seus: ella per gran amor e caritat e per special oracio los amonestava e instruya com a devocio molt plasent e servey molt agradable a Jesus Christ a ell diguessen tots jorns un psaltiri ço es .xv. pater nostres e cent cinquanta ave maries. . . . Los quals apostols dexebles e amichs volenterosament ho complir en tota lur vida. E aquels ho manifestaren a sos amichs, los quals ne feren una confraria perque tal era la voluntat dela verge Maria. E apres que la verge Maria fonch passada de aquesta vida: e fonch assumpta e portada en cors e en anima als cels los dits devots continuaren la dita confraria vesitant los la verge maria ab specials consolacions. E aquest agradable servey dura molt temps." *Trellat sumariament*, 1535, fols. A2–A3.

21. "Per discurs de molt temps per defalliment de amonestacions e preycacions per persecucions de tirans contra los christians per guerres e males gents la bona costuma e devocio se vengue a perdre en tal manera que ya no era en memoria la dita confraria." Ibid., fol. A3.

22. "tan gran mortaldat que les gent se morien per los camps e camins." Ibid.

23. "dient un pater nostre: e apres deu ave maries fins en suma de quinze pater nostres e cent cinquanta ave maries[.]" Ibid., fol. A4.

24. See James Hogg, ed., *El santo rosario en la Cartuja*, Analecta Cartusiana 103 (Salzburg: Institut für Anglistik und Amerikanistik Universität Salzburg, 1983), 22.

25. Winston-Allen, *Stories of the Rose*, 1, 16.

26. Ibid., 23–24, 66, 72, 136. On the Carthusian rosary, see chapter 4.

27. See ibid., 16–17; Thomas Esser, "Beitrag zur Geschichte des Rosenkranzes: Die ersten Spuren von Betrachtungen beim Rosenkranz," *Der Katholik* 77 (1897): 410.

28. "En la ciutat de Colunya havia un home molt devot dela verge Maria: lo qual tots jorns deya son Psaltiri: e segueix que un dia lo dit home hague paraules ab un home dela ciutat: e vingueren a mans de manera que aquell qui deya lo psaltiri mata a laltre. E lo mort tenia un germa molt valent hom: lo qual de continu entenia en fer venjança: vench un dia que lo matador volent anar cami fonch spiat de son enemich: e passant davant lo monestir de preycadors dient lo psaltiri entra en una capella dela verge Maria: e agenollas e començà a dir son psaltiri. E dient aquell lo enemich lo sperava per matarlo: lo qual enemich mira e veu questava agenyollat davant lo altar dela verge Maria: e davant ell

estava una molt excelent e molt resplandent senyora: e veu que de la boca del homicida exien roses, e aquella excelent senyora les prenia e feya delles una garlanda, enla qual garlanda havia una rosa vermella e deu blanques: e en aquest orde feu la garlanda perque en aquell orde ixqueren del homicida les roses dela boca e acabada la garlanda aquella excelent senyora la posa enlo cap del homicida: e tot aço mirava lo germa del mort quel esperava per matarlo: empero vist aço conegue quera gran misteri, e mogut de caritat lança les armes, e ab la cara molt alegra ana la via dell: lo qual homicida com lo veu pensa quel volia matar. Empero lo germa del mort molt alegrament li dix: no hajes paor car de bon cor yot perdo la mort de mon jerma: e val abraçar e besar e dixli: yot deman perdo e deman de gracia quem digues qui es aquella senyora que estava davant tu fahen una garlanda de roses. Aquell respos que no havia vist res. Dix lo germa del mort digues me quina oracio deyes a la verge Maria. Aquell respos que lo psaltiri dela verge Maria deya: ço es .xv. pater nostres e .cl. Ave Marias. E lavors lo dit germa del mort qui aquella senyora avia vist, avent conexença que aquella era la verge maria molt liberalment li perdona la mort de son germa. E preposa dir lo psaltiri e partiren bons amichs. E aquest acte se sabe de continent per lo poble dela dita ciudat de Colunya." *Trellat sumariament*, 1535, fols. A4v–A5v.

29. "Com la verge maria en la nit siguent apareque al prior del dit monestir de preycadors de Colunya." Ibid., fols. A5v–A7v.

30. "La verge maria aparegue al dit prior e manali que lo diumenge seguent puix avia de sermonar enla seu dela dita ciutat que sermonas publicament que de aqui avant tota persona digues lo psaltiri." Ibid., fol. A6.

31. "Lo dit prior reputantse indigne e molt gran peccador: molt humilment respos ala gloriosa verge Maria dient: O reyna de gloria com jo sia gran peccador diran les gents que jo estava embriach o que so tornat orat, o foll, o maniach: mas empero si tales vostra voluntat mare de deu donau me senyal per lo qual sia cregut e nos burlen de mi." Ibid.

32. "Tu diras al poble com tal dia tal hom qui volia matar a tal me veu enla mia capella feen una garlanda de roses enla qual avia .xv. roses vermelles e .cl. blanques." Ibid., fol. A6v.

33. "E mes diras que tal dia parira una noble dona: la qual es prenyada de son marit e parira un troç de carn sens alguna forma: e de continent que aura parit que tots los eclesiastichs e religiosos: e tot lo poble dela ciutat de colunya ab candeles enceres enles mans processionalment vinguen ala iglesia del teu monestir: e devotament que posen aquel troç de carn enlo altar dela mia ymagen en aquella capella que apareque al dit homicida dient me lo psaltiri. E de continent de aquell troç de carn jo donare al dita noble dona un bell fill." Ibid.

34. "E tu denunciaras al poble que lo tercer dia que aço auras preycat e totes les dites coses: tu seras remunerat: la qual remuneracio sera que tu morras e yras al regne del cel." Ibid.

35. "no solament de Colunya mas tota Alemanya comença a dir lo psaltiri o roser de la verge Maria." Ibid., fol. A7.

36. "ço es .xv. pater nostres e .cl. Ave Marias." Ibid.

37. "doctor en sacra theologia e prior del convent del monestir de Colunya dela provincia de Alemanya." Ibid., fol. A7v.

38. See the discussion of rosary confraternities in chapter 7.

39. Hieronimo Taix, OP, *Libre dela institucio, manera de dir, miracles e indulgencies del roser de la verge Maria señora nuestra* (Barcelona: Pere Monpezat, 1556), fol. 17v; Francisco Messia, OP, *Colloquio devoto y provechoso, en que se declara qual sea la sancta cofradia del rosario de Nuestra Señora la Virgen Maria, Reyna de los Cielos, Madre de Dios y Señora Nuestra* (Callar:

Nicolao Cañellas, 1567), fol. 20v; Juan López, OP, *Libro en que se trata de la importancia y exercicio del santo rosario* (Zaragoza: Domingo Portonariis y Ursino, 1584), fol. 163v; Juan Sagastizabal, OP, *Exortacion a la santa devocion del rosario dela Madre de Dios* (Zaragoza: Lorenço de Robles, 1597), 103.

40. Francisco Sánchez, OP, *Rosario de la Virgen Maria Nuestra Señora con las indulgencias, y gracias espirituales de su santa cofradia, nuevamente confirmadas por Nuestro Muy Santissimo Padre Inocencio XI. para el uso de sus cofrades* (Madrid: Geronimo Estrado, 1709), 42.

41. Jesúsa Vega González, "Impresores y libros en el origen del renacimiento en España," in *Reyes y mecenas: Los reyes católicos—Maximiliano I y los inicios de la casa de Austria en España* (Milan: Electa España, 1992), 205.

42. German, French, and Italian presses issued no fewer than fourteen editions between 1487 and 1520 and at least sixteen more between 1574 and 1669. *The Malleus Maleficarum of Heinrich Kramer and James Sprenger*, trans. Montague Summers (1928; repr., New York: Dover, 1971), vii–viii.

43. Jakob Sprenger, *Erneuerte Rosenkranz-Bruderschaft* (Augsburg: Bämler, 1476). The exemplar consulted is preserved at New York, Pierpont Morgan Library (PML 144, ChL316).

44. I am grateful to Anne Winston-Allen for providing me with these dates in a personal communication. For a brief biography, see *Malleus Maleficarum*, ix.

45. Serra i Boldú, *Llibre d'or*, 22; Post, *History of Spanish Painting*, vol. 7, pt. 1, *Catalan School* (1938), 260.

46. "Veus açi com se fa la oració e axi es aceptada. Si be se fa la oració es una erba aromática e axi adorant, que guarda la creatura de perills sperituals e temporals. Legim en los miracles de la Verge María, que era un mercader devot, qui deya certes Ave Maries per lo matí, ans que s'occupás en negocis temporals. ¿E quantes eren? XII. en reverencia de XII. gracies que Deus havie fetes a la Verge María, segons XII. parts que ha lo cors. *Primo* la cap era ple de sciencia, mes que de propheta, apostol, ne altre sant. E lavors lo mercader deye Ave María.—*Item*, aprés se acostave a ella guardantla en los huylls, pensant quantes vegades havie mirat son fill quan ere chich . . . e lavors deyeli Ave Maria.—*Item* a las orelles, quinya e quanta gracia havien hauda en hoir los preychs de son fill, anant de vila en vila . . . ab fam, set, fret, fanchs, plujes e neus, descalç.—*Aprés* pensave en las mans, com la beneyta adorava son fill . . . e com lo bolcava, el servie ab les mans.—*Aprés* a la boqua, pensant quantes vegades li havie besat la boqua, les mans, los peus.—*Apres* als pits, pensava en les mamelles virginals, com havien alletat lo fill de Deu.—*Aprés* al cor, quant ere aquell foch de caritat.—*Aprés* en los braços, pensave com havien portat son fill beneyt.—*Item*, pensave en lo ventre virginal, com havie portat aquell per nou mesos.—*Aprés* en les cames, com lo menave al temple, e ça e lla.—*Aprés*, pensave en la sua anima sagrada quanta perfecció havie.—*Aprés*, en tot lo cors, quanta penitencia.—Ara escoltats be.—Veus que aquest mercader quiscun día fahia aquesta oració, primo per l'enteniment, puix adorantla, agenollantse, puix demanava e dehye la oració. Esdevenchse, que havia anar a fira, e perço que l'camí era fort perilló de ladres, ordenás ab altres quey anaven tambe. E lo día que sich devien partir, aquests vingueren per lo matí e despertenlo: *Aytal, anem que hora es*. E tant eren cuitats, que lexá de ver la oració que ere acostumada de fer. E veus que ells anant, se esdevinguiren entre molts ladres e prenguerenlos e appartarenlos dins en un bosch e mataren tots los altres, e aquest mercader romás derrer. Ya que l'volien degollar, analí lo cor a la oració e pregals que li deguessen fer una gracia, que li lexassen fer oració. Digueren ells: *hoc, mas espacha tantost*.—*Sí faré*.—E ell començe a fer oració axi com havie acostumat. E tantost com comença de pensar en la Verge María, com dit es, ves aquí la Verge María ab senta Caterina ab hun plat ple de roses e senta Agnes ab hun fil e agulla:

e vehienles los ladres e estaven esbalaits. E axí com lo mercader havie dit una Ave María, prenie una rosa la Verge María, e a cada Ave María altra, e enfilavels e feune una garlanda e posala al cap del mercader. E ell aço non vehye mas sentíe gran odor, e elles desaparegueren. E ell girás als ladres e dix: *germans, ja he fet oració; degollaume.* Digueren los ladres: ¡*coom degollar! ¿qui son aquexes dones tan belles que han estat ab tu? Tu deus esser hun sant hom, e en tes oracions nos comanam.* E tornarenlo al camí, e tot ço del seu. Yo crech que s'convertiren los ladres per açó." As transcribed in Roch Chabás, "Estudio sobre los sermones valencianos de San Vicente Ferrer, que se conservan manuscritos en la Biblioteca de la Basilica Metropolitana de Valencia (cont'd)," *Revista de archivos, bibliotecas y museos*, 3rd ser., 7, no. 8 (1903): 45–46.

47. Cited in Joseph Dobner, *Die mittelhochdeutsche Versnovelle Marien Rosenkranz* (Borna-Leipzig: Robert Noske, 1928), 33.

48. Ibid., 28–35, 60–68.

49. Transcribed in ibid., 60–62.

50. "Sed cum animadverteret, quod non esset sui compos nec proprie voluntatis gubernator, obsequium liliorum et rosarum, quod yconte [*sic*] beate virginis inpendere solebat, in aliud dignum duxit permutandum animadvertens et cogitans, quod per salutacionem illam que sit ex Ave Maria sertum beate virgini faceret, sicut faciebant flores et lilia. Itaque pro qualibus rosa seu alio flore, quos inserere solebat in sertis in beate virginis honore, per tot Ave Maria vellet eam cotidie salutare." Ibid., 61.

51. "Sertum tamen, quod ex Ave Maria facere consueverat, nullatenus intermisit." Ibid.

52. "Accidit autem quadam die, ut idem prepositus ad quemdam locum pro pagamento recipiendo accederet, quod in acero sibi pertinebat officio. Sed pecunia recepta cum rediret, duo latrones eidem insidias preparantes in mortem eius machinati sunt, ipsum spoliare cupientes atque relinquere semivivum, vias eius consideraverunt et in quodam nemore latitantes, per quod ille sueverat transitinerare, adventum illius expectaverunt. Qui veniens vacans oracionibus assuetis incidit in latrones. At illi, in eum irruere preparati, rescipientes viderunt iuxta eum puellam pulcherrimam vestibus preciosissimis adornatam, gemmis fulgentem, supra mulam candidam equitantem, sertum diligenter ac studiose de rosis facientem, quas ab ore monachi capiebat. Et cum sertum omnino consumasset et capiti decenter inposuisset, ab oculis illorum est sublata et in tenues evanuit auras. Quod cum vidissent latrones, mente consternati turbati sunt et moti sicut ebrius et omnis sapiencia eorum devorata est et conpuncti corde ad pedes monachi corruerunt, veniam expansis manibus et fusis lacrimis postulantes. Qui videns eos attonitus et admiratus ait: Quid queritis, fratres mei? Qui respondentes dixerunt: Hô dei famulus, qui verax es et viam dei in veritate docere potes, miserere nobis et ignosce facinori, quod adversus te facere ceperamus, et dic que sit ista mulier tam venerabilis et honesta, que de rosis ex ore tuo susceptis equitans diu iuxta te tam decenter sertum propriis manibus conposuit et serto conpleto [*sic*] de nostris oculis evanuit. Et narrantes omnia, que acciderant et viderant, pedes illius amplexati sunt. Qui audiens illos hoc loquentes et contricionem eorum considerans, ultra quam credi potest admirans ait: Nemini dixeritis visionem, sed magnificate dominum, quia nescitis quod dicitis. Qui respondentes dixerunt: Ymmo, pater sancte, quod scimus loquimur et quod vidimus testatur et testimonium nostrum verum est, miserere nobis. Tunc ille ait: Quid vultis, ut faciam vobis? At illi dixerunt: Pater sancte, adiuva nos, ut in tuo monasterio et religione tua ab abbate tuo recepti tecum vivere valeamus et ibi, prece tua adiuti, sordes nostrorum peccatorum detegere valeamus. Tunc ille pietatis intuitu eorum precibus acquiescens ait: Nolite timere, confortamini et estote robusti. Venite post me, faciam vos fieri servos dei. Tunc eos secum duxit et suo abbati presentavit, cui omnia que viderant et que eis acciderant, in ordine narraverunt, et, ut eos in fratres reciperet, humiliter petierunt. Tunc abbas illis benedicens et in

fratres sui ordinis amicabiliter suscipiens, deo gracias egit et beate ac gloriose matri eius, per quam illorum anime deo reddite sunt, quas diabolus conabatur aufferre." Ibid., 61–62.

53. Background information on the *Cantigas* was drawn from Connie L. Scarborough's introduction to Kathleen Kulp-Hill, trans., *Songs of Holy Mary of Alfonso X, The Wise: A Translation of the Cantigas de Santa María* (Tempe: Arizona Center for Medieval and Renaissance Studies, 2000) xix–xxvi.

54. For a modern edition of the text, see Alfonso X, *Cantigas de Santa María*, ed. Walter Mettmann (Madrid: Clásicos Castalia, 1986), 1:55. My translation is partially adapted from Kulp-Hill, trans., *Songs of Holy Mary*, 2.

55. *Cantiga* 121, Alfonso X, *Cantigas* (1988), 2:65. See also Kulp-Hill, trans., *Songs of Holy Mary*, 149.

56. See the image reproduced in José Guerrero Lovillo, *Las cantigas: Estudio arqueológico de sus miniaturas* (Madrid: Consejo Superior de Investigaciones Científicas, 1949), pl. 134. Comprising six frames in all, each compartment in the illustration of the *Rich Codex* includes a caption to outline the story in a summary fashion. From top to bottom, and left to right, they read: (1) How a good man made each year a chaplet of roses for Holy Mary; (2) How the good man met up with his enemies in the forest; (3) How he got off his palfrey and begged Holy Mary to help him; (4) How his enemies saw Holy Mary sitting with him, both weaving a chaplet of roses; (5) How his enemies turned and mounted and rode on their way; and (6) How he told the people about it and they all greatly praised Holy Mary. As translated in Kathleen Kulp-Hill, "The Captions to the Miniatures of the 'Códice Rico' of the *Cantigas de Santa María*, a Translation," *Bulletin of the Cantigueros de Santa María* 7 (1995): 3–64.

57. *Cantiga* 209, Alfonso X, *Cantigas*, 2:259; Kulp-Hill, trans., *Songs of Holy Mary*, 251.

58. "El mismo año [1345] un religioso de San Francisco predicando en esta santa Iglesia, en el discurso de su sermon afirmò ser testigo, de que en la villa de Cervera avia una muger casada, que con oraciones continuas suplicava a la gloriosa virgen de Montserrate le diesse un hijo, y como perseverasse en su oracion, a pocos dias se sintio preñada. Llegada la hora del parto, y salida la criatura a luz se hallaron las parteras con un pedaço de carne en las manos, sin figura ni forma de cosa humana. La devota muger, que esperava tener una criatura muy hermosa, congoxada de ver lo que era, aunque no estava libre de los dolores, enbolviendole en unos paños començo con muchas lagrymas a llamar a esta gloriosa Señora, diziendole, que ella avia pedido hijo, y le dava un pedaço de carne, pero que tenia esperança en su misericordia, que de aquella carne le daria un hijo, de donde resultasse gloria a su santissimo nombre, y alegria a sus desconsolados padres. Desembolvio con esto lo que avia parido, sintiendo que començava a moverse, y hallo un perfecto y hermoso niño, por lo qual (admirados todos) dieron muchas gracias a Dios y a su santissima Madre." Fray Juan de Figueroa, *Libro de la historia y milagros, hechos a invocación de Nuestra Señora de Montserrate* (Barcelona: Sebastián de Cormellas, 1623), fols. 85v–86.

59. See Matthew 13:10–11; Mark 4:10–11; Luke 8:9–10.

Chapter Four

1. John McAndrew, *The Open-Air Churches of Sixteenth Century Mexico: Atrios, Posas, Open Chapels, and Other Studies* (Cambridge, MA: Harvard University Press, 1965), 320.

2. See the image for the *retablo* of St. Francis, Santa Cruz de la Cañada, New Mexico, in Jim Sagel, ed., *La iglesia de Santa Cruz de la Cañada, 1733–1983* (Albuquerque, NM: Archdiocese of Santa Fe, 1983), 91.

3. *Liber Usualis*, ed. Benedictines of Solesmes (Tournai: Desclée & Co., 1953; repr. Great Falls, MT: St. Bonaventura, 1997), 1642–43. The Mexican exemplar of Diez's *Quadruplicium* is discussed in Robert Duclas, *Catálogo descriptivo de los libros impresos en la ciudad de Salamanca en el siglo XVI existentes en la Biblioteca Pública de Guadalajara* (México, DF: Biblioteca Nacional de México, 1961), 137–38; the image of the frontispiece is given at no. 101-1584.

4. Jacobus de Voragine, *The Golden Legend: Readings on the Saints*, trans. William Granger Ryan, vol. 2 (Princeton, NJ: Princeton University Press, 1993), 224.

5. John Tagliabue, "The Friar, Miraculously, Marches into Sainthood," *New York Times*, June 17, 2002. The feast day of St. Padre Pio is September 23.

6. See *The Catholic Encyclopedia* (1907–14), s.v. "Stigmata, Mystical."

7. Lynette Bosch's initial observation that "the five wounds are perhaps a reference to the arms of the Acuña family" has had an undue influence in this regard. See Bosch to Craig Wright, Cortland, NY, August 22, 1990. New Haven, CT, Yale University, Beinecke Rare Book and Manuscript Library, acquisition file for Ms. 710. In papers related to the Morgan leaf, William Voelkle notes on a document from January 20, 1992: "According to Lynette Bosch, wounds are the Acuña family arms." See New York, Pierpont Morgan Library, acquisition file for M887. The catalog entry for the Getty leaf also indicates "(?)Acuña family" as the original owner. See "Manuscripts. 39. Leaf from a Gradual with an initial *I* with *The Virgin and Child with the Gentleman from Cologne and a Soldier*," *The J. Paul Getty Museum Journal, Including Acquisitions/1995* 24 (1996): 110.

8. Madrid, Biblioteca Nacional, Mss. vit. 18–19, fol. 22v, reproduced in Jesús Domínguez Bordona, *Exposición de códices miniados españoles* (Madrid: Sociedad Española de Amigos de Arte, 1929), pl. 62.

9. Fifteenth-century leaf of Burgos Cathedral, reproduced in Jesús Domínguez Bordona, *Manuscritos con pinturas: Notas para un inventario de los conservados en colecciónes públicas y particulares de España*, vol. 1, *Ávila-Madrid* (Madrid: Centro de Estudios Históricos, 1933), 85, fig. 84.

10. The device is explicitly tied to Bishop Luis Acuña y Ossorio in Lynette M. F. Bosch, "A *Terminus ante quem* for Two of Martin Schongauer's *Crucifixions*," *The Art Bulletin* 64, no. 4 (1982): 632, 633 n. 7.

11. The placement of the image in the space where one expects to find a heraldic emblem has compromised a proper interpretation. To press the issue further: a companion to the Crucifixion leaf of Burgos Cathedral, a leaf that depicts the Adoration of the Magi, has in the identical "heraldic space" an image of a sealed fountain flanked by a peacock and a finch. See the reproduction in Domínguez Bordona, *Exposición*, pl. 62. These images correspond to the Virgin and Child being adored in the large portrait directly above them. The symbol of the fountain sealed for the Virgin Mary is well-known and derives from *fons signatus* of the Song of Songs (4:12). The symbolic relationship among the peacock, the finch, and Christ will be discussed later in this chapter.

12. *Missal of Abingdon Abbey*, Oxford, Bodleian Library, Ms. Digby 227, fol. 113v, reproduced in Kathleen L. Scott, *Later Gothic Manuscripts, 1390–1490. Catalogue and Indexes*, vol. 6, pt. 2 of *A Survey of Manuscripts Illuminated in the British Isles*, ed. J. J. G. Alexander (London: Harvey Miller, 1996), fig. 382; English Book of Hours, Cambridge, MA, Harvard University, Houghton Library, Widener Ms. 2, fol. 7, reproduced in ibid., fig. 454.

13. On the earlier observance, see *The Catholic Encyclopedia* (1907–14), s.v. "Passion Sunday." In the reformed liturgical calendar, "the Sundays of this season are called the First, Second, Third, Fourth, and Fifth Sundays of Lent. The Sixth Sunday, which marks

the beginning of Holy Week, is called Passion Sunday (Palm Sunday)." *The Liturgy Documents: A Parish Resource*, 3rd ed. (Chicago: Liturgy Training, 1991), 176.

14. Indeed, the practice of drawing a veil across the sanctuary to separate the altar from its people during Lent goes back to the ninth century. See John H. Miller, *Fundamentals of the Liturgy* (Notre Dame, IN: Fides, 1959), 400–401.

15. *The Catholic Encyclopedia* (1907–14), s.v. "Judica Sunday."

16. Clemens Blume and Guido M. Dreves, eds., *Analecta hymnica medii aevi*, vol. 50, *Hymnographi latini: Lateinische Hymnendichter* (Leipzig: O. R. Reisland, 1907), 568 (382).

17. The peacock is a common device in the religious art of the Middle Ages and the Renaissance. The Dominican St. Albertus Magnus (d. 1280) noted in his *De animalibus*: "The peacock has firm white meat which keeps for a long time without undergoing putrefaction." This observation is traced back to St. Augustine's *The City of God*, book 21, chapter 4. See Albert the Great, *Man and the Beasts: De animalibus (Books 22–26)*, trans. James J. Scanlan (Binghamton, NY: Medieval and Renaissance Texts & Studies, 1987), 311.

18. See entry number 109, "Ornament with Owl Mocked by Day Birds," in Alan Shestack, *Fifteenth Century Engravings of Northern Europe from the National Gallery of Art, Washington, D.C.* (Washington, DC: National Gallery of Art, 1967). There are other notable examples of Schongauer's prints serving as models for art in Spain. On this topic, see Bosch, "*Terminus ante quem*," 632–35.

19. See Herbert Friedmann, *The Symbolic Goldfinch: Its History and Significance in European Devotional Art* (Washington, DC: Pantheon, 1946), 9–10. As Friedmann notes, the symbolism extends to other small birds as well, including the robin and the *charadrius*, for example.

20. As explained in the anonymous *Physiologus*, one of the most widely read books in the Middle Ages. See the modern edition translated by Michael J. Curley (Austin: University of Texas Press, 1979), 1, 10–12.

21. Matthew 27:15; Mark 15:25; Luke 23:33; John 19:18. Here and in the following paragraphs, I draw on the thoughtful analysis of "The Crucifixion" in Frederick P. Pickering, *Literature and Art in the Middle Ages* (Coral Gables, FL: University of Miami Press, 1970), 223–307.

22. Pickering, *Literature and Art*, 223.

23. "(. . . et nullus evangelistarum scribit.) Cum venissent ad locum Calvariae ignominiosissimum, ubi canes et alia morticina projiciebantur, nudaverunt Jesum unicum filium meum totaliter vestibus suis, et ego exanimis facta fui; tamen velamen capitis mei accipiens circumlegavi lumbis suis. Post hoc deposuerunt crucem super terram, et eum desuper extenderunt, et incutiebant primo unum clavum adeo spissum quod tunc sanguis non potuit emanare; ita vulnus replebatur. Acceperunt postea funes et traxerunt aliud brachium filii mei jesu, et clavum secundum ei incusserunt. Postea pedes funibus traxerunt, et clavum acutissimum incutiebant, et adeo tensus fuit ut omnia ossa sua et membra apparerent, ita ut impleretur illud psalmi, Dinumeraverunt omnia ossa mea." As transcribed in ibid., 238–39. The translation is adapted from ibid., 239 n. 1.

24. See Psalm 21:2; Matthew 27:46; Mark 15:34.

25. Jane Morlet Hardie, *The Lamentations of Jeremiah: Ten Sixteenth-Century Spanish Prints. An Edition with Introduction* (Ottawa: The Institute of Mediaeval Music, 2003), xxii.

26. Miri Rubin, *Corpus Christi: The Eucharist in Late Medieval Culture* (Cambridge: Cambridge University Press, 1991), 305.

27. Louis Gougaud, *Devotional and Ascetic Practices in the Middle Ages* (London: Burns, Oates & Washbourne, 1927), 79.

28. Ibid., 80.

29. Carlos M. N. Eire, *From Madrid to Purgatory: The Art and Craft of Dying in Sixteenth-Century Spain* (Cambridge: Cambridge University Press, 1995), 278.

30. Ibid., 224–25, 225 n. 113. Eire gives the Hebrew sequence Ps. 21, 34, 54, 68, 109. The numbers used here correspond to the Vulgate.

31. Gougaud, *Devotional and Ascetic Practices*, 82. See also, Richard William Pfaff, *New Liturgical Feasts in Later Medieval England* (Oxford: Clarendon, 1970), 84–91.

32. One is titled *Missa devotissima quinque plagarum* and appears in the votive missal Toledo, Biblioteca Capitular, Ms. 37.19, fol. 3. The other is called *Missa de quinque plagis* in the second volume of Alfonso Carrillo's *Missale mixtum*, Toledo, Biblioteca Capitular, Ms. Res. 3, fol. 182. Both are examples of the *Missa Humiliavit*. I am grateful to Michael J. Noone for sharing his photographs of these manuscripts.

33. Statutes for the Cofradía del Corpus Christi (Toledo, 16c), Madrid, Biblioteca Lázaro Galdiano, M 3-4, Inventario 15657, Ms. 371, reproduced in Domínguez Bordona, *Manuscritos con pinturas*, fig. 438. Statutes for the Cofradía del Santissimo Sacramento (Toledo, 1502), Cambridge, MA, Harvard University, Houghton Library, Ms. Typ 184, fol. 5v, described in Roger S. Wieck, *Late Medieval and Renaissance Illuminated Manuscripts, 1350–1525, in the Houghton Library* (Cambridge, MA: Department of Printing and Graphic Arts, Harvard College Library, 1983), 100. I am grateful to Dr. Javier Krahe for sharing his photograph of the relevant folio.

34. Changes introduced by Pope John Paul II in October 2002 are discussed in the section "MISERERE MEI and the Rosary of Cologne."

35. Anne Winston-Allen, *Stories of the Rose: The Making of the Rosary in the Middle Ages* (University Park: Pennsylvania State University Press, 1997), 25.

36. *Von dem Psalter und Rosenkranz unser lieben Frauen* (Augsburg: Anton Sorg, 1492), fol. B7. Quoted and translated in ibid., 25.

37. "Zü dem andern mal so sol der mensch beten all wochen drey rosenkrentz. Das is zü dreyen malen finfftzig ave maria und zü drey malen finff pater noster. Das ist nach tzehen weissen rosen setz er ein rote rosen entzwischen welche in den pater noster bedeüttet wirt in dem ein mensch betrachtet das rosen rott plüt christi jhesu das davon unser wegen unser vater got hat wöllen vergossen lasse werden." Jakobus Sprenger, *Erneuerte Rosenkranz-Bruderschaft* (Augsburg: Bämler, 1476), fols. 3–3v. Transcribed from the exemplar at New York, Pierpont Morgan Library, PML 144, ChL 316.

38. Winston-Allen, *Stories of the Rose*, 66, 78–79; Karl Joseph Klinkhammer, SJ, "Die Entstehung des Rosenkranzes und seine ursprüngliche Geistigkeit," in *500 Jahre Rosenkranz, 1475–1975: Kunst und Frömmigkeit im Spätmittelalter und ihr Weiterleben*. Exhibition catalog, Erzbischöfliches Diözesan-Museum Köln, October 25, 1975–January 15, 1976 (Cologne: Bachem, 1975), 43.

39. We might wonder whether it was Alanus de Rupe's death that was commemorated in the legend of "The Knight of Cologne." As we saw in chapter 3, the story involves the improbable death of the prior at Cologne who passes on to his reward after revealing all the Virgin had instructed him to say—improbable, because that prior would have been Jakob Sprenger himself. But what about Alanus de Rupe? It may be that "The Knight of Cologne" had indeed some historical basis in this regard. Reading into the legend with the greatest possible latitude we find that the story does, after all, tell us about an influential theologian who died just as the confraternity of the rosary was being founded at Cologne.

40. Winston-Allen, *Stories of the Rose*, 66–67.

41. Attempts at quantification extended to reckoning not only the number of wounds but also the number of drops of Christ's blood. See David S. Areford, "The Passion

Measured: A Late-Medieval Diagram of the Body of Christ," in *The Broken Body: Passion Devotion in Late-Medieval Culture*, ed. A. A. MacDonald, H. N. B. Ridderbos, and R. M. Schlusemann (Groningen: Egbert Forsten, 1998), 217.

42. Winston-Allen, *Stories of the Rose*, 98.

43. See the image in ibid., 13.

44. "Los quinze pater nostres per reverencia de totes aquelles plagues que Jesus Christ rebe enlo seu sagrat cos per la redempcio de natura humana. E dient cascun dia .xv. pater noster a cap del any has dit: tants pater nostres quantes foren les plagues de Jesuchrist." *Trellat sumariament fet dela bulla o confraria del psaltiri o roser e cobles alahor e gloria dela sacratissima e entemerada verge maria del roser* (Valencia: Mosen Duran Salvaniach Frances, February 27, 1535), fols. A2–A2v.

45. *Trellat sumariament fet dela bulla o confraria del psaltiri o roser* (Valencia: [Mosen Duran Salvaniach Frances?], March 18, 1546). There are two known exemplars of this later edition, one at the Biblioteca de Catalunya in Barcelona and another at the Biblioteca Universitaria of Valencia. Barcelona, Biblioteca de Catalunya, Top. 6-VI-39, was consulted here.

46. Louise M. Burkhart, *Before Guadalupe: The Virgin Mary in Early Colonial Nahuatl Literature* (Albany, NY: Institute for Mesomamerican Studies, 2001), 123.

47. Bartolomé de Castro, *Questiones logicae [et] Canones triumphi numerorum* (Toledo: Juan de Villaquirán, October 8, 1513). The exemplar Madrid, Biblioteca Nacional, R/3355, was consulted here. The printer is the same Juan de Villaquirán noted in chapter 2, n. 81.

48. Cristóbal Pérez Pastor, *La imprenta en Toledo: Descripción bibliográfica de las obras impresas en La Imperial Ciudad desde 1483 hasta nuestros días* (1887; facs., Valencia: Librerías "París-Valencia," 1994), 40.

49. Three emblems of the Five Wounds also appear on the Detroit leaf ("Nos autem gloriari") and the unrecovered Pentecost leaf ("Spiritus domini replevit").

50. See note 37.

51. "Und die tzale diser ave maria machet samentlich ein gantze wochen anderthalbhundert. Und der pater noster seind überal funftzehen. Und von des wegen hat man die tzal außwölet das do vil seind der psalmen davids. Des geleychten werdent auch die anderthalbhundert ave maria geheissen unser frawen psalter." Sprenger, *Erneuerte Rosenkranz-Bruderschaft*, 3v. I am grateful to Anne Winston-Allen for assisting me with this passage, which is incomplete in the exemplar consulted.

52. Winston-Allen, *Stories of the Rose*, 15.

53. Clemens Blume and Guido M. Dreves, eds., *Analecta hymnica medii aevi*, vol. 35, *Psalteria rhythmica: Gereimte Psalterien des Mittelalters* (Leipzig: O. R. Reisland, 1900), 123–34.

54. Winston-Allen, *Stories of the Rose*, 66–67, 136–37.

55. Ibid., 17, 66, 72–73.

56. Ibid., 17, 22–24.

57. "1. AVEMARIA: Dios te salve, María; llena eres de gracia; el Señor es contigo; bendita tu eres entre todas las mujeres y bendito es el fruto de tu vientre, JESUS, a quién al anuncio del Angel concebísteis por obra del Espíritu Santo. Amen. // 2. AVEMARIA . . . JESUS, con quién al ser concebido visitásteis a Santa Isabel. Amen. // 3. AVEMARIA . . . JESUS, al que virgen de cuerpo y alma, dísteis a luz con gozo. Amen." These stanzas are drawn from a Spanish translation of the full fifty-*Ave* rosary given in James Hogg, ed., *El santo rosario en la Cartuja*, Analecta Cartusiana 103 (Salzburg: Institut für Anglistik und Amerikanistik Universität Salzburg, 1983), 33.

58. The "Luminous Mysteries" or "Mysteries of Light" are five events from the public life of Christ: (1) his Baptism in the Jordan; (2) his self-manifestation at the wedding of Cana; (3) his proclamation of the Kingdom of God, with his call to conversion; (4) his Transfiguration; and (5) his institution of the Eucharist, as the sacramental expression of the Paschal Mystery. See the Apostolic Letter *Rosarium Virginis Mariae of the Supreme Pontiff John Paul II to the Bishops, Clergy and Faithful on the Most Holy Rosary*, October 16, 2002, sec. 21. Posted on the official Vatican Web site: http://www.vatican.va/holy_father/john_paul_ii/apost_letters/documents/hf_jp-ii_apl_20021016_rosarium-virginis-mariae_en.html.

59. The parallel extends back to a period long before Sprenger's brotherhood. Winston-Allen, *Stories of the Rose*, 135, notes that the earliest Marian *Ave*-psalters developed "out of the desire to imitate the liturgy of the Divine Office."

60. See chapter 3.

61. Winston-Allen, *Stories of the Rose*, 67.

62. Hieronim Taix, OP, *Libre dela institucio, manera de dir, miracles e indulgencies del roser de la verge Maria señora nuestra* (Barcelona: Pere Monpezat, 1556), fols. 9v, 14, 17, refer to "Alano de Rupe," "Miquel de Insulis" (who Taix identifies as a student of Alanus), and "Jaume Speuger."

63. Michael Franciscus de Insulis, *Determinatio quodlibetalis facta Colonie* (Basel: [Bernhard Richel?], after March 10, 1476), fol. 6. The exemplar consulted is New Haven, CT, Yale University, Beinecke Rare Book and Manuscript Library, Zi+7531.5, which is mistakenly identified and cataloged as *Quodlibet de veritate fraternitatis rosarii*. The latter is in fact a subsequent publication from 1480.

64. Ibid., fol. 6: "Omnia enim in numero pondere et mensura fecit. Sapientia undecimo."

65. Ibid., fols. 6–6v.

66. Ibid., fol. 7.

67. Ibid., fol. 6v: "quinquagenarius numerus salutationum non caret misterio."

68. Ibid.

69. "Nec est hic obmittendum quod psalmus misericordie et remissionis peccatorum qui super ceteros extollitur inter psalmos davidicos est quinquagesimus, scilicet miserere mei deus ad quem cum venisset david ut habetur de penitenţiis distinctione tercia .c. totam quamvis maximus esset peccatorum tamen meravit audire vocem domini per prophetam nathan transtulit dominus peccatum a te. Item in lege nova, quinquagesimo die datus est apostolis spiritus sanctus cum quibus etiam erat beata virgo. Non ergo mirum si eam que est mater misericordie et per quam peccata nobis relaxantur atque lex gratie nostris in cordibus infunditur sub quinquagesimo numero collocamus." Ibid., fols. 6v–7.

70. On Savonarola and the music inspired by his meditation on Psalm 50, see Patrick Macey, *Bonfire Songs: Savonarola's Musical Legacy* (Oxford: Clarendon, 1998). Psalm 50 figured into mundane tasks as well. According to one recipe for making ink at the *scriptorium* of the Jeronimite Monastery in Guadalupe, Spain, the monk was to place his ingredients into a pot and heat them over flame for just the length of time it took to recite the "Miserere Mei" twice [tanto hasta que se pueda decir dos veces el salmo "Miserere Mei"]. (This takes about three and a half minutes). See Vicente Rabanal, OSA, *Los cantorales de El Escorial* (El Escorial: Monasterio de El Escorial, 1947), 25.

71. Clare L. Costley, "David, Bathsheba, and the Penitential Psalms," *Renaissance Quarterly* 57, no. 4 (2004): 1242.

72. "las armas de la confraria de nuestra sennora del rosario que son siete rosas coloradas." Madrid, Archivo Histórico Nacional, Códices 1294B ("Ordenanzas de la cofradía

de Nuestra Señora del Rosario, Convento de Santo Domingo de Zaragoza. Siglo XVI"), fol. 3v.

73. Montserrat, Biblioteca del Monasterio, Ms. 1, *El Llibre Vermell*, so called because of its red velvet cover. On this important source of fourteenth-century music, see Higinio Anglés, "El 'Llibre Vermell' de Montserrat y los cantos y la danza sacra de los peregrinos durante el siglo XIV," *Anuario musical* 10 (1955): 45–78; and the edition by María Carmen Gómez i Muntané, *El Llibre Vermell de Montserrat: Cants i dances s. XIV* (Barcelona: Els Llibres de la Frontera, 2000).

74. Gómez i Muntané, *El Llibre Vermell de Montserrat*, 94–96.

Chapter Five

1. The most valuable introduction to mythology in Spanish Renaissance art remains Diego Angulo Iñiguez's "La mitología y el arte español del Renacimiento," *Boletín de la Real Academia de la Historia* 103 (1952): 63–209. Angulo Iñiguez attests to the prominence of the Hercules theme in Spain by dedicating nearly half of his study (121–90) to him, asserting: "Among the heroes or demigods who stand out in the façades, and also in the interiors of Spanish Renaissance monuments, none enjoyed as much favor as Hercules" (Entre los héroes o semidioses que campean en las fachadas, e incluso en los interiores de los monumentos renacentistas españoles, ninguno gozó de tanto favor como Hércules, 121). Isabel Mateo Gómez, "Algunos temas profanos en las sillerías de coro góticas españolas," *Archivo español de arte* 43, no. 170 (1970): 181–92, surveys interesting examples of pagan and profane subjects in late Medieval Spanish choir stalls. See also Mateo Gómez's "Fábulas, refranes y emblemas en las sillerías de coro góticas españolas," *Archivo español de arte* 49, no. 194 (1976): 145–60, and *Temas profanos en la escultura gótica española: Las sillerías de coro* (Madrid: Consejo Superior de Investigaciones Científicas, 1979).

2. See Angulo Iñiguez, "La mitología," 121–90; Fernando Checa Cremades, *Pintura y escultura del renacimiento en España, 1450–1600* (Madrid: Ediciones Cátedra, 1983), 205–10; Isabel Mateo Gómez, "Los trabajos de Hércules en las sillerías de coro góticas españolas," *Archivo español de arte* 48, no. 189 (1975): 43–55; Rosa López Torrijos, "Representaciones de Hércules en obras religiosas del siglo XVI," *Boletín del seminario de estudios de arte y arqueología* 46 (1980): 293–308.

3. The most familiar Labors of Hercules are the "canonical twelve" drawn from the *metopes* of the temple of Zeus at Olympia (ca. 450 BCE). These depict the Labors involving (1) the Nemean Lion, (2) the Lernean Hydra, (3) the Stymphalian birds, (4) the Cretan bull, (5) the Keryneian hind, (6) the girdle of Hippolyte, (7) the Erymanthian boar, (8) the mares of Diomedes, (9) Geryon, (10) Atlas and the Hesperides, (11) Cerberus, and (12) the Augean stables; Marianne Breidenthal, "The Legend of Hercules in Castilian Literature up to the Seventeenth Century," PhD diss., University of California, Berkeley, 1981, 16–19, 213. The versions, even the number of Labors, however, vary from one source to another, as will be discussed later. For an overview of variations on the Labors of Hercules in Greek, Latin, Italian, and Spanish literature, see Breidenthal, "Legend of Hercules," 213–21.

4. On the dates of the engraving, see note 25.

5. See Jane Campbell Hutchison, *Albrecht Dürer: A Biography* (Princeton, NJ: Princeton University Press, 1990), 152; Hans Rupprich, *Dürer Schriftlicher Nachlass*, 3 vols. (Berlin: Deutscher Verein für Kunstwissenschaft, 1956–69), 1:162.

6. David E. Aune, "Heracles and Christ: Heracles Imagery in the Christology of Early Christianity," in *Greeks, Romans, and Christians: Essays in Honor of Abraham J. Malherbe*, ed. David L. Balsch, Everett Ferguson, and Wayne A. Meeks (Minneapolis: Fortress, 1990), 3–19, explores the similarities between Hercules and Christ. See also Friedrich Pfister, "Herakles und Christus," *Archiv für Religionswissenschaft*, no. 34 (1937): 42–60; Marcel Simon, *Hercule et le christianisme* (Paris: Editions Orphrys, 1955). G. Karl Galinsky, *The Herakles Theme: The Adaptations of the Hero in Literature from Homer to the Twentieth Century* (Totowa, NJ: Rowman and Littlefield, 1972), 185–230, presents a broad overview of Hercules as *exemplar virtutis*.

7. Simon, *Hercule et le christianisme*, 177–79; Galinsky, *Herakles Theme*, 203, 227 n. 37.

8. Galinsky, *Herakles Theme*, 160, 165 n. 14. On the dates and authorship of *Ovide moralisé*, see Joseph Engels, *Études sur l'Ovide moralisé* (Groningen-Batavia: J. B. Wolters, 1945), 46–62.

9. Galinsky, *Herakles Theme*, 203–4. Pfister, "Herakles und Christus," 42–60, lists twenty-one parallels between the two.

10. Villena completed the original Catalan version of *Los doze trabajos de Hércules* on the evening before Palm Sunday (vispera de ramos) in April 1417. It was translated into Castilian by September 1417 and achieved such popularity in both languages that it survives today in no fewer than seven fifteenth-century manuscripts and two printed editions (one was published in Zamora in 1483, another in Burgos in 1499). There are also three manuscripts that date from the eighteenth century. See Enrique de Villena, *Los doze trabajos de Hércules*, ed. Margherita Morreale (Madrid: Real Academia Española, 1958), xxxvi–lxii, 3; for a synopsis of Villena's life, see ibid., viii. Emilio Cotarelo y Mori, *Don Enrique de Villena: Su vida y obras* (Madrid: "Sucesores de Rivadeneyra," 1896), offers a more extensive treatment of his life and works.

11. Consulted here was the exemplar at Toledo, Biblioteca de Castilla–La Mancha, Colección Borbón-Lorenzana, Inc. 2. For modern editions, see Villena, *Los doze trabajos* (1958); Villena, *Los doze trabajos*, in vol. 1 of *Obras completas*, ed. Manuel Arroyo Stephens (Madrid: Turner Libros, 1994). Each Labor is related in a four-part exposition recalling the "Four Senses" of Scripture known to every student of theology today—the historical, allegorical, tropological, and anagogical; see Harry Caplan, "The Four Senses of Scriptural Interpretation and the Mediaeval Theory of Preaching," *Speculum* 4, no. 3 (1929): 282–90. In evident emulation of this model, Villena adopted the following scheme: (1) a straightforward narrative of the Labor drawn from a classical source (historia nuda), (2) a moral allegory derived from that basic narrative (declaración), (3) the historical events on which the Labor was based (verdad), and (4) an application of the moral allegory to one of the twelve estates of society (aplicación). The twelve estates enumerated by Villena are prince (principe), prelate (perlado), knight (cavallero), member of religious order (religioso), citizen (cibdadano), merchant (mercader), laborer (labrador), artisan (oficial-menestral), teacher (maestro), disciple-student (discipulo), recluse (solitario), and woman (muger). See Villena, *Los doze trabajos* (1958), 79, 143–44.

12. Villena demonstrates a broad range of humanistic inquiry in his exposition of this Labor. In the *historia nuda* he cites Lucan (39–65), *Belli civilis libri decem*; in the *verdad* he cites Lucan, *Belli civilis*, Aulus Gellius (fl. 2 CE), *Noctium atticarum*, Suetonius (ca. 69–ca. 122), *De vita Caesarum*, Francesco Petrarca (1304–74), *Rerum memorandum libri*; and Juvenal (ca. 60–127), *Satyrae*. While not cited, the influence of the *Expositio virgilianae continentiae* of Fabius Planciades Fulgentius (fl. late 5–early 6 CE) is evident in the *declaración*. See Villena, *Los doze trabajos* (1958), xvi, 40–41, 44–45, and the "Tabla Sinóptica," between xxxiv and xxxv.

13. Villena cites Lucan, *Belli civilis*, for the *historia nuda*. In the *declaración* he cites Ovid (43 BCE–17/18 CE), *Metamorphoses*, Boethius (d. 524), *De consolatione philosophiae*, and Alanus de Insulis (d. 1202), *De planctu naturae*. In the *aplicación* he cites Boethius, *De disciplina scholarium*, and St. Jerome (d. 419/20), *Biblia sacra*, commentary on the *Epistola LIII* of St. Paul. The unacknowledged influence of Fulgentius is felt once again in the *declaración*: this time Villena draws from his *Mitologiarum libri tres*. See Villena, *Los doze trabajos* (1958), 83–86, 88, 92, 94, and the "Tabla Sinóptica," between xxxiv and xxxv.

14. For a popular account of the life of St. Dominic, see Jacobus de Voragine, *The Golden Legend: Readings on the Saints*, trans. William Granger Ryan, 2 vols. (Princeton, NJ: Princeton University Press, 1993), 2:44–58; on Savonarola, see Patrick Macey, *Bonfire Songs: Savonarola's Musical Legacy* (Oxford: Clarendon, 1998), 11–31.

15. See especially Robert B. Tate, "Mythology in Spanish Historiography of the Middle Ages and the Renaissance," *Hispanic Review* 22, no. 1 (1954): 1–18. Breidenthal, "Legend of Hercules," 119–55, provides a convenient summary of previous scholarship on historical conceptions of Hercules in Spain.

16. Two substantive documentary studies on the legend are Fernando Ruiz de la Puerta, *La cueva de Hércules y el palacio encantado de Toledo* (Madrid: Editora Nacional, 1977); and Fernando Aranda Alonso, Jesús Carrobles Santos, and José Luis Isabel Sánchez, *El sistema hidráulico romano de abastecimiento a Toledo* (Toledo: Instituto Provincial de Investigaciones y Estudios Toledanos, 1997), 197–270.

17. Ruiz de la Puerta, *La cueva de Hércules*, 27: "quando el grant Hércoles pasó en España e puso en ella aquellas cosas que todo el mundo sabe, fizo en Toledo una casa tan sotil e por tan grant maestría, que non te sabremos dezír cómmo es fecha nin por cúyo seso."

18. Ibid., 30: "Quando Hércoles fizo esta casa andava la era en quatro mill e seis años."

19. Ibid., 32: "cuando Ércoles fizo esta casa, andava la era de Adan en tres mill e seis años."

20. Blas Ortiz, *Summi templi toletani perquam graphica descriptio: Blasio Ortizio iuris pontificii doctore eiusdem templi canonico toletanaeque diocesis vicario generali autore* (Toledo: Juan de Ayala, 1549), fol. 9: "Bona tamen Hispaniarum pars huius urbis fundationem Herculi Lybio post interfectum Geryonem intimam Hispaniam peragranti adscribit. Quod comprobare videtur; Herculeum antrum subtus ecclesia sancti Genesii, in hac regia urbe structum, nam si urbs esset condita prius nullatenus illud vir strenuus Hercules inhabitasset." On the Libyan Hercules (Herculi Libio), see note 58.

21. Ortiz, *Summi templi*, fol. 9: "Caeterum de conditore Toleti affirmare certi nihil possum. Tametsi non desunt, qui ab Hercule fuisse conditam fabulantur." Lucio Marineo Sículo was among the Italian scholars under Isabel's patronage who had been invited to initiate humanistic studies at the Spanish court; see Breidenthal, "Legend of Hercules," 145.

22. See Pedro de Alcocer, *Hystoria, o descripción dela imperial cibdad de Toledo* (1554; facs., Toledo: Instituto Provincial de Investigaciones y Estudios Toledanos, 1973), fols. 11v–12.

23. "El año mil y quinientos y quarenta y seis, la quiso reconocer el Cardenal don Ioan Martinez Siliceo, y para este efecto la mando limpiar y prevenir. Entraron por ella algunos hombres con lanternas y cuerdas, que yvan dexando para la buelta, y con provisión de comida y bevida. Hallaronla muy fresca y humida, por ser verano, y aviendo entrado por la mañana, salieron al anochecer. Declararon con juramento, que aviendo caminado como media legua entre Levante y Setentrion, aunque a ellos les parecio que quatro leguas, por el trabajo con que yvan, toparon unas estatuas, a su parecer de bronce, sobre una ara, y que cayó una de ellas con ruydo que los espantó. Pasando adelante toparon con un golpe

de agua, que no pudieron atravesar, por no tener recado para ello, y causoles mucho miedo por la fuerça con que corría. Desde allí se bolvieron, penetrados de el frio, y de la humidad, y enfermaron, y murieron quasi todos." As quoted in Aranda Alonso, Carrobles Santos, and Isabel Sánchez, *El sistema hidráulico*, 218. A "half-league" is approximately 1.5 miles (2.4 km).

24. On the church, see ibid., 263, 265, which presents an excellent study of the Roman hydraulic system in Toledo. The extensive discussion, 197–220, of the cave of Hercules forms only part of the comprehensive and substantive approach taken.

25. Stylistic evidence and watermarks appearing on the earliest surviving prints support a date of production very near 1498; see Walter L. Strauss, ed., *The Intaglio Prints of Albrecht Dürer: Engravings, Etchings and Drypoints* (New York: Kennedy Galleries, 1977), 74–76. Hutchison, *Albrecht Dürer*, pl. 13, dates the engraving 1497–98.

26. David Landau, "The Print Collection of Ferdinand Columbus (1488–1539)," in *Collecting Prints and Drawings in Europe, c. 1500–1750*, ed. Christopher Baker, Caroline Elam, and Genevieve Warwick (Burlington, VT: Ashgate, 2003), 29–36; Mark P. McDonald, "Extremely Curious and Important! Reconstructing the Print Collection of Ferdinand Columbus," in *Collecting Prints*, ed. Baker, Elam, and Warwick, 37–54.

27. McDonald, "Extremely Curious," 40, 45.

28. On the art market in Renaissance Spain and recent research into the topic, see ibid., 38 n. 16.

29. See Jesús María González de Zárate, *Mitologia e historia del arte* (Vitoria-Gasteiz: Instituto Ephialte, Departamento de Cultura del Gobierno Vasco, 1997), 295, where the author contends, without citing any source, "The scene is known to have been titled *Great Oceanus* by the German artist and we would be able to offer that, in truth, the theme can correspond with the title it was given by the author." (La escena se sabe que fue titulada por el artista alemán como el *Gran Océano* y podriamos reparar que en verdad la tema pueda responder a su titulación por parte del artista.)

30. Fedja Anzelewsky, *Dürer-Studien: Untersuchungen zu den ikonographischen und geistesgeschichtlichen Grundlagen seiner Werke zwischen den beiden Italienreisen* (Berlin: Deutscher Verlag für Kunstwissenschaft, 1983), 51–52. Walter L. Strauss, ed., *The Complete Drawings of Albrecht Dürer*, vol. 3, *1510–1519* (New York: Abaris Books, 1974), 426, notes of the *Pupila Augusta*: "The monogram and reversed inscription indicate that the drawing was intended for an engraving corresponding in size to 'The Prodigal Son Amid the Swine' (B.28; SE.11), dated about 1496, and 'Sea Monster' (B.71; SE.23), of about 1498."

31. Jane Davidson Reid, *The Oxford Guide to Classical Mythology in the Arts, 1300–1990s* (New York: Oxford University Press, 1993), 112–13, 1054–55. See also Hesiod, *Theogony, Works and Days, Shield*, trans. Apostolos N. Athanassakis (Baltimore: Johns Hopkins University Press, 1983), 17–18 (ll. 188–206).

32. See, for example, the depiction of Venus and her attributes reproduced in Jean Seznec, *The Survival of the Pagan Gods: The Mythological Tradition and Its Place in Renaissance Humanism and Art*, trans. Barbara F. Sessions (New York: Pantheon, 1953), 181. Furthermore, Anne Winston-Allen, *Stories of the Rose: The Making of the Rosary in the Middle Ages* (University Park: Pennsylvania State University Press, 1997), 82, notes, "In Greek tradition the red rose was associated with the blood of a god. It is said to have originated when a thorn pierced Aphrodite's foot. As the flower of Aphrodite, it became associated with the Roman cult of Venus." See also Reid, *Oxford Guide to Classical Mythology*, 26: "as Aphrodite hastened to the side of dying Adonis, her foot was pierced by the thorn of the rose; her blood, staining the white flower's petals, turned them henceforth red." Finally, see the sources cited by Sir James George Frazer, *The Golden Bough: A Study in Magic and Religion*,

pt. 4, vol. 1, *Adonis, Attis, Osiris: Studies in the History of Oriental Religion*, 3rd ed. (New York: Macmillan, 1935), 226.

33. Albricus, *De deorum imaginibus libellus*, quoted in Seznec, *Survival of the Pagan Gods*, 205. On the identity of Albricus and his influence during the Renaissance, see ibid., 170–79.

34. On the symbolism of the red and white roses and their particular arrangement in the rosary, see also chapter 4.

35. Chandler Rathfon Post, *A History of Spanish Painting*, vol. 9, pt. 2, *The Beginning of the Renaissance in Castile and Leon* (Cambridge, MA: Harvard University Press, 1947), 825: "The painter is so carried away by his enthusiasm for the dawning Renaissance as actually to dare to depict, as if classical statuettes embellishing further niches at the piers' bases, two nudes, a woman toying with a bird (Venus?) and a man with a club (Hercules?)."

36. See the relevant iconography in Seznec, *Survival of the Pagan Gods*, 181, 204–5, 207, 239. It seems unlikely that the cherubic nudes in the border painting of the Kyriale represent the Graces, since the three (possibly four) nudes on the shore of Dürer's engraving have been reduced to only two in the chantbook. On the antique motif of the three Graces, see ibid., 208–9.

37. See also Dürer's *Venus, Cupid, and Hercules* (W.711; ca. 1506) and *Venus and Cupid, the Honey Thief* (W.665; 1514). The "W" refers to the entry number in Friedrich Winkler, *Die Zeichnungen Albrecht Dürers*, 4 vols. (Berlin: Deutscher Verein für Kunstwissenschaft, 1936–39).

38. See Hutchison, *Albrecht Dürer*, 42–47.

39. See Walter L. Strauss, ed., *The Complete Engravings, Etchings and Drypoints of Albrecht Dürer* (New York: Dover, 1972), 46; Erwin Panofsky, *The Life and Art of Albrecht Dürer* (Princeton, NJ: Princeton University Press, 1955), 73; Giulia Bartrum, *Albrecht Dürer and His Legacy: The Graphic Work of a Renaissance Artist* (Princeton, NJ: Princeton University Press, 2002), 121; Anzelewsky, *Dürer-Studien*, 45; Hutchison, *Albrecht Dürer*, 55–56.

40. Anzelewsky, *Dürer-Studien*, 45–46, 56.

41. Ibid., 46.

42. Panofsky, *Life and Art*, 73.

43. Ibid.

44. Hutchison, *Albrecht Dürer*, 57. For a relevant contribution on this topic, see Wolfgang Schmid, *Dürer als Unternehmer: Kunst, Humanismus und Ökonomie in Nürnberg um 1500* (Trier: Porta Alba, 2003).

45. Gudrun Ahlberg-Cornell, *Herakles and the Sea-Monster in Attic Black-Figure Vase-Painting* (Stockholm: Svenska Institutet i Athen, 1984), 5.

46. Apollodorus, *The Library*, trans. Sir James George Frazer, vol. 1 (Cambridge, MA: Harvard University Press, 1961), 205–9 (2.5.9).

47. Alfonso X, *General estoria. Segunda parte*, eds. A. C. Solalinde, Lloyd A. Kasten, and Victor R. B. Oelschlager, vol. 2 (Madrid: Consejo Superior de Investigaciones Científicas, 1961), 5.

48. Ibid., 53–56.

49. Breidenthal, "Legend of Hercules," 98–100; Seznec, *Survival of the Pagan Gods*, 224. Three fifteenth- and sixteenth-century sources for the *Genealogie deorum* in Spanish translation are cited by Charles B. Faulhaber, Ángel Gómez Moreno, David Mackenzie, John J. Nitti, and Brian Dutton (with the assistance of Jean Lentz), *Bibliography of Old Spanish Texts*, 3rd ed. (Madison: Hispanic Seminary of Medieval Studies, 1984): (#1130) Madrid, Fundación Lázaro-Galdiano, Ms. 657; (#1651) Madrid, Biblioteca Nacional, Mss. 10062 (formerly Toledo, Librería del Cabildo, Ms. 103–25); and (#1726) Madrid, Biblioteca Nacional, Mss. 10221.

50. Madrid, Biblioteca Nacional, Mss. 10062 (formerly Toledo, Librería del Cabildo, Ms. 103–25). Unfortunately, the source is incomplete and, while consulted, was of little practical use here.

51. Giovanni Boccaccio, *Genealogiae deorum* (Venice: Bonetus Locatellus, 1494), fol. 95: "Cuius labores praecipuos fere omnes duodecim tantum fuisse confirmant: cum .xxxi. esto non omnes aequos fuisse comperiam." All excerpts are from the edition at Toledo, Biblioteca de Castilla–La Mancha, Inc. 93.

52. Ibid., fol. 95v: "Vigesimoprimo Hesionam Laomedontis filiam liberavit a monstro marino: ut supra patet ubi de Laomedonte. Vigesimosecundo Troiam delevit: ut ubi de Laomedonte plenius." According to Boccaccio's enumeration, the battle with Antaeus was twelfth in the series and the battle with the Hesperian dragon fourteenth.

53. Ibid., fol. 48v: "Laomedon rex Troiae, filius fuit Ilionis: ut scribitur in Iliade ab Homero. Hunc dicunt veteres voluisse Ilionem muris circumdare: et cum Apolline et Neptunno aquis convenisse: ut ipsi muros facerent mercede promissa: et observandi iuramento praestito. Qui cum fecissent: nec sibi promissum servari cernerent: omnis Troia a Neptunno aquis repleta est: et Apollo ipsum misit pestem. Quam ob rem anxius Laomedon de remedio oraculum consuluit: cui responsum oportere quotannis virginem Troianam ceto marino, scilicet monstro exponere. Quod sorte apud troianos fiebat. Tandem Hesioni Laomedontis filiae sors contigit. Quae cum in scopulo religata monstrum expectaret: advenit Hercules qui cum Laomedonte pactionem fecit: videlicet si liberaret a monstro filiam: sibi equos divine semine procreatos: quos constabat Laomedontem habere: largiretur: Attamen cum Hercules virginem liberasset noluit Laomedon servare promissum. Quam ob rem: seu ut aliis placet, quia dum Illam puerum perditum quereret: a Laomedonte portu Troiano prohibitus est: et ideo cum amploribus copiis venies Ilionem expugnavit: et Laomedontem occidit: et omnia eius vertit in praedam." Galinsky, *Herakles Theme*, 109–22, notes that some sources speak of the boy Hylas as Hercules's lover.

54. Boccaccio, *Genealogiae deorum*, fol. 48v: "Is appositis quid sibi velit fictio videamus. Volunt enim apud Troianos pecuniam fuisse in sacra Neptuni: atque Apollonis reservatam: quam Laomedon iureiurando praestito se non solum eandem restituturum: sed insuper ex propria largiturum in predictis sacris in aedificatione murorum civitatis expendit: nec tandem petentibus pecuniam restituere voluit. Sane adveniente postea aquarum inundatione: et post eam non satis a sole digestam: ut fit aer infectus aquarum putredine pestem intulit: quae duo quoniam ad Apollonem et Neptunum pertinere videntur: adinventum est ea ob periurium a deceptis diis inmissa. Quod virgines monstro appositae sint responso oraculi: cum sic illos deciperet persaepe diabolus: possibile puto et hinc historiam habere caetera arbitror. Fuere huic filii filiaeque plures: quanquam solus Priamus esset ei in regno successor."

55. See Breidenthal, "Legend of Hercules," 217–18.

56. Juan Pérez de Moya, *Philosophia secreta*, ed. Eduardo Gómez de Baquero, 2 vols. (Madrid: Campañia Ibero-Americana de Publicaciones, 1928), 1:213–17.

57. Ibid., 217: "Por el perjuro de Laomedon contra Apolo y Neptuno, nos pintan un hombre desagradecido, que en sus necesidades se vuelve a Dios con grandes ruegos y promesas, y alcanzando lo que pretende, no se acuerda dél, por lo cual merece el castigo de la inundación de las aguas que le quiten toda su hacienda, dejándole en la miseria, que se dice déste rey. El ser también perjuro a Hércules, denota que quien a Dios es desagradecido, también lo es a los hombres. Finalmente, los sabios antiguos nos exhortan por esta fábula la Religión y verdad en los contratos."

58. Alcocer, *Hystoria*, fols. 6–7. These two generations of Hercules, in particular the Egyptian Hercules, reflect in part the influence of the Italian Dominican Giovanni Nanni

(Annius of Viterbo) who flattered the rising house of Castile in 1498 with his *Commentaria super opera auctorum diversorum de antiquitatibus loquentium*, an important section of which is titled "De primus temporibus et quatuor ac viginti regibus primis hispaniae et eius antiquitate." Dedicated to the Catholic Monarchs of Spain, Fernando and Isabel, Nanni claims there was a tradition of Spanish literature that predated the Greeks by eight centuries and lists Spanish kings from six hundred years before Troy was founded. Most important here, playing to contemporary interests in pre-Greek mythology, Hercules (or Oron Libio) is described as the son of the Egyptian Osiris. It is this Hercules and his descendants who round out Nanni's list of Spanish monarchs predating the Trojan era. See Tate, "Mythology in Spanish Historiography," 11–13; Breidenthal, "Legend of Hercules," 144–45.

As noted in note 20, Blas Ortiz acknowledged a Libyan Hercules (Herculi Lybio) in his *Summi templi toletani* (Toledo, 1549). Florian de Ocampo, *Los cinco libros primeros dela Crónica general de España* (1553; repr., Vitoria-Gasteiz: Gráficas Santamaria, 1997), also distinguishes between "Oron Libio, called by the other name, Egyptian Hercules" (fol. 42, Oron Libio, llamdo por otro nonbre Hercoles Egypçiano), and the Greek "Hercoles Alçeo," captain of the Argonauts (fol. 67v). For Ocampo's discussion of the historical Hercules, see his chapters 13–15, 18, and 29. The concept of two Herculeses finds precedents in the works of Herodotus (ca. 484–ca. 430/20 BCE), who had also distinguished between an Egyptian Hercules and a Greek Hercules, and the Roman mythographer Marcus Terentius Varro (116–27 BCE), who enumerated at least forty-three different figures who bore the name Hercules. See Aune, "Heracles and Christ," 5–6.

59. Alcocer, *Hystoria*, fol. 6: "La quinta generacion fue, de Hercules Lybico, o Egypcio hijo del dicho Osiris, que poco despues vino a España con muchas gentes contra los dichos Geriones: conlos quales ovo batalla, en que los vencio, y mato: cuyos cuerpos fueron sepultados enla ysla de Caliz: segun escrive Philostrato en la vida de Apolonio." Compare with book 5, chapters 1–5, in Philostratus, *The Life of Apollonius of Tyana: The Epistles of Apollonius and the Treatise of Eusebius*, vol. 1, trans. F. C. Conybeare (Cambridge, MA: Harvard University Press, 1948), 467–75.

60. Alcocer, *Hystoria*, fol. 7: "La novena generacion de gentes fue de otros muchos Griegos, que de mas de los sobre dichos vinieron a España: adonde poblaron muchas poblaciones (segun lo escriven Iustinio, Estrabon, Plinio, Tito Livio, y otros muchos escriptores) y el primero destos que vino a España, fue Hercules Griego, con otros cossarios sus compañeros que viniendo de la ysla de Colchos, de robar los thesoros a el rey Aeta, aribo en España: adondo (segun escrive Estrabo, alegando a Thimostenes) edifico y poblo la cibdad, llamada Heraclea, que por otro nombre se llam Calpe, del nombre del monte: en cuya rayz, la edifico: a que despues llamaron los Moros, Gibraltar: En la qual Hercules dexo algunos de sus compañeros: y el se torno a sus naves, sin que se sepa, que entrasse mas a dentro de España. Y no mucho despues, vino a ella Teukro, hijo de Thelamon rey de Egina: y assento con sus compañeros en Galicia."

61. For modern editions, see Apollonios Rhodios, *The Argonautika: The Story of Jason and the Quest for the Golden Fleece*, trans. with introduction, commentary, and glossary by Peter Green (Berkeley: University of California Press, 1997); Gaius Valerius Flaccus, *The Voyage of the Argo: The Argonautica of Gaius Valerius Flaccus*, trans. David R. Slavitt (Baltimore: Johns Hopkins University Press, 1999).

62. Peter Green has commented on the stark contrast posed by Hercules's superhuman abilities and Jason's relative inadequacy or resourcelessness in the Argonautic legend. See his introduction to Apollonios Rhodios, *The Argonautika*, 17, 34, 36–37, 39–40. In dispensing with Jason altogether, Alcocer might have exploited this inherent disparity to highlight the accomplishments of Hercules.

63. The connection is explicit in book 6, chapter 8, entitled "De Hesiona Laomedontis filia et Teucri matre." As outlined there: "Hesiona filia fuit Laomedontis: quae cum primo: ut supra dictum est: fuisset a monstro marino ab Hercule liberata: postmodum ab eodem Hercule: deiecto Ilione et occiso Laomedonte: capta est: et Thelamoni: quonium primus muros conscendisset civitatis in partem predae concessa est. Qui eam Salaminam detulit: et cum frustra saepius a Priamo repetita esset: Thelamoni Teucrum peperit" (Boccaccio, *Genealogiae deorum*, fol. 48v).

64. Alcocer, *Hystoria*, fol. 7v: "La decima generacion de gentes, que a España vinieron, fue de los Troyanos: que poco despues de la ultima guerra Troyana, vinieron a ella con un capitan Troyano, llamado Anthenor: el qual (segun escrive Estrabo) vino a España y assento en la provincia de Cantabria: adonde el, y los con que el vinieron, edificaron una cibdad llamada, Obcisela, y por otro nombre, Lactisma: y que moro con sus hijos, y familia al tiempo que yvan a Ytalia, que vinieron a España otros muchos Troyanos con un capitan llamado Astur, criado o compañero de Menon que los poetas fingen que era hijo del Alva: el qual assento conlos suyos enlas Asturias, y las poblo, y dio nombre."

Chapter Six

1. The scholarly repertory on tropes is extensive and varied. For general discussions see David Hiley, "Tropes," in *Western Plainchant: A Handbook* (1993; repr. Oxford: Clarendon, 1995), 196–238; Eva Castro Caridad, *Tropos y troparios hispánicos* (Santiago de Compostela: Universidad de Santiago de Compostela, Servicio de Publicaciónes e Intercambio Científico, 1991), 17–58.

2. In addition to the basic sources cited in appendix C.1, I also consulted Gunilla Iversen, *Corpus troporum*, vol. 4, *Tropes de l'Agnus Dei* (Stockholm: Almqvist & Wiksell International, 1980); the more specialized lists of tropes in Castro Caridad, *Tropos*; and Ismael Fernández de la Cuesta, *Manuscritos y fuentes musicales en España: Edad media* (Madrid: Editorial Alpuerto, 1980).

3. On the distinctions among *melogene*, *logogene*, and *meloform* (an added musical phrase without added text), see Ritva Jonsson, "Corpus troporum," *Journal of the Plainsong & Mediaeval Society* 1 (1978): 102; Hiley, "Tropes," 196.

4. See Kathleen E. Nelson, *Medieval Liturgical Music of Zamora*, Musicological Studies 67 (Ottawa: The Institute of Mediaeval Music, 1996), 10–19; Ismael Fernández de la Cuesta, *Historia de la música española. 1. Desde los orígenes hasta el ars nova*, 2nd ed. (Madrid: Alianza Editorial, 1988), 217–28; Ismael Fernández de la Cuesta, "La irrupción del canto gregoriano en España: Bases para un replanteamiento," *Revista de musicología* 8 (1985): 239–48; Michel Huglo, "La pénétration des manuscrits aquitains en Espagne," *Revista de musicología* 8 (1985): 249–56; Castro Caridad, *Tropos*, 53–58. On Old-Hispanic chant, see especially Clyde W. Brockett, *Antiphons, Responsories and Other Chants of the Mozarabic Rite*, Musicological Studies 15 (New York: Institute of Mediaeval Music, 1968); Don Michael Randel, *The Responsorial Psalm Tones for the Mozarabic Office*, Princeton Studies in Music 3 (Princeton, NJ: Princeton University Press, 1969).

5. Castro Caridad, *Tropos*, 195–97, examines the arguments regarding its origins in Toulouse or Urgell. Montserrat 73 was acquired by the Benedictine abbey of Montserrat in 1919.

6. Ibid., 165–66, 171–73. Salamanca 2637 was acquired by the Biblioteca Universitaria de Salamanca in 1954.

7. Ibid., 182–83, contends that Toledo 35-10 was copied from a French model in Toledo as early as the end of the twelfth century. I favor the more conservative estimate of "thirteenth century" found in German Prado, "El kyrial español," *Analecta sacra tarraconensia* 14 (1941): 102; José Janini and Ramón Gonzálvez, *Catálogo de los manuscritos litúrgicos de la catedral de Toledo* (Toledo: Diputación Provincial, 1977), 106; Fernández de la Cuesta, *Manuscritos y fuentes*, 175–76.

8. See the description in José Janini and José Serrano, *Manuscritos litúrgicos de la Biblioteca Nacional* (Madrid: Dirección General de Archivos y Bibliotecas, 1969), 284–85.

9. Prior to his tenure as archbishop of Toledo from 1086 to 1124, Bernard had been appointed by Hugh of Cluny as abbott of the Cluniac monastery of Sahagún (about 55 km southeast of León, Spain). His influence as Toledan archbishop expanded considerably in 1088 when Pope Urban II (Otto of Lagery, b. ca. 1042; prelacy 1088–99) issued a Bull that conferred upon Toledo primacy over all Spanish churches. Other notable Frenchmen who assisted in implementing the new Roman-Carolingian rite in Toledo and elsewhere include the cantors Bernard of Périgord, Bernard of Agen, and the Cluniac Gerald of Moissac who later served as bishops of Zamora, Sigüenza, Santiago de Compostela, and Braga (Portugal). See Nelson, *Medieval Liturgical Music of Zamora*, 14; *The Catholic Encyclopedia*, s.v. "Toledo"; Fernández de la Cuesta, *Historia de la música*, 222; José Miranda Calvo, *La reconquista de Toledo por Alfonso VI* (Toledo: Instituto de Estudios Visigótico-Mozárabes de San Eugenio, 1980), 137–72.

10. German Prado, *Supplementum ad kyriale ex codicibus hispanicis excerptum* (Paris: Desclée & Socii, 1934), Kyrie I, lists the source for his melody as an eleventh-century manuscript of San Millán de Cogolla.

11. Margareta Melnicki, *Das einstimmige Kyrie des lateinischen Mittelalters*. Forschungsbeiträge zur Musikwissenschaft 1 (Regensburg: Gustav Bosse Verlag, 1955), 103, 121–22.

12. Prado, *Supplementum*, Kyrie III, notes only that his melody is from a manuscript of Santo Domingo de Silos. No date is specified.

13. Beyond the first three words, the "O pater immense" in the Rosary Cantoral is entirely distinct from the text given in Clemens Blume and Guido M. Dreves, eds., *Analecta hymnica medii aevi*, vol. 47, *Tropen des Missale im Mittelalter* (Leipzig: O. R. Reisland, 1905), 98–99 (33).

14. See the description and inventory in Ismael Fernández de la Cuesta, "A propósito de un 'Manuale chori' de 1539," in *De música hispana et aliis: Miscelánea en honor al Prof. Dr. José López-Calo, S.J., en su 65° cumpleaños*, vol. 1, ed. Emilio Casares and Carlos Villanueva (Santiago de Compostela: Universidade de Santiago de Compostela, 1990), 263–74.

15. This very source (Granada, *Officia ad missas*, 1544) commemorates the occasion with a frontispiece depicting the surrender of Granada by Sultan Boabdil (Abu 'abd Allah Muhammad XI, d. 1527) to King Fernando (1452–1516), Queen Isabel (1451–1504), and the powerful Toledan cardinal Pedro González de Mendoza (b. 1428; prelacy 1482–95). Francisco Bermudez de Pedrazas, *Historia eclesiastica, principios, y progresos de la ciudad, y religion catolica en Granada* (Granada, 1638), fols. 169v–171, 172–173v, describes the surrender of Granada and subsequent implementation of Toledan musical-liturgical practices.

16. The rubric for the Kyrie indicates: "in Sabbatis Beate Marie Virginis tantum quando fit eius officium." The rubric for the Gloria is similar: "in festis Beatissime Virginis Marie et in Sabbatis quando fit eius officium." On the history of the Marian trope for the Gloria, see Bernhold Schmid, *Der Gloria-Tropus Spiritus et alme bis zur Mitte des 15. Jahrhunderts*, Münchener Veröffentlich zur Musikgeschichte 46 (Tutzing: Hans Schneider, 1988).

17. *Liber Usualis* (Tournai: Desclée & Co., 1953; repr., Great Falls, MT: St. Bonaventura, 1997), 40–42. On the traditional linking of "Spiritus et alme" with Gloria IX (Bosse 23), see Schmid, *Der Gloria-Tropus Spiritus*, 13; Hiley, "Tropes," 161.

18. It is coarse, in my view, because of the inelegant "flamen amen" that brings the verse to a clumsy end. One gets the impression that the "amen" was merely tacked on to obtain the required sixth metrical foot.

19. Gunilla Iversen, *Corpus troporum*, vol. 7, *Tropes de l'ordinaire de la messe: Tropes du Sanctus* (Stockholm: Almqvist & Wiksell International, 1990), 49, 122–23, 160, 187, 405, 407–8.

20. Ibid., 122–23, 160. On the contents and origins of concordant manuscripts (Tortosa, Biblioteca Capitular, Ms. 135; Huesca, Biblioteca Capitular, Ms. 4; Montserrat, Biblioteca del Monasterio, Ms. 73), see Castro Caridad, *Tropos*, 127–39, 143–56, 189–97.

21. Madrid, Biblioteca Nacional, Ms. 19421. See Iversen, *Corpus troporum*, vol. 7, *Tropes du Sanctus*, 264.

22. The rubric on fol. 214v reads: "In sabbatis cum dicitur missa de Beata Virgine Maria."

23. Peter Josef Thannabaur, *Das einstimmige Sanctus der römischen Messe in die handschriftlichen Überlieferung des 11. bis 16. Jahrhunderts*. Erlanger Arbeiten zur Musikwissenschaft 1 (Munich: Walter Ricke, 1962), 142. The similarities are evident at the first and third statements of "Sanctus" and from "Dominus deus sabaoth" forward. On the contents and origins of concordant manuscripts (Madrid, Biblioteca Nacional, M1361; Tortosa, Biblioteca Capitular, Ms. 135; Barcelona, Biblioteca del Orfeó Català, Ms. 1), see Janini and Serrano, *Manuscritos litúrgicos*, 284–85; Castro Caridad, *Tropos*, 127–39; Fernández de la Cuesta, *Manuscritos y fuentes*, 77.

24. "Notandum que in duplicibus et dominicis diebus dicitur prosa post sanctus," fol. 77.

25. See the edition in Iversen, *Corpus troporum*, vol. 7, *Tropes du Sanctus*, 178, where listed concordances reveal a particular concentration in southern France (Limoges, Moissac, Narbonne) and northern Spain (Gerona, Huesca, Tortosa, Vich). Castro Caridad, *Tropos*, 311, erroneously classifies this trope as unique to Spain.

26. This text was transcribed directly from the manuscript, Madrid 1361: Osanna salvifica concinentes in hac aula / Et eterna celi premia / Consequamur celi gracia / De culpis expiati celesti venia / Cum sanctis mereamur ditari laurea / Letantes sancta patria / Super celi palacia / In excelsis.

27. According to St. Jerome (*Epistola*): "Osi ergo salvifica interpretatur; anna interiectio deprecantis est. Si ex duobus hi velis compositum verbum facere, dices osianna, sive ut nos loquimur, osanna, media vocali littera elisa." St. Isidore's explanation (*Etymologiae*) is clearly derived from Jerome's: "Osi enim salvifica interpretatur; anna interiectio est, motum animi significans sub deprecantis affectu. Integre autem dicitur osianna, quod nos, corrupta media vocabuli littera, et elisa, dicimus osanna sicut fit in versibus cum scandimus." As cited in Iversen, *Corpus troporum*, vol. 7, *Tropes du Sanctus*, 43.

28. See note 3.

29. "In festis duplicibus majoribus et in festivitatibus beate virginis" (fol. 81v). A tab sewn onto the folio labels the chant in Castilian as "Agnus de Nuestra Señora."

30. Higinio Anglés, ed., *El códex musical de Las Huelgas (Música a veus dels segles XIII–XIV)*, 3 vols. (Barcelona: Institut d'Estudis Catalans, Biblioteca de Catalunya 1931); Gordon A. Anderson, ed., *The Las Huelgas Manuscript: Burgos, Monasterio de Las Huelgas*, 2 vols., Corpus Mensurabilis Musicae 79 (Neuhassen-Stuttgart: American Institute of Musicology, Hanssler-Verlag, 1982); Juan Carlos Asensio Palacios and Josemi Lorenzo Arribas, eds., *El códice de Las Huelgas* (Madrid: Fundación Caja, Editorial Alpuerto, 2001).

31. Martin Schildbach, *Das einstimmige Agnus Dei und seine handschriftliche Überlieferung von 10. bis zum 16. Jahrhunderts* (Erlangen-Nürnberg: J. Hogl, 1967), 110, 196; Blume and Dreves, eds., *Analecta hymnica*, 47, 398 (453).

32. On the origins of Tortosa 135 and Orfeó Catalá 1, see Castro Caridad, *Tropos*, 127–39; Fernández de la Cuesta, *Manuscritos y fuentes*, 77.

33. Castro Caridad, *Tropos*, 139.

34. See the discussions by Karl-Werner Gümpel, "El canto melódico de Toledo: Algunas reflexiones sobre su origen y estilo," *Recerca musicológica* 8 (1988): 25–46; and Ismael Fernández de la Cuesta, "El canto toledano, estrato musical en la polifonía sacra de la catedral de Las Palmas y otras iglesias de España," *El Museo Canario* 54 (1999): 305–38. I am grateful to Prof. Fernández de la Cuesta for providing me with a copy of his article.

35. Barcelona, Biblioteca de Catalunya, Ms. 1325. A modern edition of the treatise is given in Gümpel, "El canto melódico de Toledo," 38–45. The original was consulted here.

36. "con que el canto lano pareciesse más dulce cantando, como paresce en las cantorías de la missa mosarue antiquíssimas en Toledo y su yglesia." Barcelona, Ms. 1325, fol. 21. The "Mozarabic Mass" refers to a Catholic liturgy celebrated by Christians in Toledo while living under Muslim rule from the early eighth century until the Roman rite was reintroduced after the reconquest in 1085. For relevant studies on the Mozarabic liturgy, see Randel, *Responsorial Psalm Tones*; Brockett, *Antiphons, Responsories and Other Chants*.

37. "Tocus es figura sicut brevis con dos plicas azia riba [diagram], fue inventada en senyal de repelar la vos aza riba y tornar al mesmo puncto en lugar de melodía." Barcelona, Ms. 1325, fol. 21v.

38. "Uncus est figura como breve con dos plicas azia baxo [diagram], y fue inventada para repelar la voz azia baxo y tornar al mesmo puncto." Ibid.

39. "Y estas dos laman en Toledo estrunto." Ibid.

40. See the relevant discussion on rhythm in chant in Richard Sherr, "The Performance of Chant in the Renaissance and Its Interactions with Polyphony," in *Plainsong in the Age of Polyphony*, ed. Thomas Forrest Kelly (Cambridge: Cambridge University Press, 1992), 178–208.

41. On this point, see the relevant observations in Jack Eby, "Chant-Inspired Music in the Chapel of Louis XVI," in *Chant and Its Peripheries: Essays in Honour of Terence Bailey*, ed. Bryan Gillingham and Paul Merkley, Musicological Studies 72 (Ottawa: The Institute of Mediaeval Music, 1998), 391. I am also indebted to organist Ed Pepe of Oaxaca, Mexico, for his thoughts on the role of plainchant in Spanish and Mexican organ music.

42. Albert Smijers, ed., *Werken van Josquin Des Prez. Missen XVII. Missa sine nomine* (Amsterdam: Vereniging voor Nederlandse Musiekgeschiedenis, 1952), 177–78.

43. The Josquin fragment was first identified by Craig Wright in "A 16th Century Plainsong Manuscript at Yale," unpublished paper delivered at a conference in honor of David Hughes at Harvard University, Cambridge, MA, in 1990. I thank Professor Wright for sharing his paper with me.

44. "In festis beatissime virginis marie," fol. 64v. A tab sewn onto the folio labels the chant in Castilian as "Credo de Nuestra Señora."

45. On the "L'homme armé" phenomenon in Renaissance music and culture, see Craig Wright, *The Maze and the Warrior: Symbols in Architecture, Theology, and Music* (Cambridge, MA: Harvard University Press, 2001), 164–205, and the conspectus of Masses on "L'homme armé" on 288.

46. There is a celebrated precedent for setting the tune against itself in the third Agnus Dei of Josquin's *Missa L'homme armé sexti toni*. Josquin's example is far more complex,

however, since he set the prime form of the "B section" in the tenor against a simultaneous unfolding of the "A section" in retrograde in the bass, then reversed the process from the midpoint of the movement to the end; that is, with "B" moving in retrograde in the tenor against "A" unfolding in its prime form in the bass. See ibid., 189.

47. François Reynaud, *La polyphonie tolédane et son milieu des premiers témoignages aux environs de 1600* (Paris: CNRS Éditions, 1996), 272, 279; Robert J. Snow, ed., *A New-World Collection of Polyphony for Holy Week and the Salve Service: Guatemala City, Cathedral Archive, Music MS 4*, Monuments of Renaissance Music 9 (Chicago: University of Chicago Press, 1996), 29.

48. Cf. John 1:14.

49. El Escorial, Monasterio de San Lorenzo de El Escorial, Cantoral 210, sign. S-1, Kyriale, fols. 86v–87. I am very grateful to Fr. Jafet Ortega, OSA, for allowing me to see this manuscript during a period of renovation at El Escorial.

50. The inclusion of this faburden is interesting in light of the ongoing debate regarding the use of polyphony at El Escorial. Philip II seems to have prohibited its use in the Escorial's letter of foundation dated 1567—a position he reaffirmed in 1592. According to José de Sigüenza's important chronicle of El Escorial from 1605, however, the Jeronymite monks did "raise the voice and the spirit to the Lord with a plain consonance which they call *fabordones*" (levantasen la voz y el espíritu al Señor con una consonancia llana que llaman fabordones). Sigüenza, *La fundación del monasterio de El Escorial* (1605; repr. Madrid: Aguilar, 1963), 333. The "Et incarnatus est" discussed here supports Sigüenza's observation and provides at least one instance during which such *fabordones* were performed. For differing views on the use of polyphony at El Escorial, compare Michael J. Noone, *Music and Musicians in the Escorial Liturgy under the Habsburgs, 1563–1700* (Rochester, NY: University of Rochester Press, 1998), 87–90, 187; and José Sierra Pérez, *Música para Felipe II Rey de España (Homenaje en el IV centenario de su muerte)* (El Escorial: San Lorenzo de El Escorial, 1998), 23–26.

51. The regularity with which the "Et incarnatus est" was performed polyphonically might account for the absence of text underlay in the excerpt on "L'homme armé" transmitted by the Rosary Cantoral. It is telling that several polyphonic manuscripts at Toledo Cathedral include settings of the "Et incarnatus est" section alone. There are two by Cristóbal de Morales (ca. 1500–53) in Toledo, Biblioteca Capitular, Mss. B.16 and B.33. Another by Ginés de Bolunda (ca. 1545–after 1604) is in Toledo, Biblioteca Capitular, Ms. B.33. Both Morales and Ginés de Bolunda served as chapelmasters at the Cathedral of Toledo.

52. Henry Kamen, *Empire: How Spain Became a World Power, 1492–1763* (New York: HarperCollins, 2003), 183–84; Kamen, *Philip of Spain* (New Haven, CT: Yale University Press, 1997), 138–39.

53. Kamen, *Empire*, 185.

54. Juan López, OP, *Libro en que se trata de la importancia y exercicio del santo rosario* (Zaragoza: Domingo Portonariis y Ursino, 1584), fol. 166v.

55. "en memoria, y agradecimiento perpetuo de la milagrosa victoria que el Señor dio al pueblo esse día contra la armada del Turco." Ibid.

56. "piadosamente se cree, que por los meritos de la Virgen, y por las oraciones de los cofrades (que aquel mismo domingo y hora andavan por toda la Christianidad en su acostumbrada procession, rogando por la Iglesia) hizo el Señor aquella merced tan grande a la Christianidad." Ibid.

57. Marina Warner, *Alone of All Her Sex: The Myth and the Cult of the Virgin Mary* (New York: Vintage Books, 1983), 308. This particular legend goes back only as far as the writings

of Alanus de Rupe in the late fifteenth century. Anne Winston-Allen, *Stories of the Rose: The Making of the Rosary in the Middle Ages* (University Park: Pennsylvania State University Press, 1997), 72, asserts that no connection between St. Dominic and the rosary existed before then.

58. Wright, *The Maze and the Warrior*, 288.

59. See the discussion and representative painting by Piero della Francesca (ca. 1416–92) in Warner, *Alone of All Her Sex*, 326–27, and plate VIII.

60. Linda B. Hall, *Mary, Mother, and Warrior: The Virgin in Spain and the Americas* (Austin: University of Texas Press, 2004), 46–47. In plate III, Hall reproduces Alejo Fernández's *Virgin of the Navigators* (ca. 1535), depicting Mary with an outstretched mantel that protects the Spanish nobility, their maritime explorers, and, beneath them, a flotilla.

61. The metaphor of the knight's armor for Christian virtues to guard against life's challenges goes back to St. Paul's letter to the Ephesians 6:11–17: "Put you on the armour of God, that you may be able to stand against the deceits of the devil. For our wrestling is not against flesh and blood; but against principalities and power, against the rulers of the world of this darkness, against the spirits of wickedness in the high places. Therefore take unto you the armour of God, that you may be able to resist in the evil day, and to stand in all things perfect. Stand therefore, having your loins girt about with the truth, and having on the breastplate of justice, and your feet shod with the preparation of the gospel of peace: In all things taking the shield of faith, wherewith you may be able to extinguish all the fiery darts of the most wicked one. And take unto you the helmet of salvation, and the sword of the Spirit (which is the word of God)." For the subsequent development of this theme, see Wright, *The Maze and the Warrior*, 169–74.

62. Fols. 1v, 2v, 32, 32v.

63. Even Martin Luther, a musician himself, went so far as to confer a god-like status on Josquin, remarking. "Josquin is the master of the notes. They must do as he wishes. The other composers must do as the notes wish." See the relevant commentary in Patrick Macey, "Josquin as Classic: *Qui habitat*, *Memor esto*, and Two Imitations Unmasked," *Journal of the Royal Musical Association* 118, no. 1 (1993): 3, 6–7.

64. Robert Stevenson, "Josquin in the Music of Spain and Portugal," in *Josquin des Prez: Proceedings of the International Josquin Festival-Conference Held at The Juilliard School at Lincoln Center in New York City, 21–25 June 1971*, ed. Edward E. Lowinsky with Bonnie Blackburn (New York: Oxford University Press, 1976), 215–67, remains the most useful overview.

65. Ibid., 220–22.

66. Ibid., 220; Reynaud, *La polyphonie tolédane*, 112–15.

67. Toledo, Biblioteca Capitular, Ms. B.9, fol. 115v.

68. Here I fully embrace the interpretation offered only tentatively by Peter Urquhart as a postscript to his article "An Accidental Flat in Josquin's *Sine Nomine* Mass," in *From Ciconia to Sweelinck: Donum natalicium Willem Elders*, ed. Albert Clement and Eric Jas (Amsterdam: Editions Rodopi, 1994), 144.

Chapter Seven

1. "das derselbigen menschen gebet, als die heilig geschrifft sagt, got behäglicher und gefelliger dann der reychen und hoch geachtten menschen ist." Jakob Sprenger, OP, *Erneuerte Rosenkranz-Bruderschaft* (Augsburg: Bämler, 1476), fol. 2v. Transcribed from the exemplar at New York, Pierpont Morgan Library, PML 144, ChL 316. On the "blessed poor," see, for example, the well-known passages in Luke 6:20–25 and Matthew 19:23–24.

2. "Zü dem andern mal so sol der mensch beten all wochen drey rosenkrentz. Das is zü dreyen malen finfftzig ave maria und zü drey malen finff pater noster." Sprenger, *Erneuerte Rosenkranz-Bruderschaft*, fol. 3.

3. "zu hilff den armen selen der menschen die auß der bruderschaft abgestorben seind" Ibid., fol. 5. Details on the exact Marian feasts that were celebrated were supplied by the *Trellat sumariament fet dela bulla o confraria del psaltiri o roser e cobles alahor e gloria dela sacratissima e entemerada verge maria del roser* (Valencia: Mosen Duran Salvaniach Frances, February 27, 1535), fol. B2.

4. "Wann vil menschen versheyden auß disem tzeit den laider wenig gutes nach geschicht, wider die selben versaumnuß mag sich der mensch bewaren und behüten der da kommet in dise bruderschafft." Sprenger, *Erneuerte Rosenkranz-Bruderschaft*, fol. 5.

5. "majorment per los confrares e confraresses que son enla ciutat de Colunya hom aquesta santa institucio ha hagut principi." *Trellat sumariament*, 1535, fol. B2.

6. "Constitución la tercera. Que ninguna cofradía del rosario se pueda fundar en parte alguna, sin particular licencia del General del Orden." Diego de Ogea, OP, *Breve instrucion de la devocion, cofradia, e indulgencias y milagros del rosario de Nuestra Señora* (Madrid: Biuda de Querinos Gerardo, 1589), fol. 9b.

7. "Primerament ordena que cascuna persona de qualsevol stat condicio o dignitat o stament que sia home o dona, puxa entrar e fer scrivre en aquesta confraria sense algun preu o paga." *Trellat sumariament*, 1535, A8v.

8. "Esta es una de las excellençias honorables . . . que la sancta cofradia goza, que tenga por cofrades Pontifices, y Prelados, Emperadores, y Reyes: principes, y Varones: Monges y Canonges: Cavalleros, y communales: hombres, y mujeres: ricos, y pobres: cosa que no se halla en las otras cofradias, tan por el cabo: porque una sera de clerigos, otra de legos, otra e cavalleros, otra de hidalgos, otra en fin de labradores, tiniendo cada uno de los offiçios sus cofradias señaladas. La cofradia del rosario, todo, y a todos abraça, porque es en serviçio de la madre que a todos abriga y ampara, siendo universal valedora." Francisco Messia, OP, *Colloquio devoto y provechoso, en que se declara qual sea la sancta cofradia del rosario de Nuestra Señora la Virgen Maria, Reyna de los Cielos, Madre de Dios y Señora Nuestra* (Callar: Nicolao Cañellas, 1567), fols. 22–22v.

9. Sources for the sixteenth century are exceedingly rare. Based on my survey of documents tied to Spanish rosary confraternities at the Archivo Histórico Nacional in Madrid, 92 date from the nineteenth century, 131 from the eighteenth, 43 from the seventeenth, and only 11 from the sixteenth century. Of relevant sources preserved at the diocese archive of Toledo, none dates from before the seventeenth century. Of those examined in the parish churches of Toledo Province, none dates from before 1578.

10. "Iten que se hobliga la dicha confraria de nuestra sennora del rosario de dar y pagar en cada un anno el dia del aniversario que sera enel otro dia de la fiesta de nuestra sennora que por las doze misas y bisperas y misa y sermon el dia de nuestra sennora y enel otro dia la misa de las animas." Madrid, Archio Histórico Nacional, Códices 1294B ("Ordenanzas de la cofradía de Nuestra Señora del Rosario, Convento de Santo Domingo de Zaragoza, siglo XVI"), fols. 4–4v. These statutes are the earliest found during my research in Spain and date from the first quarter of the sixteenth century.

11. "el confraire que faltare al evangelio tenga de pena seys dineros"; ibid., fol. 6. "Iten es hordenacion que estando enel capitulo o en algun capitulo que nadi pueda jurar el nombre de dios ni de nuestra sennora sino el tal confrayre que los tal jurare bese la cruz en el suelo o pague seys dineros para el servicio de nuestra sennora y el confraire que sintiere jurar a otro confraire aya de acusar sino que pague la sobre dicha pena sino lo acusare y esto se haze por honrrar el nombre de dios y de nuestra sennora del rosario"; ibid., fols. 8v–9.

12. "estando enel dicho capitulo general ayan dar las espadas o punnales que traxeren al dicho corredor o llamador . . . el confrayre que no las quisiere dar a dichas dichas armas tenga de pena por cada vez que no las de una libra de cera." Ibid., fols. 8–8v.

13. "Iten es hordenacion que ningun cofraire no venga alas bisperas de nuestra sennora niel dia de la fiesta suya nien el otro dia que sera del haniversario sin capa nisin calcas o medias calcas suyo o prestadas y puesta en su persona . . . y si al contrario hizieren yno vinieren como esta por hordenaciones tenguan de pena una alroba de azeite." Ibid., fols. 12–12v.

14. "el dicho notario aya de pasar el libro declarando las faltas que cada un cofraire avra hecho y el corredor tome una prenda al cofraire que tuviere faltas en el libro la qual prenda no le sea tornada hasta aver pagado en continente todas las penas que deviere." Ibid., fol. 6.

15. Ibid., fols. 9–12. See the relevant issues addressed in Maureen Flynn, *Sacred Charity: Confraternities and Social Welfare in Spain, 1400–1700* (Ithaca, NY: Cornell University Press, 1989).

16. "porque la dicha cofradía es pobre y no tiene renta ninguna y habiendose de cumplir todo lo que de suso va ordenado y adelante se ordenare, no tiene renta ni caudal para cera ni misas; ordenamos y queremos que todos los cofrades así hombres como mujeres que de la dicha cofradía fueren en cada un año para ayuda de los dichos gastos por caridad, las personas ricas y de caudal un real, y a las otras personas de menos trato y mareantes a medio real, y las viudas pobres y de pobre miserables que no paguen nada, y el que cada un año no pagare la dicha caridad no se le dé vela." *Constituciones de la cofradía redactadas y ordenadas por sus cofrades en el año 1574*, ed. Antonio Gil Merino (La Coruña: Real e Insigne Cofradía de Nuestra Señora del Rosario, 1968), 14 (Ordinance 19).

17. Ibid., 8 (Ordinance 12).

18. Ibid., 7–10 (Ordinances 1, 2, 5, 8).

19. Mohedas de la Jara, Archivo Parroquial de San Sebastian ("Libro de la cofradía del rosario, 1598–99"), fol. 7v. I wish to thank Father Pedro-Pablo Hernández Laín for his kind and generous assistance during my visit to his parish.

20. Ibid., fol. 8.

21. Ibid., fols. 8–8v.

22. The work is attributed problematically to Agustín de Moreto y Cabaña (1618–69). See Juan Luis Alborg, *Historia de la literatura española*, vol. 2, *Época barroca* (Madrid: Editorial Gredos, 1977), 780–804. Moreto's popularity as an author of religious theater led to numerous posthumous attributions during the eighteenth century. Alborg, 783.

23. "Oy asido visitado / de aquella que preserbo / Dios de culpa, y le dexo / sumamente encomendado / esta celestial Maria / a Domingo mi aduersario / que instituya del Rosario / una santa cofradia. / Esta es mi afliccion y afrenta / este es mi desasosiego / y esto temo mas que el fuego / eterno que me atormenta." Madrid, Biblioteca Nacional, Mss. 17088 ("El rosario perseguido. Comedia en tres jornadas. De Don Agustin Moreto"), fol. 7v.

24. "Any person can enter into this Holy Confraternity, being inscribed into the enrollment book by anyone who has the authority to do so, without any obligation to pay a single thing; nor can anyone ask that a fee be paid. And so it was confirmed afterward and ordered anew by Leo X's Bull *Pastoris aeterni*; and Pius V's Brief, *Inter desiderabilia*. But, as Leo X says, anything can be received of what the faithful wish to give by their own free charity and donation." [Qualquiera persona puede entrar en esta Santa Cofradia haziendose escribir en su Libro, por quien tenga autoridad para ello, sin obligacion à pagar cosa alguna; ni por essa razon nadie se lo pueda demandar, ò pedir. Y assi lo confirmaron despues, y mandaron de nuevo Leon X. Bul. Pastoris aeterni; y Pio V. Breve

Inter desiderabilia; pero se puede recibir lo que los Fieles de su voluntad, ò por limosna quisieren dar, como lo dize Leon X]. Francisco Sánchez, OP, *Rosario de la Virgen Maria Nuestra Señora con las indulgencias, y gracias espirituales de su santa cofradía, nuevamente confirmadas por Nuestro Muy Santissimo Padre Inocencio XI. para el uso de sus cofrades* (Madrid: Geronimo Estrado, 1709), 42–43.

25. Chapter 2, note 82.
26. Ibid., note 84.
27. Ibid., note 87.
28. The prominence of silk in Toledo is attributed to *conversos* in Linda Martz, *A Network of Converso Families in Early Modern Toledo: Assimilating a Minority* (Ann Arbor: University of Michigan Press, 2003), 139–41. See also the discussions of Jewish and *converso* silk masters in Paulino Iradiel Murugarren and Germán Navarro Espinach, "La seda en Valencia en la edad media," in *España y Portugal en las rutas de la seda: Diez siglos de producción y comercio entre oriente y occidente*, Comisión Española de la Ruta de la Seda (Barcelona: Universitat de Barcelona, 1996), 187–90; José María Madurell y Marimon, "El arte de la seda en Barcelona entre judios y conversos (notas para su historia)," *Sefarad* 25 (1965): 247–81.
29. In Toledo, Jews were allowed to remain in their ghettos after a meeting of the Cortes there in 1480. The ancient Jewish Quarter consisted of about forty houses when the order of expulsion was given on March 31, 1492. See Henry Kamen, *The Spanish Inquisition: A Historical Revision* (New Haven, CT: Yale University Press, 1997), 12, 15, 20.
30. Ibid., 70, 71, 174.
31. Ibid., 235.
32. Ibid., 112.
33. See Henry Charles Lea, "El Santo Niño de la Guardia," *English Historical Review* 4, no. 14 (April 1889): 229–50.
34. Francisco de Pisa, *Descripción de la Imperial Ciudad de Toledo, y historia de sus antiguedades, y grandeza, y cosas memorables que en ella han acontecido* (1605; facs. Madrid: Villena Artes Gráficas, 1974), 216.
35. Kamen, *Spanish Inquisition*, 148–50; Martz, *Network of Converso Families*, 58.
36. Kamen, *Spanish Inquisition*, 149, 151, and the quotation on 153.
37. See ibid., 198–99.
38. Ibid., 149.
39. Julián Montemayor, "La seda en Toledo en la época moderna," in *España y Portugal en las rutas de la seda: Diez siglos de producción y comercio entre oriente y occidente*, Comisión Española de la Ruta de la Seda (Barcelona: Universitat de Barcelona, 1996), 121.
40. Martz, *Network of Converso Families*, 140 and 140 n. 55.
41. The original has not survived. A seventeenth-century copy is preserved at the Archivo Historico Nacional in Madrid, Sección de Inquisición, Toledo, Leg. 120, núm. 36. I have relied here on the edition of that copy in Francisco Cantera Burgos and Pilar Leon Tello, *Judaizantes del arzobispado de Toledo habilitados por la Inquisición en 1495 y 1497* (Madrid: Universidad de Madrid, 1969), 3–65.
42. "para la sustentaçion y neçesidades del ofiçio de la santa Ynquisyçion et para ayuda a pagar los gastos que se hizieron en la guerra de Granada, et asi mismo para la guerra que s'espera haser contra los moros de allende et para otras obras." Ibid., 3–4.
43. San Juan de la Leche ranked first, with 792,500 *maravedis*, and San Vicente second, with 518,600 *maravedis*. Ibid., XXVI.
44. Ibid., XXXI.

45. Ricardo Izquierdo Benito, "Historia de un singular edificio toledano," in *San Pedro Mártir el Real, Toledo,* ed. Ángel Alcalde and Isidro Sánchez (Ciudad Real: Universidad de Castilla–La Mancha, 1997), 20.

46. Ibid.

47. See the litany of offenses from an "Edict of Faith" dated 1512, in Cecil Roth, *The Spanish Inquisition* (1964; repr. New York: W. W. Norton, 1996), 76–83. In 1568 one woman was detained and tortured to elicit a confession of judaizing, all because she was accused of not eating pork and of regularly changing her linens on Saturdays. See Kamen, *Spanish Inquisition,* 191.

48. Kamen, *Spanish Inquisition,* 175–77.

49. Blas Ortiz, *Summi templi toletani perquam graphica descriptio; Blasio Ortizio iuris pontificii doctore eiusdem templi canonico toletanaeque diocesis vicario generali autore* (Toledo: Juan de Ayala, 1549), fol. CXLV–CXLVIII. Ortiz does note one other confraternity whose members practiced the art of silk (cuius confratres serici infectores sunt). It was dedicated to St. John the Evangelist (number 61 in his inventory) and founded in the parish district of San Lorenzo.

50. Kamen, *Spanish Inquisition,* 263.

51. Joan Meznar, "Our Lady of the Rosary, African Slaves, and the Struggle against Heretics in Brazil, 1550–1660," *The Journal of Early Modern History* 9, nos. 3–4 (2005): 379.

52. On the various punishments, see Kamen, *Spanish Inquisition,* 200–213. Torture, incidentally, was not used as a punishment but rather as a means of eliciting information and confessions. See Kamen, 189–92.

53. Ibid., 244. See also Kamen's discussions on the wearing of penitential garments to perpetuate "infamy" and the use of genealogy as a social weapon in ibid., 200, 242–44. The families of those condemned to wear penitential garments (called *sanbenitos*) for life were disgraced in perpetuity by the fact that even after the condemned had died, the *sanbenitos* bearing their names would be displayed before the public in local churches. The embarrassment was so great in Toledo that numerous name changes took place among the descendants of condemned individuals after a decision in 1538 to transfer the displayed *sanbenitos* from the cathedral cloister to parish churches. See Cantera Burgos and Leon Tello, *Judaizantes del arzobispado de Toledo,* XXXII–XXXIII.

54. A second veil was forthcoming from the silkworms, and, as legend has it, King Alfonso himself took the more beautiful of these veils for his chapel, bringing it out on holy days "to eradicate heresy in those who foolishly doubt the Virgin." See Kathleen Kulp-Hill, *Songs of Holy Mary of Alfonso X, The Wise: A Translation of the Cantigas de Santa Maria* (Tempe: Arizona Center for Medieval and Renaissance Studies, 2000), 27.

55. See chapter 3, note 52.

56. Ibid., note 46.

57. Acts 9:1–18.

Epilogue

1. A surge of attention, however, has been fueled by enthusiasm for the "symbology" that helps drive the plot in Dan Brown's popular *Da Vinci Code: A Novel* (New York: Doubleday, 2003). See, for example, David Ovason, *The Secret Symbols of the Dollar Bill* (New York: HarperCollins, 2004).

2. Gretel C. Kovach, "Pizza Chain Takes Pesos, and Complaints," *The New York Times,* January 15, 2007.

3. See William Lichtenwanger, "The Music of the 'Star-Spangled Banner'—Whence and Whither?" *College Music Symposium* 18, no. 2 (1978): 34–81. The music to which Francis Scott Key set his lyrics is traditionally credited to Englishman John Stafford Smith (1750–1836).

4. David Montgomery, "An Anthem's Discordant Notes; Spanish Version of 'Star-Spangled Banner' Draws Strong Reactions," *The Washington Post*, April 28, 2006. Individuals on both sides of the debate seem to have overlooked the fact that in the early twentieth century, the United States Bureau of Education brought together a commission that included Oscar G. Sonneck and John Philip Sousa to prepare a Spanish version of "The Star-Spangled Banner." The result: "La Bandera de las Estrellas," a translation by Francis Haffkine Snow, set to the familiar tune by John Stafford Smith and harmonized by Walter Damrosch. It was published in 1919 by G. Schirmer. The score is available via the Library of Congress's Web site at http://memory.loc.gov/cocoon/ihas/loc. natlib.ihas.100000007/pageturner.html?page=1§ion=

5. On this topic, see Richard R. Flores, *Remembering the Alamo: Memory, Modernity, & the Master Symbol* (Austin: University of Texas Press, 2002); Holly Beachley Brear, *Inherit the Alamo: Myth and Ritual at an American Shrine* (Austin: University of Texas Press, 1994).

6. "Congressman Takes Oath of Office on Thomas Jefferson's Quran," States News Service, Washington, DC, January 4, 2007.

7. http://www.tldm.org/News6/lepanto.htm.

8. http://www.tldm.org/news4/rosarycrusade.htm.

9. Edward Rothstein, "A Mosaic of Arab Culture at Home in America," *The New York Times*, October 24, 2005; "New Museum Celebrates the Lives of Arab Americans," Associated Press Worldstream, July 17, 2005.

10. http://www.arabamericanmuseum.org/About-the-Museum.id.3.htm.

Appendix C

1. *Officia ad missas cantandum in festivitatibus sanctorum per annum secundum consuetudinem romane curie: atque etiam de novo additis iuxta usum sancte granatensis ecclesie* (Granada: Sancho de Nebrija, 1544).

2. *Manuale chori romanum noviter compilatum super omnia alia completissimum* (Seville, 1539).

Appendix D

1. A manufacturer of *tejillo*, which seems to have been a type of silk braid worn by women as a waistbelt. See Cantera Burgos and Leon Tello, *Judaizantes del arzobispado de Toledo* XVII n. 25, XIX.

Appendix E

1. Rubric: In die resurrectionis prosa.
2. Rubric: Prosa in die sancto penthecostes et per totam octavam.
3. Rubric: Ffinita tercia, a sacerdote celebrantur missam primo aspergatur aqua benedicta altare maius tantum genibus flexis coram altare, et statim incipiatur a cantore

antiphona Asperges, et dum comuniter cantatur cum uersum et gloria patri ab eodem sacerdote aspergatur fratres. Antiphona.

 4. Rubric: Et repetatur antiphona Asperges me. Supradicta antiphona predicto modo dicitur in aspersione aqua benedicte in dominicis diebus per totum annum, excepto quo in dominica de passione et in dominica palmarum non dicitur gloria patri, sed post psalmarum, Miserere, repetatur antiphona, Asperges me, et excepto tempore paschali a dominica pasche usque ad penthecostem quo tempore cantetur. Antiphona.

 5. Rubric: In festo sancti Ioachimi ad Missam. Tractus. Beatus vir. verso primo. Gloria et divitie. versus.

 6. Rubric: Sequens tractus dicitur a septuagesima usque ad feriam iiij. majoris ebdomine. Tractus.

 7. Rubric: Item alius tractus. Now assigned to the Common of Several Martyrs outside of Paschal Time. See *Graduale sacrosanctae romanae ecclesiae de tempore et de sanctis* (Rome: Typis Vaticanis, 1908), [21].

 8. Rubric: Sequens tractus dicitur a septuagesima usque ad feriam iiij. majoris ebdomine. Tractus.

 9. This new mass fragment on "L'homme armé" is discussed at length in chapter 6.

 10. Rubric: In festo sanctissime trinitas. Tractus.

 11. Rubric: In missa votiva de spiritu sancto. Tractus.

 12. Rubric: In missa votiva Sancti Angeli custodis. Tractus.

 13. Rubric: In natu virginum. Tractus.

 14. Rubric: In dedicatione ecclesie post septuagesima. Tractus.

 15. No rubric given. Now assigned to the Feast of St. Gabriel Archangel (March 24). See *Graduale sacrosanctae* [149].

Bibliography

Reference Works Cited

The Catholic Encyclopedia. 1907–14.
The Dictionary of Art, ed. Jane Turner. 1996.
Dictionnaire de Spiritualité. 1932–95.
The New Grove Dictionary of Music and Musicians. 2nd ed., 2001.

Primary Sources—Manuscripts

Barcelona, Biblioteca de Catalunya, Ms. 1325. *Arte de melodía sobre canto lano y canto d'organo.*
Barcelona, Biblioteca del Orfeó Catalá, Ms. 1. Troparium-Prosarium. 14c. Tarragona.
Burgos, Monasterio de las Huelgas, s.n. "Las Huelgas Manuscript." 14c. Burgos.
Cambridge, MA, Harvard University, Houghton Library, Ms. Typ 184. "Institucion de la regla y hermandad de la cofradia del Sanctissimo Sacramento (Toledo, 1502)."
Cambridge, MA, Harvard University, Houghton Library, Widener Ms. 2. English Book of Hours. 15c.
Detroit, MI, Detroit Public Library, Burton Historical Collection. Acquisition file for "Spanish Antiphonal Leaf."
Detroit, MI, Detroit Public Library, Burton Historical Collection. "Spanish Antiphonal Leaf." Gradual leaf. 16c. Dominican Convent of San Pedro Mártir, Toledo.
El Escorial, Monasterio de San Lorenzo de El Escorial, Cantoral 210, sign. S-1. Kyriale. 16c.
Huesca, Biblioteca Capitular, Ms. 4. Troparium-Prosarium. 12c.
Los Angeles, CA, J. Paul Getty Institute, Ms. 61. Gradual leaf. 16c. Dominican Convent of San Pedro Mártir, Toledo.
Madrid, Archivo Histórico Nacional, Clero-Secular Regular, Libro 15246. Toledo. Dominicos. San Pedro Mártir, "Recibo general de la hacienda de Ntra. Sra. del Rosario, A. 1671–1730."
Madrid, Archivo Histórico Nacional, Clero-Secular Regular, Libro 15296. Toledo. Dominicos. San Pedro Mártir, "Libro de las memorias de Ntra. Sra. del Rosario, A. 1731–1763."
Madrid, Archivo Histórico Nacional, Códices 1294B. "Ordenanzas de la cofradia de Nuestra Señora del Rosario, Convento de Santo Domingo de Zaragoza. Siglo XVI."

Madrid, Biblioteca Lázaro Galdiano, M 3–4, Inventario 15675, Ms. 371. "Ordenanzas de la Cofradia del Corpus Christi de Santa María Magdalena de Toledo."
Madrid, Biblioteca Nacional, M.1361. Gradual. 14c. Toledo.
Madrid, Biblioteca Nacional, Mss. 10062 (formerly Toledo, Librería del Cabildo, Ms. 103–25). Boccaccio, *De genealogie deorum*. Castilian translation. 15c.
Madrid, Biblioteca Nacional, Mss. 17088. "El rosario perseguido. Comedia en tres jornadas. De Don Agustin Moreto." 17c.
Madrid, Biblioteca Nacional, Mss. 18724/51. Offerentium secundum regulam Beati Isidori Archiepiscopi Hispalensis [Ordo Missae del Misal Mixto Mozárabe]. 1707. Copied in Toledo.
Madrid, Biblioteca Nacional, Mss. 19421. Troparium. 12–13c.
Madrid, Biblioteca Nacional, Mss. vit. 18–19. Liber pontificalis. 15c. Burgos.
Mohedas de la Jara, Archivo Parrochial de San Sebastian, s.n. "Libro de la cofradía del rosario, 1598–99."
Monserrat, Biblioteca del Monasterio, Ms. 1. *El Llibre Vermell.*
Montserrat, Biblioteca del Monasterio, Ms. 73. Troparium-Prosarium. 12c. Urgell? Toulouse?
New Haven, CT, Private collection. Gradual leaf. Late 15c/early 16c. Dominican Convent of San Pedro Mártir, Toledo.
New Haven, CT, Yale University, Beinecke Rare Book and Manuscript Library. Acquisition file for Ms. 710.
New Haven, CT, Yale University, Beinecke Rare Book and Manuscript Library, Ms. 710. Kyriale. 16c. Dominican Convent of San Pedro Mártir, Toledo.
New Haven, CT, Yale University, Beinecke Rare Book and Manuscript Library, Ms. 794. Gradual leaf. 16c. Dominican Convent of San Pedro Mártir, Toledo.
New York, NY, Pierpont Morgan Library. Acquisition file for M887.
New York, NY, Pierpont Morgan Library, M887-1. Gradual leaf. 16c. Dominican Convent of San Pedro Mártir, Toledo.
New York, NY, Pierpont Morgan Library, M887-2. Gradual leaf. 16c. Dominican Convent of San Pedro Mártir, Toledo.
Ocaña, Convento de Santo Domingo, s.n. Miscellany of fragments cut from the *cantorales* of San Pedro Martir, Toledo.
Oxford, Bodleian Library, Ms. Digby 227. *Missal of Abingdon Abbey.* 15c.
Salamanca, Biblioteca Universitaria, Ms. 2637. Missale. Troparium. 12c. Silos?
Santo Domingo de Silos, Biblioteca del Monasterio, s.n. Gradual. 16c.
Toledo, Archivo Diocesano, Sección Cofradías y Hermandades, Legajo To. 13, Expediente 36. Parroquia de San Ginés, Hermandad de Nuestra Señora del Rosario, "Presentación y aprobación de ordenanzas."
Toledo, Archivo Diocesano, Sección Cofradías y Hermandades, Legajo To. 25, Expediente 2, 1651. Convento de San Pedro Mártir, Cofradía de Nuestra Señora del Rosario, "Presentación de ordenanzas para su aprobación."
Toledo, Archivo Diocesano, Sección Cofradías y Hermandades, Legajo To. 25, Expediente 5, 1636. Convento de San Pedro Mártir, Cofradía de Nuestra Señora del Rosario, "Presentación de las constituciones para su aprobación."
Toledo, Biblioteca Capitular, Ms. 35-10. Gradual. 13c.
Toledo, Biblioteca Capitular, Ms. 37-19. Misal votivo de Toledo. 15c.

Toledo, Biblioteca Capitular, Ms. 52-14. Antifonarium-Troparium. 15–16c.
Toledo, Biblioteca Capitular, Ms. B-9. Choirbook. Polyphonic Masses and motets. 16c.
Toledo, Biblioteca Capitular, Ms. B-16. Choirbook. Polyphonic Masses. 16c.
Toledo, Biblioteca Capitular, Ms. B-33. Choirbook. Polyphonic Masses. 16c.
Toledo, Biblioteca Capitular, Ms. Res 3. *Missale mixtum* (vol. 2) of Alfonso Carrillo. 15c.
Tortosa, Biblioteca Capitular, Ms. 135. Troparium-Prosarium. 13c. Tortosa.

Primary Sources—Printed Works

Apostolic Letter Rosarium Virginis Mariae of the Supreme Pontiff John Paul II to the Bishops, Clergy and Faithful on the Most Holy Rosary. October 16, 2002: http://www.vatican.va/holy_father/john_paul_ii/apost_letters/documents/hf_jp-ii_apl_20021016_rosarium-virginis-mariae_en.html.

Bermudez de Pedrazas, Francisco. *Historia eclesiastica, principios, y progressos de la ciudad, y religion catolica de Granada.* Granada, 1638.

Boccaccio, Giovanni. *Genealogiae deorum.* Venice: Bonetus Locatellus, 1494.

Breviarium secundum regulam beati Hysidori. Toledo: Pedro de Hagenbach, October 25, 1502.

Castro, Bartolomé de. *Questiones magistri Bartoli Castrensis habitae pro totius logice prohemio. Questiones eiusdem in predicamenta Aristotelis disputatae secundum opinionem Thome Scoti et Ocham textu ex traslatione Argiropili inserto. Canones triumphi numerorum ab eodem Bartolo castrense primitus ad iuuenti cum carmini chartarum.* Toledo: Juan de Villaquirán, October 8, 1513.

Figueroa, Fray Juan de. *Libro de la historia y milagros, hechos a invocación de Nuestra Señora de Montserrate.* Barcelona: Sebastián de Cormellas, 1623.

Furs nous del regne de Valencia e capitols ordenades per lo rey don Ferrando II. en la cort general de Oriola. 31 jul 1488. Valencia: Leonardo Hutz and Pedro de Hagenbach, September 6, 1493.

Graduale . . . iuxta ritum sacrosanctae romanae ecclesiae cum cantu, Pauli V. pontificis maximi iussu reformatio . . . ex typographica Medicea. Rome, 1614–15.

Gutiérrez, Julian. *Cura de la piedra y dolor de la yjada y colica rreñal.* Toledo: Pedro de Hagenbach, April 4, 1498.

Insulis, Michael Franciscus de. *Determinatio quodlibetalis facta Colonie.* Basel: [Bernhard Richel?], after March 10, 1476.

Leyes del estilo: y declaraciones sobre las leyes del fuero. Toledo: [Pedro de Hagenbach?], February 26, 1498.

López, Juan, OP. *Libro en que se trata de la importancia y exercicio del santo rosario.* Zaragoza: Domingo Portonariis y Ursino, 1584.

———. *Tercera parte dela historia general de Sancto Domingo, y de su Orden de Predicadores.* Valladolid: Francisco Fernández de Córdova, 1613.

Manuale chori romanum noviter compilatum super omnia alia completissimum. Seville, 1539.

Manual procesional para el uso de la provincia de San Joseph de Franciscanos Descalzos en Castilla la Nueva. Madrid: Viuda de Ibarra, Calle de Gorguera, 1789.

Messia, Francisco, OP. *Colloquio devoto y provechoso, en que se declara qual sea la sancta cofradia del rosario de Nuestra Señora la Virgen Maria, Reyna de los Cielos, Madre de Dios y Señora Nuestra.* Callar: Nicolao Cañellas, 1567.

Missale mixtum secundum regulam beati Isidori dictum Mozarabes. Toledo: Pedro de Hagenbach, January 9, 1500.

Officia ad missas cantandum in festivitatibus sanctorum per annum secundum consuetudinem romane curie: atque etiam de novo additis iuxta usum sancte granatensis ecclesie. Granada: Sancho de Nebrija, 1544.

Ogea, Diego de, OP. *Breve instrucion de la devocion, cofradia, e indulgencias y milagros del rosario de Nuestra Señora.* Madrid: Biuda de Querinos Gerardo, 1589.

Ortiz, Blas. *Summi templi toletani perquam graphica descriptio; Blasio Ortizio iuris pontificii doctore eiusdem templi canonico toletanaeque diocesis vicario generali autore.* Toledo: Juan de Ayala, 1549.

Pérez, Miguel. *De imitatione Christi et de contemptu mundi.* Valencia: [Leonardo Hutz and Pedro de Hagenbach?], February 16, 1491.

Rupe, Alanus de. *Unser lieben frauen psalter.* Ulm: Conrad Dinckmut, 1483.

Sagastizabal, Juan, OP. *Exortacion a la santa devocion del rosario dela Madre de Dios.* Zaragoza: Lorenço de Robles, 1597.

Sánchez, Francisco, OP. *Rosario de la Virgen Maria Nuestra Señora con las indulgencias, y gracias espirituales de su santa cofradía, nuevamente confirmadas por Nuestro Muy Santissimo Padre Inocencio XI. para el uso de sus cofrades.* Madrid: Geronimo Estrado, 1709.

Sprenger, Jakob, OP. *Erneuerte Rosenkranz-Bruderschaft.* Augsburg: Bämler, 1476.

Taix, Hieronimo, OP. *Libre dela institucio, manera de dir, miracles e indulgencies del roser de la verge Maria señora nuestra.* Barcelona: Pere Monpezat, 1556.

Trellat sumariament fet dela bulla o confraria del psaltiri o roser e cobles alahor e gloria dela sacratissima e entemerada verge maria del roser. Valencia: Mosen Duran Salvaniach Frances, February 27, 1535.

Trellat sumariament fet dela bulla o confraria del psaltiri o roser. Valencia: [Mosen Duran Salvaniach Frances?], March 18, 1546.

Villena, Enrique de. *Los doze trabajos de Hércules.* Zamora, 1483.

———. *Los doze trabajos de Hércules.* Burgos, 1499.

Von dem Psalter und Rosenkranz unser lieben Frauen. Augsburg: Anton Sorg, 1492.

Secondary Sources

Adams Jr., Fredrick B. *Ninth Report to the Fellows of the Pierpont Morgan Library, 1958 & 1959.* New York: Pierpont Morgan Library, 1959.

Ahlberg-Cornell, Gudrun. *Herakles and the Sea-Monster in Attic Black-Figure Vase-Painting.* Stockholm: Svenska Institutet i Athen, 1984.

Albert the Great. *Man and the Beasts: De animalibus (Books 22–26).* Translated by James J. Scanlan. Binghamton, NY: Medieval and Renaissance Texts & Studies, 1987.

Alborg, Juan Luis. *Historia de la literatura española.* Vol. 2, *Época barroca.* Madrid: Editorial Gredos, 1977.

Alcocer, Pedro de. *Hystoria, o descripción dela imperial cibdad de Toledo.* 1554. Facsimile, Toledo: Instituto Provincial de Investigaciones y Estudios Toledanos, 1973.

Alfonso X. *Cantigas de Santa María*. Edited by Walter Mettmann. 3 vols. Madrid: Clásicos Castalia, 1986.
———. *General estoria. Segunda parte*. Edited by A. C. Solalinde, Lloyd A. Kasten, and Victor R. B. Oelschlager. Vol. 2. Madrid: Consejo Superior de Investigaciones Científicas, 1961.
Anderson, Gordon A., ed. *The Las Huelgas Manuscript: Burgos, Monasterio de Las Huelgas*. 2 vols. Corpus Mensurabilis Musicae 79. Neuhassen-Stuttgart: American Institute of Musicology, Hannsler-Verlag, 1982.
Anglés, Higinio, ed. *El códex musical de Las Huelgas (Música a veus dels segles XIII–XIV)*. 3 vols. Barcelona: Institut d'Estudis Catalans, Biblioteca de Catalunya, 1931.
———. "El 'Llibre Vermell' de Montserrat y los cantos y la danza sacra de los peregrinos durante el siglo XIV." *Anuario musical* 10 (1955): 45–78.
Angulo Iñiguez, Diego. "La mitología y el arte español del Renacimiento." *Boletín de la Real Academia de la Historia* 103 (1952): 63–209.
Anzelewsky, Fedja. *Dürer-Studien: Untersuchungen zu den ikonographischen und geistesgeschichtlichen Grundlagen seiner Werke zwischen den beiden Italienreisen*. Berlin: Deutscher Verlag für Kunstwissenschaft, 1983.
Apollodorus. *The Library*. Translated by Sir James George Frazer. Vol. 1. Cambridge, MA: Harvard University Press, 1961.
Apollonios Rhodios. *The Argonautika: The Story of Jason and the Quest for the Golden Fleece*. Translated with introduction, commentary, and glossary by Peter Green. Berkeley: University of California Press, 1997.
Aranda Alonso, Fernando, Jesús Carrobles Santos, and José Luis Isabel Sánchez. *El sistema hidráulico romano de abastecimiento a Toledo*. Toledo: Instituto Provincial de Investigaciones y Estudios Toledanos, 1997.
Areford, David S. "The Passion Measured: A Late-Medieval Diagram of the Body of Christ." In *The Broken Body: Passion Devotion in Late-Medieval Culture*, edited by A. A. MacDonald, H. N. B. Ridderbos, and R. M. Schlusemann. Groningen: Egbert Forsten, 1998.
Arellano García, Mario, and Ventura Leblic García. "Estudio sobre la heráldica toledana." *Toletum: Boletín de la Real Academia de Bellas Artes y Ciencias Historicas de Toledo* 19 (1986): 267–87.
"Arthur Rau. Rare Old Books (advertisement)." *The New York Times*. September 18, 1932.
Asensio Palacios, Juan Carlos, and Josemi Lorenzo Arribas, eds. *El códice de Las Huelgas*. Madrid: Fundación Caja, Editorial Alpuerto, 2001.
Aune, David E. "Heracles and Christ: Heracles Imagery in the Christology of Early Christianity." In *Greeks, Romans, and Christians: Essays in Honor of Abraham J. Malherbe*, edited by David L. Balch, Everett Ferguson, and Wayne A. Meeks. Minneapolis: Fortress, 1990.
Barrado, José, OP. "El convento de San Pedro Mártir. Notas históricas en el V centenario de su imprenta (1483–1983)." *Toletum: Boletín de la Real Academia de Bellas Artes y Ciencias Históricas de Toledo* 18 (1985): 181–211.
Bartrum, Giulia. *Albrecht Dürer and His Legacy: The Graphic Work of a Renaissance Artist*. Princeton, NJ: Princeton University Press, 2002.
Bauman, Guy C. "A Rosary Picture with a View of the Park of the Ducal Palace in Brussels, Possibly by Goswijn van der Weyden." *Metropolitan Museum Journal* 24 (1989): 135–51.

Biblioteca colombina: Catálogo de sus libros impresos. Seville and Madrid, 1888–1948.
Blume, Clemens, and Guido M. Dreves, eds. *Analecta hymnica medii aevi*, Vol. 35, *Psalteria rhythmica: Gereimte Psalterien des Mittelalters.* Leipzig: O. R. Reisland, 1900.
———. *Analecta hymnica medii aevi.* Vol. 47, *Tropen des Missale im Mittelalter.* Leipzig: O. R. Reisland, 1905.
———. *Analecta hymnica medii aevi.* Vol. 50, *Hymnographi latini: Lateinische Hymnendichter.* Leipzig: O. R. Reisland, 1907.
Bosch, Lynette M. F. *Art, Liturgy, and Legend in Renaissance Toledo: The Mendoza and the Iglesia Primada.* University Park: Pennsylvania State University Press, 2000.
———. "A *Terminus ante quem* for Two of Martin Schongauer's *Crucifixions.*" *The Art Bulletin* 64, no. 4 (1982): 632–35.
Bosse, Detlev. *Untersuchung einstimmiger mittelalterlicher Melodien zum "Gloria in excelsis deo."* Forschungsbeiträge zur Musikwissenschaft 2. Regensberg: Gustav Bosse Verlag, 1955.
Brear, Holly Beachley. *Inherit the Alamo: Myth and Ritual at an American Shrine.* Austin: University of Texas Press, 1994.
Breidenthal, Marianne. "The Legend of Hercules in Castilian Literature up to the Seventeenth Century." PhD diss., University of California, Berkeley, 1981.
Brockett, Clyde W. *Antiphons, Responsories and Other Chants of the Mozarabic Rite.* Musicological Studies 15. New York: The Institute of Mediaeval Music, 1968.
Brown, Dan. *The Da Vinci Code: A Novel.* New York: Doubleday, 2003.
Burkhart, Louise M. *Before Guadalupe: The Virgin Mary in Early Colonial Nahuatl Literature.* Albany, NY: Institute for Mesoamerican Studies, 2001.
Candelaria, Lorenzo. "*El Cavaller de Colunya*: A Miracle of the Rosary in the Choirbooks of San Pedro Mártir de Toledo." *Viator: Medieval and Renaissance Studies* 35 (2004): 221–64.
———. "Hercules and Albrecht Dürer's *Das Meerwunder* in a Chantbook from Renaissance Spain." *Renaissance Quarterly* 58, no. 1 (2005): 1–44.
———. "Tropes for the Ordinary in a 16th-Century Chantbook from Toledo, Spain." *Early Music* 34, no. 4 (2006): 587–611.
Cantera Burgos, Francisco, and Pilar Leon Tello. *Judaizantes del arzobispado de Toledo habilitados por la Inquisición en 1495 y 1497.* Madrid: Universidad de Madrid, 1969.
Caplan, Harry. "The Four Senses of Scriptural Interpretation and the Mediaeval Theory of Preaching." *Speculum* 4, no. 3 (1929): 282–90.
Castro, Juan Nicolau. "La capilla de la Virgen del Rosario y otras obras del siglo XVIII en el monasterio de San Pedro Mártir." *Anales toledanos* 26 (1989): 303–34.
Castro Caridad, Eva. *Tropos y troparios hispánicos.* Santiago de Compostela: Universidad de Santiago de Compostela, Servicio de Publicaciónes e Intercambio Cientifico, 1991.
Cerro Malagón, Rafael del. "Siglo y medio de uso civil." In *San Pedro Mártir el Real, Toledo,* edited by Ángel Alcalde and Isidro Sánchez. Ciudad Real: Universidad de Castilla–La Mancha, 1997.
Chabás, Roch. "Estudio sobre los sermones valencianos de San Vicente Ferrer, que se conservan manuscritos en la Biblioteca de la Basílica Metropolitana de Valencia." *Revista de archivos, bibliotecas y museos* III(VI)/6 (1902): 1–6, 155–58; III(VI)/7 (1902): 131–42, 419–39; III(VII)/8 (1903): 38–57, 111–26, 291–95; III(VII)/9 (1903): 85–98, 99–102.

Chapman, Catherine Weeks. "Printed Collections of Polyphonic Music Owned by Ferdinand Columbus." *Journal of the American Musicological Society* 21, no. 1 (1968): 33–84.
Checa Cremades, Fernando. *Pintura y escultura del renacimiento en España, 1450–1600.* Madrid: Ediciones Cátedra, 1983.
Chevalier, Ulysse. *Repertorium hymnologicum. Catalogue des chants, hymnes, proses, séquences, tropes en usage dans l'église latine depuis les origines jusqu'à nos jours.* 6 vols. Louvain and Brussels, 1892–1921.
Coll, José María, OP. "Dos artistas cuatrocentistas desconocidos (Pablo de Senis y Fr. Francisco Doménech)." *Analecta sacra tarraconensia* 24 (1951): 141–44.
"Commentary (Obituary for Nicolas Rauch)." *The Book Collector* 11, no. 4 (Winter 1962): 416–19.
"Congressman Takes Oath of Office on Thomas Jefferson's Quran." States News Service, Washington, DC. January 4, 2007.
Constituciones de la cofradía redactadas y ordenadas por sus cofrades en el año 1574. Edited by Antonio Gil Merino. La Coruña: Real e Insigne Cofradía de Nuestra Señora del Rosario, 1968.
Costley, Clare L. "David, Bathsheba, and the Penitential Psalms." *Renaissance Quarterly* 57, no. 4 (2004): 1235–77.
Cotarelo y Mori, Emilio. *Don Enrique de Villena: Su vida y obras.* Madrid: Sucesores de Rivadeneyra, 1896.
Dobner, Joseph. *Die mittelhochdeutsche Versnovelle Marien Rosenkranz.* Borna-Leipzig: Robert Noske, 1928.
Domínguez Bordona, Jesús. *Exposición de códices miniados españoles.* Madrid: Sociedad Española de Amigos de Arte, 1929.
———. *Manuscritos con pinturas: Notas para un inventario de los conservados en colecciónes públicas y particulares de España.* Vol. 1, *Ávila-Madrid.* Madrid: Centro de Estudios Históricos, 1933.
Duclas, Robert. *Catálogo descriptivo de los libros impresos en la ciudad de Salamanca en el siglo XVI existentes en la Biblioteca Pública de Guadalajara.* México, DF: Biblioteca Nacional de México, 1961.
Duschnes, Philip C. *Medieval Miniatures and Illumination*, cat. no. 174. New York: Philip C. Duschnes, 1965.
Eby, Jack. "Chant-Inspired Music in the Chapel of Louis XVI." In *Chant and Its Peripheries: Essays in Honour of Terence Bailey*, edited by Bryan Gillingham and Paul Merkley. Musicological Studies 72. Ottawa: The Institute of Mediaeval Music, 1998.
Eire, Carlos M. N. *From Madrid to Purgatory: The Art and Craft of Dying in Sixteenth-Century Spain.* Cambridge: Cambridge University Press, 1995.
Elliott, J. H. *Imperial Spain, 1469–1716.* New York: St. Martin's, 1967.
Engels, Joseph. *Études sur l'Ovide moralisé.* Groningen-Batavia: J. B. Wolters, 1945.
Esser, Thomas. "Beitrag zur Geschichte des Rosenkranzes: Die ersten Spuren von Betrachtungen beim Rosenkranz." *Der Katholik* 77 (1897): 346–60, 409–22, 515–28.
Faulhaber, Charles B., Ángel Gómez Moreno, David Mackenzie, John J. Nitti, and Brian Dutton (with the assistance of Jean Lentz). *Bibliography of Old Spanish Texts.* 3rd ed. Madison: Hispanic Seminary of Medieval Studies, 1984.

Fernández de la Cuesta, Ismael. "El canto toledano, estrato musical en la polifonía sacra de la catedral de Las Palmas y otras iglesias de España." *El Museo Canario* 54 (1999): 305–38.

———. *Historia de la música española: Desde los orígenes hasta el ars nova.* 2nd ed. Madrid: Alianza Editorial, 1988.

———. "La irrupción del canto gregoriano en España: Bases para un replanteamiento." *Revista de musicología* 8 (1985): 239–48.

———. *Manuscritos y fuentes musicales en España: Edad media.* Madrid: Editorial Alpuerto, 1980.

———. "A propósito de un 'Manuale chori' de 1539." In *De música hispana et aliis: Miscelánea en honor al Prof. Dr. José López-Calo, S.J., en su 65° cumpleaños,* edited by Emilio Casares and Carlos Villanueva. 2 vols. Santiago de Compostela: Universidade de Santiago de Compostela, 1990.

Flores, Richard R. *Remembering the Alamo: Memory, Modernity, & the Master Symbol.* Austin: University of Texas Press, 2002.

Flynn, Maureen. *Sacred Charity: Confraternitites and Social Welfare in Spain, 1400–1700.* Ithaca, NY: Cornell University Press, 1989.

Frazer, Sir James George. *The Golden Bough: A Study in Magic and Religion.* Pt. 4, Vol. 1, *Adonis, Attis, Osiris: Studies in the History of Oriental Religion.* 3rd ed. New York: Macmillan, 1935.

Friedmann, Herbert. *The Symbolic Goldfinch: Its History and Significance in European Devotional Art.* Washington, DC: Pantheon, 1946.

Galinsky, G. Karl. *The Herakles Theme: The Adaptations of the Hero in Literature from Homer to the Twentieth Century.* Totowa, NJ: Rowman and Littlefield, 1972.

García Craviotto, Francisco, ed. *Catálogo general de incunables en bibliotecas españolas.* 2 vols. Madrid: Ministerio de Cultura, 1989–90.

Gómez i Muntané, María Carmen. *El Llibre Vermell de Montserrat: Cants i dances s. XIV.* Barcelona: Els Llibres de la Frontera, 2000.

Gómez-Menor Fuentes, José Carlos. "Datos documentales sobre la rama toledana de los Silvas." *Toletum: Boletín de la Real Academia de Bellas Artes y Ciencias Historicas de Toledo* 17 (1985): 217–25.

González de Zárate, Jesús María. *Mitologia e historia del arte.* Vitoria-Gasteiz: Instituto Ephialte, Departamento de Cultura del Gobierno Vasco, 1997.

Gonzálvez Ruiz, Ramón. "Las bulas de la catedral de Toledo y la imprenta incunable castellana." *Toletum: Boletín de la Real Academia de Bellas Artes y Ciencias Históricas de Toledo* 18 (1985): 11–165.

Gougaud, Louis. *Devotional and Ascetic Practices in the Middle Ages.* London: Burns, Oates & Washbourne, 1927.

Graduale sacrosanctae romanae ecclesiae de tempore et de sanctis. Rome: Typis Vaticanis, 1908.

Guerrero Lovillo, José. *Las cantigas: Estudio arqueológico de sus miniaturas.* Madrid: Consejo Superior de Investigaciones Científicas, 1949.

Gümpel, Karl-Werner. "El canto melódico de Toledo: Algunas reflexiones sobre su origen y estilo." *Recerca musicológica* 8 (1988): 25–46.

Günther, Jörn, and Bruce P. Ferrini. *Overlooking the Ages: A Private Exhibition of Illuminated Manuscripts, Miniatures and Printed Books.* Hamburg: Jörn Günther, October 1999.

Hall, Linda B. *Mary, Mother, and Warrior: The Virgin in Spain and the Americas.* Austin: University of Texas Press, 2004.
Hardie, Jane Morlet. *The Lamentations of Jeremiah: Ten Sixteenth-Century Spanish Prints. An Edition with Introduction.* Ottawa: The Institute of Mediaeval Music, 2003.
Herrero, Manuel. *Historia de la provincia de España de la Orden de Predicadores desde la muerte del Rmo. Quiñones hasta la Expusión de los Franceses.* Bk. 2 of Justo Cuervo, OP, *Historiadores del convento de San Esteban de Salamanca.* Vol. 3. Salamanca: Imprenta Católica Salmanticense, 1915.
Hesiod. *Theogony, Works and Days, Shield.* Translated by Apostolos N. Athanassakis. Baltimore: Johns Hopkins University Press, 1983.
Hiley, David. *Western Plainchant: A Handbook.* 1993. Reprint, Oxford: Clarendon, 1995.
Hillgarth, J. N. *The Spanish Kingdoms, 1250–1516.* 2 vols. Oxford: Clarendon, 1976–78.
Hinnebusch, William A., OP. *The History of the Dominican Order.* Vol. 1, *Origins and Growth to 1500.* Staten Island, NY: Alba House, 1966.
Hogg, James, ed. *El santo rosario en la Cartuja.* Analecta Cartusiana 103. Salzburg: Institut für Anglistik und Amerikanistik Universität Salzburg, 1983.
Housely, Norman. *The Later Crusades, 1274–1580: From Lyons to Alcazar.* Oxford: Oxford University Press, 1992.
Hoyos, Manuel María de los, OP. *Registro historial de nuestra provincia.* Madrid: Selecciones Gráficas, 1967.
Hughes, Andrew. "Medieval Liturgical Books in Twenty-Three Spanish Libraries: Provisional Inventories." *Traditio: Studies in Ancient and Medieval History, Thought, and Religion* 38 (1982): 366–94.
Huglo, Michel. "La pénétration des manuscrits aquitains en Espagne." *Revista de musicología* 8 (1985): 249–56.
Huntington, Archer M., ed. *Catalogue of the Library of Ferdinand Columbus, Reproduced in Facsimile from the Unique Manuscript in the Columbine Library of Seville.* New York, 1905.
Hutchison, Jane Campbell. *Albrecht Dürer: A Biography.* Princeton, NJ: Princeton University Press, 1990.
Iradiel Murugarren, Paulino, and Germán Navarro Espinach. "La seda en Valencia en la edad media." In *España y Portugal en las rutas de la seda: Diez siglos de producción y comercio entre oriente y occidente.* Comisión Española de la Ruta de la Seda. Barcelona: Universitat de Barcelona, 1996.
Iversen, Gunilla. *Corpus troporum.* Vol. 4, *Tropes de l'Agnus Dei.* Stockholm: Almqvist & Wiksell International, 1980.
———. *Corpus troporum.* Vol. 7, *Tropes de l'ordinaire de la messe: Tropes du Sanctus.* Stockholm: Almqvist & Wiksell International, 1990.
Izquierdo Benito, Ricardo. "Historia de un singular edificio toledano." In *San Pedro Mártir el Real, Toledo,* edited by Ángel Alcalde and Isidro Sánchez. Ciudad Real: Universidad de Castilla–La Mancha, 1997.
Janini, José, and Ramón Gonzálvez. *Catálogo de los manuscritos litúrgicos de la catedral de Toledo.* Toledo: Diputación Provincial, 1977.
Janini, José, and José Serrano. *Manuscritos litúrgicos de la Biblioteca Nacional.* Madrid: Dirección General de Archivos y Bibliotecas, 1969.

Jonsson, Ritva. "Corpus troporum." *Journal of the Plainsong & Mediaeval Society* 1 (1978): 98–115.
Kamen, Henry. *Empire: How Spain Became a World Power, 1492–1763*. New York: HarperCollins, 2003.
———. *Philip of Spain*. New Haven, CT: Yale University Press, 1997.
———. *The Spanish Inquisition: A Historical Revision*. New Haven, CT: Yale University Press, 1997.
Klinkhammer, Karl Joseph, SJ. "Die Entstehung des Rosenkranzes und seine ursprüngliche Geistigkeit." In *500 Jahre Rosenkranz, 1475–1975: Kunst und Frömmigkeit im Spätmittelalter und ihr Weiterleben*. Exhibition catalog, Erzbischöfliches Diözesan-Museum Köln, October 25, 1975–January 15, 1976. Cologne: Bachem, 1975.
Kovach, Gretel C. "Pizza Chain Takes Pesos, and Complaints." *The New York Times*. January 15, 2007.
Kulp-Hill, Kathleen. "The Captions to the Miniatures of the 'Códice Rico' of the *Cantigas de Santa María*, a Translation." *Bulletin of the Cantigueros de Santa María* 7 (Spring 1995): 3–64.
———. *Songs of Holy Mary of Alfonso X, The Wise: A Translation of the Cantigas de Santa Maria*. Tempe: Arizona Center for Medieval and Renaissance Studies, 2000.
Lambert, Bruce. "N.H. Strouse, Chairman, 86, of Ad Agency." *The New York Times*. January 23, 1993.
Landau, David. "The Print Collection of Ferdinand Columbus (1488–1539)." In *Collecting Prints and Drawings in Europe, c.1500–1750*, edited by Christopher Baker, Caroline Elam, and Genevieve Warwick. Burlington, VT: Ashgate, 2003.
Lea, Henry Charles. "El Santo Niño de la Guardia." *The English Historical Review* 4, no. 14 (April 1889): 229–50.
Liber Usualis. Tournai: Desclée & Co., 1953. Reprint, Great Falls, MT: St. Bonaventura, 1997.
Lichtenwanger, William. "The Music of the 'Star-Spangled Banner'—Whence and Whither?" *College Music Symposium* 18, no. 2 (1978): 34–81.
The Liturgy Documents: A Parish Resource. 3rd ed. Chicago: Liturgy Training, 1991.
López del Álamo, María Paloma, and Fernando Valdés Fernández. "Arqueología del sitio." In *San Pedro Mártir el Real, Toledo*, edited by Ángel Alcalde and Isidro Sánchez. Ciudad Real: Universidad de Castilla–La Mancha, 1997.
López Torrijos, Rosa. "Representaciones de Hércules en obras religiosas del siglo XVI." *Boletín del seminario de estudios de arte y arqueología* 46 (1980): 293–308.
Macey, Patrick. *Bonfire Songs: Savonarola's Musical Legacy*. Oxford: Clarendon, 1998.
———. "Josquin as Classic: *Qui habitat, Memor esto*, and Two Imitations Unmasked." *Journal of the Royal Musical Association* 118, no. 1 (1993): 1–43.
Madurell y Marimon, José María. "El arte de la seda en Barcelona entre judios y conversos (notas para su historia)." *Sefarad* 25 (1965): 247–81.
The Malleus Maleficarum of Heinrich Kramer and James Sprenger. Translated by Montague Summers. 1928. Reprint, New York: Dover, 1971.

"Manuscripts. 39. Leaf from a Gradual with an Initial *I* with *The Virgin and Child with the Gentleman from Cologne and a Soldier.*" *The J. Paul Getty Museum Journal, Including Acquisitions/1995* 24 (1996): 109–10.

Martz, Linda. *A Network of Converso Families in Early Modern Toledo: Assimilating a Minority.* Ann Arbor: University of Michigan Press, 2003.

Mateo Gómez, Isabel. "Algunos temas profanos en las sillerías de coro góticas españolas." *Archivo español de arte* 43, no. 170 (1970): 181–92.

———. "Fábulas, refranes y emblemas, en las sillerías de coro góticas españolas." *Archivo español de arte* 49, no. 194 (1976): 145–60.

———. *Temas profanos en la escultura gótica española: Las sillerías de coro.* Madrid: Consejo Superior de Investigaciones Científicas, 1979.

———. "Los trabajos de Hércules en las sillerías de coro góticas españolas." *Archivo español de arte* 48, no. 189 (1975): 43–55.

Matter, Anne E. *"The Voice of My Beloved": The Song of Songs in Western Medieval Christianity.* Philadelphia: University of Pennsylvania Press, 1990.

McAndrew, John. *The Open-Air Churches of Sixteenth Century Mexico: Atrios, Posas, Open Chapels, and Other Studies.* Cambridge, MA: Harvard University Press, 1965.

McDonald, Mark P. "Extremely Curious and Important! Reconstructing the Print Collection of Ferdinand Columbus." In *Collecting Prints and Drawings in Europe, c. 1500–1750,* edited by Christopher Baker, Caroline Elam, and Genevieve Warwick. Burlington, VT: Ashgate, 2003.

Melnicki, Margareta. *Das einstimmige Kyrie des lateinischen Mittelalters.* Forschungsbeiträge zur Musikwissenschaft 1. Regensburg: Gustav Bosse Verlag, 1955.

Meznar, Joan. "Our Lady of the Rosary, African Slaves, and the Struggle against Heretics in Brazil, 1550–1660." *The Journal of Early Modern History* 9, nos. 3–4 (2005): 371–97.

Miller, John H. *Fundamentals of the Liturgy.* Notre Dame, IN: Fides, 1959.

Miranda Calvo, José. *La reconquista de Toledo por Alfonso VI.* Toledo: Instituto de Estudios Visigótico–Mozárabes de San Eugenio, 1980.

Montemayor, Julián. "La seda en Toledo en la época moderna." In *España y Portugal en las rutas de la seda: Diez siglos de producción y comercio entre oriente y occidente.* Comisión Española de la Ruta de la Seda. Barcelona: Universitat de Barcelona, 1996.

Montgomery, David. "An Anthem's Discordant Notes; Spanish Version of 'Star-Spangled Banner' Draws Strong Reactions." *The Washington Post.* April 28, 2006.

Moxó, Salvador de. *Los antiguos señorios de Toledo.* Toledo: Instituto Provincial de Investigaciones y Estudios Toledanos, 1973.

Muelas Jiménez, Mario, and Agustín Mateo Ortega. "La rehabilitación." In *San Pedro Mártir el Real, Toledo,* edited by Ángel Alcalde and Isidro Sánchez. Ciudad Real: Universidad de Castilla–La Mancha, 1997.

Muntada Torrellas, Anna. *Misal Rico de Cisneros.* Madrid: Real Fundación de Toledo, 2000.

Nelson, Kathleen E. *Medieval Liturgical Music of Zamora.* Musicological Studies 67. Ottowa: The Institute of Mediaeval Music, 1996.

Netanyahu, Benzion. *The Origins of the Inquisition in Fifteenth Century Spain.* 2nd ed. New York: New York Review, 2001.

"New Museum Celebrates the Lives of Arab Americans." Associated Press Worldstream. July 17, 2005.
"News & Comment (Obituary for Arthur Rau)." *The Book Collector* 22, no. 1 (Spring 1973): 86–89.
Noone, Michael J. *Music and Musicians in the Escorial Liturgy under the Habsburgs, 1563–1700*. Rochester, NY: University of Rochester Press, 1998.
O'Callaghan, Joseph F. *Reconquest and Crusade in Medieval Spain*. Philadelphia: University of Pennsylvania Press, 2003.
Ocampo, Florian de. *Los cinco libros primeros dela Crónica general de España*. 1553. Facsimile, Vitoria-Gasteiz: Gráficas Santamaria, 1997.
Ovason, David. *The Secret Symbols of the Dollar Bill*. New York: HarperCollins, 2004.
Panofsky, Erwin. *The Life and Art of Albrecht Dürer*. Princeton, NJ: Princeton University Press, 1955.
Parro, Sixto Ramón. *Toledo en la mano, ó descripcion histórico-artistica de la magnífica catedral y de los demas célebres monumentos*. Vol. 2. 1857. Facsimile, Toledo: Instituto Provincial de Investigaciones y Estudios Toledanos, 1978.
Pérez de Moya, Juan. *Philosophia secreta*. Edited by Eduardo Gómez de Baquero. 2 vols. Madrid: Campañia Ibero-Americana de Publicaciones, 1928.
Pérez Pastor, Cristóbal. *La imprenta en Toledo: Descripción bibliográfica de las obras impresas en La Imperial Ciudad desde 1483 hasta nuestros dias*. 1887. Facsimile, Valencia: Librerías "París-Valencia," 1994.
Pfaff, Richard William. *New Liturgical Feasts in Later Medieval England*. Oxford: Clarendon, 1970.
Pfister, Friedrich. "Herakles und Christus." *Archiv für Religionswissenschaft* 34 (1937): 42–60.
Philostratus. *The Life of Apollonius of Tyana: The Epistles of Apollonius and the Treatise of Eusebius*. Translated by F. C. Conybeare. Vol. 1. Cambridge, MA: Harvard University Press, 1948.
Physiologus. Translated by Michael J. Curley. Austin: University of Texas Press, 1979.
Pickering, Frederick P. *Literature and Art in the Middle Ages*. Coral Gables, FL: University of Miami Press, 1970.
Pisa, Francisco de. *Apuntamientos para la segunda parte de la "Descripción de la Imperial Ciudad de Toledo" según la copia manuscrita de D. Francisco de Santiago Palomares, con notas originales autógrafas del Cardenal Lorenzana*. Transcribed with notes by José Gómez-Menor Fuentes. Toledo: Instituto Provincial de Investigaciones y Estudios Toledanos, 1976.
———. *Descripción de la Imperial Ciudad de Toledo, y historia de sus antiguedades, y grandeza, y cosas memorables que en ella han acontecido*. 1605. Facsimile, Madrid: Villena Artes Gráficas, 1974.
Porres Martín-Cleto, Julio. "Las casas de la Inquisición en Toledo." *Toletum: Boletín de la Real Academia de Bellas Artes y Ciencias Históricas de Toledo* 20 (1986): 125–35.
———. *La desamortización del siglo XIX en Toledo*. Toledo: Diputación Provincial, 1965.
———. *Historia de las calles de Toledo*. Vol. 2. Toledo: Diputación Provincial, 1971.
Post, Chandler Rathfon. *A History of Spanish Painting*. 14 vols. Cambridge, MA: Harvard University Press, 1930–66.
———. *A History of Spanish Painting*. Vol. 7, pt. 1, *The Catalan School in the Middle Ages*. Cambridge, MA: Harvard University Press, 1938.

Post, Chandler Rathfon. *A History of Spanish Painting.* Vol. 8, pt. 1, *The Aragonese School in the Late Middle Ages.* Cambridge, MA: Harvard University Press, 1941.
———. *A History of Spanish Painting.* Vol. 9, pt. 2, *The Beginning of the Renaissance in Castile and Leon.* Cambridge, MA: Harvard University Press, 1947.
———. *A History of Spanish Painting.* Vol. 11, *The Valencian School in the Early Renaissance.* Cambridge, MA: Harvard University Press, 1953.
Prado, German. "El kyrial español." *Analecta sacra tarraconensia* 14 (1941): 97–128; 14 (1942): 43–63.
———. *Supplementum ad kyriale ex codicibus hispanicis excerptum.* Paris: Desclée & Socii, 1934.
Purtle, Carol J. *The Marian Paintings of Jan van Eyck.* Princeton, NJ: Princeton University Press, 1982.
Rabanal, Vicente, OSA. *Los cantorales de El Escorial.* El Escorial: Monasterio de El Escorial, 1947.
Randel, Don Michael. *The Responsorial Psalm Tones for the Mozarabic Office.* Princeton Studies in Music 3. Princeton, NJ: Princeton University Press, 1969.
"Recent Acquisitions Briefly Noted. The Witten Purchase." *Yale University Library Gazette* 64, nos. 3–4 (April 1990): 176–90.
Reid, Jane Davidson. *The Oxford Guide to Classical Mythology in the Arts, 1300–1990s.* New York: Oxford University Press, 1993.
Reynaud, François. *La polyphonie tolédane et son milieu des premiers témoignages aux environs de 1600.* Paris: CNRS Éditions, 1996.
Riesco de Iturri, María Begoña. "Propiedades y fortuna de los condes de Cifuentes: La constitución de su patrimonio a lo largo del siglo XV." *En la España Medieval* 15 (1992): 137–59.
Roschini, Gabriele. *Maria santissima nella storia della salvezza.* Isola del Liri: Pisani, 1969.
Rosell y Torres, Isidoro. "Estampa española del siglo XV grabada por Fray Francisco Domenec." *Museo español de antiguedades* 2 (1873): 445–64.
Roth, Cecil. *The Spanish Inquisition.* 1964. Reprint, New York: W. W. Norton, 1996.
Rothstein, Brett. "Vision and Devotion in Jan van Eyck's *Virgin and Child with Canon Joris van der Paele.*" *Word & Image* 15, no. 3 (1999): 262–76.
Rothstein, Edward. "A Mosaic of Arab Culture at Home in America." *The New York Times.* October 24, 2005.
Rubin, Miri. *Corpus Christi: The Eucharist in Late Medieval Culture.* Cambridge: Cambridge University Press, 1991.
Rubio, Samuel, OSA. *Las melodías gregorianas de los "libros corales" del monasterio del Escorial: Estudio crítico.* El Escorial: Ediciones Escurialenses, Real Monasterio del Escorial, 1982.
Ruiz de la Puerta, Fernando. *La cueva de Hércules y el palacio encantado de Toledo.* Madrid: Editora Nacional, 1977.
Rupprich, Hans. *Dürer Schriftlicher Nachlass.* 3 vols. Berlin: Deutscher Verein für Kunstwissenschaft, 1956–69.
Russell, John. "Morgan Library Gets Rare Manuscript Collection." *The New York Times.* May 9, 1984.
Sagel, Jim, ed. *La iglesia de Santa Cruz de la Cañada, 1733–1983.* Albuquerque, NM: Archdiocese of Santa Fe, 1983.

Schildbach, Martin. *Das einstimmige Agnus Dei und seine handschriftliche Überlieferung von 10. bis zum 16. Jahrhunderts.* Erlangen-Nürnberg: J. Hogl, 1967.

Schmid, Bernhold. *Der Gloria-Tropus Spiritus et alme bis zur Mitte des 15. Jahrhunderts.* Münchener Veröffentlich zur Musikgeschichte 46. Tutzing: Hans Schneider, 1988.

Schmid, Wolfgang. *Dürer als Unternehmer: Kunst, Humanismus und Ökonomie in Nürnberg um 1500.* Trier: Porta Alba, 2003.

Scott, Kathleen L. *Later Gothic Manuscripts 1390–1490. Catalogue and Indexes.* Vol. 6, pt. 2 of *A Survey of Manuscripts Illuminated in the British Isles,* edited by J. J. G. Alexander. London: Harvey Miller, 1996.

Serra i Boldú, Valeri. *Llibre d'or del rosari a Catalunya.* Barcelona: Edició Privada, 1925.

Seznec, Jean. *The Survival of the Pagan Gods: The Mythological Tradition and Its Place in Renaissance Humanism and Art.* Translated by Barbara F. Sessions. New York: Pantheon, 1953.

Sherr, Richard. "The Performance of Chant in the Renaissance and Its Interactions with Polyphony." In *Plainsong in the Age of Polyphony,* edited by Thomas Forrest Kelly. Cambridge: Cambridge University Press, 1992.

Shestack, Alan. *Fifteenth Century Engravings of Northern Europe from the National Gallery of Art, Washington, D.C.* Washington, DC: National Gallery of Art, 1967.

Sierra Pérez, José de. *Música para Felipe II Rey de España (Homenaje en el IV centenario de su muerte).* El Escorial: San Lorenzo de El Escorial, 1998.

Sigüenza, José. *La fundación del monasterio de El Escorial.* 1605. Reprint, Madrid: Aguilar, 1963.

Simon, Marcel. *Hercule et le christianisme.* Paris: Editions Orphrys, 1955.

Smijers, Albert, ed. *Werken van Josquin Des Prez. Missen XVII. Missa sine nomine.* Amsterdam: Vereniging voor Nederlandse Musiekgeschiedenis, 1952.

Snow, Robert J., ed. *A New-World Collection of Polyphony for Holy Week and the Salve Service: Guatemala City, Cathedral Archive, Music MS 4.* Monuments of Renaissance Music 9. Chicago: University of Chicago Press, 1996.

Sotheby's. *Western Manuscripts and Miniatures.* London. Tuesday, June 21, 1994.

Stevenson, Robert. "Josquin in the Music of Spain and Portugal." In *Josquin des Prez: Proceedings of the International Josquin Festival-Conference Held at The Juilliard School at Lincoln Center in New York City, 21–25 June 1971,* edited by Edward E. Lowinsky with Bonnie Blackburn. New York: Oxford University Press, 1976.

Stewart, Stanley. *The Garden Enclosed: The Tradition and the Image in Seventeenth-Century Poetry.* Madison: University of Wisconsin Press, 1966.

Strauss, Walter L., ed. *The Complete Drawings of Albrecht Dürer.* Vol. 3, *1510–1519.* New York: Abaris, 1974.

———, ed. *The Complete Engravings, Etchings and Drypoints of Albrecht Dürer.* New York: Dover, 1972.

———, ed. *The Intaglio Prints of Albrecht Dürer: Engravings, Etchings and Drypoints.* New York: Kennedy Galleries, 1977.

Tagliabue, John. "The Friar, Miraculously, Marches into Sainthood." *The New York Times.* June 17, 2002.

Tate, Robert B. "Mythology in Spanish Historiography of the Middle Ages and the Renaissance." *Hispanic Review* 22, no. 1 (1954): 1–18.

Thannabaur, Peter Josef. *Das einstimmige Sanctus der römischen Messe in der handschriftlichen Überlieferung des 11. bis 16. Jahrhunderts*. Erlanger Arbeiten zur Musikwissenschaft 1. Munich: Walter Ricke, 1962.
Urquhart, Peter. "An Accidental Flat in Josquin's *Sine Nomine* Mass." In *From Ciconia to Sweelinck: Donum natalicium Willem Elders*, edited by Albert Clement and Eric Jas. Amsterdam: Editions Rodopi, 1994.
Valerius Flaccus, Gaius. *The Voyage of the Argo: The Argonautica of Gaius Valerius Flaccus*. Translated by David R. Slavitt. Baltimore: Johns Hopkins University Press, 1999.
Vega González, Jesúsa. *La imprenta en Toledo: Estampas del Renacimiento, 1500–1550*. Toledo: Instituto Provincial de Investigaciones y Estudios Toledanos, 1983.
———. "Impresores y libros en el origen del renacimiento en España." In *Reyes y mecenas: Los reyes católicos—Maximiliano I y los inicios de la casa de Austria en España*. Milan: Electa España, 1992.
Villena, Enrique de. *Los doze trabajos de Hércules*. Edited by Margherita Morreale. Madrid: Real Academia Española, 1958.
———. *Los doze trabajos de Hercules*. In Vol. 1 of *Obras completas*, edited by Manuel Arroyo Stephens. Madrid: Turner Libros, 1994.
Voragine, Jacobus de. *The Golden Legend: Readings on the Saints*. Translated by William Granger Ryan. 2 vols. Princeton, NJ: Princeton University Press, 1993.
Walther, Hans. *Carmina medii aevi posterioris latina*. Vol. 1, *Initia carminum ac versuum medii aevi posterioris latinorum*. Göttingen: Vandenhoeck & Ruprecht, 1959.
Warner, Marina. *Alone of All Her Sex: The Myth and the Cult of the Virgin Mary*. New York: Vintage, 1983.
Wieck, Roger S. *Late Medieval and Renaissance Illuminated Manuscripts, 1350–1525, in the Houghton Library*. Cambridge, MA: Department of Printing and Graphic Arts, Harvard College Library, 1983.
Winkler, Friedrich. *Die Zeichnungen Albrecht Dürers*. 4 vols. Berlin: Deutscher Verein für Kunstwissenschaft, 1936–39.
Winston-Allen, Anne. *Stories of the Rose: The Making of the Rosary in the Middle Ages*. University Park: Pennsylvania State University Press, 1997.
Witten, Laurence. "Vinland's Saga Recalled." In *Proceedings of the Vinland Map Conference*, edited by Wilcomb E. Washburn. Chicago: University of Chicago Press, 1971.
Wright, Craig. "A 16th Century Plainsong Manuscript at Yale." Paper presented at a conference in honor of David Hughes, Harvard University, Cambridge, MA, 1990.
———. *The Maze and the Warrior: Symbols in Architecture, Theology, and Music*. Cambridge, MA: Harvard University Press, 2001.

Index

Note: Figures are located after page 127 in the text and are indicated by fig. in the index.

Abingdon Abbey, Missal of, 60
Acuña family, 7, 59–60, 166n7
"Ad te levavi," 8, 16, 62
Adolf of Essen, 45
Agnus Dei, 2–3, 18, 94–95, 99–101, 134, 138–41
Ahlberg-Cornell, Gudrun, 88
Alanus de Rupe, 68, 69, 71, 72, 183n57
Albigensian heresy, 110, 125
Alcocer, Pedro de, 83, 92, 93
Alexander VI (pope), 27
Alfonso (king of Portugal), 66
Alfonso de Cusanza, 25
Alfonso X (king of Castile), 83, 187n54; *Cantigas de Santa María,* 52–56, 126, 165n56; *General estoria,* 89, 90
Alfonso XI (king of Castile), 24
Andrew (saint), fig. 30, 127, 128
Angulo Iñiguez, Diego, 171n1
Anselm (saint), 63–64
Antaeus, fig. 15, 2, 79, 82, 85, 89
Anzelewsky, Fedja, 86, 87
Apollodorus, 88, 91
Aquinas, Thomas (saint), 43
Archivo de la Coruña (Barcelona), 7
Archivo Histórico Nacional (Madrid), 34–36
Armed Man, 108–14. *See also* "L'homme armé"
Art Institute of Chicago, 13–15
Arte de melodía sobre canto lano y canto d'organo, 101–2
autos de fé, 27–29
"Ave Maria," 1, 67, 94, 111; in *Cantigas de Santa María,* 54–55; Domènech's engraving for, fig. 11, 41–42; in *Llibre Vermell,* 75–78; psalms and, 70–72; as test for heretics, 124–25
"Ave Stella Maris," 111
Ayala family, 23–24

Babcock, Robert, 15
Barrado, José, 153n27
Beinecke Library Ms. 710. *See* Rosary Cantoral
Beinecke Library Ms. 794, fig. 4, 7–8, 14, 39, 64–66
Benedict XIII (pope), 23
Bermudez de Pedrazas, Francisco, 152n47, 179n15
Bernard de la Sauvetat, 96
Bernard of Clairvaux (saint), 63, 68
Black Madonna of Montserrat, 56, 75
Boccaccio, Giovanni, 89–91, 93
Bonaventura (saint), 61–63, 68
Boniface II (pope), 67
Bosch, Lynette, 6–7, 166n7
Botticelli, Sandro, 86
Breviary, Mozarabic, 32
Brewer, Frances J., 10
buletas, 31–32, 123
Burgos, 6, 18, 58–60, 95, 99
Burton Historical Collection (Detroit), 9

Cantigas de Santa María, 52–56, 126, 165n56
cantorales, 1, 20, 21
Carlist War, 37
Castro, Bartolomé de, fig. 14, 69–70
Castro, Juan Nicolau, 36
Catherine of Siena (saint), 43
Cavaller de Colunya, 39–57, 161n17; devotional writings on, 43–47; in Domènech's engraving, fig. 11, 43; iconography of, fig. 10, fig. 27, 41–43. *See also* Knight of Cologne; Miracle of the Gentleman of Cologne
Charles V (Holy Roman Emperor), 121–22
Cifuentes, counts of, 23–26
Códice Rico, 55

cofradías. See confraternities
Cologne, Gentleman of, 8–9, 12, 14–20, 40–44. *See also* confraternity of Cologne
Columbus, Ferdinand, 44, 85, 161n19
compound trope, for Agnus Dei, 99–101, 140–41
Conat, Mabel, 9, 13
confraternities, 1, 67, 117–18; Brazilian, 124; finances of, 35–36, 118–20
confraternity of Cologne, 19, 45–46; founding of, 46–47, 56; membership in, 116–17; "Miserere Mei" and, 70–75; prayer of, 67–70. *See also* Cologne, Gentleman of
confraternity of La Coruña, 119, 120
Confraternity of the Psalter [Rosary] of Our Lord Jesus Christ and the Virgin Mary, 68
confraternity of Toledo, 33–35, 116–27; emblem of, 75–78; finances of, 35–36, 119–20; Inquisition and, 122–23; Knight of Cologne and, 57, 125–27; silk weavers and, 20, 32, 35, 120–26, 142–44, 186n28
confraternity of Zaragoza, 75–78, 118–20
conversos, 28–29, 121–22, 124, 127, 186n28
Credo, 2, 18, 94, 101; of Josquin Desprez, 4, 105–7
Crónica general de 1344, 83
Crusade, 109; Bulls of the, 31–32, 123; Rosary, 130

Dante Alighieri, 80
Desamortización (Great Disentailment), 21, 36–37
Desprez, Josquin, fig. 24, 3–4, 105–9, 112–14, 183n63
Determinatio quodlibetalis facta colonie, 72–73
Detroit Public Library, 9–12, 14
Dialogus beatae Mariae et Anselmi de passione Domini, 63–64
Diez, Felipe, 59
Dobner, Joseph, 49–50
Domènech, Francisco, fig. 11, 41–47
Dominic (saint), 22, 43, 82, 110; Albigensian heresy and, 125; in "El rosario perseguido," 120
Dominic of Prussia (monk), 45, 71
Dominican Order: history of, 22; rosary confraternities and, 19; at San Pedro Mártir, 22–23

Los doze trabajos de Hércules, 80–82, 90, 91, 172n10
dragon, Hesperian, fig. 5, fig. 16, 2, 8, 79, 80, 84, 89
Dürer, Albrecht: *Das Meerwunder*, fig. 18, 2, 79–80, 85–88, 91; *Pupila Augusta*, 86; *Venus Riding on a Dolphin*, 87
Duschnes, Philip C., 9–10, 12–14, 16

Edmund of Canterbury (saint), 66, 67
Ellison, Keith (U.S. congressman), 130
Engelbert (abbot), 70–71
Enrique II (king of Castile), 24
Enrique III (king of Castile), 24, 25
Enrique IV (king of Castile), 27
estrunto, 102, 103
"Et incarnatus est," fig. 24, fig. 25, 106–8, 110–14
Eulalia (saint), 42
exclaustration (of San Pedro Mártir), 36–37
Eyck, Jan van, 40

faburden, 108, 182n50
Fernando III (king of Castile), 22
Fernando V (king of Castile), 18, 26, 27, 31, 179n15
Ferrajoli, Enzo, 16–17
Ferrini, Bruce, 14
finch (as symbol), fig. 29, 63, 167n19
Five Wounds of Christ, fig. 1, fig. 2, 6; Christ's Passion and, 58–63; cult of, 66–67; as heraldic emblem, 2, 6–7, 9, 60, 66; Knight of Cologne and, 126; "Miserere Mei" and, fig. 12, 2, 7, 8, 14, 58; prophesies of, 63–66; rosary and, 67–70. *See also* stigmata
Fogg, Sam. *See* Sam Fogg Rare Books
Francis of Assisi (saint), 6, 10, 19, 58–59
Franco, Francisco, 38
Frederick III (Holy Roman Emperor), fig. 11, 42
Friedmann, Herbert, 167n19
Fritzlar monastery, 67
Fuensalida, counts of, 23–25

Gaitan, Lope, 23
Genealogie deorum, 89–91, 93
Gentleman of Cologne. *See* Miracle of the Gentleman of Cologne
Getty Museum Ms. 61, fig. 6, fig. 28, 12–14, 60–62

Giraldi, Lilio Gregorio, 90
Glazier, William S., 8, 9, 13–14, 16
Gloria, 2–3, 18, 101; mensural chant for, fig. 23, 104, 105; tropes for, fig. 26, 94–95, 138
"golden flower necklace," 69
Gómez de Silva, Arias, 24, 25
Gómez, Diego, 123
González de Mendoza, Pedro, 18, 179n15
González de Zárate, Jesús María, 86
González, Manuel, 152n54
Gonzálvez Ruiz, Ramón, 155n66
Gorricio, Melchor, 32
grace notes. *See locus, uncus*
Graff, Everett D., 13
Granada, 18, 31, 179n15
Green, Peter, 177n62
Gregorian chant, 95. *See also* plainchant
Gregory XIII (pope), 109
Guerrero Lovillo, José, 165n56
Günther, Jörn, 14
Gutiérrez, Julián, 32
Guzmán, Leonor de, 24

Hagenbach, Pedro de, 32–33, 47, 85, 156n77
Hall, Linda B., 183n60
Hamusco, Diego de, 23, 25
heraldry, 2, 6–7, 9, 60, 66, 153n13
Hercules, 17, 79–85; Antaeus and, fig. 15, 2, 79, 82, 85, 89; Labors of, 171n3; in Spain, 80–82; in Toledo, 19, 83–85, 129
heresy, 110, 124–25
Hesperian dragon, fig. 5, fig. 16, 2, 8, 79, 80, 84, 89
Hispanic Society of America (New York), 6
Holy League, 109, 111, 125
Honorius III (pope), 22
Hospital de la Misericordia (Toledo), 23
Houghton Library (Harvard), 60
Housely, Norman, 155n67
Las Huelgas manuscript, 99
Hughes, Andrew, 151n46
Hutz, Leonardo, 32, 156n77
Hymne de l'Hercule Chrestien, 80

indulgences, 31–32
Innocent VI (pope), 67
Innocent VIII (pope), fig. 11, 31, 42

Inquisition, 27–30; *conversos* and, 121, 127; finances of, 30, 121–22; silk weavers and, 122–25, 142–44
Insulis, Michael Franciscus de, 72–73, 75
"Intret in conspectu tuo," 7, 65
Isabel I (queen of Castile), 18, 26, 27, 31, 179n15
Isidore of Seville (saint), 99

Jeremiah (prophet), 65–66
Jerome (saint), 99, 180n27
Jiménez de Cisneros, Francisco, 32
Jiménez de Préxano, Pedro, 32
Jiménez de Rada, Rodrigo, 22, 83
John Paul II (pope), 59, 72
John XXII (pope), 67
Josquin. *See* Desprez, Josquin
Juan I (king of Castile), 24, 27
Juan II (king of Castile), 25
Juan of Austria, 109
"Judica me deus," 12, 60–61

Kamen, Henry, 28, 125
Key, Francis Scott, 188n3
Knight of Cologne, fig. 10, fig. 30, 69, 109, 114–15, 125–28; *Cantigas de Santa María* and, 52–55; Five Wounds of Christ emblem and, 126; Medieval origins of, 47–51; Spanish confraternities and, 57, 117. *See also* Cavaller de Colunya
Kramer, Heinrich, 47
Kyrie, 2–3, 39, 94–97, 102, 133–34, 137–40

La Coruña, rosary confraternity of, 119
La Sisla monastery (Toledo), 121
"Las Gaitanas" convent (Toledo), 23
Laurence Witten Rare Books. *See* Witten, Laurence
Leo X (pope), 120, 185n24
Lepanto, Battle of, 109–11, 125, 130
"L'homme armé" (song), fig. 25, 4, 105–7, 110–11, 114
Liber Experientiarum, 45
Liber Pontificalis, 60
Llibre Vermell, 75–78
logogene tropes, 95, 99–101
López de Ayala, Pedro, 24, 25
López, Juan, 30, 47, 109
Luther, Martin, 183n63

Madonna della Misericordia, 111
Maenad, fig. 19
Maggs Brothers, 15
Magnificat, 7, 65, 127
Maíno, Juan Bautista, 37
Malleus Maleficarum, 47
Marineo Sículo, Lucio, 83
Martínez, Ferrán, 28
Martínez Silíceo, Juan, 84, 114
Martz, Linda, 186n28
Maximilian I (Holy Roman Emperor), fig. 11, 42
Medicean Gradual, 4
melogene tropes, 178n3; for Kyrie, 95–97; for Sanctus, 97–99
Mendizábal, Juan Álvarez, 21, 37
Meneses, Guiomar de, 23, 25, 26
mensural chant, for Gloria, fig. 23, 104, 105
Messia, Francisco, 47, 118
Metamorphoses (Ovid), 80, 173n13
Metropolitan Museum of Art (New York), fig. 11, fig. 20, 87
Mexico, 58, 69
Miracle of the Gentleman of Cologne, 12, 14, 20; Post on, 8–9, 15, 17, 19, 40–44. See also Cavaller de Colunya
"Miserere Mei": Five Wounds of Christ and, fig. 12, 2, 7, 8, 14, 58; Psalm 50 and, 19–20, 73–75; rosary and, 70–75
Missa quarta (Palestrina), 110
Missa Humiliavit, 66–67
Missa sine nomine (Josquin Desprez), fig. 24, 3–4, 105–7, 112–14
Missal of Abingdon Abbey, 60
Montserrat, Black Madonna of, 56, 75
Morales, Cristóbal de, 110, 114
Morales, Fernando de, 70
Moreto y Cabaña, Agustín de, 185n22
Morgan Library Ms. M887-1, fig. 5, fig. 27, fig. 29, 8–13, 16, 62–63, 80, 82
Morgan Library Ms. M887-2, 8–11, 13
Moses, 46
Mozarabic Breviary, 32
Mozarabic Mass, 95, 102
Mysteries (of the rosary): Fifteen, fig. 11, 1, 42, 67; Luminous, 170n58

Nereid, fig. 20, 87
Newberry, John S., Jr., 9
"Nos autem gloriari," 9
number symbolism, 19–20
Nürnberger Garten, 68–69

Ogea, Diego de, 118
Old-Hispanic rite, 95
"Omnes virgines," 97–98
Ortiz, Blas, 33, 83, 84, 120, 177n58, 187n49
Osanna. See Sanctus
Our Lady of the Rosary chapel (Toledo), 20, 33, 34, 35
Ourique, Battle of, 66
Ovid, *Metamorphoses* of, 80, 173n13
owl (as symbol), fig. 29, 63

Palestrina, Giovanni Pierluigi da, 110
Panofsky, Erwin, 87
Passion of Christ, 58–63
"Pater noster," 67–70, 94; Domènech's engraving for, fig. 11, 41–42; Five Wounds of Christ and, 20; as test for heretics, 124–25
Paul (saint), fig. 4, fig. 30, 127, 128, 183n61
peacock (as symbol), 63, 167n17
Pedro I (king of Castile), 24
Pentecost, 4, 11, 12
Pérez de Moya, Juan, 90–92
Peter Martyr (saint), 43
Peter of Verona (saint), 23. See also Peter Martyr (saint)
Philip II (king of Spain), 66, 67, 107, 109
Philip III (king of Spain), 32
Philosophia secreta, 90–92
Pierpont Morgan Library (New York), 8–11, 13–15
Pio da Pietrelcina (saint), 59
Pisa, Francisco de, 34
Pius V (pope), 109–11, 185n24
plainchant, 1, 18–20, 95, 107; five-line staff for, 17; ornamented, 2–3, 101–3
Plummer, John, 8–9, 13
polyphony, 5, 17, 103–8, 145–47
Portugal, 23–24, 52, 66
Post, Chandler Rathfon, 8–9, 15, 17, 19, 40–44
printing press: at San Pedro Mártir, 30–33, 35, 123; at Valencia, 43–44
prosulae, 95
Psalm(s), 66, 70, 72; #21, 64; #42, 60; #50, 19–20, 73–75
Psalterium Beatae Mariae Virginis, 70–71
"Puer natus est," 14
punctus, 18

Quadruplicium concionum super evangelia, 59
"Quasi modo geniti infantes," 14
Questiones logicae, fig. 14, 69–70
Quevedo, Bartolomé de, 114

Rau, Arthur, 12–16, 131–32, 151n36
Rauch, Nicolas, 16
"Resurrexi et adhuc," 8
"Rex virginum amator," 3, 39
Rhön, Kaspar von der, 87
Riera, Jaume, 7
Rivera, Juan Francisco, 10
Ronsard, Pierre de, 80
rood legend, 75
"El rosario perseguido" (play), 120
rosary: cult of, 8, 17, 19; Domènech's engraving for, fig. 11, 41–42; exercise of, 1; Five Wounds of Christ and, 67–70; as "golden flower necklace," 69; manuals on, 47, 118; Mass of, 109; "Miserere Mei" and, 70–75; versions of, 67–68, 70–72. *See also* confraternities
Rosary Cantoral, fig. 1, fig. 2, fig. 22, fig. 23, fig. 24, fig. 25, fig. 26; collation of, 4–5; detailed images of, fig. 10, fig. 12, fig. 15, fig. 16, fig. 17; music of, 2–4, 94–115, 133–34, 137–38, 145–47; related folios of, 7–17, 131–33; size of, 1, 40
Rosary Crusade, 130
Rupe, Alanus de, 68, 69, 71, 72, 183n57

"Sacerdos et pontifex," 7, 39, 65, 127
Sachs, Hans, 87
Sagastizabal, Juan, 47
Saint Andrew's Church (Cologne), 19, 47, 48, 70, 116, 127
Saint Romanus church (Toulouse), 22, 23
Salazar de Mendoza, Pedro, 84
Salterio y rosario de nuestra señora, 70
Salutati, Coluccio, 90
Salvaniach, Duran, 43–44
Sam Fogg Rare Books, 7, 12, 15
San Andrés Calpan church (Puebla, Mexico), 58
San Ginés church (Toledo), 19
San Juan de los Reyes convent (Toledo), 58
San Pablo del Granadal convent (Toledo), 22–23, 25
San Pedro Mártir de Toledo convent, 20–38, 127, 135–36; exclaustration of, 36–37; Inquisition and, 27–30, 123; patronage of, 125–26; printing press of, 30–33, 35, 123; Silva family and, 23–27
San Román church (Toledo), 23, 26
San Román parish (Toledo), 123, 142–43
Sánchez, Francisco, 47
Sánchez, Manuel, 123
Sanctus, 2–3, 18, 94–99, 134, 138, 140
Santa Cruz de la Cañada church (New Mexico), 59
Santa María la Blanca (Toledo), 28
Santa María la Real de Las Huelgas convent (Burgos), 99
Santo Domingo de Ocaña convent, fig. 8, fig. 9, 21, 37, 152n55
Santo Domingo de Silos monastery, 95
Santo Tomé parish (Toledo), 33, 123, 142
Saragossa [Zaragoza], Cathedral of, 16. *See also* Zaragoza
Savonarola, Girolamo, 73–74, 82
Schongauer, Martin, 63
September 11th attacks, 129–30
Serra i Boldú, Valeri, 41, 43, 44, 47–48
Seznec, Jean, 174n32
Shaffer, Ellen, 11
Sider, Sandra, 6
Silíceo, Cardinal and Archbishop. *See* Martínez Silíceo, Juan
silk industry, Toledan, 20, 33, 57, 120–26, 142–44, 186n28
Silva family, 23–27
Silverado Museum (St. Helena, CA), 10–11
Sixtus IV (pope), 27, 31
Solinus, C. Julius, 91
Songs of Holy Mary. *See Cantigas de Santa María*
Sotheby's, 12–13, 15
Spanish Civil War (1936–39), 11, 12, 14, 21, 37–38
"Spiritus domini," 11
"Spiritus et alme," fig. 26, 111–12, 138
Sprenger, Jakob, 47, 48, 56; "Ave Marias" and, 70–73; Five Wounds of Christ and, 19–20; Insulis and, 72, 75; rosary confraternity of, 19, 68, 70, 116–17
"Star-Spangled Banner," 129
Stevenson, Robert Louis, 10
stigmata, 6, 10, 19, 59. *See also* Five Wounds of Christ
Strouse, Norman, 10–16
Summi templi toletani, 33, 120

Taix, Hieronimo, 47, 72
Téllez, Antonio, 32
tempus imperfectum, 102
Tenorio de Silva, Alfonso, 23–26
Tenorio, Pedro, 25
Tenorio, Urraca, 24
teocuitlaxuchicozcatl ("golden flower necklace"), 69
tocus, fig. 22, 18, 102
Toledo, 10; Alcocer's history of, 83, 92, 93; *conversos* in, 28, 121–22, 124; Hercules in, 19, 83–85, 129; Inquisition in, 28–30; plainchant in, 101–3; silk industry of, 20, 33, 120, 122–26, 142–44
Toro, Battle of, 27
Torquemada, Juan de, 27
Torquemada, Tomás de, 26–28, 30, 123
Torrentes, Andrés de, 114
Toulouse, 22, 95, 98
Trastámaran kings, 24, 27
Trellat sumariament fet dela bulla, o cofraria del psaltiri o roser, fig. 13, 44–45, 69, 70, 117, 118
tropes, fig. 26, 2–3, 94–99, 138, 178n1; compound trope, 99–101, 140–41
troubadours, 52
uncus, fig. 22, 18, 102

Unser Jungfrauwen Mariae Rosengertlin, 45
Urquhart, Peter, 183n68

Vázquez, Juan, 32
Villaquirán, Juan de, 69, 70
Villena, Enrique de, 80–82, 90, 91, 172n10
Vincent Ferrer (saint), 28, 42, 48–49, 56, 127
"Vinland Map," 16
Virgil, 91
"Virgin Mary's Chaplet of Roses," 50–51, 126–27
Visigothic rite, 95
Vitis Mystica, 68
Vitry, Philippe de, 80
Vivar, Alonso de, 34–35
Voelkle, William, 10–11, 14, 15

Warner, Marina, 182n57
Whit Sunday. *See* Pentecost
Winston-Allen, Anne, 174n32, 183n57
Witten, Laurence, 1, 6, 15–16, 132–33

Yale University Art Gallery, fig. 18
Yarza, Juan de, 30

Zaragoza, 16–17, 22; rosary confraternity of, 75–78, 118–20. *See also* Saragossa [Zaragoza], Cathedral of
Zechariah (prophet), 64–66

Eastman Studies in Music

The Poetic Debussy: A Collection of His Song Texts and Selected Letters (Revised Second Edition)
Edited by Margaret G. Cobb

Concert Music, Rock, and Jazz since 1945: Essays and Analytical Studies
Edited by Elizabeth West Marvin and Richard Hermann

Music and the Occult: French Musical Philosophies, 1750–1950
Joscelyn Godwin

"Wanderjahre of a Revolutionist" and Other Essays on American Music
Arthur Farwell, edited by Thomas Stoner

French Organ Music from the Revolution to Franck and Widor
Edited by Lawrence Archbold and William J. Peterson

Musical Creativity in Twentieth-Century China: Abing, His Music, and Its Changing Meanings
(includes CD)
Jonathan P. J. Stock

Elliott Carter: Collected Essays and Lectures, 1937–1995
Edited by Jonathan W. Bernard

Music Theory in Concept and Practice
Edited by James M. Baker, David W. Beach, and Jonathan W. Bernard

Music and Musicians in the Escorial Liturgy under the Habsburgs, 1563–1700
Michael J. Noone

Analyzing Wagner's Operas: Alfred Lorenz and German Nationalist Ideology
Stephen McClatchie

The Gardano Music Printing Firms, 1569–1611
Richard J. Agee

"The Broadway Sound": The Autobiography and Selected Essays of Robert Russell Bennett
Edited by George J. Ferencz

Theories of Fugue from the Age of Josquin to the Age of Bach
Paul Mark Walker

The Chansons of Orlando di Lasso and Their Protestant Listeners: Music, Piety, and Print in Sixteenth-Century France
Richard Freedman

Berlioz's Semi-Operas: Roméo et Juliette *and* La damnation de Faust
Daniel Albright

The Gamelan Digul and the Prison-Camp Musician Who Built It: An Australian Link with the Indonesian Revolution
Margaret J. Kartomi

*"The Music of American Folk Song"
and Selected Other Writings on
American Folk Music*
Ruth Crawford Seeger, edited by
Larry Polansky and Judith Tick

Portrait of Percy Grainger
Edited by Malcolm Gillies
and David Pear

Berlioz: Past, Present, Future
Edited by Peter Bloom

*The Musical Madhouse
(Les Grotesques de la musique)*
Hector Berlioz
Translated and edited by
Alastair Bruce
Introduction by Hugh Macdonald

The Music of Luigi Dallapiccola
Raymond Fearn

*Music's Modern Muse: A Life of
Winnaretta Singer, Princesse de Polignac*
Sylvia Kahan

The Sea on Fire: Jean Barraqué
Paul Griffiths

*"Claude Debussy As I Knew Him" and
Other Writings of Arthur Hartmann*
Edited by Samuel Hsu,
Sidney Grolnic, and Mark Peters
Foreword by David Grayson

*Schumann's Piano Cycles and the
Novels of Jean Paul*
Erika Reiman

*Bach and the Pedal Clavichord:
An Organist's Guide*
Joel Speerstra

*Historical Musicology:
Sources, Methods, Interpretations*
Edited by Stephen A. Crist and
Roberta Montemorra Marvin

*The Pleasure of Modernist Music:
Listening, Meaning, Intention, Ideology*
Edited by Arved Ashby

*Debussy's Letters to Inghelbrecht:
The Story of a Musical Friendship*
Annotated by Margaret G. Cobb

*Explaining Tonality:
Schenkerian Theory and Beyond*
Matthew Brown

*The Substance of Things Heard:
Writings about Music*
Paul Griffiths

*Musical Encounters at the
1889 Paris World's Fair*
Annegret Fauser

*Aspects of Unity in J. S. Bach's
Partitas and Suites: An Analytical Study*
David W. Beach

Letters I Never Mailed: Clues to a Life
Alec Wilder
Annotated by David Demsey
Foreword by Marian McPartland

*Wagner and Wagnerism in Nineteenth-
Century Sweden, Finland, and
the Baltic Provinces:
Reception, Enthusiasm, Cult*
Hannu Salmi

*Bach's Changing World:
Voices in the Community*
Edited by Carol K. Baron

CageTalk: Dialogues with and about John Cage
Edited by Peter Dickinson

European Music and Musicians in New York City, 1840–1900
Edited by John Graziano

Schubert in the European Imagination, Volume 1: The Romantic and Victorian Eras
Scott Messing

Opera and Ideology in Prague: Polemics and Practice at the National Theater, 1900–1938
Brian S. Locke

Ruth Crawford Seeger's Worlds Innovation and Tradition in Twentieth-Century American Music
Edited by Ray Allen and Ellie M. Hisama

Schubert in the European Imagination, Volume 2: Fin-de-Siècle Vienna
Scott Messing

Mendelssohn, Goethe, and the Walpurgis Night: The Heathen Muse in European Culture, 1700–1850
John Michael Cooper

Dieterich Buxtehude: Organist in Lübeck
Kerala J. Snyder

Musicking Shakespeare: A Conflict of Theatres
Daniel Albright

Pentatonicism from the Eighteenth Century to Debussy
Jeremy Day-O'Connell

Maurice Duruflé: The Man and His Music
James E. Frazier

Representing Non-Western Music in Nineteenth-Century Britain
Bennett Zon

The Music of the Moravian Church in America
Edited by Nola Reed Knouse

Music Theory and Mathematics: Chords, Collections, and Transformations
Edited by Jack Douthett, Martha M. Hyde, and Charles J. Smith

The Rosary Cantoral: Ritual and Social Design in a Chantbook from Early Renaissance Toledo
Lorenzo Candelaria

www.ingramcontent.com/pod-product-compliance
Lightning Source LLC
Chambersburg PA
CBHW060948230426
43665CB00015B/2112